Onsen water snow clearing

Camilla makes more friends

It's Been a Busy Morning

Nagai-San, AKA Mr Bond

SNOW SEARCH JAPAN

The origins of this book can be dated back to a party conversation in New Zealand, during the NZ winter of 2006. A media trip to Hokkaido was suggested, with the goal of reviewing the lesser-known Hokkaido-based resorts on behalf of the World Snowboard Guide.

It quickly became apparent that so much more information than just a resort guide was needed for visitors, and what began as a three-week trip for two in February 2007 grew into three long (but extremely fun) years of extensive travelling and research, throughout Japan's mountainous regions.

With the invaluable support of Japan's tourism organisations and a vastly skilled team of contributing snow sport experts, this three year process resulted in producing the ultimate travel companion for skiing and snowboarding visitors to a country known for its cultural obscurities, compact technology and crispy-dry powder.

...sents to ...rch Japan!

D0721665

Front cover, photo taken by Camilla Stoddart (whiteroompictures.com) of Jamie MacKay
Back cover photo taken by Natalie Mayer (NatalieMayer.com) of Orlando von Einsiedel
Opposite photo: Steve Dowle

Book template design by lindsey bodenham, www.ogeedesign.com

Big thanks to: James Mutter, Jacobina (Beanie) Milne Home ,Shintaro
Koizumi, Takeshi Mizuguchi, Mike Harris, Tomoka Takayama, Amy
and Shirou Shimizu, Kylie Clark, Noriko Sasaki, Raegan Tipping,
Nahoko Harazawa, James Woodward, Nina Judge, Yuya Nagai, Kyle
Drubek, major thanks to our advertisers for supporting us. All of
our contributing team and, most importantly, Kenji Matsuzawa –
without you Kenji this book would never have happened.

Snow-search Japan 1st edition
ISBN 978-0-9548014-3-4

1st edition – October 2009
First published 2009

Produced and published by:
WSG Media Ltd, Regency House
2 Wood Street, Queen Square
Bath BA1 2JQ, England

Email: info@wsg-media.com
Web: www.wsg-media.com

UK & Europe distribution: Vine House Distribution Ltd
Telephone: +44 (0)1825 723 398 Web: www.vinehouseuk.co.uk

USA distribution: SCB Distributors
Telephone: +1 (800) 729-6423 Web: www.scbdistributors.com

Australasia distribution: Australian Book Group
Telephone: 03 5625 4290 Web: www.australianbookgroup.com.au

Printed in China by: 1010 Printing Ltd
www.1010printing.com

Contents

Contributors

Keith Stubbs – Coordinating Author
WWW.WSG-MEDIA.COM/TEAM/KEITHSTUBBS

Our own trip organising extraordinaire, Keith ran each and every research trip for this guidebook, and has dedicated a large portion of his of his life to this project over the past three years. Based in New Zealand, Keith has been working directly in the snow sports industry continuously throughout his adult life; from instructing and coaching through to marketing and writing – the list of his industry involvements never seems to end.

Recently, Keith's been dividing his time between Wanaka, NZ and Hokkaido, Japan. He still keeps a few fingers well submerged in the instructing game, working for New Zealand Snowsport Instructor Alliance, and currently rides for Rome Snowboards and Adidas Eyewear. He loves writing about Japan's striking uniqueness (almost as much as practicing his very elementary 'Nihongo' with tipsy locals in Japanese bars), and manages to find the time to dabble in web communications with his own business Tactic Group.

Keith's favourite Japanese ski resort: "Myoko Akakura for its sweet pillow lines and true Japanese vibe. Or maybe Sapporo Teine for its convenience and spectacular ocean views."

Keith's must-do recommendation when visiting Japan: "Pay the Snow Monkeys a visit. Absolutely captivating!"

Steve Dowle – Publisher
WWW.WSG-MEDIA.COM/TEAM/STEVEDOWLE

Steve gave up a well paid yet unfulfilling life as a full-time software developer back in 2000 when he discovered snowboarding, and soon after took over running the World Snowboard Guide. He has since visited about 150 resorts across 13 countries and this is the 4th book he has published.

He currently lives in Zurich in Switzerland and is slowly inching towards his dream of living permanently in the mountains.

Steve's favourite Japanese ski resort: "Ishiuchi for the man-made, Myoko Akakura for the nature-made, and Niseko for the worst hangover ever."

Steve's must-do recommendation when visiting Japan: "Eat first, ask later, and don't be sceptical when someone offers you something. Having lived in London for 10 years I'd grown so untrusting of people. When a stranger offered me a chocolate bar on a ski-bus, my first thought was that it was laced with something."

Andrew Kelly – Resort Reviewer
WWW.SNOWSEASONJAPAN.COM

Andrew has lived and worked in the mountains of Japan for five years, after studying Japanese History at Oxford. With extensive local knowledge, Andy has guided action sports media trips and founded Snow Season Japan offering winter season holidays with Japanese language courses, to share the amazing culture of Japan.

Now based in Nagano and Tokyo, Andy teaches at Waseda University in the off-season and chases powder throughout the winter months. Alongside writing, he organises and MC's snowboard competitions, and tries to find time to improve his skateboard photography.

Andy's favourite Japanese ski resort: "Nothing beats the magnificence of the Japanese Alps, and Happo-One in Hakuba is where I want to be when the snow falls."

Andy's must-do recommendation when visiting Japan: "A trip to the Nozawa Onsen Fire Festival, the 'Dosojin Hi-matsuri', is one of the most intense and exciting experiences in Japan."

Camilla Stoddart – Photographer
WWW.WHITEROOMPICTURES.COM

Camilla has been shooting still photos in the snow industry since 2005, specialising in travel and photojournalism. Some of Camilla's more recent trips include Kashmir, Japan, New Zealand and various European locations. In addition to her countless frequently published images, Camilla writes a number of feature articles for various international magazines.

Camilla spends the Southern Hemisphere winters based out of Wanaka, New Zealand, and the rest of the year moving around the globe with frequent stops back in her Scottish homeland.

Camilla's favourite Japanese ski resort: "It's got to be Myoko Akakura."

Camilla's must-do recommendation when visiting Japan: "Have an onsen EVERY day; perfect for aching muscles and all around goodness."

Marilyn Poon – Photographer
WWW.MARILYNPOON.COM

Marilyn is a Hong Kong born American who has dedicated many a season to park shaping in Europe. Even with a degree in photography from CU-Boulder, she only recently began shooting full-time – expect to see more of her work at newsstands and galleries worldwide.

2010 will see Marilyn based out of Seattle, covering the Olympic and Paralympic Games in Vancouver, followed by her annual surf trip with Seeker Surf Camp, a community project she shares with a few friends. Aside from snow sport photography, Marilyn focuses her lens on flow visualization, and environmental portraits.

Marilyn's favourite Japanese ski resort: "Tengindaira or Urabandai Nekoma."

Marilyn's must-do recommendation when visiting Japan: "Spend a day in Tokyo and have an onsen".

Posy Dixon – Resort Reviewer
WWW.FINALAGENCY.COM

Posy is an ex-Professional Snowboarder (Burton, Gravis and TSA) who joined the WSG-Media crew on one of the earlier Japan trips. After retiring from full-time riding at the old age of 24, Posy pursued a more varied career in marketing, press, team management and journalism. She now manages the Nike 6.0 teams and is building a bespoke press and events collective in London. Posy is also rather partial to a Charge Plug fixed wheel bike, which she rarely leaves the house without.

Posy's favourite Japanese ski resort: "Seki Onsen near Myoko. Two lifts and one million square feet of powder."

Posy's must-do recommendation when visiting Japan: "Stock up on small presents (just little token gifts) from your home country to give to people you meet in Japan. Gift giving is massively appreciated by all Japanese and is something you can offer in return for their generous advice and hospitality."

Samuel Nelson – Resort Reviewer
SAMUEL.NELSON@DRAGONALLIANCE.COM

Samuel started riding pretty late (aged 19) but quickly set about making up for lost time (and money) as he hit up most of Europe, North America, South America, New Zealand and, of course, Japan. Looking for a way to fund his increasingly far-reaching trips Sam began writing about his travels for the British press; something which ultimately led to him to being on the Snow-search Japan reviewing team.

Sam is currently the UK Team Manager for Dragon Eyewear, and rides for Atomic Snowboards, Union Bindings, Deeluxe Boots, Coal Headwear and Forcefield Protection.

Sam's favourite Japanese ski resort: "Zao Onsen. It has something so magical and serene about it, that it really is so hard to put into words, I did try though!"

Sam's must-do recommendation when visiting Japan: "Peep Tokyo yo!"

Sarah Mulholland – Photographer / Resort Reviewer
WWW.BASECAMPPHOTOGRAPHY.COM

Sarah grew up in Scotland and, after graduating from university with a Political Science degree she went in search of adventure, wilderness and a raw cultural experience in Japan. She spent five years based in Hakuba, Nagano. There she taught English, worked as a Mountain Bike Guide, developed a keen eye for photography and started Snow Season Japan, a unique travel company organising winter season trips with beginner Japanese language courses.

Sarah's favourite Japanese ski resort: "Driving through the rustic snow-covered village of Otari to the hidden treasure of Cortina just never gets old."

Sarah's must-do recommendation when visiting Japan: "Eat soba noodles and 'sansai' (edible wild mountain vegetables). Spot 'Kamoshika' (powder loving mountain goat/deer animals) and visit a different onsen everyday."

Tim Myers – Resort Reviewer
WWW.ONEHITWONDEREVENT.COM

As the grandson of Col Myers, founder of Mt Selwyn Ski Resort in Australia, Tim literally grew up on the snow. and has become one of Australia's most renowned freeskiers. He spends his Northern Hemisphere winters travelling between Canada, North America and Japan, and he spent the '08 / '09 season sampling the fine powder offerings of Niseko and other Japanese resorts, feeding his addiction to the white stuff.

Unfortunately there's no methadone clinic for this kind of addiction, so Tim is now condemned to a life of travelling the globe in search of greater thrills. His Dynastar skis have worn a groove into his shoulder and his feet have been permanently molded into the shape of a pair of Lange boots. Tim also skis for Sinner Outerwear, Scott Goggles, Bern Helmets and Sony Playstation.

Tim's favourite Japanese ski resort: "Tengindaira, because it's steep and consistently deep. However, you should be warned that on a good powder day all of about 20 locals converge on the mountain so expect lift queues around 5secs long."

Tim's must-do recommendation when visiting Japan: "Backcountry powder sledding with Niseko Snowmobiling Adventures and while you're in Niseko, go and ask Simon for a 'Double Round Eye' at the Tanuki Bar."

Vicci Miller – Resort Reviewer
TEAM.OAKLEY.CO.UK

As a Professional Snowboarder hailing from the UK, but a permanent resident of Grenoble in France, Vicci discovered the delights of Japan on her first trip in 2008 whilst competing on the Burton TTR International Competition Tour. She soon became addicted to floating around in Japanese onsen, eating un-named foods, riding endless fields of powder and visiting her former family at the snow monkey colony in Nagano.

Vicci is sponsored by Oakley, Bataleon, Deeluxe and The Snowboard Asylum, and has recently finished filming for a new movie called 'Cliché' out in 2010. She whiles the rest of her spare time away renovating French barns and racing Ducati motorbikes.

Vicci's favourite Japanese ski resort: "Definitely Myoko Akakura!"

Vicci's must-do recommendation when visiting Japan: "Try every onsen possible & eat honey fried crickets, they are yummy but tend to stick in the teeth so flossing is recommended!"

Other contributors
SAM BALDWIN - Sam is the founder of SnowSphere.com and has written for most of the UK's snow sport publications, many national newspapers and a number of different guidebooks. Sam spent two years living and working in rural Japan, and wrote the working in Japan article and top-tips. For more information visit www. SnowSphere.com

STEPHEN KING - Stephen is based in Japan and runs a company called North Star Translation Services Co., Ltd, he was the perfect person to put together our Japanese language article. For more information on their services visit www.northstartranslations.com

ARNIE WILSON - Arnie is editor for Ski+board Magazine, writes for the Financial Times and many other publications, as well as being the author of a number of Skiing books. He has visited Japan many times over the past 15 years and was invaluable in helping us put together the history & culture articles. Visit www.arniewilson.com

Japan: Land of the Rising Sun and phenomenal amounts of pow!

Full of intriguing contradictions and mystifying opposites, Japan conjures up many an image in one's mind. Fat men wrestling in over-sized g-strings. Kimono-clad geisha shuffling along cobbled streets. Micro technologies, traditional shrines, samurais and ninjas, compact cars, eccentric fashions, exotic foods, super-fast trains and, of course, we can't forget the ridiculous amounts of snow. Japan's modern-day reputation is possibly best described as 'contrastingly diverse'.

"Japow" – as it's fondly known by many globe trotting skiers and snowboarders – has become a world-renowned destination for snow sports, and has established itself as the number one place to go for deep, dry powder. But beyond this, Japan is a place of captivating culture, stunning scenery, antiquated architecture and, most notable of all, some remarkably friendly people.

The Japanese Culture

Many first-time visitors to Japan are surprised by the welcoming kindness they receive, particularly outside of the cities. The instilled politeness evident in almost every part of Japanese society appears completely genuine in most cases, but is potentially a result of their conforming nature – not to say that that's a bad thing.

Japanese culture is so rich and distinctive that one's inaugural visit is often spent in a state of wide-eyed wonderment. Traditions are evidential everywhere you go and, even today, continue to be passed down from generation to generation. Few traditions are lost, even with the obsession over American culture that's fairly noticeable in young Japanese adults today.

Crime in Japan appears to be almost non-existent and one's personal safety is very rarely compromised. Japanese cuisine is extraordinary and particularly appealing to those with adventurous tastes. Furthermore, eating is almost always a social activity. Forms of entertainment vary dramatically, from traditional geisha dancing and sumo wrestling, to sensory-overloading arcades and karaoke bars.

But it all comes back to the people in the end. The most defining characteristics of the Japanese as individuals is their loyalty, respect for others and hard working attitudes. Many young fathers will put in 10-12 hour days, 6 days a week. This isn't typically done out of greed, but more an attitude of wanting to provide for their families.

All these facts combined make this country so unbelievably unique that it's almost too perplexing to put into words.

Shoe etiquette

EVER WONDERED WHY THE JAPANESE REMOVE THEIR SHOES SO OFTEN? IT'S A CASE OF CLEANLINESS! HERE'S HOW IT WORKS...

BE READY TO CHANGE YOUR FOOTWEAR WHENEVER CONFRONTED WITH A STEP UP OR DOWN. ON ENTERING A HOUSE, YOU DISCARD STREET SHOES IN THE HALL AND PUT ON A PAIR OF SLIPPERS. HOTELS, MOST RYOKANS AND SOME PUBLIC ONSENS WILL HAVE VERY SIMILAR PROTOCOLS. YOU MAY EVEN COME ACROSS THE ODD RESTAURANT THAT REQUIRES SHOE REMOVAL TOO.

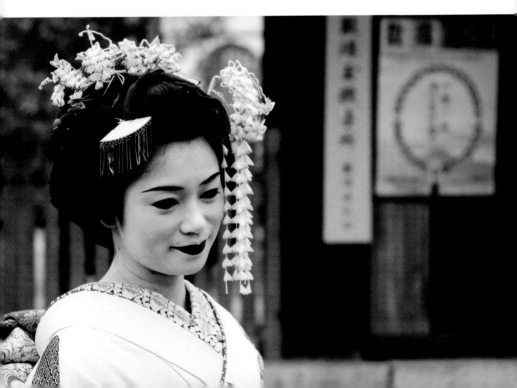

A little bit of history

In the fifty years from 1895 to 1945, Japan fought two wars with China, one with Russia, one with Germany and, most destructive of all, the war with Britain and the United States from 1942 to 1945.

Such a long history of governmental rises and falls, along with the Buddhist influences, has led the Japanese people to where they are now: strong willed, culturally proud and content with their place in the world. Now a prosperous democracy, Japan's history sits more with imperial traditions and, as a country, it has had its fair share of civil wars. Whilst it has 'borrowed' elements of Chinese culture and is well in touch with the rest of the world, Japan has been through extended periods of isolation, when its indigenous cultural identity was encouraged to strengthen and evolve untainted by other influences.

Bowing etiquette

BOWING IS SO INGRAINED IN JAPANESE SOCIETY THAT COMPANIES OFTEN PROVIDE TRAINING FOR THEIR EMPLOYEES ON HOW TO BOW CORRECTLY. HERE'S HOW IT WORKS...

GENERALLY SPEAKING, AN INFERIOR PERSON BOWS LONGER, MORE DEEPLY AND MORE FREQUENTLY THAN A SUPERIOR. BOWS OF APOLOGY TEND TO BE DEEPER AND LAST LONGER THAN OTHER TYPES OF BOW. BOWS OF THANKS FOLLOW A SIMILAR PATTERN. WHEN DEALING WITH FOREIGNERS, MANY JAPANESE PEOPLE WILL SHAKE HANDS. SINCE MANY NON-JAPANESE ARE FAMILIAR WITH THE CUSTOM OF BOWING, THIS OFTEN LEADS TO A COMBINED BOW AND HANDSHAKE WHICH CAN BE QUITE COMPLICATED TO EXECUTE – BUT RATHER COMICAL.

World War II destroyed approximately half of Japan's industry. Japan's economy was almost completely ruined. Yet it bounced back. The devastation of the war years caused the Japanese Government to turn away from conflict as an instrument of foreign policy. Impressively, it only took Japan about 10 years to recover economically. And their economy continued to flourish. In the 1980s Japan experienced a 'bubble' period – becoming the world's largest creditor nation – and suddenly found themselves home to some of the world's largest banking and financial institutions. The bubble burst in the early 1990s, but the Japanese economy has since stayed reasonably stable.

It was during this 'bubble' period that the Japanese ski industry really took off.

For a long time women have been considered inferior to men in Japanese society. Even after they were given the right to vote in 1946 their standing did not significantly improve. However, as Japan faced a shrinking workforce in the 1980s and 1990s, increasing numbers of women were brought into industry, resulting in improved educational, political and economic opportunities. Nevertheless, women's status still remained far below that of men and and debate still simmers over their role as mothers, workers and consumers in Japan's aging society.

From sometime in the late 1800s Japan's leaders decided upon a path of 'international security'. This quest for 'security' led the nation to war many a time.

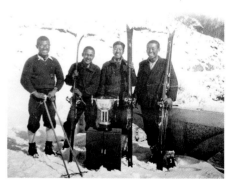

 TOP: NOZAWA ONSEN, BOTTOM: 1ST NAGANO SKI COMPETITION. PHOTOS: JAPAN SKI MUSEUM

When skiing came to Japan

On March 24th 1930, the legendary Austrian skier Hannes Schneider bade farewell to the Japanese ski resort of Nozawa Onsen with the words: "Hello, Nozawa!" Quite why he did not say "farewell" is not clear, but one thing is certain: he had taught the Japanese to ski. And they in turn became "sukii-kichigai" - ski-crazy.

This was to have a profound effect on the Japanese psyche and economy, and would lead to a skiing craze which would manifest itself in four major ski events: the Winter Olympics in Sapporo in 1972, the World Alpine Championships at Shizukuishi in 1993, the Global InterSki Championships at Nozawa in 1995, and the 1998 Winter Olympics in Nagano.

Although Hannes Schneider had introduced his famous Arlberg technique to the Japanese at Nozawa and Myoko, it was not really until the beginning of the '80s that young Japanese 'salarymen' and cohorts of young secretaries, riding the crest of the post-war economic boom, were alerted to the therapeutic notion of escaping the cacophony of urban life in Japan's big cities, heading for the tranquillity of the mountains. They seized upon the idea with typical enthusiasm and by the '90s Japanese skiers and snowboarders were pouring more money into the sport than any other nation on earth. It was regarded as "kakko ii" (roughly translated to "trendy").

And since, for the Japanese, time really is money, weekend skiing became an exhausting yet attractive option. Many Japanese skiers poured into the resorts by the bus- and train-load on Fridays, spent all day and half the night on the slopes, and were somehow back at their desks by Monday morning. For a decade or so this meant vast numbers of skiers on the slopes, which also meant ridiculously long lift-lines. Japanese ski areas tried to get round this by building more lifts than you would typically find in Europe or America, but of course this simply produced too many skiers on the snow itself.

Japan's ski industry hit an all-time high in the '90s. So much so that it rivalled the US for the world's largest ski market. However, around the time of the Nagano 1998 Winter Olympics the Japanese winter sports industry starting experiencing a hefty decline (interesting timing to say the least). Interestingly enough, this was around the same time the video gaming industry started to boom.

Gift giving etiquette

GIFT GIVING IS ONE OF THE MOST ADORABLE PARTS OF JAPANESE CULTURE. MANY FOREIGNERS RECEIVE TOKEN GIFTS WHEN VISITING JAPAN AND ARE TAKEN ABACK BY THE SINCERE KINDNESS THEY ARE SHOWN. HERE'S HOW IT WORKS...

IT'S CONSIDERED IMPOLITE TO GO TO SOMEONE'S HOUSE WITHOUT A GIFT. WHILST EXCEPTIONS ARE FREQUENTLY MADE FOR FOREIGNERS, A SMALL EFFORT AT GIFT GIVING WILL BE GREATLY APPRECIATED. THE EMPHASIS IS ON 'GIFT GIVING' AS OPPOSED TO THE ACTUAL GIFT ITSELF. YOUR GIFT CAN BE RELATIVELY INSIGNIFICANT - EVEN JUST A SIMPLE SOUVENIR FROM YOUR HOME COUNTRY - BUT IT WILL BE RECEIVED WITH MUCH JOY AND ADMIRATION.

Today, that's all changed, with an influx of foreign skiers and snowboarders leading a long-awaited revival in Japanese snow sports. Boom markets for Japan include their Asian neighbours and the Australians, who benefit from shorter flights and less jetlag than travelling to North America. Domestically, the market is also growing, but at a much slower rate. Much like others parts of the world, snow sports in Japan have become much more affordable and accessible than they have been in the past.

Onsen Guide

Japan has thousands of natural hot springs that are used as public bathing areas known as Onsen. There is a Japanese phrase, "Hadaka-No-Tsukiai" or "Naked Communication", that refers not only to bathing itself, but also to the way in which people speak with one another at the onsen. All barriers are broken: age, nationality, cultural background; One can communicate freely in the atmosphere of the onsen. The onsen is truly one of Japan's unique cultural experiences and a must for any visiting foreigner.

What defines onsen?

There are laws in place that regulate the definition, protection, etc. of an onsen. According to these laws, an onsen is defined as hot water and water vapor that springs from the Earth either naturally or from artificially-bored holes. The water temperature needs to be higher than 25°C. However, meeting other conditions, the water can be cooler and still be authorized as an onsen.

One of the reasons that onsen are so popular is because of the many health benefits people enjoy when using them. Soothing your skin, easing stiff shoulders, and relaxing your muscles are just some of these effects.

The history of onsen

Japan is a volcanically active country, and as such, onsen have been used for centuries, and are mentioned in Japanese legends and mythologies. Descriptions are found in renowned Japanese texts such as; Kojiki, Nihonshoki, and Manyosyu. During the Kamakura and Sengoku era (12th-17th century), records indicate that the samurai healed their wounds there. In the Edo era (17th-19th century), the culture of onsen spread to common people. In the Meiji era (early 20th century), scientific studies began and by the Showa era (mid 20th century) the medical benefits of onsen were proven.

Through the years, more and more people come to use onsen for different reasons. Today people enjoy them not only for medical treatment but also for sightseeing, socializing, and leisure. Onsen are a multipurpose place to have a great time.

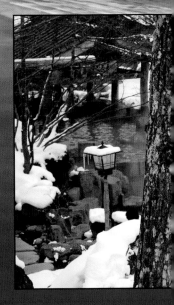

MAIN PHOTO: JUERGEN SACK, INSET PHOTOS: KEITH STUBBS

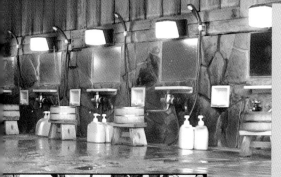

ESSENTIAL ONSEN

YOU'RE NEVER VERY FAR FROM AN ONSEN, NO MATTER WHERE YOU ARE IN JAPAN. HOWEVER, IF YOU'VE DEVELOPED A BIT OF AN ONSEN ADDICTION (LIKE MANY PEOPLE DO), HERE'S A TOP 10 ESSENTIAL ONSEN LIST:

1. TAKARAGAWA ONSEN, MINAKAMI IN GUNMA – THE LARGEST OUTDOOR ONSEN IN JAPAN,

2. KUSATSU ONSEN, GUNMA – CONSISTENTLY VOTED NUMBER ONE IN JAPAN,

3. NOZAWA ONSEN, NAGANO – 13 DIFFERENT PUBLIC ONSENS AND THEY'RE FREE!

4. HAKUGINSU LODGE, TOKACHIDAKE IN HOKKAIDO – PERFECT PLACE TO STAY WHEN ENJOYING THE TOKACHIDAKE BACKCOUNTRY.

5. TSUBAME ONSEN NEAR MYOKO, UNIQUE AND TRADITIONAL, THIS 'CLOUDY' ONSEN IS OUT OF THE WAY BUT WORTH THE VISIT.

6. THE GRAND HOTEL, NISEKO. A MIXED ONSEN WITH TRANQUIL, SNOW-COVERED SURROUNDS,

7. IKAHO ONSEN, GUNMA – FAMOUS FOR ITS STONE STAIRS, & A HIGH CONCENTRATION OF IRON IN THE WATER.

8. ZAO DAI ROTEN BURO, ZAO ONSEN, BUILT INTO A BEAUTIFUL MOUNTAIN RAVINE.

9. SHIBU-YUDANAKA ONSEN, NAGANO A TRADITIONAL ATMOSPHERE CLOSE TO THE WILD JAPANESE SNOW MONKEYS.

10. OBUYA ONSEN IN GORYU, HAKUBA – A NICE BLEND OF MODERN & TRADITIONAL WITH 6 POOLS & 3 INDIVIDUAL BATHTUB-STYLE POTS, PLUS A LITTLE STEAM ROOM GAZEBO.

How to use an onsen

At first, most foreigners have a dergee of trouble understanding the proper etiquette when visiting an onsen. The most important point is to enjoy yourself without bothering others. Consideration for others is a major part of the onsen culture.

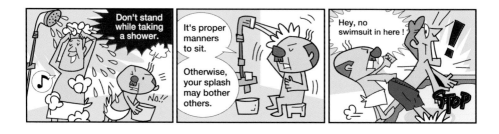

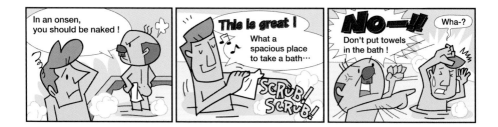

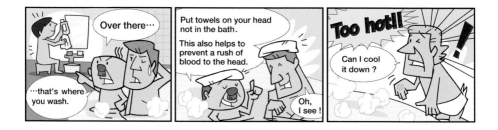

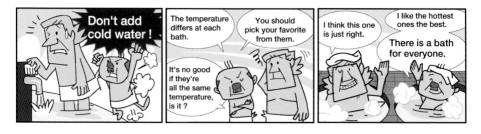

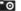 ORIGINAL WRITER TAKAKO CHIBA, ILLUSTRATOR RYOICHI OKUBO

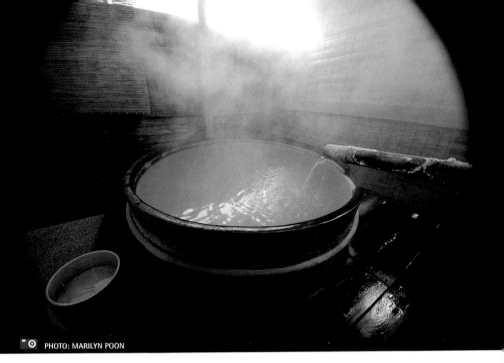

A step-by-step guide to onsen bathing

Step 1: Enter and pay

Visit the onsen of your choice and pay the entrance cost if applicable. Don't forget to take a large towel for drying yourself afterwards and a small "modesty" towel for use during your bathing time.

Step 2: Get naked

After selecting the correct door (male or female), find yourself a 'locker' (usually in the form of a weaved basket) and take all your clothes off, jewelery included. Don't be shy now!

Step 3: Scrub yourself clean

When you're finished in the changing room, enter the steamy bathing area and find yourself a washing spot; identified by the very low stools or potty-like plastic seats located in front of a mirror and some form of water dispensary (typically a shower head). Now scrub yourself from head to toe.

Step 4: Take a dip

Select a bath that suits your temperature requirements (assuming more than one is on offer) and ease yourself in. Relax and make the most of it, but don't fall asleep!

Step 5: Rinse off

When you're finished bathing, rinse yourself off back at a washing spot. Then wipe any excess drips from your body with the smaller towel before re-entering the changing area.

Step 6: Dry and dress

Dry yourself properly, perform any other cosmetic routines you may have and put your clothes back on. Now leave feeling all refreshed and ready to go about the rest of your day.

Food and Drink

A Journey for your taste buds...

One of the highlights of visiting a destination so culturally different to that of English-speaking countries is the opportunity to challenge your taste buds and experience delights that you wouldn't otherwise get the chance to sample. Eating in Japan is half the fun of skiing and riding here. Ordering your food is genuinely amusing and never gets old. And there's the constant menu exploration that comes with every meal, keeping your curiosity well and truly perked.

Those familiar with Japanese cuisine in their own country will undoubtedly have sampled the likes of sushi, tempura, and maybe even sashimi. Many people are surprised by how different these are when served in the country of origin and some are taken aback by the lack of token Japanese dishes, discovering numerous new and unknown foods instead. The majority of English-speaking visitors find themselves eating sushi, one of Japan's biggest culinary exports, less here than in their homelands.

The Japanese view eating as a social activity. Friends, colleagues and family will often go out together for a meal and talk away the hours whilst eating and drinking at an almost intermittent frequency.

PHOTO: JAMES .WOODWARD

Menus

Your first meal in Japan can be a little intimidating; assuming you decide to avoid the Western fast food restaurants. Menus are generally not in English and whilst you can always ask to see if they have an English menu available (some do, although the translations can verge on the humorous side), a little guess work is always fun.

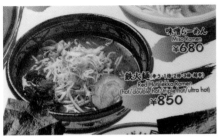

Fortunately, many Japanese menus do have pictures. The restaurant you choose may even have a window display with plastic models of their main dishes. Combine this with a little animated attempt at conversation with the waiter or waitress and you'll kick your evening off with a many a smile and a few good chuckles.

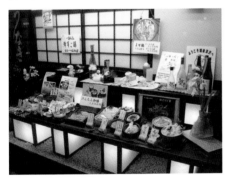

Restaurant types and common dishes

Styles of restaurant and cuisine in Japan can vary quite dramatically. Whilst there are a number of classic Japanese dishes that are very popular, Chinese and Korean food is also common. Many eating establishments are dish-specific restaurants specialising in one main style of cuisine, however there are scores of different eateries offering a wider selections.

Teishoku-ya or Shokudo

Serving set meals consisting of a main course with meat or fish, and rice or a fried item of sorts, along with various side dishes; these are the most common type of restaurants to be found in Japan. Often distinguished by the presence of plastic replica dishes in the windows, Teishoku-ya are usually located near train stations and shopping malls, or any other such place that people pass through regularly.

Izakaya

The Japanese pub, Izakayas are social establishments where groups of people go to eat casually and drink with friends or colleagues. Often open late, this type of restaurant / bar serves a wider variety of food frequently combining Japanese and Western cuisine. Ordering is usually done intermittently over a longer period and dishes are typically shared between all those at the table. Izakaya restaurants can usually be identified by their red lanterns adorning the shop fronts.

Yakitori

Similar to that of Izakayas, Yakitori restaurants are also aimed at social eating and visits here are generally combined with a few drinks. In most Yakitori restaurants, customers sit around a central counter and watch the chef cook the meat skewers after which Yakitori is named. Yakitori is also a common

Okonomiyaki

Meaning 'cook what you like', Okonomiyaki is a style of restaurant that, traditionally speaking, allows their customers to make their own Okonomiyaki dish. Some Okonomiyaki restaurants have a chef that cooks the dish in front of you – this is especially apparent in tourist areas, as foreigners tend not to be well versed in this style of cooking. The Okonomiyaki dish is considered to be a Japanese pancake or a form of pizza, and is often vegetarian.

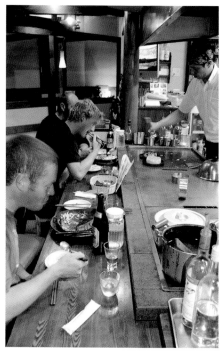

dish served in Izakayas and can be purchased from convenience stores as a quick snack.

Barbecue Restaurants

A popular type of restaurant serving prepared but uncooked food that you cook yourself on your own hot plate, usually built into the restaurant tables. Originating in Korea, the Japanese BBQ isn't like that of Western countries. Instead, the chefs prepare thinly sliced meats, such as lamb, beef and chicken, along with various different vegetables, that you cook it to suit your own taste.

Sushi and Kaiten-zushi

These are restaurants that specialise in sushi and sashimi. Sushi bars are typically the more expensive variety, where customers sit either at their own table or at the counter, behind which the learned sushi chef is working. In Kaiten-zushi, the sushi dishes are presented to the customers on a conveyor belt. Customers can freely pick the dishes that they like as they pass in front of them. This style is usually a little cheaper, but can be more fun.

Tempura

Found in both Tempura-specific eateries and standard Izakayas / Shokudos, Tempura consists of vegetables, prawns and fish cooked in non-greasy batter, but dipped in a brown sauce known as 'ten-tsuyu'.

Shabu-shabu

This is a communal style of eating, whereby think slices of beef and different vegetables are cooked in a soupy broth, in a large pot in the centre of your table. Most Shabu-shabu Restaurants also serve Sukiyaki, which follows a very similar process but with the addition of the food being dipped in raw egg before it is eaten.

Ramen

Japan's own version of fast food, Ramen is Chinese-style noodles served in a soup, usually meat based, with extra vegetables thrown in. Ramen restaurants usually develop their own soup recipe (the most crucial ingredient for a restaurant's success) and are often identified by their long counters with people slurping noisily over their steaming bowls.

Soba

Specialising in Soba and Udon, these are often smaller establishments offering noodle dishes that come in either a hot soup or a cold dipping sauce, depending on the season.

Staple foods

Despite the variation of dishes served throughout Japan, the staple foods that accompany most meals are standard throughout the country. These staples are known for maintaining the nations health.

Rice

Often eaten for breakfast, lunch and dinner, the Japanese eat rice like the French eat bread. Almost every household will have a rice cooker in the kitchen, much like Western homes have a toaster. This is by far the most consumed food in Japan, with figures of more than 60kg of annual consumption per person being publicised. White rice is the norm, with brown rice being much less common. Rice is eaten on it's own and as part of a meal, or a side dish, and even as a dessert in the form of 'sticky mochi' (rice cakes).

Tofu

Used frequently in soups and bowls of noodles, stuffed or served deep-fried, or eaten on it's lonesome (usually garnished with ginger), tofu originated in China centuries ago but has been adopted by the Japanese and is now a bit of a national treasure. Tofu comes in soft and firm varieties, and is produced from long hours of curdling soymilk. An extremely healthy food, tofu is low in calories, contains a relatively large amount of iron and very little fat.

Miso

Another Japanese commodity with Chinese origins, Miso accompanies most meals in Japan and is consumed on a daily basis by many. Used as the basis for soups and also as a dressing, Miso can be made from rice, soybeans and barley. It is frequently drank at breakfast and served as a starter for larger lunches and dinners. Miso is high in protein and low in calories: another extremely healthy Japanese staple.

Traditional meals

Traditional Japanese meals are often served in up-market Ryokans. The opportunity to partake in a formal Japanese dinner should be snapped up by any visitor interested in culture or cuisine.

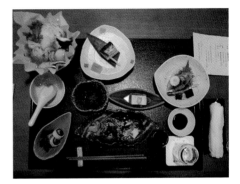

Similar in respects to formal dinners in other parts of the world, the traditional Japanese meal is spread out over a larger number of courses. Where it differs, is in the number and size of dishes presented during each course. Serving much smaller portions than that of Western countries, these meals often involve huge variety and an almost inconceivable amount of crockery.

A dinner such as this will always include fresh ingredients and it will often utilise local produce. It may incorporate some of the previously described food types, but more often than not it will include variations of pickles, a form of salad / tofu, numerous vegetable side dishes like seasoned bean sprouts or spinach with bonito flakes and soy sauce, and usually one dish of meat or fish.

Drinks

Different forms of drink are served with most meals. Alcoholic drinks are as popular here as the rest of the world and the legal drinking age is 20. That said, non-

alcoholic drinks accompany meals just as much as those with alcohol, very similar to Western countries. In Japan it's polite to pour other people's drinks before your own.

Sake

Famed for being such an acquired taste, sake is rice wine and has a very long history. Brewed throughout Japan and served at pretty much all restaurants and bars, sake is revered as the national Japanese drink. Many foreigners visiting Japan for the first time will already have tried sake, often with negative opinions being formed. This is usually a result of the low-grade brands sold overseas and many visitors change their opinions when they get their hands on the good stuff. Sake can be drank both warm and cold, and may be served in a flask or bottle from which you poor into smaller glasses or miniature pottery mugs of sorts. There are several different types and grades of sake, so be sure to identify which type or grade you are sampling.

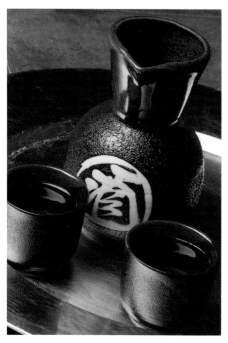

Shochu

With a higher alcohol percentage than sake, but not as strong as other spirits like whiskey or vodka, shochu (usually around 30%) is often served as a cocktail with a fruity mixer, but also drank neat and on the rocks. Made from barley and potato, and sometimes rice,

shochu is distilled rather than brewed. Shochu has become quite a fashionable drink in recent years and is even more popular than sake in some areas of Japan.

Beer

Japan's most popular alcoholic beverage, Beer (or "Biiru" as known in Japan) is available in all restaurants, most cafes and even vending machines – which are found all over the place, from high streets to hotel lobbies. Japan's beer drinking history dates back to the 1800s and was first introduced by the Dutch and Germans. These days, there are four main Japanese breweries: Sapporo, Kirin, Asahi and Suntory. Each brand produces different grades of beer, with the distinction being based on the amount of malt used in each type. Lower grades can be bought in shops, but most restaurants only serve the top grades of beer. This is a result of Japanese law forbidding the use of the word 'beer' in anything with less than 67% malt. Of course, many restaurants and bars also serve imported brands and some offer Japanese beer on tap.

Wine

As a country not known for its wine production, only some parts of Japan (including Hokkaido, Tohoku, Nagano and Yamanashi – where grape growing apparently began) partake in this highly competitive international industry. There are a few national producers of wine, but also a number of smaller local varieties, especially in central parts of Hokkaido where countryside space is more freely available. Imported wines are available, but are typically very expensive and not readily purchased in the domestic marketplace.

Coffee

Whilst coffee is popular with the Japanese, real coffee (barista style) can be hard to find. With the exception of Starbucks and a few other nominal coffee houses, coffee served in cafes and restaurants is usually a 'from-the-pot' variety. The popularity of coffee in Japan seems to be a result of the thousands of hot and cold drink vending machines, literally found all over the place.

There are a huge number of exotically named brands which range from the sweet to the incredibly sweet but they all cost between 120-150 yen a can. If you don't want it sweet then go for the black coffee, but the key thing to remember is to look at the coloured bar on the shelf under the can; red is hot, blue is cold. The cans make excellent boot warmers while you are waiting for it to cool down.

Tea

Also served in vending machines (both hot and cold), black tea is somewhat popular in Japan but considered a bit of a luxury. Tea at breakfast is almost always available in hotels and other forms of accommodation, with a small selection of variety available. Most forms of tea are imported, but there are a very small number of domestic producers.

Green Tea

Extremely popular and very healthy, green tea is the hot drink of choice in Japan. Served socially in Japanese homes, offices and meeting rooms, green tea is the customary drink at almost all everyday gatherings. Unlike black tea, it contains large amounts of vitamin c and is made solely with the leaves of Camellia. It still has plenty of caffeine, but the health benefits are certainly considerable – proven to help reduce the chances of heart disease and developing certain types of cancer. Green tea is often served complementary in restaurants and all accommodation operators.

Special circumstances

There are a number of interesting Japanese dining characteristics that are important to take note of when visiting Japan for the first time.

Service charges

Please note that many restaurants and Izakayas will automatically bring you a small snack known as 'Otooshi' when you order alcoholic drinks, and will automatically add a few hundred yen to your bill for each 'Otooshi' in lieu of an entrance fee or service charge. 'Otooshi' typically comes with alcoholic beverages, so if there are five people in your group but you only three order alcoholic beverages, only three 'Otooshi' snacks will be brought to the table.

In some bars and restaurants, there is a seating charge or 'charm charge' that is automatically charged to the bill when you enter the establishment. This may be indicated on the menu, but some cases it is not displayed in open view. Whenever you enter a snack bar or other such drinking establishment, make sure you ask about the 'charm charge' before sitting down to avoid any unexpected surprises when the bill comes.

Vegetarians

Vegetarianism is not widely known throughout Japan. Therefore, vegetarian people may struggle to find a wide range of foods available. Traditional Japanese cooking typically contains plenty of vegetable-based foods not containing any meat, but for flavouring they often use stock, or 'dashi', that contains fish. Therefore, if you're a very strict vegetarian, make sure you can ask the waiter/waitress whether the food contains any meat or fish.

All-you-can-eat and all-you-can-drink options

Restaurants in Japan often offer cheap all-you-can-eat and/or drink plans that work out cheaper than simply ordering from the menu, and make it a lot easier when settling the bill. Everyone pays the same amount, which includes the service charges. However, there are a few rules that you have to follow when following these plans. Firstly, if you are in a large group partaking in an all-you-can-drink plan, individuals cannot opt-out of the plan. It's all or none! Secondly, there's often a limit on the number of food dishes you can order at one point. Once you have cleared and returned a plate, you are then free to order another dish. The same applies to drinks. You can only order another drink when you have returned an empty glass. Thirdly, be aware of any such time limit. Most plans last for 90 or 120 minutes.

Please note: It is not culturally acceptable in Japan to string out your last drink for two hours after you have finished eating.

Travelling to and getting around

A country known for it's speedy trains and compact cars, travel in and around Japan is simple, efficient and effective.

Travelling to Japan

With a large percentage of Japan's ski resorts being north of Tokyo on the Honshu Island or up in Hokkaido, most snow-bound international visitors use Tokyo itself as their gateway city, or fly direct to Sapporo if heading to Hokkaido. The alternate gateway to these is the city of Osaka. Whilst a little further from the Japan's main ski resorts, Osaka is a good substitute, and with Kyoto just an hour away, it's an appealing option for many.

All Nippon Airways (ANA) and Japan Airlines (JAL) are the two national carriers and offer the widest network, however there are plenty of alternatives.

Direct flight operators to Japan								
Airline	Website	Australia	Europe	Hong Kong	NZ	UK	USA	
Air France	www.airfrance.co.uk		Nagoya, Tokyo, Osaka					
Air New Zealand	www.airnewzealand.com				Tokyo, Osaka			
Alitalia	www.alitalia.com		Tokyo, Osaka					
All Nippon (ANA)	www.ana.co.jp/eng		Tokyo	Tokyo, Osaka		Tokyo	Tokyo	
British Airways	www.ba.com					Tokyo		
Cathay Pacific	www.cathaypacific.com			Tokyo, Sapporo, Nagoya, Fukuoka, Osaka				
China Airlines	www.china-airlines.com/en						Tokyo	
Delta	www.delta.com						Tokyo	
Japan Airlines	www.jal.co.jp/en	Tokyo, Osaka	Tokyo, Osaka, Nagoya	Tokyo, Osaka, Fukuoka , Nagoya	Tokyo, Osaka	Tokyo	Tokyo	
Jetstar	www.jetstar.com	Tokyo, Osaka						
Korean Air	www.koreanair.com						Tokyo	
Northwest Airlines	www.nwa.com			Tokyo			Tokyo, Nagoya	
Qantas	www.qantas.com	Tokyo, Osaka						
Singapore Air	www.singaporeair.com						Tokyo	
Swiss Air	www.swiss.com		Tokyo					
United Airlines	www.united.com						Tokyo	
US Airways	www.usairways.com						Tokyo, Osaka	
Virgin Atlantic	www.virgin-atlantic.com					Tokyo		

Getting around Japan

Japan's internal travel networks are exactly what you would expect; very well established and extremely efficient.

Air travel

Both All Nippon Airways (ANA) and Japan Airlines (JAL) maintain an extensive domestic network, and operate regularly between all of Japan's islands, particularly Honshu and Hokkaido. In addition to the two major international airlines, Japan has a number of budget airlines worth considering. Skymark (www.skymark.co.jp/en) offer an excellent service but have a bewildering amount of ticket types - however it's easy and painless to book online with the English version of their website. Air Do (www.airdo.jp) on the other hand offer no English version, but you can book flights by phoning their main office on 03-6741-1122. Both budget airlines have a more restricted route network but do offer flights between Tokyo, Sapporo and Asahikawa amongst others.

Tokyo's domestic airport is Haneda (HND) and its international airport is Narita (NRT). It is possible to find domestic flights out of Nartia but they're typically more expensive and have less availability. However, the extra cash can be worthwhile if you're not planning to spend time in Tokyo itself, as it's quite a journey across the city to Haneda.

To get between Narita Airport and Tokyo there are two train services available. Keisei (www.keisei.co.jp) operate the Skyliner express, and JR Trains the Narita Express (www.jreast.co.jp/e/nex). There's little difference between either service, and both run approximately every hour and every half-hour at peak times, and take approximately 60 minutes.

From Haneda Airport take the Tokyo monorail service (www.tokyo-monorail.co.jp/english), which runs to the Hamamatsu-cho station and then take the subway into the heart of Tokyo. The service takes no more than 30 minutes, and runs every 5-10 minutes from 5am until midnight.

Osaka and Kyoto have two 'designated' international airports within their reach, Osaka International Airport (ITM) and Kansai International Airport (KIX). Whilst the official title is 'international' the Osaka airport operates almost entirely as a domestic airport. Both airports have large numbers of domestic flights and both offer routes up to Hokkaido. The Sapporo New Chitose Airport (CTS), serving as Hokkaido's main gateway, has large numbers of both domestic and international flights. New Chitose can get extremely busy but it's the only flying option when heading to the Western parts of Hokkaido. Alternatively, you can fly domestically through Asahikawa Airport when travelling to or from the Central-Hokkaido resorts.

Flying tip

PLANNING ON FLYING BETWEEN HONSHU AND HOKKAIDO?

CHECK OUT THE JAPAN AIR PASS. THIS IS A SPECIAL DEAL ON DOMESTIC FARES FOR NON-JAPANESE RESIDENTS, OFFERING SUBSTANTIAL DISCOUNTS ON FLIGHTS OPERATED BY EITHER JAL OR ANA. THE AIRPASS CANNOT BE PURCHASED IN JAPAN. VISIT A-KIND.COM FOR MORE INFORMATION.

Rail travel

The Japan Railways Group (JR), www.japanrail.com, runs one of the best rail networks in the world. Fast, efficient, clean and on time! Kyuko (Express) and Tokkyu (the faster Limited Express) trains are best for shorter routes, with frequent services running between popular destinations.

Shinkansen, the 'bullet trains', are the fastest, and have compartments for wheelchair passengers, buffet facilities, bathrooms and some have buffet cars.

Shinkansen routes generally operate between the main cities, so a combination of Shinkansen and local trains is usually required when accessing ski resort towns. Other types of train include Kaisoku (Rapid Train) and Futsu (Local Train). For short-distance trains, tickets can be bought at vending machines outside train stations. Prices are generally very reasonable, but the faster the train the higher the price usually is.

Night trains run throughout Japan and there's even options to travel between Honshu and Hokkaido under the sea through a tunnel. Most Japanese night trains are equipped with couchettes (bunk beds) and private rooms with beds, and some have cars with seats. In addition, some night trains offer a 'Special A Class' with rather luxurious suites. All night trains are equipped with toilets and sinks, and the better ones also have public phones, showers, a restaurant and a lounge or lobby car.

National and Regional Japan rail passes are available for purchase enabling discounted travel throughout Japan or a specified region. National Rail Passes allow unlimited travel over a set period, either 7, 17 or 21 days. Regional Rail Passes offer travellers flexible 3- and 4-day options to be used within 1 month, or consecutive 5- and 10-day passes. It's worth noting that the Japan Rail Pass doesn't cover night trains. Visit their website www.japanrailpass.net for more details.

Whilst the above options are all reasonable value for money and the rail network provide efficient means of exploring the country, travelling with large ski or snowboard bags on Japanese trains is always a challenge, and there is little space on the train to stash such baggage.

Many Japanese people use a courier service (takkyubin) to send bulky bags ahead of schedule, particularly when travelling between islands. You'll find takkyubin companies such as Yamato Transport (www.kuronekoyamato.co.jp/english) at most airports and stations, and any convenience store that displays their logo (look out for a spiky black cat in a yellow oval). You can pay a bit extra and they'll even pick your bags up from where ever you are.

For foreigners on a resort road trip around the country, this isn't usually a viable option as it means extra time off the snow. So whilst trains are excellent for the one-off trips to other resorts or even accessing one main destination, any multi-stop trips are usually best done in a car.

Subway

All of the major cities have an underground subway system. You'll find the maps for Tokyo, Kyoto, Osaka and Sapporo in their respective gateway city articles within this book.

PHOTO: MARILYN POON

As with most subway systems you can purchase single journey, day passes and longer term passes, and there are plenty of machines from which to purchase them from. Just to make things a little more complex, Tokyo has two different systems, the Tokyo Metro system and the Toei line., Tickets are not valid between them, so you will need to buy a transfer ticket to move between them.

If you get confused and haven't purchased the required ticket, then just before you go through the barriers at the end of your journey there is usually a fare adjustment machine. Just insert your ticket and pay the excess.

Subway tip
CRUISING AROUND A CITY ON THE SUBWAY?

KEEP YOUR RECEIPT AFTER PURCHASING YOUR TICKET AS GETTING OFF AT THE WRONG STOP IS AN EASY MISTAKE TO MAKE – MACHINES WILL SWALLOW YOUR TICKET.

Driving

Traffic drives on the left in Japan. Roads are of a high standard and are kept clear of snow as much as possible. Understanding the road signs can be a problem as not all are translated into English, although the main tourist centres have prominent enough English signage.

Traffic in cities is often congested but mountain roads can be very quiet. There are four main expressways linking Japan's major Pacific coastal cities, but the tolls are high for using them. Seat belts are compulsory and speed limits on highways is 80kmp (50mph), although many drivers exceed this. In cities the speed limit is usually 40kph (25mph). An International Driving Permit is required, no exceptions. Minimum driving age is 18.

Renting a vehicle is simple enough, but your International Driving Permit is a must have. Many international car hire firms are present in Japan and the standard of rental vehicle is high.

4WD's are easily available and most depots in snowy areas issue cars with snow tyres. Whilst not a legal requirement, snow tyres are an essential, but snow-chains make for a good alternative. If you are hiring a car for a few weeks then it will probably be most cost effective to buy rather than hire a set of snow-chains.

Many cars come equipped with Satellite Navigation but it's almost impossible to change the language, so try and get a demonstration of how to use it when you pick-up your car.

Overall, travelling via car in Japan is worthwhile when you're looking to visit a number of different resorts in a certain region. Due to the sheer numbers of vehicles, driving in cities is not recommended.

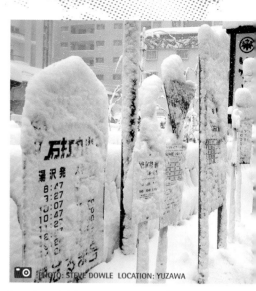

PHOTO: STEVE DOWLE LOCATION: YUZAWA

Driving tip

DRIVEN AND WANT TO HAVE A DRINK?

USE A "DAIKO" SERVICE TO GET HOME. THEY'LL PICK YOU UP AND DRIVE YOUR CAR HOME. IT'S NORMALLY CHEAPER THAN A TAXI AS WELL.

ANY AMOUNT OF DRINK DRIVING IS JAPAN IS ILLEGAL AND HEAILY FROWNED UPON.

Bus & coach travel

Buses are popular in Japan's smaller cities, towns and when accessing ski resorts. Many resorts run their own buses from the local areas of residence or train stations, to their slopes. In larger cities buses serve as the second means of public transport. Highway buses operate between Japan's main cities and can be a much cheaper alternative to rail travel, all be it a much slower one. Seat reservations are necessary on most long distance buses. Visit the websites for Willer Express (willerexpress.com), Nihon Bus Association

(www.bus.or.jp/e) and the JR Bus Kanto (www.jrbuskanto.co.jp/bus_route_e) for route maps and more information.

Taxis

Taxis are generally expensive and you will pay a base fee and then an additional charge for every ¼ mile. If you have a ski/snowboard bag then most taxis will tie it to the roof, but if you're waiting in a taxi line don't make your bags too obvious as many taxi drivers don't want the hassle, and will try and pick-up a different passenger. Always have handy the address or phone number of where you are going, as it makes it so much easier than to try and explain if your Japanese language is limited.

Ferries & water transport

With hundreds of smaller islands, Japan is home to a large number of ferry routes. This can serve as a means of transport for snow-bound visitors, but only really when travelling between Honshu and Hokkaido.

There are ferry routes between Honshu ports such as Tokyo, Sendai and Hachinohe, to Tomakomai in Hokkaido. On the other cost, Niigata, in the Chubu region, links to Otaru in Hokkaido. Shinkansen services travel frequently to the ports helping link it all together. Not really any cheaper than rail or air travel, ferries really just make a more interesting way to connect the dots.

PHOTO: STEVE DOWLE LOCATION: HAKUBA 47

Top tips

1. Visit a Japanese supermarket; aisles of alien vegetables, jars of pickled oddities and parts of animals you never knew you could eat. As interesting a tourist attraction as any guidebook 'must see'

2. Bring your own medicine (Japanese pharmaceuticals are renowned for their weakness) – but make sure you have the right documentation to back it up at customs and be aware that some medicines that are legal in your country, might be illegal in Japan, so check up first.

3. Don't dabble with illegal drugs whilst in Japan – it's just not worth it. The Japanese have very strict drugs laws which don't distinguish between hard and soft, so that puff of Mary Jane will cost you jail time, a very heavy fine and deportation if you get caught.

4. Carry cash. Despite its high-tech reputation, Japan is a cash based society. Most of its ATMs even close at night! Carrying wads of yen is the norm as the chance if getting mugged is almost non-existent.

5. Get a jacket with a decent hood. Japan's crazy snowfalls mean that you'll likely spend a lot of days riding whilst it's snowing heavily, so a hood is an absolutely essential item.

6. Be respectful of your Japanese hosts. Don't take advantage of the Japanese nature to avoid confrontation by jumping queues or ignoring rules.

7. Japan is obsessed with all things new and the second hand market is a relatively new phenomenon. This means that you can pick up some amazing bargains in second hand shops. Look out for ski and snowboard gear, as well as other interesting souvenirs

8. Learn the word "Sumimasen" and use it regularly. This very useful word can mean "excuse me", "sorry" and thanks", depending on the situation.

Back cover shot

"THE PHOTO WAS TAKEN ON A FREEZING COLD DAY IN NISEKO AND I HAD BEEN FILMING DAN WAKEHAM, HAMISH MCKNIGHT AND NELSON PRATT MOST OF THE DAY, RATHER THAN RIDING MYSELF. JUST AS EVERYONE HAD FINISHED THE SESSION, NAT (MAYER) SUDDENLY ASKED IF SOMEONE WOULD RUN UP AND HIT THE RAIL AGAIN AS SHE HAD SEEN A REALLY GOOD SHOT. EVERYONE ELSE WAS PRETTY TIRED FROM THE SESSION SO I VOLUNTEERED TO GO AND GIVE IT A BASH. I COULDN'T SEE WHAT NAT WAS SHOOTING ON THE ROAD ABOVE AND SO HAD NO IDEA HOW AMAZING THE SHOT WAS GOING TO BE. I STRAPPED IN AND PULLED WHAT WAS PROBABLY A FAIRLY ROPEY 50-50 AND TO MY SURPRISE NAT WAS SHOUTING SOMETHING ABOUT HAVING A GREAT SHOT! WHAT WAS SO INCREDIBLE WAS THAT WE WERE ALL THERE UNDER THIS BRIDGE DRESSED IN FULL SNOWBOARD GEAR BUT FREEZING OUR BUNS OFF AND ABOVE US WERE THESE SCHOOL GIRLS WITH SHORT SKIRTS AND BARE LEG!"

ORLANDO VON EINSIEDEL

Accommodation in Japan

From hotels with all the mod-cons, to homely 'minshukus' and 'ryokans', Japan offers a very diverse range of accommodation types, catering to all tastes and budgets.

Hostels and Backpackers

Typically between 2,000 and 4,000 yen per night, this is this cheapest form of accommodation in Japan. Much the same as other parts of the world, hostels in Japan provide dormitories and occasionally some double rooms. Use of kitchen facilities is fairly standard and some establishments provide meal options too.

Mishukus

Minshukus, Japan's equivalent to bed and breakfasts, are generally small family-run accommodations.

Bedding is in the traditional Japanese style (futons rolled out on tatami mats), and all nightly stays come with breakfast. Whilst many minshuku hosts will dote over you as foreigners, you are traditionally left to your own devices and are expected to clear up after yourself. Prices vary, but expect to pay between 3,000 and 8,000 yen per night.

Pensions

Very similar to minshukus, pensions are also small privately-run establishments, the main difference being the option to take a Western-style room with a bed. This is a popular form of accommodation in ski

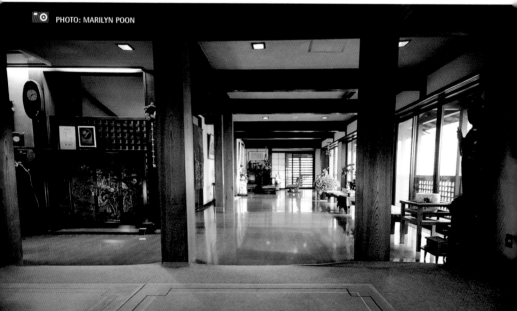

PHOTO: MARILYN POON

resorts, as international guests don't have to sacrifice what might be considered an everyday comfort, but still get to experience the tranquil Japanese atmosphere. Pension prices can vary just as much as minshukus but tend to be slightly more expensive, usually varying between 4,000 and 10,000 yen per night.

Ryokans

Traditional Japanese inns offering rooms with charming Japanese decor and tatami mats covering the floors. Costing as little as 5,000yen, but sometimes as much as 30,000 yen in some cases, a stay at a traditional ryokan is recommended to all first-time visitors to Japan – particularly if you want to immerse yourself properly in Japanese culture.

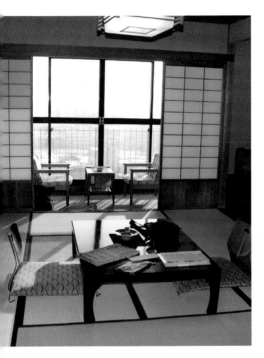

The nightly rate comes with breakfast and sometimes dinner, and will very much reflect the level of service and the quality of your experience. Expensive ryokans are usually very impressive, and are considered the height of Japanese elegance and luxury.

Unlike hotels, many ryokans close during the afternoon, so make sure you check the opening times before you arrive.

Hotels

Much like the rest of the first world, hotels in Japan offer a comfortable, but somewhat uninspiring stay. Japanese hotels typically class themselves as either 'Western' or 'Business', the latter offering more compact rooms and cheaper rates. In both cases rooms almost always have their own en-suite bathrooms, whilst other facilities around the hotel are reflected in the price. Nightly rates might start at 4,000 yen for cheaper business hotels and reach 50,000 yen for exclusive five-star establishments.

Unique Accommodations

Aside from the ryokans, pensions and minshukus, Japan has a few completely unique accommodation types that are rarely found in other parts of the world.

Capsule Hotels – found in city centres or close to train stations, and usually catering to male clientele, capsule hotels are exactly how they sound: small capsules with nothing but a bed and maybe a television. Shared bathrooms and lockers are also provided.

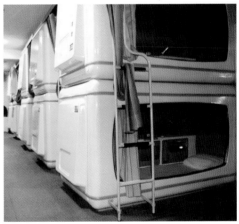

Love Hotels – certainly not designed as tourist lodgings, love hotels are visited by couples that lack private space in which to enjoy some intimate time together. Rooms are usually rented for 2 or 3 hour periods and sometimes overnight.

Temple Lodgings (Shukubo) – some temples open their doors to worshippers and non-worshippers alike, Buddhist or otherwise. The peaceful simplicity in which the Buddhist monks live is attractive to many and worth the experience as you are usually expected to participate in the daily temple routines.

Working a season in Japan

If just a week or two of Japanese powder isn't enough to satisfy you, why not join the increasing number of adventurous Westerners who are extending their snow time in this amazing country by getting a job in a Japanese ski resort or close by?

Who can work in Japan?

Most westerners working a season in Japan do so on a working holiday visa. Some skilled workers manage to get a form of sponsored working visa, where a well-recognised Japanese business will sponsor you to work for them exclusively. This is less common and is usually only possible for returning staff.

For the citizens of the UK, Ireland, Australia, New Zealand, Canada, the Republic of Korea, France, Germany and Denmark, the easiest option is to apply for the Japanese working holiday visa. The exact conditions vary from country to country; Brits get a one-year visa straight off, whereas Australians, New Zealanders and Canadians start off with a six-month visa, which can then be extended for another six months.

To apply for the working holiday visa, you must:

• Intend primarily to holiday in Japan for a specific length of time;

• Be between 18 and 30 years of age;

• Be in good health and not have a criminal record;

• Possess a valid passport and a return ticket or sufficient funds to purchase a return ticket;

• Possess reasonable funds for living expenses, including medical expenses, during the period of the initial stay in Japan. For a single person the minimum is US$2000, for a married couple it's US$3000, or equivalent amount of the national currency.

For more visa info visit: www.mofa.go.jp/j_info/ visit/w_holiday/index.html

PHOTO: KEITH STUBBS

Scan the websites of the bigger, most famous resorts that attract a lot of foreigners; some have job sections (in English) where they advertise vacancies.

Other useful job websites include SnowWorkers.com, and the jobs section on SnowJapan.com. Another option is to apply for a job with a tour operator that runs ski holidays into Japan. There are several in Australia, the UK and North America that recruit outside of Japan.

Perks of Working in a Japanese Ski Resort

Aside from the massive volumes of powder snow and the crazy cultural adventure, the perks for staff working at Japanese ski resorts are similar to elsewhere in the world: free season pass, subsidised accommodation and the chance to get out on the mountain a lot.

The difference between other international destinations and Japan, is the opportunity to immerse yourself in a culture so different to that of western countries. Working in a ski resort will allow you to meet many Japanese people and learn about the ways and wonders of this interesting society.

Teaching English – the wild card

Aside from the normal ski resort jobs, there's another option that you may not have considered – teaching English. The Japanese have a love affair with our native tongue and there are opportunities to earn money from teaching it.

There are three basic options:

1. The JET programme

This is a government-run scheme that places native English speakers in schools all over the country. They fly you in and out, offer good pay, your own apartment or house and provide an excellent support system. The downside for seasonaires is that there is no guarantee that you will be given your first (or second or third!) choice of placement, so you might request sub-arctic Hokkaido but end up in sub-tropical Okinawa (it has happened!). The application process is lengthy, taking over six months; competition for places is strong and you will need to commit to one-year minimum contract. However, if you're looking

What jobs are there and do I need to speak Japanese?

Like other ski resorts around the world, jobs such as 'lifties', rental technicians, shop workers and ski instructors are all possible, and if you have a working visa you can apply for these positions. However, jobs like these tend only to be available to those who can speak the lingo. But if your 'nihongo' isn't great (or non-existent), do not fear; there are some jobs in a few locations where speaking Japanese is not a requirement. As Japan continually gains recognition as a world class skiing and snowboarding destination, more and more English-speaking guests visit and there is a growing need for English-speaking staff, mainly dealing with foreign clientele. Therefore, unless you speak Japanese to a good standard, your best bet for finding work will be at one of the larger, internationally-known resorts that cater more for overseas visitors.

I'D HEARD SO MANY INTRIGUING TALES ABOUT AMAZING SNOW IN JAPAN, THAT I DECIDED TO QUIT MY JOB IN ENGLAND AND GO AND SEE IT THROUGH MY OWN GOGGLES. I APPLIED TO TEACH ENGLISH ON THE JET PROGRAMME, AND ASKED TO BE PLACED IN NAGANO OR HOKKAIDO BUT I ENDED UP A SMALL MOUNTAIN TOWN CALLED ONO, IN A FUKUI PREFECTURE; A RURAL BACKWATER THAT NO ONE (INCLUDING MOST JAPANESE!) SEEMED TO KNOW MUCH ABOUT.

AT FIRST I CURSED MY LUCK AT BEING SENT TO A PLACE NOT REGARDED AS A SKI HOTSPOT, BUT IT TURNED OUT THAT THIS SECRET AND SECLUDED CORNER WAS A HIDDEN GEM IN JAPAN'S SKI WORLD. I HAD AN AMAZING TWO WINTERS WITH MORE SNOW THAN I'VE EVER EXPERIENCED.

I NORMALLY FINISHED MY TEACHING JOB AT THE SCHOOL BY 4:30 AND MANY OF THE SKI AREAS (THE CLOSEST WAS 20 MINUTES DRIVE AWAY) OFFERED NIGHT RIDING TILL 10PM. EVEN THOUGH MOST WERE FAIRLY SMALL, THERE WAS SO MUCH SNOW AND THE CONDITIONS WERE ALWAYS SUPERB. I ALSO JOINED THE SCHOOL CROSS COUNTRY SKI CLUB AND GOT TO SKI OVER THE SNOW COVERED RICE PADDIES, AND I BOUGHT SNOW SHOES SO I COULD EXPLORE THE SNOW LADED WOODEN SHRINES AND BAMBOO FORESTS IN THE AREA.

OVERALL, MY EXPERIENCE WASN'T THE CONVENTIONAL WAY OF 'DOING A SEASON' BUT I GOT TO RIDE AND SKI SEVERAL TIMES A WEEK, GOT MY OWN APARTMENT AND GOT PAID MORE THAN A SEASONAIRE WOULD. MOST IMPORTANTLY IT WAS AN INCREDIBLE ADVENTURE THAT ALLOWED ME TO IMMERSE MYSELF IN JAPAN, MIX WITH THE LOCALS AND LEARN SOME OF THE LANGUAGE – AS WELL AS ENJOY THE INCREDIBLE SNOW – AND WAS THE BEST TWO YEARS OF MY LIFE SO FAR.

such as Aeon or ECC recruit outside of Japan. Do your research on Japanese ski areas, and then search for jobs with language schools in these areas. Websites like GaijinPot.com and JapanEnglishTeacher.com also advertise English teaching jobs and are a good place to search.

3. Private English Lessons

Teaching English on a casual basis can be used either to subsidize the day job or if you're lucky, support you full-time. It's quite possible to pick up casual cash-in-hand conversational classes. The pay can range from 3000 yen an hour to up to 10,000 yen and can either be found by word of mouth of by advertising in a local bar or cafe. Classes can vary from babysitting the young ones, to high-level conversation with well-educated Japanese who are happy to pay just to chat with you over a green tea.

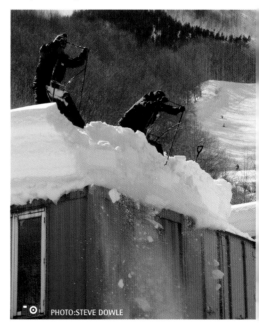

PHOTO:STEVE DOWLE

for a real taste of Japan, which can also offer the chance to do a lot of skiing and snowboarding, the JET Programme is well worth considering. You don't need to speak Japanese or have any teaching experience, but you'll need a degree (in any subject) and to be a native speaker of English. More info can be found at JetProgramme.org.

2. Private English Schools

There are also private English conversation schools (called 'Eikaiwa') all over Japan that recruit native English speakers as teachers, and the bigger ones

Hotel Work

Singapore, Hong Kong and other parts of South East Asia form a vital target market for and, generally speaking, most tourists travelling to Japan from destinations like these will speak fluent English, but no Japanese. Therefore, the need for English-speaking hotel staff is consistent and can't really be satisfied domestically.

Most larger hotels in Japanese ski towns and resorts employ a number of native English speakers for customer-facing positions. Such jobs don't tend to pay well, but do offer good perks such as very cheap accommodation and the opportunity to truly immerse yourself in a Japanese working environment. To get a position in a hotel you would almost always need to handle spoken Japanese, otherwise communication with management isn't generally possible.

Bar and Restaurant Work

Working in bars and restaurants is also viable, but more so in the well-known destinations like Niseko and Hakuba. Again, conversational Japanese is certainly an advantage but not always essential. Like most skiing destinations around the world, this type of work usually offers very average pay, but most positions

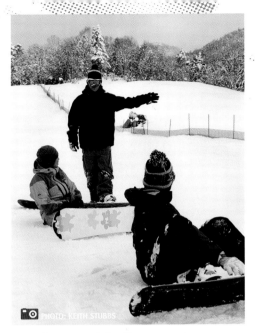

PHOTO: KEITH STUBBS

come with accommodation. Those restaurants specialising in non-Japanese fare are more likely to employ foreigners, but that's not to say you can't get a job in a traditional Japanese place.

PHOTO: STEVE DOWLE

Instructing and Guiding

With the increase in English-speaking visitors comes a need for English-speaking instructors and guides. The demand for Ski Instructors is certainly higher than that of Snowboard Instructors, however there are still a few opportunities for the latter. Whilst places like Niseko and Hakuba employ larger numbers of English-speaking instructors, there are fewer English-only instructor opportunities at locations like Minakami, Furano, Kiroro and Shiga-Kogen and the schools in these areas usually require you to speak some basic Japanese. Guiding is also possible and it's relatively easy to secure a position if you have experience and the qualifications to back it up. A number of Niseko outfits regularly recruit international guides, as do some companies in Hakuba, Furano and Minakami.

Instructors and Guides often get paid a daily rate in Japan, with some organisations paying hourly. Most offer very reasonably-priced accommodation and good perks. The larger organisations can sponsor you for a visa, but if it's your first season in Japan you're better off getting a working holiday visa, which allows you the flexibility to pick and choose somewhat.

Tokyo City

An incredible patchwork of distinctly different districts, high-tech wizardry and rebuilt history; this is a city of discovery and contrast.

Not one for taking anything for granted, Tokyo has had a turbulent history. Following Nara and Kyoto as Japan's capitals, it wasn't until 1603 when the commander of the Japanese armed forces (or 'Shogun'), Tokugawa Leyasu, decided that the town of Edo should become its main base, and that Tokyo as we know it today started to sprout. By 1867, at the end of the Edo period, the city had grown to over 1 million residents, dwarfing any other Japanese city. Emperor Meiji, realising its importance, renamed the city to Tokyo and it became Japan's new capital city. Volcanic eruptions, earthquakes, fires, not to mention being almost obliteration during World War II have left only small reminders of its epic history. To date, Tokyo is renowned internationally as the epicentre of hi-tech and is home to over 12 million people.

The main joy of Tokyo is not the ticking off of tourist sights; it's the random wanderings where you'll find the most pleasure. Sure, read up about Tokyo and hit some of the main tourist spots, but then take a map, head to a district and walk around: the contrast as you turn each corner is the real beauty of Tokyo.

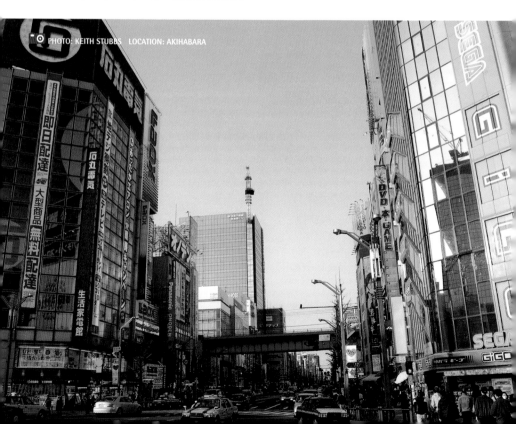

PHOTO: KEITH STUBBS LOCATION: AKIHABARA

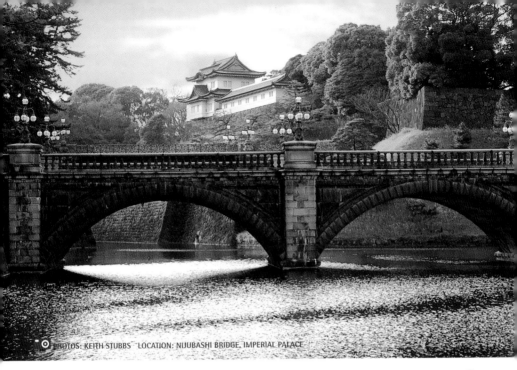

PHOTOS: KEITH STUBBS LOCATION: NIJUBASHI BRIDGE, IMPERIAL PALACE

Sightseeing

To regain some balance, head to Asakusa and visit the Buddhist Sensoji Temple. It was destroyed in WWII and duly rebuilt, but the huge Incense Cauldron and five-storey pagoda serve as a good respite despite the large number of worshippers and visitors.

The Imperial Palace is a short walk from the main station and is not only home to the Emperor of Japan, but also one of the only green spaces you'll find in the city. The East Gardens with its Koi carp ponds lead on to the moat, surrounding the palace and maintaining restricted access via the Nijubashi double-bridge to the inner castle.

The Shinjuku Gyoen national garden is a stunning 144 acres arranged into a formal French-English landscape and traditional Japanese garden. Originally created for the royal family on the site of their private mansion, the layout is meticulous and breathtaking no matter what time of year you visit.

Ueno-koen is one of the largest parks in Tokyo and the place to be when the cherry blossoms bloom. With over 1,000 trees it makes a spectacular sight every

spring. Home to several important museums, as well as Ueno Zoo, the park is dotted with historically-interesting temples and shrines, including the Tokyo 'branch' of the Nikko Toshogu Shrine which dates back to 1651.

Shinjuku is also home to the towering Tokyo Metropolitan Government Offices. There are two free to access observations decks, which give an impressive panorama, and are best viewed at dusk as the city lights start to illuminate the surrounding metropolis.

The Tokyo International Forum in Obayashi is a fine example of modern Tokyo architecture and resembles a huge glass ship hull. This is located close to Tokyo

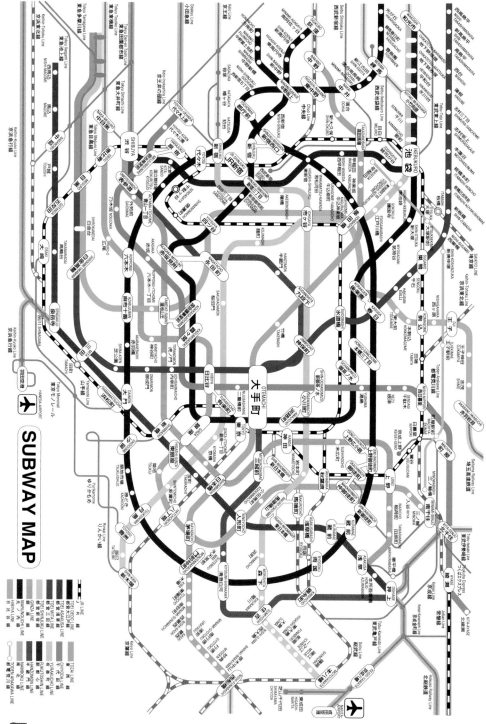

SUBWAY MAP

©2008 by Japan National Tourist Organization

SUBWAY MAP © JNTO

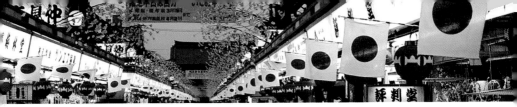

station and is a quick stop if you only have a few hours in the city.

Odaiba land reclamation project is the most recent addition to Tokyo's landscape and is a new island built in the port. It's home to numerous attractions including a 115m Ferris wheel, leisure centre, the 'Megaweb' (which is a car theme park), the Sega Joypolis and a man-made beach... yes, really!

Tsukiji Market is a huge working fish market and has become a tourist attraction in its own right, but by 9am it's just a massive empty warehouse. To experience this impressive and integral element of working Tokyo, you'll need to set you alarm clock and get up very early, Monday to Saturday (it's closed on Sundays). Over 2,000 tons of fish of unimaginable diversity pass through its doors every day. Try and get there before 6am to see the frantic selling and gutting. Then as the action dies down, go and enjoy the freshest sushi breakfast possible in one of the many cosy nearby restaurants, before going back to bed.

For your shopping needs: Tech-heads should head to the Akihabara district which is littered with next year's gadgets and enough competition to find a good deal. For the best fake plastic food in the world head to Kappabashi-dori and have a go at making your own sushi restaurant window display. Roppongi is known for it's slightly alternative fashions, where as Ginza is the place to go for the big name shops and brands. Shibuya is where the Tokyo youth hang out, being home to the Abbey Road zebra crossing on steroids that you would have seen on various films including Lost in Translation.

Evening Entertainment

From local to international, you can eat pretty much any type of cuisine here; Gordon Ramsay even has a restaurant here! For a good izakaya restaurant you can't go wrong with the Tengu chain which offers cheap eats and a menu you can point at. Jangara Ramen has a great reputation for those in the know and is located right outside the Harajuku station. Simple and unpretentious, it hits the spot every time!

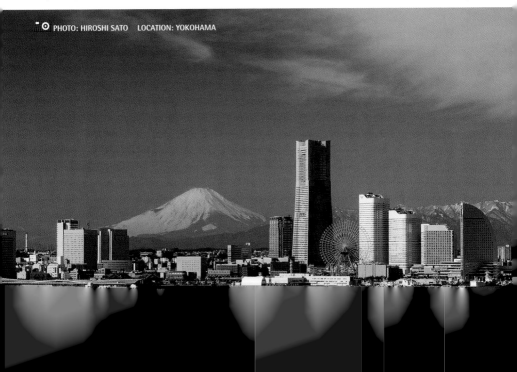

PHOTO: HIROSHI SATO LOCATION: YOKOHAMA

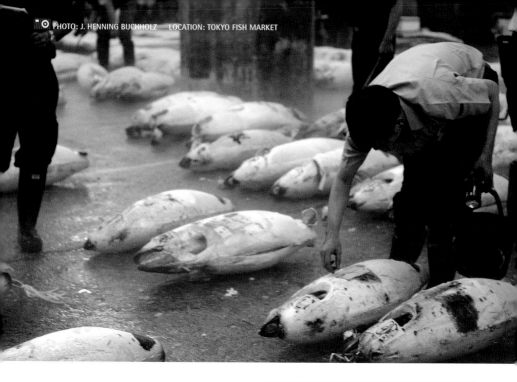

The Pink Cow is an old favourite located near the Shibuya station. The atmosphere is colourful and relaxed, with funky furnishings and a maze of rooms hung with the work of local artists, and it's priced at the opposite end of the spectrum to messrs Ramsey. Also on the cheaper end is the 'Tenya' chain of restaurants, offering inexpensive but tasty tempura. The restaurant name is displayed in Japanese only, but the blue and yellow sign is easy to recognise.

Overall, there are so many places to eat in Tokyo that you'll easily find something to suit your tastes. The Roppongi area, more known for shopping that eating, has plenty of restaurants in the medium and upper pricing brackets. For sushi and sashimi try Fukuzushi, and for teppanyaki go to Seryna.

As you would expect from any city of this size, there are plenty of places to soak up Tokyo's evening atmosphere and enjoy a drink or two. Hajime in Ginza is one of the most popular and trendy bars with a very minimalist design. You'll struggle to miss the Asahi Beer Hall in Azumabashi housed in the Philippe Starck designed building – just look out for a gold flame/slug on the top of the roof. Popular with ex-pats is the Gas

Tokyo Tips

BAGGAGE STORAGE - CHECKING OUT TOKYO SIGHTS FOR JUST ONE DAY? DON'T WANT TO DRAG YOUR MASSIVE SKI/SNOWBOARD BAGS AROUND THE CITY? HEAD TO THE BASEMENT FLOOR OF THE TOKYO CENTRAL STATION AND PAY TO STORE YOUR BAGS. STORAGE RATES ARE REASONABLE AND IT'S SUPER CONVENIENT.

MASSAGE CHAIRS - BEEN TREKKING AROUND THE CITY ALL DAY SEEING ALL THE SIGHTS? SORE FEET? TIRED LEGS? FIND A MULTI-STORY DEPARTMENT STORE, THE ONES THAT SELL EVERY ELECTRONIC ITEM UNDER THE SUN. HEAD UP TO ONE OF THE UPPER FLOORS AND LOOK FOR THE SAMPLE MASSAGE CHAIRS. SIT AND RELAX FOR AN HOUR WHILST ENJOYING A FULL-BODY MASSAGE, BUT DON'T FORGET TO PRETEND LIKE YOU'RE INTERESTED IN BUYING ONE.

SUBWAY TICKETS - NOT SURE WHERE YOU'RE HEADING? JUST GOING WITH THE FLOW? BUY A FULL-DAY SUBWAY PASS FOR AROUND 800 YEN AND GIVE YOURSELF THE FREEDOM TO HOP ON AND OFF AS MUCH AS YOU LIKE WITHOUT HAVING TO PURCHASE NEW TICKETS AT EVERY STOP.

Panic Cafe in Roppongi; this place has a reputation for being the ultimate sharking bar and serves plenty of cheap booze to keep things that way.

Tokyo is home to so many late night party spots, it's had to summarise. Check out the trendy Womb in Shibuya for some good times. For a pocket emptying experience, the Alife on Nishi-Azabu is the place to head, but you'll need to be wearing your smartest clothes to make it past the door. The Ginza also has a number of clubs like this; multi-level clubs filled with well-dressed Tokyoites drinking cocktails and dancing the night away.

Accommodation

Unless you've got pockets deeper than the snow in Niseko, you're going to be priced out of staying in one of the many luxury hotels here. The Park Hyatt was where Bill Murray's character stayed in Lost in Translation, and every single room across all 52 storeys will cost you an arm and a leg. Continuing in dreamland, the magnificent Imperial Hotel dates back to 1890 and offers over 1,000 rooms of pure luxury, along with the eye-popping price tags.

For something a bit more traditional try the Ryokan Shigetsu, near the Sensoji Temple in Asakusa. Bedrooms are spacious with sliding doors and en-suite bathrooms, all in the simple Japanese style and they have a small onsen.

There are plenty of business hotels which offer somewhere in the middle ground, but moving further down the price bracket, possibly the cheapest rooms can be found in the Asia Centre of Japan. It's all a bit

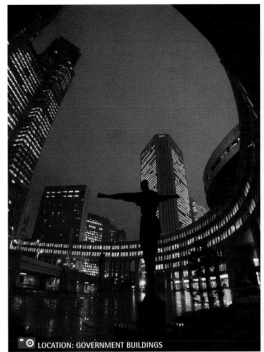

LOCATION: GOVERNMENT BUILDINGS

old fashioned but as a central base within staggering distance back from the Gas Panic Café it's a fair option.

For 4,000yen a night you can stay in the Capsule Inn in Akihabara, which is just a few minutes from the station. Each unit is a cosy 1m x 1m x 2m and has a TV, and there's wireless Internet in the lounge. Even cheaper at 3,000yen is the Capsule hotel at the Asakusa Riverside. For love hotels the easiest option is to head to the Dogenzaka area in Shibuya where there are plenty of options to choose from.

Access

Narita International airport is about 60km from the centre and Haneda is 16kms away. The 'getting there' section on page 24 has full details on how to get from the airport into Tokyo. Getting around is easy once you acclimatise to the subway map, and should you miss the five-hour window when the subways are closed, you can either hail one of the many taxis, or sit it out in one of the all night bars. If you do take a taxi, generally the level of English is much higher than outside of Tokyo, but certainly don't take it for granted and have your hotel written down or pick up an address card before you head out.

PHOTOS: STEVE DOWLE LOCATION: KAPPABASHI-DORI

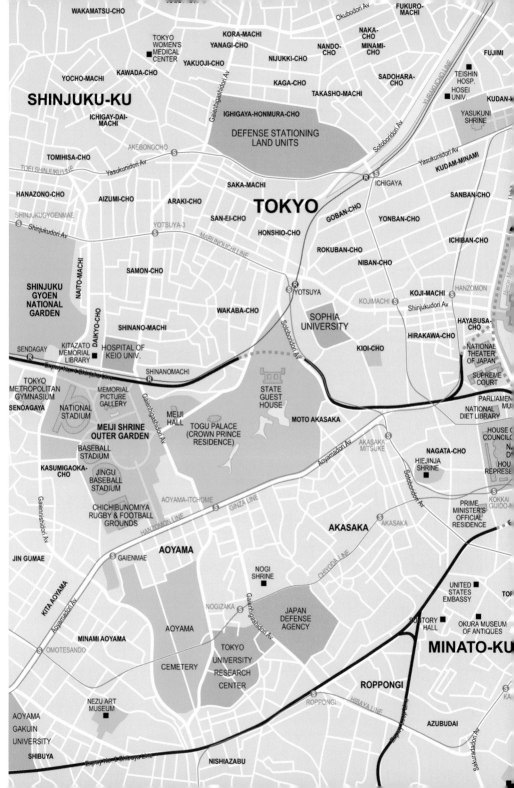

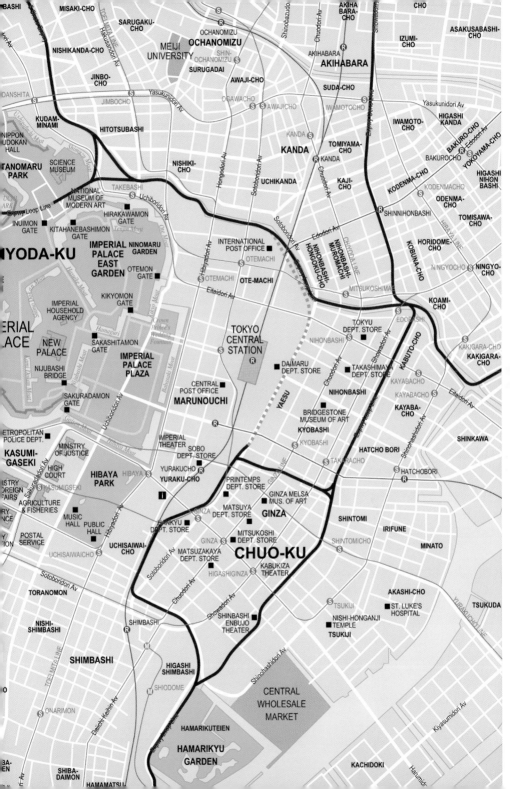

Osaka City

A modern city known for its culinary delights and impressive nightlife.

Located in the Kansai region, a little further away from Japan's major winter sport destinations, Osaka isn't the typical first-choice gateway city for snow-bound tourists. That said, it's a good substitute for Tokyo when looking at alternative flight routes/prices into Honshu.

Japan's third largest city at around 9 million, Osaka has throughout its history been more famous for its economic power than for its political standing. Whilst it is no longer Japan's commercial capital, Osaka is still a powerful business centre with a large working population. Formerly known as Naniwa, Osaka was twice the Imperial Capital of Japan, but only for short periods. These days, it's better known

for its skyscraper-studded skyline, vast underground shopping complexes and gourmet cuisine, than for its stints as the capital.

The city has two main centres, Kita to the North, which is the main business and retail district, and Minima to the South, which includes the main shopping, food and entertainment areas. There's plenty to see and do in Osaka, but it's not the main place to go if you want to see Japanese temples and other such cultural attractions – having lost most of its historical landmarks during World War II. Instead, enjoy the buzzing city atmosphere, legendary nightlife and expansive shopping.

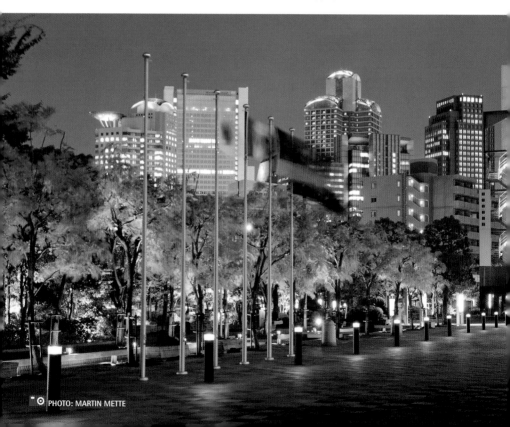

PHOTO: MARTIN METTE

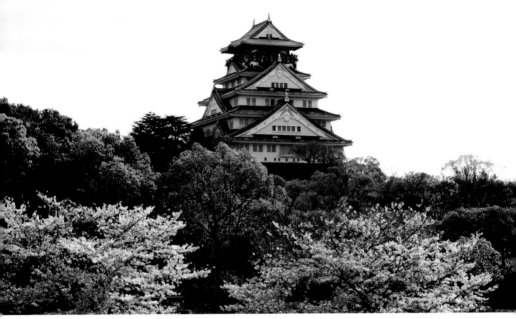

Sightseeing

Catering for more modern tastes, Osaka does well at offering all kinds of interesting exhibitions, and a large number of museums. Osaka's Museum of History provides a fascinating view of the city's development, and the Osaka Science Museum, with its amazing planetarium and various displays of peculiar physical phenomena, offers plenty of displays and activities to hold the interest of adults and kids alike. The huge Kayukan Aquarium (one of the world's largest) down by the harbour is home to a massive whale shark as well as around 30,000 other sea creatures. And then there's Osaka's Universal Studios theme park, with its many rides, shows, guided tours, restaurants and cafes.

One of Osaka's few cultural sites is the 400 years old castle (partly reconstructed in the 1990s) found centrally in amongst the city's enormous skyscrapers – a 'must-see' if ever there was one. But if you fancy a good view of the city (and are not afraid of heights) head for the open-air Floating Garden Observatory on top of the Umeda Sky Building. The views are magnificent.

Evening Entertainment

Osaka is just as busy after dark as during the daytime, with thousands of bars, restaurants and amusement venues to choose from. The most famous of the night spots is the Dotonbori area, a hectic neon jungle along the Dotonbori canal lined with food, drink and entertainment establishments, and a giant moving crab billboard at its heart.

Osaka has traditionally been known as the 'nation's kitchen' and is regarded as the country's gourmet food capital or the culinary heart (or indeed belly) of Japan. It's the place to go whether you want top-notch kaiseki food or more hearty and generous fare like okonomiyaki, the local speciality. Osakans themselves use the word "kuidaore", literally meaning "eat until you drop".

Accommodation

With everything from bargain lodgings to luxury hotels, Osaka has something to cater for all tastes – and budgets! On the lower end of the spectrum, the New Japan Sauna and Capsule Hotel offers capsule-style accommodation for men only, starting at about 2500 yen per night and located in a busy entertainment district.

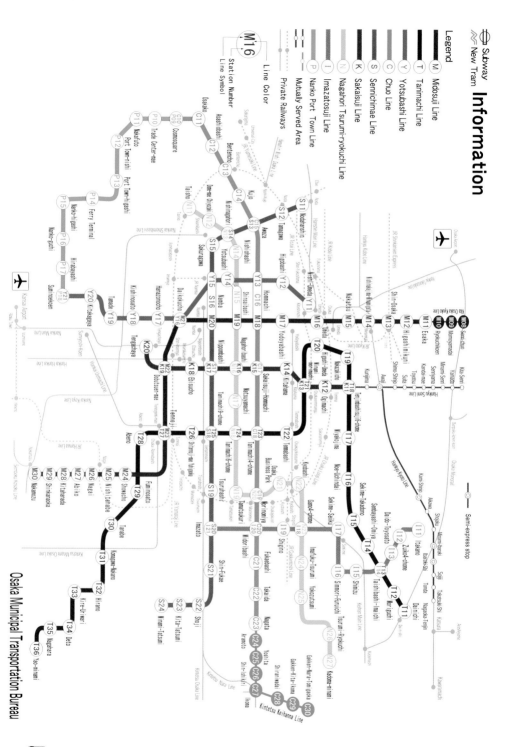

Osaka Municipal Transportation Bureau

SUBWAY MAP © JNTO

Hotel Sunroute Umeda is a reasonably cheap and conveniently located option, offering good facilities for its price bracket. The Claiton Shin Osaka Hotel provides easy access to the Shinkansen and a subway station nearby; its location makes it quick and easy to explore out-of-town destinations like Kyoto.

Access

With two international airports (Kansai and Osaka), access from afar is as simple as booking a flight on the net. As previously mentioned, Osaka is a great gateway alternative to Tokyo. Maybe you've been to Tokyo before and want to check out another city, or maybe you're searching for the best flight deals. Either way, this city is very accessible.

Getting around the city itself is simple enough. Whilst both the subway and train networks in Osaka are both excellent, the subway is probably the most efficient and easy-to-use mode of transport when exploring the city. One-day passes for the subway are available, except on the so-called 'No-My-Car-Days' when a special discount ticket is available instead. These are days (every Friday and on the 20th of every month) when people are encouraged to use the subway rather than their cars.

PHOTO: KOMOGOROV LOCATION: DOTONBORI

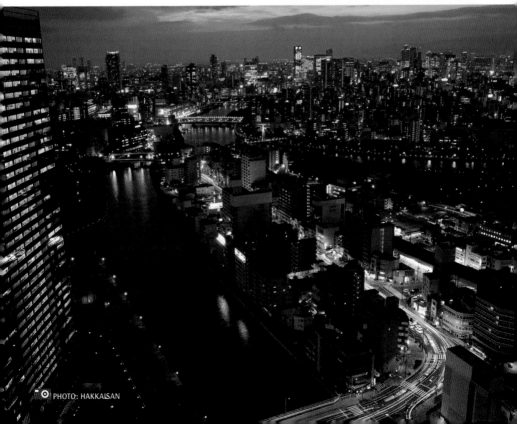

PHOTO: HAKKAISAN

Sapporo City

A well-rounded city with convenient ski resort access

Few cities in the world can boast easy access to this many ski resorts. Sapporo is within a few hours drive of 20-odd resorts; at least five of which are up there with the international best. With a population less than two million, Sapporo has an incredible ratio of slopes-to-people. For that main reason, it was chosen as the venue for the 1972 Winter Olympics.

As a relatively new Japanese city, Sapporo is untroubled, well-planned and easy enough to navigate. It's kind of like a mini-Tokyo but with snow, and is very pleasant when the fluffy flakes are falling to mask the habitual greyness. Sapporo is known internationally for its indigenous, self-titled beer, and for its delicious 'ramen' noodles.

The best time of year to visit is early February during the Yuki Matsuri (Sapporo Snow Festival), assuming you can hack the well-below freezing temperatures. This week-long celebration, revolving around ice sculpting, has an array of different events including a Toyota Big Air comp. Other tourist sites in and around Sapporo include the Jozankei Onsen and Odori Park – although if you're reading this book, you're probably snow-crazy and will spend most of your time skiing/ riding the famous Hokkaido powder instead.

Sightseeing

Sapporo is set up as a western-style grid with Odori Park acting as the main dividing line between the North and South. To the South of Odori Park are the main shopping and nightlife districts, and to the North is Sapporo's Central Station. Aside from the park itself, the Clock and TV Towers, most of the tourist sites are a little way out from the city centre.

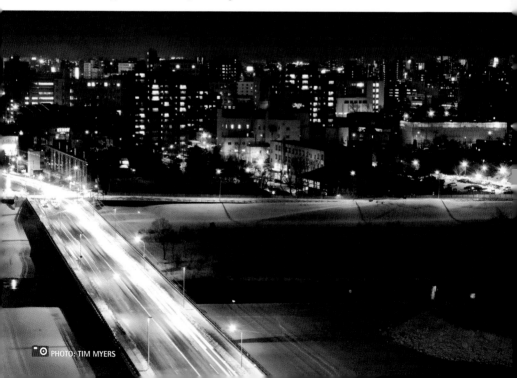

PHOTO: TIM MYERS

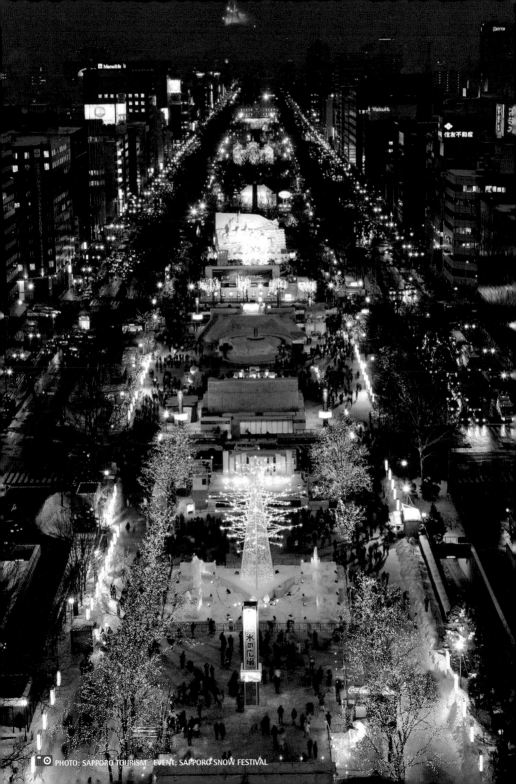

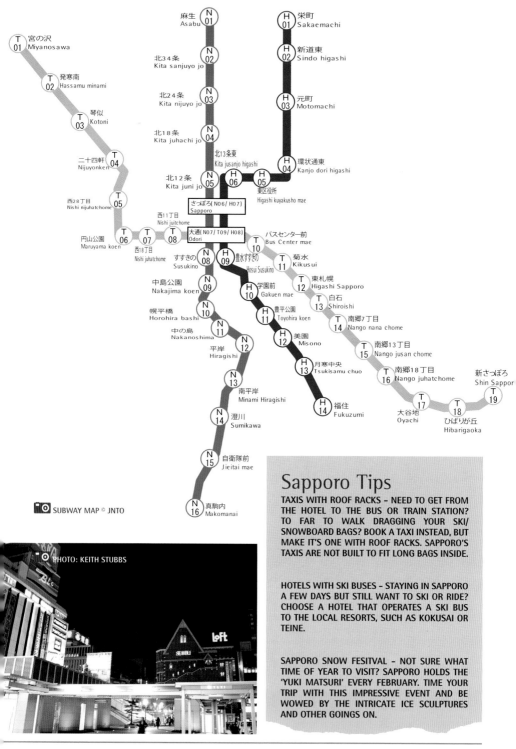

SUBWAY MAP © JNTO

PHOTO: KEITH STUBBS

Sapporo Tips

TAXIS WITH ROOF RACKS – NEED TO GET FROM THE HOTEL TO THE BUS OR TRAIN STATION? TO FAR TO WALK DRAGGING YOUR SKI/ SNOWBOARD BAGS? BOOK A TAXI INSTEAD, BUT MAKE IT'S ONE WITH ROOF RACKS. SAPPORO'S TAXIS ARE NOT BUILT TO FIT LONG BAGS INSIDE.

HOTELS WITH SKI BUSES – STAYING IN SAPPORO A FEW DAYS BUT STILL WANT TO SKI OR RIDE? CHOOSE A HOTEL THAT OPERATES A SKI BUS TO THE LOCAL RESORTS, SUCH AS KOKUSAI OR TEINE.

SAPPORO SNOW FESITVAL – NOT SURE WHAT TIME OF YEAR TO VISIT? SAPPORO HOLDS THE 'YUKI MATSURI' EVERY FEBRUARY. TIME YOUR TRIP WITH THIS IMPRESSIVE EVENT AND BE WOWED BY THE INTRICATE ICE SCULPTURES AND OTHER GOINGS ON.

In addition to the Yuki Matsuri – which is certainly worthy of change in one's schedule to include a visit – Sapporo offers small a selection of museums and temples, and a few different onsen that are worth the visit. Hokkaido Jingu is a temple set in dense forest in Maruyama area. Not too far away is the Sapporo Winter Sports Museum, complete with the 1972 Olympics ski jump, which can be re-lived by all who visit with the help of a fun simulator. Jozankei Onsen and Koganeyu Onsen are also worth a visit, particularly in you're in need of some relax time.

Evening Entertainment

Like most international cities, Sapporo offers a huge array of eating and drinking establishments, which focus heavily on local produce. Menus generally have

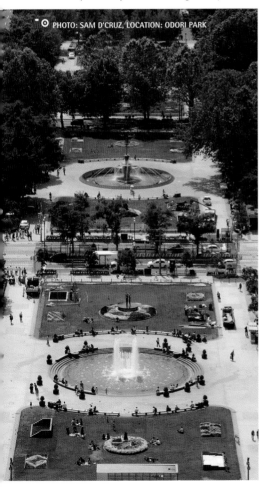

PHOTO: SAM D'CRUZ, LOCATION: ODORI PARK

a massive seafood influence and everywhere seems to sell the indigenous thirst-quenching Sapporo beer. Sapporo Central and Odori Park both have a good selection of restaurants close by; alternatively head to the Susukino suburb, which is best known for its nightlife. There's plenty of clubs and late-night bars in this part of town, although most levy a substantial cover charge.

Accommodation

Anyone looking to spend a few nights in Sapporo will be presented with a decent range of accommodation to choose from. The downtown area in Sapporo Central (around Odori Park and JR Sapporo Station) has many options with prices starting at about 4,000 yen per night for a half-decent three star hotel like the Sapporo Washington. Nakajima-park, located on the southern edge of the Susukino area, has 3 star options starting at around 3,500 yen per night.

Most hotels here offer very compact rooms, as is typical in all Japanese cities. However if you like a little more space or you're keen to lap up some luxury, the Sheraton Sapporo is the one for you. The Sheraton is an inexpensive five star hotel found in the Shin Sapporo area, complete with seven restaurants/bars and an amazing spa. It's ideal if you're looking for a night or two of indulgence without breaking the bank. You can find discounted rates from as little as 7,600 yen per night per person. Plus they offer a shuttle bus service direct to Sapporo Kokusai ski area, with the option to purchase lift tickets and rentals included in your accommodation package. If you do stay here, definitely take an evening to chill with the live music and cocktails at the 'Stars Bar' on the 31st floor, where you get a truly epic view over the city lights.

Access

Being the major gateway for Hokkaido's ski industry, Sapporo has to offer good accessibility for both international and domestic tourists. The main airport, Sapporo New Chitose, offers routes from some of the closer international airports – Hong Kong being the most useful transfer point for western visitors.

The easiest way to travel around Sapporo is by subway. This super-clean underground system is perfectly laid out accessing all the main districts, and reasonably priced too with half price day tickets available on weekends. Most signs and all announcements have

English translations and the staff are habitually helpful. The only drawback to this subway system seems to be finding the station entrances at ground level: pick up a city map, study it well and take your time when looking around - it's easy enough once you work out what to look for.

Driving in Sapporo is not particularly hard if you're already used to navigating big cities and driving on the left. Road rules are fairly standard and abided by. Place names are written in English as well as Japanese and signage generally includes international road symbols.

Getting out to the resorts from Sapporo can be tricky depending on where you're heading. Some resorts have a daily bus service from major hotels or the central bus station. Others rely on the Hokkaido Resort Liner, or other such companies, to transport their customers. Avoid using the JR lines (Japanese Railway over-ground trains) where possible, as they are simply not set up for English-speaking tourists dragging large ski or snowboard bags behind them.

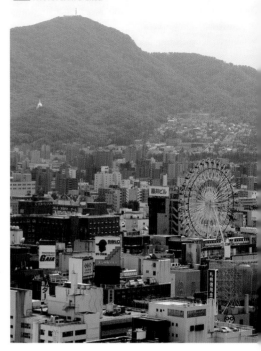

PHOTO: SAM D'CRUZ

PHOTO: KEITH STUBBS

Kyoto City

A city overflowing with traditional Japanese architecture and culture.

Founded more than 1200 years ago, Kyoto became the Imperial Capital of Japan in 794 and remained so for over a millennium. Today, it's the 7th largest city in Japan and is both a historical and industrial epicentre. It's a treasure trove of traditional Japanese culture with over 1800 temples, hundreds of shrines and many famous gardens.

Kyoto is located in the central part of the Honshu Island in the Kansai province, where you can also find the city of Nara – the capital prior to Kyoto. Nara is easily accessible from Kyoto and has some of the oldest wooden buildings still standing on earth. Kyoto was largely spared from bombing in World War II, resulting in a cornucopia of pre-war buildings, which were typically lost in other parts of Japan. It contains

20% of Japan's National Treasures and about 14% of Japan's important cultural properties exist within the city. Although a popular tourist destination, Kyoto is very Japanese. It's considered to be the traditional capital of the flower- and willow-world of geisha and is where geisha traditions are strongest – although it can be tricky to even get a glimpse of Japan's traditional female entertainers.

Arriving at Kyoto's main station with its 15 different floors feels somewhat overwhelming on your first visit to this city. But once you've found your feet it's an easy city to navigate, and using the public transport is pretty straightforward. There are signs everywhere in English and lots of restaurants have English menus, so if you're lacking in Japanese language you won't feel

completely bewildered. And if you do, the corporate giants of the West such as McDs and the Colonel can be found here.

Sightseeing

Unlike Tokyo, Osaka and Sapporo, which serve mostly as gateways for international tourists, a visit to Kyoto is almost purely for the purpose of sightseeing. The city's East side is where traditional Kyoto can be discovered, offering temples, shrines, museums and the geisha district of Gion – located just one minute's walk from Keihan Shijo Station. The West side of the city, also home to dozens of temples, is where many iconic Japanese Zen rock gardens can be found. The centre of the city contains the commercial and nightlife districts and is located directly between the areas known as Kawaramachi (East) and Karasuma (West).

A 'must-see' for every visitor is the shrine of Fushimi Inari Taisha, built in 711, and found close to the city centre. Here you walk through more than 4kms of 'torii gates', which have been donated to the shrine and are painted red – an impressive sight to say the least. One of Kyoto's most popular temples is Kiyomizu-dera. Enjoy a beautiful walk through old Kyoto up to the temple, from which you can look back over the whole city.

Evening Entertainment

There's plenty going on in Kyoto after dark, with most of the action happening around the Kawaramachi area. Here you'll discover numerous restaurants catering for every taste. If you're looking for traditional Japan, step into the side streets and you're likely to come across many intimate izakayas serving traditional fare at reasonable prices.

Kyoto is famed for its cuisine throughout Japan. Some hotels host Kyoto Cuisine and Maiko evenings where you can experience the local delicacies and watch the geisha performing their elegant dance. Evenings like this typically cost from 18,000 yen so, whilst unique, it's a hefty price tag. Late night entertainment comes in varying forms, with nightclubs and karaoke bars taking the lion's share. Most clubs generally have a cover charge at around 2,000yen, but will generally include a complimentary drink.

There are numerous festivals taking place in Kyoto throughout the year. Marking the end of winter is Setsubun Matsuri, held at Yoshida-jinja in February each year and marked with a huge bonfire that is lit at dusk. For more information about various festivals and other events, Kyoto has its own Time Out magazine, publicizing all goings on throughout the city.

Accommodation

Accommodation options in Kyoto are plentiful. From budget hostels and capsule hotels to nice B&B's and some of Japan's finest five-star outlets. Kyoto is one of the few places in Japan where ryokans are found in abundance and are not yet exclusive. The Budget Inn, close to the main station, is a modern ryokan at backpacker prices – great for those on a lower budget still looking to experience Japanese living. Gion Hatanaka is a traditional style ryokan, with large rooms and a beautiful onsen. It's also within walking distance of many temples and close to the main area of Kawaramachi.

Access

Even without it's own International Airport, Kyoto is still very accessible. Flying into either Kansai International Airport or Osaka International Airport are both suitable options, with just a 1hr train journey to follow. The Haruka Express from Kansai is the easiest route. Alternatively, fly into Tokyo and ride the Shinkansen taking precisely 2hrs and 22mins.

Kyoto's main station is the 2nd largest in Japan with 15 floors, incorporating a shopping mall, hotel and movie theatre. It's where the Tokaido Shinkansen Line and local train lines all connect, as well as the national and local bus services. There's an easy-to-use subway system with a stop at the main station, and stops close to shrines and temples throughout Kyoto.

Bike culture is integral to Kyoto life. The scale and setup of the city makes it easy to negotiate, even for a visitor. Most of the city is flat, meaning no major uphill struggles, and bike rentals are simple and readily available. The only downside to this is the lack of bike-parking facilities – bicycle impounding by the city council for illegal parking has been known to happen.

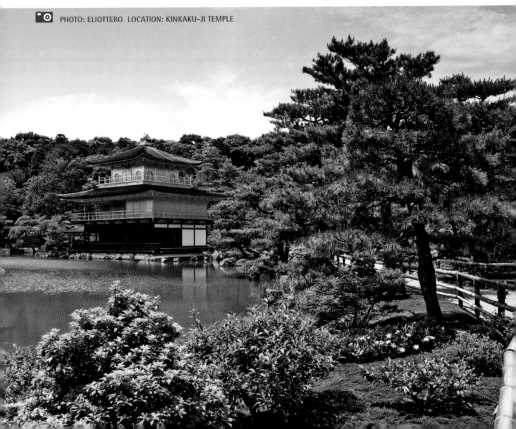

PHOTO: ELIOTTERO LOCATION: KINKAKU-JI TEMPLE

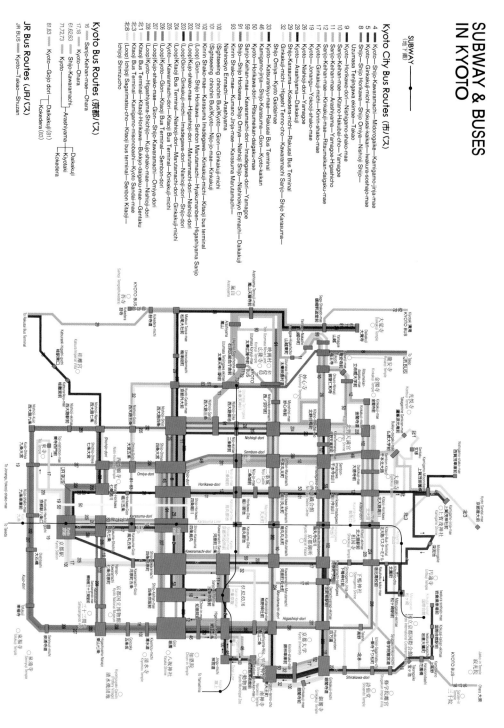

Backcountry and Off-piste

More and more people are venturing past the safety of ropes, chairlifts and groomed trails all the time. A love of powder unites many skiers and snowboarders around the world and with resort snowfalls becoming more inconsistent the search for freshies gets extended a little further each year.

In Japan, there are many 'new frontiers' to continue ones personal search for fresh lines, and the snow certainly continues to fall. In this backcountry section we endeavour to give you some knowledge and guidance to help you with your search. There's plenty of powder out there waiting to be claimed, you just have to know where to look.

PHOTO: SARAH MULHOLLAND LOCATION: TOKACHIDAKE BACKCOUNTRY

General backcountry advice

Fact: 90% of people who are caught in an avalanche either set it off themselves or someone in their party does.

Before you think of heading into the backcountry there is knowledge and equipment you MUST have. Start by reading any and all information regarding avalanches and backcountry travel that you can get your hands on. Watch videos. Use the web. Learn from others. Ultimately, none of this will replace actually attending a backcountry or avalanche course and gaining the knowledge first hand. If your experience in the backcountry is limited or knowledge of an area is questionable, there's only once choice... hire a guide. Those places that offer snow cat or heli-skiing and -boarding trips will usually include a guide in the price, but if you're venturing into the unknown, take the time to select an established professional guiding service.

If you're embarking upon a new hobby and are shelling out for new backcountry gear, do not skimp on equipment. Carrying a transceiver without a shovel is mindless; all you can do is find the location where you SHOULD be digging. If you have a shovel but no probe, you'll be digging a lot longer because you haven't managed to pin point the exact spot your friend is buried. Most people buried in an avalanche survive if dug out within 15 minutes. Pack your rucksack for all eventualities. Remember the weather in the mountains can change fast; just because you started the day in sunshine doesn't mean that you won't end it stuck in a white out. Always be prepared to stay overnight in the worst-case scenario.

Japanese weather and snow conditions

There are many renowned powder destinations around the world, but very few compare to Japan's unique environment. As a country that receives one of the highest snowfalls in the world, you'd almost expect the snow to be a little wet and heavy. Think Tahoe or Whistler: huge amounts of snow, but not as dry as their in-land counterparts like Colorado and Banff.

Japan gets the best of both worlds. Northwest winds bring intense cold air streams and strengthening weather systems down from Siberia picking up just enough moisture on their way over the Sea of Japan. And the first thing these systems hit is the Japanese mountainside, where they bust their almighty load unleashing some of the driest powder snow in the world.

Not convinced yet? Well, the water content in Japanese snow is often as low as 4%. Compared to Utah's usual 7% (another internationally renowned

powder haven) and you have quite a difference. Typical temperatures in Japan's ski resorts can range from -5° to -10° C, during mid-winter months. Whilst not as cold as snowy destinations like Norway or Quebec, this temperature helps maintain the balance between frequent sizable snowfalls and the preserving of the snow's condition days after a storm.

Of course, as with any ski destination, fresh snow is not always guaranteed. The current changes in climate have seen a small increase in weather systems coming from the south and east. These weather patterns, whilst not yet common, bring stronger winds and wetter, heavier snow to the Japanese ski resorts. Don't let this put you off though; climate change is happening the world over and the effect on the ski industry seems to be an increase in fluctuating conditions rather than one of declining snow levels.

The confusion around Japan's off-piste

The controversy around off-piste in Japan has become notorious throughout the international snow sports industry. It's frequently covered in magazine articles, discussed continuously on web sites and blogs, debated on chairlifts between well-informed (and sometimes not-so-well-informed) skiers and riders, and so very often complained about by Western winter tourists visiting Japan for the first time.

It's no surprise really. Imagine its day number 1 on your first ever trip to Japan and you're exploring the resort. You've skied in Europe. You've done North America too. It hasn't snowed for a few days and after a few warm up runs on the groomers you look for an easy spot to duck into the trees. It's then you notice all the ropes down the side of the runs. Strange! You finally find a patch of trees that aren't roped off and in you go. After a few nice powder turns you come out at the chairlift only to be told by a lifty or patroller that this area is not allowed.

So what's the truth behind this somewhat obscure situation? Are the trees really seen as being sacred in the Japanese Buddhist traditions? How much avalanche danger actually is there? Why do some resorts allow off-piste and others not? There are so many contributing factors around this topic that there's no 100% correct answer, but let's take a look at the different points anyway...

Firstly, I feel obliged clear up a common misconception. Whilst Japanese Buddhists may well consider trees to be sacred, this is NOT the reason that various resorts don't allow tree skiing and riding. Repeat this myth to the average Japanese skier or snowboarder and you're bound to get a quizzical look in return, followed by a few laughs. For some reason or other, this 'sacred trees' myth has spread far and wide and many people believe that this is the reason why Japanese skiers and riders usually stick to the marked trails.

By nature the Japanese are conformists. A rule is established and few question it, let alone actually break it. In recent years an increasing number of Japanese have been venturing off-piste and into the trees. This is not necessarily a reflection of changing society but more a result of the increase in Western visitors – who will bend the rules further to score a fresh track.

In the present day, if a resort has a 'no off-piste' policy there could be a number of reasons why. Some resorts are located in National Parks and are restricted by the laws the government has established. These laws restrict resort management by stating that off-piste areas are not within the operating lease and must be kept out of bounds to avoid conflict with nature (or

PHOTO: KEITH STUBBS

something to that effect). That said, it seems a few Japanese resorts that are located within National Parks have managed to get around these laws – or they could just be turning a blind eye.

So could this issue be more of an avalanche safety consideration? In some cases the answer is yes. However, in a lot of cases this is used more as an excuse than a reason. Tree-covered faces under 35 degrees rarely slide. Why is it that resorts such as Niseko United manage to open their off-piste and backcountry, even though they have one of the largest snowfalls in Japan and offer some of the steepest accessible terrain? Compare this to other resorts that keep their 'avalanche prone' faces constantly closed, even though it's mellower in pitch and receives less snow, and questions will arise. Of course, there's more than pitch and size of snowfall to consider when managing risks and many Japanese resorts just say that skiing and riding in the trees isn't safe. Well yes, it's not as safe as staying on groomed trails – you may get a twig in your eye after all – but it certainly begs the question: is this enough of a reason to keep this terrain closed?

After quite a bit of research into this matter, I came to the conclusion that it's not about the snow or terrain, but about the people. To operate a successful ski patrol team at a mountain prone to avalanches, or a resort that allows off-piste, is challenging at best. Patrollers performing avalanche control and risk assessment work need to be highly trained and qualified. Unfortunately, in Japan there's no national qualification framework for this. Now, that's not to say there are no avalanche-qualified patrollers in Japan. Mountains like Niseko frequently employ foreign qualified patrollers and encourage their Japanese staff to gain qualifications overseas, the standard choice being the Canadian Avalanche Association, which has been a forerunner to many other national avalanche associations, including New Zealand. They're even starting to run some Canadian courses in Japan.

Without the skills to assess the risks and control avalanches how are resort management supposed to open off-piste terrain to the public? It's a tricky situation but times are changing and some resorts are really taking the bull by the horns, under the realisation that steep-and-deep powder is one of the main things attracting many international visitors.

What is considered off-piste?

Every resort in Japan is different. However, generally speaking, off-piste is considered anywhere within the resort boundaries that isn't a marked trail. So if it ain't shown on the map, it's probably off-piste.

Many resorts blatantly state that off-piste is not permitted. Others offer a 'at your own risk approach'. The forward thinking resorts open certain areas of their off-piste that can be easily controlled and managed. This provides skiers and snowboarders with enough adventure without creating too much risk. It also reduces the likelihood of people ducking ropes and accessing the actual dangerous off-piste. So, where does the off-piste end and the backcountry begin?

Backcountry is anywhere outside of the resort boundary. Although it can be hard to see where the resort boundary actually is or even if there is one. Resorts that do allow off-piste within their in-bounds terrain will typically have an obvious boundary line. Some even offer gates to access this 'slackcountry', allowing the patrol team to control the entry and close the gates when it's too dangerous. Other resorts (that allow off-piste) just show a boundary line on the map, leaving it to your own judgement as to whether you cross it or not. Bear in mind, that resorts offering this approach are unlikely to be performing much in the way of avalanche control work.

Insurance

The big question for many people visiting Japan in search of powder is; 'Should I get insurance that covers off-piste'? If you're planning on skiing and riding off-piste then the obvious answer is yes. Most insurance companies specify that cover for off-piste is only when within areas permitted by the resort. I.e. if it's a resort that doesn't allow off-piste, you're not covered.

Some insurance companies offer specific backcountry insurance, although it can be very expensive. If this is a concern for you, read the fine print. Establish what exactly they cover you for. Is it rescue, or medical only? Japanese Search and Rescue is operated by the military and in conjunction with the local police. It's unclear as to what this costs and it differs depending on the region and size of the rescue operation. That said, helicopter rescues are often free of charge.

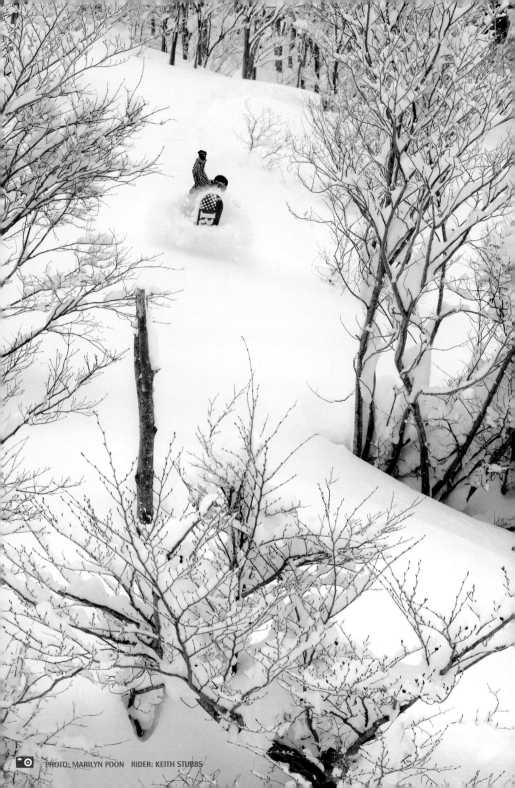

Accessing Backcountry areas

Even though many of Japan's snow-going tourists are out to experience the infamous 'day-of-reckoning' sized powder dumps, most people don't visit this snow-laden country to solely ski the backcountry. Japan doesn't have quite the same adventurous mountain exploring traditions as countries like France and Switzerland, and the peaks themselves are a wee bit smaller. But they generally get a whole lot more snow.

It's becoming more common in recent times for both domestics and internationals to venture into the Japanese backcountry in search of fresh lines and freedom that the mainstream resorts can't provide. Of course, powder can be found all over the place in resorts up and down the country, but there are always restrictions and limitations in place.

If you're a high-intermediate powder skier/rider heading to Japan, think about incorporating a real backcountry mission into your next trip.

Lift-accessible backcountry

Despite the 'no off-piste' reputation, there are a number of resorts around Japan that do allow off-piste – or, at the very least, turn a blind eye to it. You'll discover a few ski areas that can't quite be considered resorts but rather they're one large ropeway (or cable car as most Westerners would call it) accessing a large amount of backcountry or off-piste terrain.

PHOTOS: KEITH STUBBS

I say backcountry because most of the areas these ropeways access are not controlled. There's no real avalanche control work, no obvious boundary line and not much information out on the hill. Proper trail maps are usually out of the question as there are rarely any groomed runs to follow. Generally, these are local hideouts that are recognised as havens for serious backcountry skiers and riders. It goes without saying that if you don't know these areas you must hire a guide who does.

If you've already had a good browse through our resort reviews you may have come across a few of these lift-accessible backcountry areas. The most well known ones are Asahidake and Kurodake both in Hokkaido, Hakkoda in Aomori prefecture, Tohoku and Tanigawadake Tengindaira in Gunma prefecture, Kanto – although the last of these, Tengindaira, is a little more 'resorty' than the others.

Other, more comprehensive resorts that provide good access to the backcountry include Niseko United in Hokkaido, Kagura (joined to Naeba) in Niigata, and Happo One in Nagano.

Cats, Helis and Sleds

On the whole, Japan doesn't have a huge range of cat and heli options, which is surprising for such a renowned powder destination. What it does have however, is well worth a look and if you're a high intermediate or above skier/rider, you should definitely make room in your schedule for a day of easy-access backcountry bliss.

Your own two feet

Sometimes there's nothing better than ascending a peak completely under your own steam, in the anticipation of some hard-earned powder turn rewards. But doing so in places that can be accessed by lifts of other forms of transport usually goes against ones logic. So instead, go where vehicles are not permitted and explore the wonders of Japan's National Parks. Like most countries around the world, Japanese National Parks do not permit the use of snowmobiles or other machine-driven transport. Access is 100% you - and nothing else. Most parks don't even permit dog sledding. There are 29 national parks in Japan, but not all are suitable for backcountry skiing and riding.

Backcountry areas

Alpha Resort Tomamu: Cat and heli

Located in central-Hokkaido, this is a standard ski resort that offers cat skiing/riding and even heli. For these purposes it utilises a fairly mellow range of mountain close by and provides everything you require, from transceivers and guides to transport and scrumptious lunches in Japanese tee-pees.

The cat skiing is scheduled every weekend throughout the peak-season months. It's best suited to high-intermediate skiers and riders comfortable in the trees, and wanting to experience Japanese backcountry for the first time. The terrain is fairly mellow, with widely spaced vegetation and rolling pitches. There's nothing that could be considered steep here, so it's not really suitable for anyone of expert standards, looking for more demanding backcountry lines.

Tomamu's heli skiing is much less frequent. With a set number of days they operate each season (sometimes as few as 4), it's very hit and miss. To get on one of these trips you are required to book at the start of the season (dates are usually posted in October) by calling Tomamu direct – be sure to brush up on your Japanese first. The heli trips head to the same area as the cat skiing trips, but take you further up the ridge accessing some slightly steeper faces.

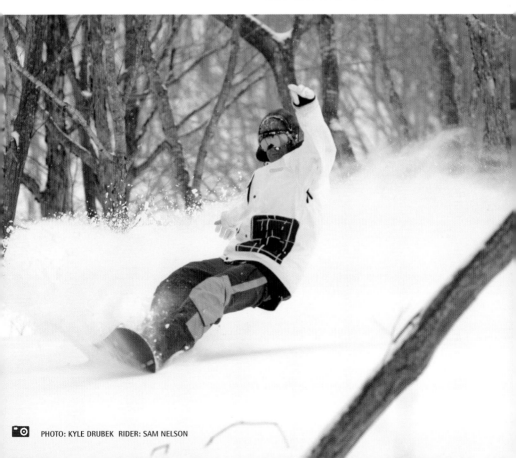

PHOTO: KYLE DRUBEK RIDER: SAM NELSON

Niseko Snow Adentures: Cat and sled

Niseko Snow Adventures, a backcountry cat and sled operation, was started in 2005 by a Kiwi guy named Nick Gutry and an Aussie by the name of Scott Bowman, who after years of exploring Hokkaido's backcountry decided to share the experience with the greater public. If your skiing or snowboarding is of a high level Nick or Scott, together with guide Cam McKay (also a Kiwi), will take you out to the best possible terrain for a number of backcountry activities. These guys know where the goods are and often find themselves riding powder weeks after a storm.

NSA specialises in photo shoots catering mostly for pro riders/photographers wanting something other than the token Japan ski shot. They've guided some of the world's best from North America and Europe as well as Australia and New Zealand. With the ultimate combination of a snow cat for access and a sled for quick ascents or tow-ins, you'll get the opportunity to hit backcountry features until your legs give out. For those who don't have your own published snapper, you can add into the mix NSA's on-call professional photographer to get the ski shot of a lifetime – great to show the boys back in the office. Alternatively, NSA offers a variety of snowmobile tours suitable to all abilities. The word 'tour' really doesn't do this justice though. You'll be carving a snowmobile through waist deep powder on purpose-built high-performance snowmobiles. These guys are the only ones offering real backcountry terrain and high-performance sleds.

Beware, you will be asked to sign a liability waiver and before each trip and will have to undergo a safety briefing as well as a familiarisation with all the machinery and backcountry safety equipment being used. NSA is a member of the Canadian Avalanche Association and Nick, Scott and Cam all have high levels of avalanche, first aid and winter guiding qualifications as well as a huge amount of experience in Hokkaido's backcountry. You'll be in safe hands here.

Niseko Weiss: Snow cat only

Niseko Weiss is the perfect place for intermediate powder seekers looking for their first Cat Skiing/ Boarding experience. Located close to the well known linked resorts of Niseko United and about 2hrs drive from Sapporo City, this is an old ski area with disused chairlifts that has been converted into a small Cat Ski operation.

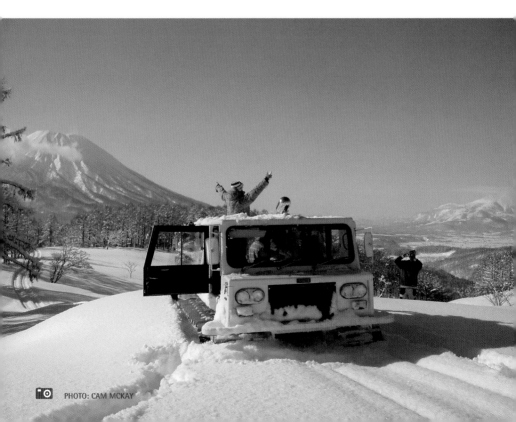

PHOTO: CAM MCKAY

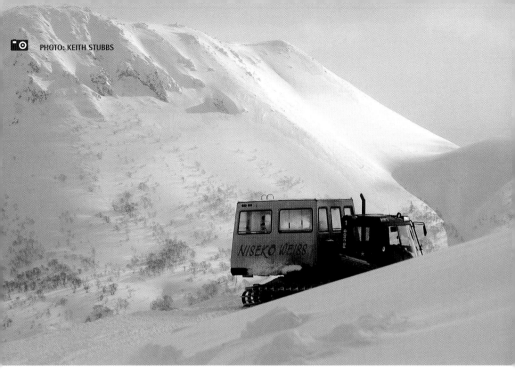

There are no groomed courses here, just simply lots of untracked fresh powdery lines to be had. Niseko Weiss gets over 12 meters of snow each season and although the terrain isn't particularly challenging, riding fresh lines every single run is something to be cherished. For a dirt-cheap price that's equivalent to that of a single day pass in most other resorts you get 7 runs of 800m vertical. But this is really just a one-day deal, any more than that and you'll be struggling to stay interested.

The terrain at the top (where the Snow Cat drops you off) has the steepest pitch and is definitely face-shot potential, whereas from halfway down it gets rather flat and you often need to ride the cat tracks to get your speed up. If you want something more challenging grab a pair of snowshoes and take the 15min hike up the ridgeline to the top; here you will find a nice big bowl to crank out some huge powder turns. Be careful to stay above the tree line when traversing back and don't forget to take your avalanche safety gear with you.

Kuatsu Kokusai: Heli only

This smaller ski resort in Gunma prefecture, offers heli skiing and riding, usually in the months of February and March. They offer about 1000m of vertical drop

starting around the 2200m mark. It's available at reasonable prices, paying per flight, and makes an excellent day trip from Tokyo or the closer ski towns of Minakami and Yuawa. You'll be treated to some awesome views, both on the chopper and whilst skiing down. The terrain itself is fairly mellow and has quite a few flatter sections, which will see skiers poling themselves along and snowboards struggling.

Tokachi-dake area: on foot

A renowned backcountry area in central-Hokkaido close to the town of Furano, this is a place of beauty, explorative culture and Japanese mountain spirit. Located in the centre of Hokkaido's largest national park, which incidentally is about ten times the size of Osaka city at more than 35 hectares, the Daisetsuzan National Park (meaning "great snowy mountains"), Mt Tokachi stands head and shoulders above its 15 surrounding peaks. At just at 2077m it is not comparable with the likes of European and North American higher mountains, but this is Hokkaido... and it snows down to sea level for many months of the year.

Created from the convergence of two major volcanic belts, this collection of jagged peaks is known just as

much for its natural onsens as it is for its backcountry skiing. Within the ski and snowboard community this area is commonly referred to as Tokachi-dake (pronounced "Toe-catchie—dacky"), even though most skiers/riders don't ascend the highest peak itself, preferring instead to enjoy the lower surrounding ridges.

Vehicle access is permitted up to the few trailheads, where small car parks are found with onsen lodges nearby. From this point, it's you, yourself and your crew. Strap on your skins or crank out the snowshoes, there are endless lines to be had here. You'll discover a good number of quick hike-and-ride routes and many a longer option too. The terrain here offers everything from wide-open powder faces through to tight-tricky chutes with hefty cliff drops. From the main car park at Tokachi-dake Hot Springs (or within 2mins walk of) you'll get a good idea of the full expanse and begin spotting potential lines. But coming here without a guide means you must be a highly experienced backcountry skier/rider utterly prepared with topographical maps, transceivers, shovels, probes (and all the other necessities); or you are very foolish. For guiding services at Tokachi-dake speak to Hokkaido Powder Guides, based in Furano town. This is their regular haunt and they know this range of mountains intimately.

Staying up in the National Park is certainly possible and a worthwhile experience. But don't fret, you don't need to bring a tent or dig a snow cave. There are three different lodges here, all with their own natural onsens. The Ryounkaku Onsen offers up-market

ryoken-style accommodation with meals inclusive, but on the pricey side. Kamihoroso also offers tatami mat rooms, but on the lower end of the prices spectrum. The pick of the bunch, if you're on any sort of limited budget, has to be Hakuginsu Hot Spring Lodge. Here you will find excellent value accommodation in the form of bunkrooms, with use of a well-supplied communal kitchen and their large selection of onsen baths. Different temperature open-air pools with a mixed-gender option or the smart indoor baths; take your pick, or sweat it out in the sauna instead.

Tateyama area: on foot

One of the highest backcountry areas Japan has to offer, Tateyama is located in Toyama prefecture but also creeps into Nagano prefecture. At over 3000m, the Tateyama range, within the Hida Mountains, is a spectacular exhibition of peaks and well known among Japanese alpine climbers and backcountry skiers/riders, as well as with general tourists. Mt Tate itself is one of Japan's Sanreizan (holy mountains), along with Mt Fuji and Mt Haku. Still commonly referred to as Tateyama (pronounced "Tat-ey-ama"), the area shares its name with a local town.

The terrain here can be gentle or intimidating, depending on your routes. All the skiing is done above the Morodu Plateau. Here you can choose between an array of accommodation and hike on a daily basis. Mikurigaike Onsen is one of these lodgings and is the highest in Japan at 2400m. It's a 20min walk from the bus terminal. Alternatively you can camp further up, but take a down-filled sleeping bag and all the usual winter camping necessities, and don't forget to get the inside scoop from the locals.

Getting to the Morodu Plateau can be done by highland bus through a 20-meter-high snow corridor on the Toyama prefecture side – sit on the right side of the bus heading up and you'll enjoy some impressive views. On the Nagano prefecture side you have to access via a series of buses, trams and a ropeway. The whole process takes a while (due to the large numbers of general tourists) and isn't cheap, but it's worth it when you're there. Note that the whole alpine route only opens middle of April each year and is closed in winter, meaning skiing is only really viable for a few months, from mid-April through until June or sometimes July depending on snow levels.

PHOTO: JAMES MUTTER

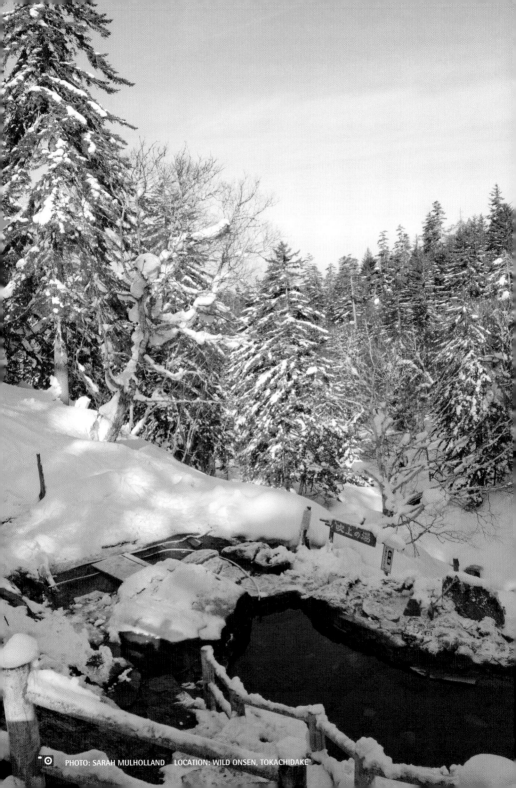

炎上の湯

PHOTO: SARAH MULHOLLAND LOCATION: WILD ONSEN, TOKACHIDAKE

An interview with Kyle Drubek:
A Professional Photographer with a long history in the industry.

Hi Kyle, can you tell us a little about yourself, and what you do here in Japan?

"Well, 'nationality challenged' may best describe me: born in the States, raised in Canada and Japan, with a British passport. Worked at World Cups, Big Air contests, snowboard shop, and eventually as the team manager of Burton, Japan before returning to my first love, photography. After a few years of heavy travel, I pulled back from magazine shoots to stay local. I currently run a small photography business based on outdoor action photography both summer and winter."

How long have you been in Japan and what brought you here in the first place?

"22 years now, hard to believe! Tagged along with my parents when they came to work in Sapporo."

So you've photographed some big names in the industry, care to share a few of them?

"Man, that's a heavy task, hmmm. Start big I guess: Terje, Craig Kelly, MFM, Rippey, Iguchi, Ranquet, Gerry Lopez to name a few, and heaps of Japanese talent."

Do you mostly work with Japanese or international publications and businesses?

"I work with only a smattering of publications now, sort of took a big step back from the actual industry side of things. The less time I have to spend in an office the better."

What's been the biggest challenge for you as a photographer in Japan?

"Probably dealing with magazines here, the whole system is very political and it's more about who you know. I was lucky since I knew quite a few people from the start, but the actual system is quite closed."

Have you always been based in Minakami, or have you lived elsewhere in Japan?

"Lets see, Sapporo 8yrs total, lots of riding up there at Sapporo Kokusai, and lots of night riding. Down in Tokyo for 5yrs. Gypsy for another 5 or so, and here in Minakami for 8 yrs now."

You must have seen some big changes over the years in the Japanese ski industry, what's been some of the more notable changes?

You must have seen some big changes over the years in the Japanese ski industry, what's been some of the more notable changes?

"Well, the resort I just mentioned, Sapporo Kokusai, you used to have to duck ropes and be pretty quick to get some pow. These days it's almost all open and the whole resort is completely tracked out, people have changed their whole attitude to riding. There was insane amounts of money being pumped into the contests back in the day because of the bubble economy, that's sort of turned around the other way now. Almost the opposite to the rest of the world I guess."

So where some are your favourite spots to ski/ride or shoot across Japan?

"Alright, this is important. Asahidake in Hokkaido; check out the new cable car but don't get lost. Hachimantai; get ready to hike a bit and receive some heavy rewards. Hakuba; find a friendly local and get ready to cough up some beers in return for some of the absolute steepest and most amazing powder to be had in Japan. That said, well, I'm here in Minakami for a reason so I guess you might want to drop by here too!"

What's the best piece of advice you can give a skier/rider visiting Japan for the first time?

"Remember to bring cash - most of the country is still very analogue. Just like anywhere else in the world, a few local words or phrases will bring you friendship where-ever you go. The most helpful word: "Domo" - it can be used as thanks, hi, and bye!"

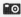 PHOTO: KYLE DRUBEK RIDER: KEITH STUBBS

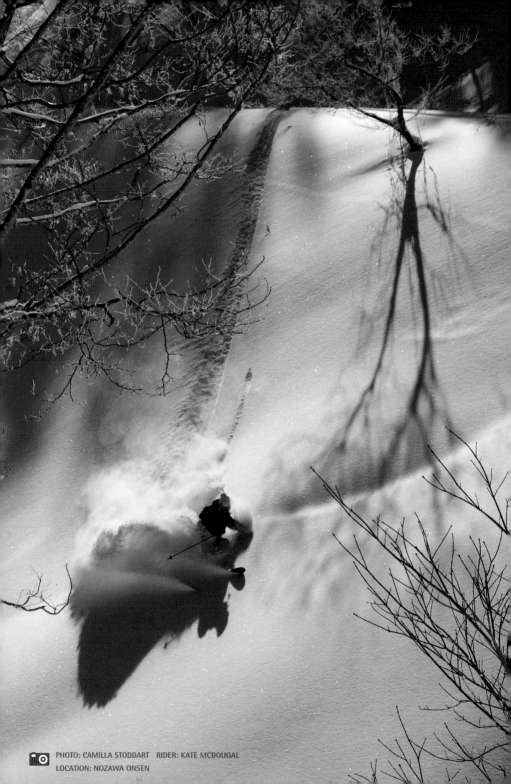

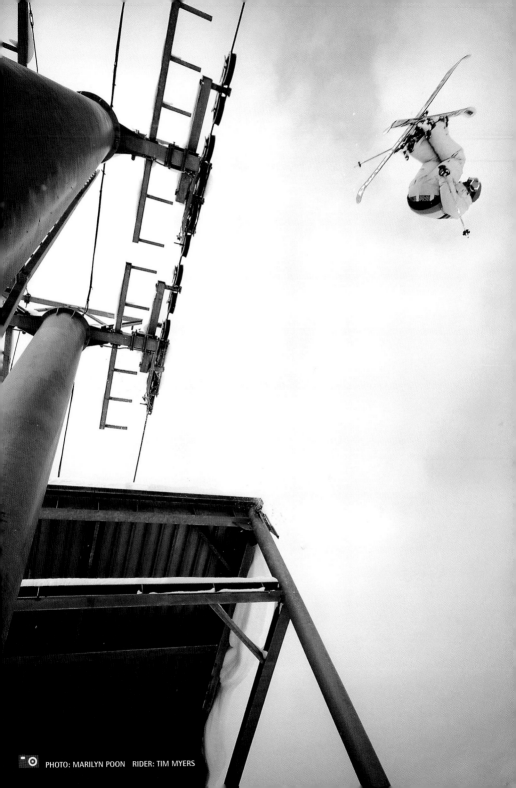

PHOTO: CAMILLA STODDART RIDER: JAMIE MACKAY
LOCATION: WEST COAST OF HOKKAIDO NEAR SAPPORO

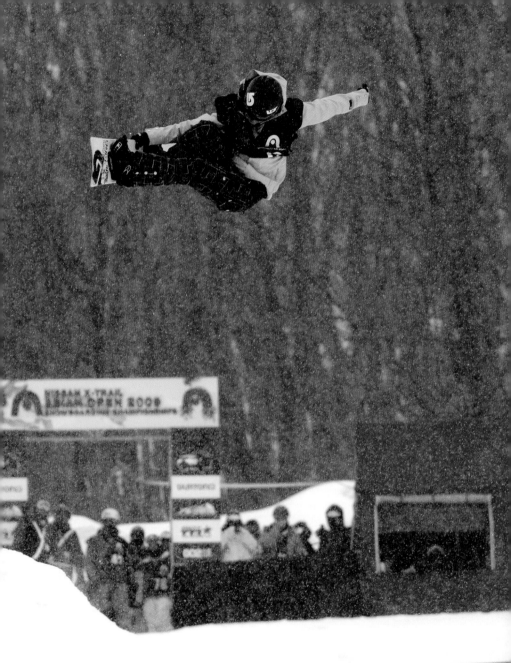

Resort & Town Reviews

Interpreting and getting the most out of our reviews

The Snow-search Japan resort and town reviews provide un-biased opinions and insights into every aspect and characteristic necessary. Each review discusses both the highlights and the lowlights, providing you with all possible details needed to make an informed decision when planning a trip to Japan's snowy mountains.

Ski resort reviews

Ratings

Outside of the introduction paragraphs, each review covers three specific terrain choices or styles of skiing/riding:

Powder – Addressing snowfall, snow quality, pitch (steepness), trees, chutes, gullies, bowls, pillows, drops, windlips, un-groomed faces, ease of access and, most importantly, the resort's off-piste policy.

Park – Addressing all man-made features including tabletops/kickers, step-ups, step-downs, gaps, spines, hips, rails, rollers/waves, boxes, other jibs, and halfpipes.

Piste – Addressing grooming quality, trail width and length, fall line, pitch variation, run selection, and other maintained trails like mogul runs and gates courses.

Those in search of Japan's renowned pow should look for resorts with a high 'Powder' rating. Obviously, the same goes for 'Park' and 'Piste'. A five star rating indicates the best resorts in Japan for the relevant terrain choice. These ratings are accompanied by a very short summary, and a more in-depth description in the review text itself. Also outlined in each resort review is 'Beginner suitability', 'Off the slopes', and 'Access'.

Snowfall

Where data from the resort has been available we show the average accumulated annual snowfall for each resort and also the average snow base. Annual snowfall is the approximate amount of snow that falls on a resort across the entire season. Snow base is the current depth of snow that you ski on top of at any one time. How and where these figures are measured is a very contentious issue, so we have been able to supplement it with data from an independent source.

Snow-forecast.com have kindly given us access to their hindcasts which we have compiled to show how much snow actually fell during each month. We have used their mid-mountain figure rather than the top where most snowfall data is measured, which we feel gives a good indication of what to expect. These figures are only based on the 2007/8 and 2008/9 winter seasons.

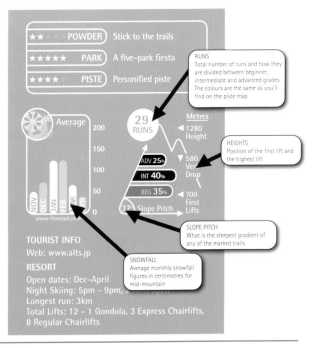

Resort statistics

The other diagram shown details all further mountain statistics, including the vertical drop (bottom lift to top lift), number of marked runs, percentage of beginner, intermediate and advanced terrain, and slope pitch. This last statistic indicates the steepest marked run that a resort offers.

Finally, each resort review has a listed web site (the English language version where available), opening periods, night skiing times and area open (if available), the resort's longest run, and number of lifts – providing you with every essential detail required.

Lifts are defined as following:

Cable car – Often referred to as a "Ropeway" in Japan, this is one long cable with two large cabins that whisk up and down the mountain, switching places as they go.

Gondola – Much like the rest of the world, Japanese gondolas are a series of smaller cabins, fitting between 4 and 10 people each, circling around on a cable and operating the same as an express chairlift.

Express chairlifts – Also known as high-speed chairlifts, the term 'express' means the chairs are detachable, slowing in the lift stations and speeding up when ascending or descending.

Regular chairlifts – Typically with smaller two and three person chairs, regular chairlifts are of the slower fixed-grip variety.

Surface lifts – This usually means magic carpets, as draglifts are very uncommon in Japan. A magic carpet is essentially a conveyor belt which you stand on to transport you. There typically are used for beginners and cover a short distance up to 100m

Ski town reviews

Ratings

These town reviews should be utilised in helping you plan which region is most suitable for your needs. Other than the introductions, each town review covers three specific characteristics:

Accessibility – Addressing ease of access from Japan's major cities and international airports, as well as the different options to access local ski resorts from the town itself.

Evening entertainment – Addressing bars, nightclubs and selection of restaurants; the variety of options, value for money and the overall feel/scene.

Culture shock – Addressing accommodation types, English signage and menus, local customs and architecture, plus local tourist information; this section describes how 'Japanese' or 'Western' each town really is.

★★★	ACCESSIBILITY
Simple enough	
★★	EVENING ENTERTAINMENT
A little too quiet	
★★★★	CULTURE SHOCK
Rich in history	

TOURIST INFO
100 Shirominami, Inawashiro-Town
Tel: (0242) 62-2111
E-mail: inawashiro@town.inawashiro.fukushima.jp
Web: www.town.inawashiro.fukushima.jp

Each of these sections is accompanied by a five star rating. Those people in search of a real Japanese culture experience should look for a town with a higher 'Culture shock' rating. People looking for a big party scene should be considering towns with a high 'Evening entertainment' rating. And those wanting somewhere easy to get to should check out destinations with a high 'Accessibility' rating. Also outlined in each town review is 'Accommodation' and 'Sightseeing'. Finally, each town review has contact information for the local tourist office that services the town.

Town Maps

Where possible we have placed on the town maps the following features which relate to the review:

- Tourist Information
- Bar
- Accommodation
- Bus Station
- ATM Cash machine
- Restaurant

Resort Quick Reference

Resort Name	Prefecture	Powder	Park	Piste	Runs	Season	Night	Snowfall	Page
Alpha Resort Tomamu	Hokkaido	★★★★	★★★★	★★★★	16	Dec-Mar	✓	-	234
ALTS Bandai	Fukushima	★★	★★★★★	★★★★	29	Dec-Apr	✓	-	181
Asahidake	Hokkaido	★★★★★	-	★★	3	Dec-May	✗	12m	238
Furano Ski Resort	Hokkaido	★★★	★	★★★★	25	Nov-May	✓	8m	240
Gala Yuzawa	Niigata	★	★★★	★★	10	Dec-May	✗	-	141
Grandeco Snow Resort	Fukushima	★★★	★★★	★★★★	7	Nov-May	✗	-	187
Hakuba 47 & Goryu	Nagano	★★★	★★★★	★★★	23	Nov-May	✓	-	88
Hakuba Cortina & Norikura	Nagano	★★	★	★★★	14	Dec-Mar	✗	-	91
Hakuba Iwatake	Nagano	★★	★★★	★★★	15	Dec-Mar	✗	-	93
Happo One	Nagano	★★★★	★★★	★★★★	13	Nov-May	✓	-	96
Ikenotaira Onsen	Niigata	★★	★★★★	★★	6	Dec-Apr	✗	-	110
Ishiuchi Maruyama	Niigata	★	★★★★★	★★★	23	Dec-Apr	✓	-	143
Iwaparra Ski Resort	Niigata	★★★	★	★★★	12	Dec-Mar	✓	-	145
Kamui Ski Links	Hokkaido	★★★★	★★	★★★	14	Dec-Mar	✗	9m	243
Kawaba Ski Resort	Gunma	★★★	★★★	★★★	10	Dec-Apr	✗	-	162
Kiro Snow World	Hokkaido	★★★	★★★	★★★★	21	Nov-May	✓	13m	221
Listel Ski Fantasia	Fukushima	★	-	★★	6	Dec-Mar	✗	-	190
Madarao Kogen & Tangram Ski Circus	Nagano	★★★★	★★	★★★	40	Dec-Apr	✓	-	112
Minakami Houdaigi	Gunma	★★★	★★	★★★	16	Dec-Apr	✗	-	164

Resort Name	Prefecture	Powder	Park	Piste	Runs	Season	Night	Snowfall	Page
Minakami Kogen	Gunma	★★	★★	★★	12	Dec-Apr	✘	-	166
Miyagi Zao	Myagi	★★★	★★	★★★	11	Nov-Mar	✔	-	196
Myoko Akakura	Niigata	★★★★★	★★★	★★★	26	Dec-Apr	✘	-	115
Myoko Suginohara	Niigata	★★★	★★★★	★★★	16	Dec-Mar	✔	-	120
Naeba-Kagura & Asagi	Niigata	★★★★	★★★★	★★★★	17	Nov-May	✔	-	148
Niseko United	Hokkaido	★★★★★	★★★★★	★★★★	67	Nov-May	✔	11m	212
Norn Minakami	Gunma	★★	★★	★★	5	Dec-Mar	✔	-	168
Nozawa Onsen Ski Resort	Nagano	★★★	★★★★	★★★	43	Nov-Apr	✔	-	128
Pine Ridge Resort Kandatsu	Niigata	★★★	★★	★★	13	Dec-Mar	✘	-	152
Rusutsu Resort	Hokkaido	★★★★	★★	★★★★	37	Nov-Apr	✔	11m	216
Ryuoo Ski Park	Nagano	★★	★★	★★	14	Dec-Apr	✔	-	130
Sapporo Bankei	Hokkaido	★★	★★	★★	13	Dec-Apr	✔	-	223
Sapporo Kokusai	Hokkaido	★★★	★★★	★★★	7	Nov-May	✘	13m	225
Sapporo Teine	Hokkaido	★★★★	★★★	★★★	15	Nov-May	✔	-	227
Seki Onsen	Niigata	★★★★	★★	★	6	Dec-Apr	✘	-	122
Shiga Kogen	Nagano	★★★	★★★	★★★★★	104	Dec-May	✔	-	134
Snow Paradise Inawashiro	Fukushima	★★	★★★	★★★	16	Dec-Mar	✔	-	191
Sun Alpina Linked Resorts	Nagano	★★	★★	★★★	40	Dec-Mar	✔	-	100
Tanigawadake Tengindaira	Gunma	★★★★★	★★	★★	12	Nov-May	✘	-	169
Tsugaike Kogen	Nagano	★★★	★★★	★★	12	Dec-May	✔	-	101
Urabandai Nekoma	Fukushima	★★★	★★★★	★★★	11	Dec-Apr	✘	-	193
Yanaba Ski Resort	Nagano	★★	★★★	★	7	Dec-Apr	✔	-	103
Zao Onsen Resort	Yamagata	★★★	★★	★★★★★	25	Nov-May	✔	-	198

Chubu Region

Chubu introduction

Located in central Honshu, Chubu encompasses nine prefectures and the most ski resorts out of any Japanese region. It stretches from Nagoya City and the Pacific Ocean up to Nagano, Niigata and the Sea of Japan. Most notably, Chubu is home to the well-known ski resort towns of Hakuba, Nozawa, Myoko and Yuzawa

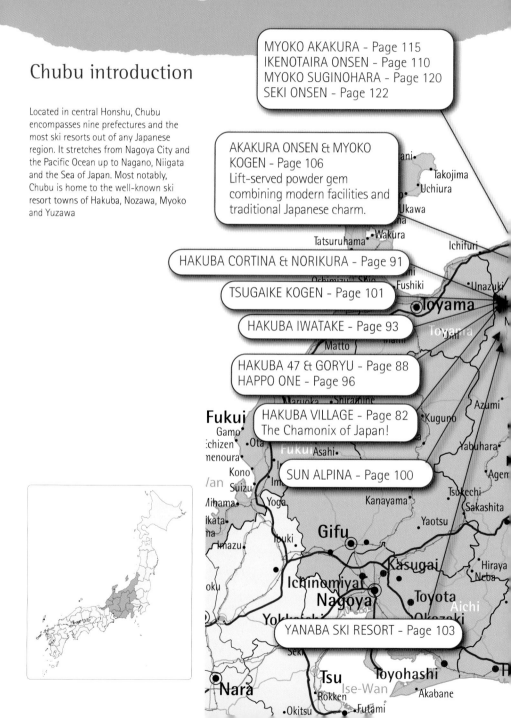

MYOKO AKAKURA - Page 115
IKENOTAIRA ONSEN - Page 110
MYOKO SUGINOHARA - Page 120
SEKI ONSEN - Page 122

AKAKURA ONSEN & MYOKO KOGEN - Page 106
Lift-served powder gem combining modern facilities and traditional Japanese charm.

HAKUBA CORTINA & NORIKURA - Page 91

TSUGAIKE KOGEN - Page 101

HAKUBA IWATAKE - Page 93

HAKUBA 47 & GORYU - Page 88
HAPPO ONE - Page 96

HAKUBA VILLAGE - Page 82
The Chamonix of Japan!

SUN ALPINA - Page 100

YANABA SKI RESORT - Page 103

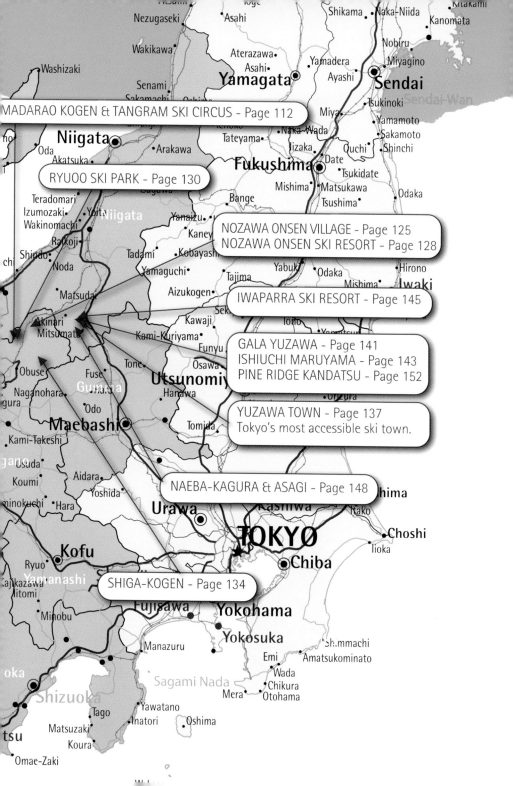

MADARAO KOGEN & TANGRAM SKI CIRCUS - Page 112

RYUOO SKI PARK - Page 130

NOZAWA ONSEN VILLAGE - Page 125
NOZAWA ONSEN SKI RESORT - Page 128

IWAPARRA SKI RESORT - Page 145

GALA YUZAWA - Page 141
ISHIUCHI MARUYAMA - Page 143
PINE RIDGE KANDATSU - Page 152

YUZAWA TOWN - Page 137
Tokyo's most accessible ski town.

NAEBA-KAGURA & ASAGI - Page 148

SHIGA-KOGEN - Page 134

Hakuba village

The Chamonix of Japan!

The town of Hakuba, with a population of around 9,000, spreads itself across a flat valley of rice fields in the shadow of some of Japan's most awe-inspiring peaks. If you're looking for epic alpine scenery, of the sort you might find in North America or Europe, blended with a Japanese landscape, not to mention some of Japan's steepest skiable terrain, Hakuba should definitely be on the top of your list. However, don't be misled into thinking that Hakuba only caters for the hardcore crowd hungry for steep and scary lines. With 13 ski resorts, 137 lifts, 7 terrain parks, night skiing and endless hiking possibilities, there's plenty on offer for every level of skier and

★★★★	ACCESSIBILITY
	Close to Nagano City
★★★★	EVENING ENTERTAINMENT
	Regular weekend entertainment
★★	CULTURE SHOCK
	Slowly becoming more westernised

TOURIST INFO
Nagano-ken Kita Azumi-gun Hakuba-mure Kitashiro
Tel: 0261-72-7100
Web: www.vill.hakuba.nagano.jp/english

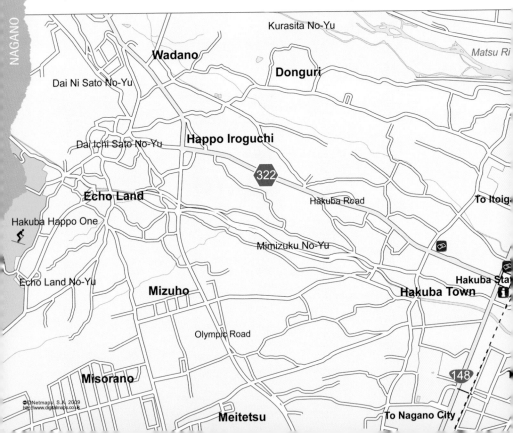

NAGANO

Kurasita No-Yu

Matsu Ri

Wadano

Donguri

Dai Ni Sato No-Yu

Happo Iroguchi

Dai Ichi Sato No-Yu

322

Echo Land

Hakuba Road

To Itoig

Hakuba Happo One

Mimizuku No-Yu

Echo Land No-Yu

Hakuba Sta

Mizuho

Hakuba Town

Olympic Road

Misorano

148

© Netmaps, S.A. 2009
http://www.digitalmaps.co.uk

Meitetsu

To Nagano City

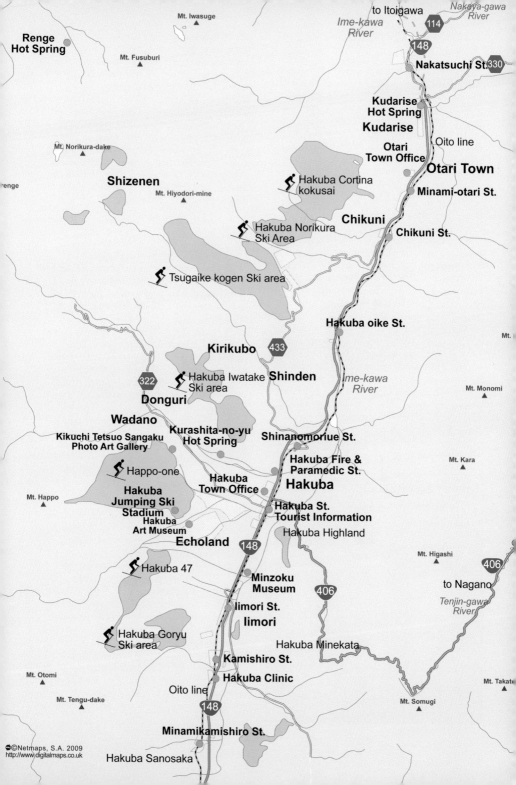

snowboarder, families and backcountry riders alike.

The Japanese characters for Hakuba (白馬) mean "White Horse", which is also the name of Hakuba's highest peak at 2,937m. The name is derived from a unique annual occurrence in the snow, when the shape of a horse galloping is revealed in the rocks as the snow melts in Spring. In the green season Hakuba is home to hiking, a growing mountain bike scene, watersports on Aoki Lake, paragliding and canyoning

Accessibility

From Tokyo, there are a variety of ways to reach Hakuba. The quickest, but most expensive way is to take the Shinkansen (bullet train) from Tokyo Station to Nagano Station (approximately 1hr 30mins), followed by a well-connected bus service taking you on to Hakuba in under an hour. Alternatively, you could hop on board the Azusa Express train from Shinjuku Station to Matsumoto Station (1hr 30mins South of Hakuba) and pay the city of Matsumoto and it's traditional castle a visit. From Matsumoto you can take a slow local train on the Oito Line to Hakuba. The cheapest option however, is to take the highway bus from Shinjuku (the bus terminal is located at the West side of the station) to Hakuba, which takes 4hrs 30mins, but is a pleasant and scenic ride with great views of the Japanese Alps. If you're skipping Tokyo altogether and wish to travel directly from Narita Airport to Hakuba, it's possible to book a taxi shuttle bus for a reasonable price. This is a popular option with many visitors and should be booked in advance.

Within Hakuba itself, there is a shuttle bus service in operation, giving access to the main resorts from various locations across the town. Unfortunately, the services don't run in a loop linking the different resorts; rather the shuttles are run by individual resorts with the goal of getting customers to their own slopes. The slightly further a field resorts such as Tsugaike, Yanaba and Cortina can be accessed via local buses, trains and taxis. For maps and timetables head to the information centre in Happo Village. Renting a car is a good option if you're planning on exploring all the resorts in the area. In addition, this will give you the freedom to enjoy the many local onsens and restaurants on your own schedule.

Evening entertainment

The Japanese après ski habit of heading to the onsen, followed by drinking copious amounts of beer purchased at a convenience store, in one's hotel room, doesn't exactly make for great night life especially if you are accustomed to vibrant parties, like those found all over ski resorts in Europe and North America. Having said that, Hakuba sets itself apart from other ski towns in Japan with a growing party scene, popular with the locals and seasonal workers alike. Bars and clubs do tend to be quiet during the week, with most parties and events taking place on the weekends. And when the weekend does roll around, there's plenty to choose from all over town! Check out the long time local haunt '902' in Echoland with its huge vinyl collection and 'The Pub' in Wadano for DJ parties. If you're in the Goryu area, 'Tracks Bar' and 'Sauce' are popular spots. For more traditional drinking holes, where you can sample Japanese beer and sake, walk into any izakaya bar-restaurant.

Drinking and dancing aside, Hakuba offers a great variety of restaurants, with everything from conveyor belt Sushi to Mexican, Thai and Italian. One of Nagano's specialities is 'soba' noodles and, with an abundance of specific restaurants dotted all over, some local soba is a must try. You'll also find lots of traditional izakaya restaurants serving up many small dishes to be shared, allowing you to sample lots of weird and wonderful new foods. 'Zen' located near the central 7-Eleven convenience store is a great traditional izakaya and soba restaurant, as is 'Hie' in Echoland. For organic Italian in a toasty log cabin setting with an old school retro snowboard collection hanging from the walls, visit the very friendly English speaking Shoko at 'Gravity Worx' near to the main train station. 'Uncle Stevens' Mexican near the Happo

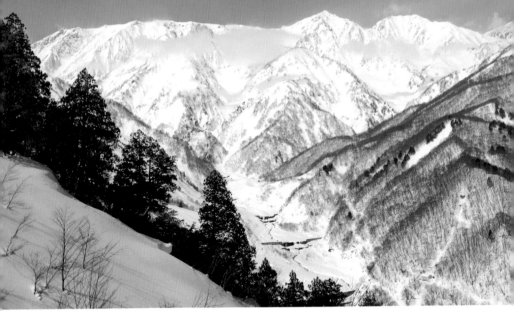

gondola has been a firm favourite for years and is a must visit for the unique atmosphere, friendly service and mouth watering menu.

Culture shock

A few years back, Hakuba was an unknown winter paradise, offering big mountains and a plentiful supply of fresh powder, with overseas visitors consisting mainly of families from the likes of Hong Kong and Singapore with the odd curious European snowboarder thrown in the mix. In recent years however, Hakuba has become one of Japan's real winter hot spots attracting many skiers and snowboarders from all over Asia, Australasia, North America and Europe. As a result the town and the surrounding ski resorts have adapted accordingly, catering for the influx with English-language signage, maps, menus and English-speaking staff.

The newest addition, and a great starting point for any visit to Hakuba, is the English-friendly Information Centre located at the Happo bus terminal, where you can get directions, ski resort and town information, shuttle bus timetables and book transport. The spread out nature of the town absorbs new foreign influences to a certain extent, meaning you can still enjoy a nice Japanese cultural experience here. Natural hot springs, little local restaurants and non-English speaking locals to test your language skills on, are common.

Accommodation

There are a few different areas of Hakuba making for good bases to explore the surrounding resorts. The Goryu area on the Southern end of the valley offers a great varied selection of ski-in / ski-out accommodation options. Echoland is situated right in the middle of town, with the frequent shuttle buses making it easy to access all the local resorts. It offers everything from English-friendly backpackers, higher-end lodges and traditional Japanese pensions, with plenty of nearby bars and restaurants.

If you are after something more sophisticated, the Wadano Forest area at the base of Happo One resort is where all the top-end hotels are located, along with lots of smaller ski-in / ski-out lodges. Do your homework and choose which ski resort you want to spend most time skiing at, then select your accommodation accordingly.

Sightseeing and other activities

Hakuba is rich with history and culture. Go looking and you'll find temples, shrines, statues and engraved rocks hidden in all kinds of places. Alternatively, just 10mins south of Hakuba is Aoki Lake – worth a walk if you need a day off the snow but still want to enjoy the outdoors.

A 1hr 30min train journey south of Hakuba will take you to Matsumoto City, where you can check out the local historical Japanese castle, do a little shopping and explore some varied restaurants.

A trip to Nagano City to see the Zenkoji Temple is also worthwhile and is just 1hr on the bus..

Hakuba 47 & Goryu

The best halfpipe in Hakuba!

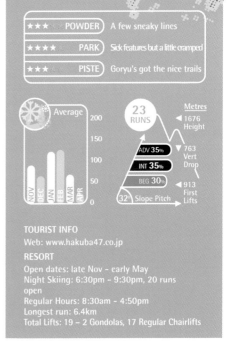

★★★	POWDER	A few sneaky lines
★★★★	PARK	Sick features but a little cramped
★★★	PISTE	Goryu's got the nice trails

Average

	Metres	
200	23 RUNS	◀ 1676 Height
150		
100	ADV 35%	▼ 763 Vert Drop
50	INT 35%	
0	BEG 30%	◀ 913 First Lifts
NOV DEC JAN FEB MAR APR	32° Slope Pitch	

TOURIST INFO
Web: www.hakuba47.co.jp
RESORT
Open dates: late Nov - early May
Night Skiing: 6:30pm - 9:30pm, 20 runs open
Regular Hours: 8:30am - 4:50pm
Longest run: 6.4km
Total Lifts: 19 - 2 Gondolas, 17 Regular Chairlifts

Hakuba 47 and Goryu are two different and diverse resorts linked together through their upper most lifts. The two resorts are managed separately but your lift pass covers both areas. Together they offer a large variety of groomed courses, a good selection of freestyle features and a small amount of off-piste. Of the two Goryu is the bigger and caters well to all levels of on-piste skier and snowboarder, except keen freestylers that is. 47, known for its longstanding park and pipe, and it's marketing towards snowboarders, fills this gap well with what they call the 'Big Snow Park' - original hey?

In addition to two gondolas, 47 and Goryu between them have numerous high-speed 4-man chair lifts and upwards of a dozen smaller chairs. Overall, the lift systems are well designed and waiting in a long line is a rarity.

Powder

Hakuba, being fairly coastal, gets large amounts of snow and frequent powder days. Although there are certainly a few good freeriding options here, 47 and Goryu don't allow the general public to go off-piste. The only option to shred the tree-lined powder is to join the 'Double Black Diamond Club'. This is a programme for regulars where by you attend a safety seminar, prove your capabilities and are then granted permission to use a small face of steep trees. The area isn't marked on the piste map, but it's found somewhere off of Route 3 on the 47 side of the hill. To enter without causing trouble you need an armband of sorts, provided by ski patrol on a daily basis, identifying you as a member of the DBD Club.

The only other powder possibilities are the un-groomed runs marked with a black dotted line on the map. There are three of these in total, Adventure Course being the longest. After a big dump they could be worth a look but generally they turn into moguls in the time it takes you to spell out "t-r-a-c-k-e-d".

Park

Hakuba 47 is a reputable resort for freestyle. It has a quality superpipe, although not necessarily the best terrain park in the region. The appropriately named 'Big Snow Park' is found at the top of the 47 Express Line gondola and is serviced by it's own 4-man high-speed chair. The superpipe, located at the top of the run, is well maintained with smooth transitions and a nice amount of vert. It's very popular so expect to wait a while when dropping in - although the Japanese are so polite it's never a hassle. It is hikable but probably not worth it as lapping the chair doesn't take long. To the right of the pipe, the resort usually keeps a line of two or three sizeable kickers ranging from 10 to 20m (30-60ft) depending on the time of season. Other jump options include a few small and medium sized tables, varying in size. Towards the bottom of the park you'll find a nice array of rails and boxes catering for most levels.

NAGANO

The one big draw back of 47's terrain park is that it's built within a pretty small area, meaning they have limited space to work with. This often results in awkward lines between features that can get messy, particularly when it's busy. Also worth a quick mention is the very small beginners park on the Goryu side. It's found right in between the Escal and Iimori Base Centres and presents a short line of rollers and a mini tabletop or two; a fun place to get started on the freestyle buzz.

Piste

If it's freshly groomed runs you seek then stick to the Goryu side of the hill. 47 has a couple of reasonable red runs (intermediate) but they tend to get scraped by all the side slipping snowboarders. Goryu however has a wider variety of groomed trails for you to hit up, helping keep the corduroy in good nick for longer.

Near the top of Goryu you'll find the Alps-Daira Zone presenting a nice array short fast red runs. If you prefer a little more speed head to the Iimori Zone and ride the Cosmo chairlift. This gives you access to a few longer reds and the area they use for gate training/racing.

Beginner suitability

Beginners should also head to Goryu and avoid the lower half of 47 completely. The Toomi Zone on Goryu, accessible from Escal Plaza, is a perfect place for novices to get things flowing. It has some wonderfully long green runs that are super-wide and consistent in pitch. The Iimori Zone also offers a few smooth beginner trails, but they're a little shorter and not so demanding on the legs – definitely good for children.

Over on the 47 side there are simply not as many beginner options. The only green course descending to Base Centre Euclid is a flat cat track that winds it's way down the hill – not the most encouraging terrain for those linking their first turns. The only good beginner choice on 47 is the long green accessible from either a 2-man chair or a high-speed quad called Line E.

Off the slopes

There are three base areas you can access the mountain through, two on Goryu and one on 47. Base Centre Escal Plaza, on Goryu, provides access to the longest gondola almost reaching the top of the resort, just a few hundred metres short of the 1676m Zizou Peak. Although the Escal Plaza is rather horrible

PHOTO: EDO JUNGERIUS

looking – a big obtuse concrete structure – it does have a good range of amenities. Base Centre Iimori is much smaller and has no ski hire facility, but caters well to beginners and families with young children, assuming you have your gear already. The third option, found on the 47 side, is Base Centre Euclid. Here you will find ample parking and a good range of facilities, as well as a gondola landing you at the top of the terrain park.

As the name suggests Hauba 47 and Goryu is generally accessed from Hakuba town. The only real walking access from Hakuba to the resort chairlifts is at the Escal Plaza Base Centre. Here there are a limited number of accommodations and a small selection of places to eat and drink. Check out Tracks Bar if you looking for a little late night drinking action.

Access

With frequent shuttle's running around Hakuba town, both 47 and Goryu areas are easy to access. Driving is also easy and only takes 5mins or so from all areas of Hakuba. Hakuba town itself is 1hr away from Nagano City.

PHOTO: STEVE DOWLE

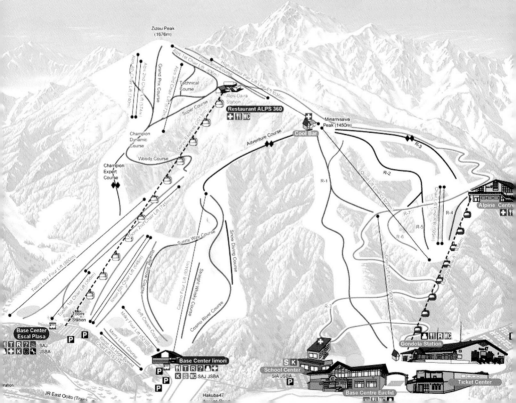

Hakuba Cortina & Norikura

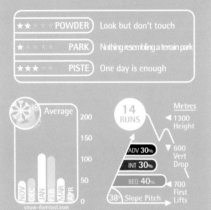

★★ ☆ ☆	POWDER	Look but don't touch
★ ☆ ☆ ☆	PARK	Nothing resembling a terrain park
★★★ ☆ ☆	PISTE	One day is enough

Average

NOV DEC JAN FEB MAR APR
snow-forecast.com

200
150
100
50
0

14 RUNS

Metres
◄ 1300 Height

ADV **30%**
INT **30%**
BEG **40%**

▼ 600 Vert Drop

◄ 700 First Lifts

38 Slope Pitch

TOURIST INFO
Web: www.hakubanorikura.jp
RESORT
Open dates: Dec – March
Night Skiing: one run open
Longest run: 5km
Total Lifts: 6 – 2 Express Chairlifts, 4 Regular Chairlifts

Strictly no off-piste allowed!

At first glance Cortina seems to present a nice array of freeride options; but only once you manage to look passed the visually intruding, Tudor-like hotel at the resort's base. Set in the northern end of the Hakuba Valley and known for its quality snowfalls, Cortina has some sweet-looking lines on tree-covered steep faces. However, Cortina does NOT allow you to ride off-piste – at all!

Cortina does present a reasonable array of groomed trails and with over 700m of vertical drop there's enough to keep you busy for a few days. It also links with the smaller resort of Norikura: a more family-orientated resort accessible from chairlift No.7, with nice wide trails on gentle gradients. Lift passes are generally purchased specific to resort, however it's only a small amount extra to get a combined ticket, worth while to have the extra variety.

NAGANO

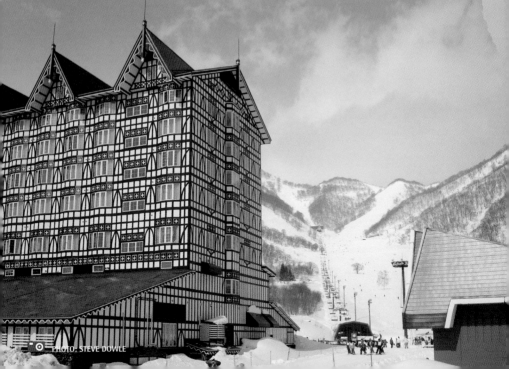

PHOTO: STEVE DOWLE

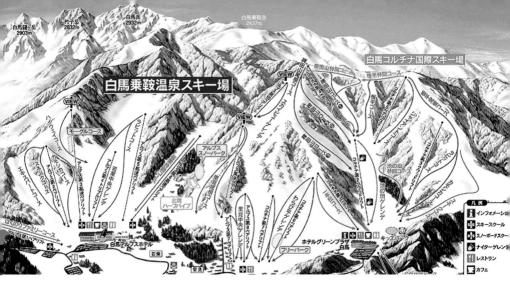

Powder

So where do powder seekers go at Cortina? Well, there are a few un-groomed runs accessible from chairlift No.4 reaching the resort's peak, which are okay on a powder day (but are quickly tracked out). Pouching the off-piste is heavily frowned upon and ski patrol WILL confiscate your pass (and potentially ban you from returning) if they catch you, although this is still a popular undertaking with locals. There is access to the backcountry from Cortina, but knowing the routes is essential. If you're keen to explore the backcountry here it's best to utilise the experienced guiding services of Evergreen Outdoor Centre, based in the Happo Village part of Hakuba.

Park

Cortina chooses not to offer a proper park so freestyle options are very limited, although they have been known to build the odd tabletop and put in a rail. Unfortunately there are no natural features either, that is without breaking the 'no off-piste' rule. Alternatively, Norikura features a very small park with a few roller-style jumps and what you could call a small halfpipe.

Piste

This is where Cortina's strength lies. If you enjoy steep groomers and like to layout some long carving turns, you will enjoy spending a day here. Notable runs for this include Bandaira and Bandaira One (pronounced "ban-die-ra on-ey") and meaning ridge. If you prefer the more mellow trails, just stick to the obvious runs in the centre of the resort.

Beginner suitability

English-speaking lessons are very limited at Cortina but the lower-level terrain is reasonable. The run under quad chair No.2 will help novices to build their confidence linking turns without too many problems. Beginners (and any skier or snowboarder actually) would do their best to avoid the run named Tsuchikura leading down towards the local village of Otari. It's extremely flat and both skiers and snowboarders end up skating most of the way. Over the ridge, Norikura also has plenty of smooth trails catering well to the beginner market.

Off the slopes

As mentioned previously, Cortina has an incredibly overbearing resort-style hotel, with Tudor-like décor. This seems to capture the Japanese mindset rather well, but most Westerners consider it to be a complete eyesore. It's named Hotel Green Plaza Hakuba and generally caters for short-stay all-inclusive visitors from Tokyo and Osaka. It does however provide a nice lunch in the Alps Restaurant up on the 2nd floor.

Hakuba is the typical service town for Cortina, although the town named Otari is a little closer – about 10mins drive. Otari is a small, traditionally Japanese town with some nice little restaurants and a few accommodation options, but somewhat limiting for international tourists.

Access

About 20mins drive from the centre of Hakuba, or just 10mins from Otari, Cortina is best accessed by car. There is a local bus service but it's not ideal for tourists. The only other alternative it taxi.

Hakuba Iwatake

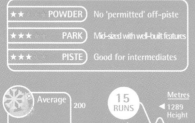

Average
200
150
100
50
0
NOV DEC JAN FEB MAR APR
snow-forecast.com

15 RUNS
35° Slope Pitch

ADV 20%
INT 55%
BEG 25%

Metres
1289 Height
539 Vert Drop
750 First Lifts

TOURIST INFO
Web: www.tokyu-hakuba.co.jp/english
RESORT
Open dates: mid Dec – end March
Night Skiing: not available
Regular Hours: 8am – 5pm
Longest run: 4km
Total Lifts: 16 – 1 Gondola, 1 Express Chairlift, 14 Regular Chairlifts

A local's resort popular with beginners and intermediates

haphazardly and many of the runs are disappointingly short, often depositing you at the bottom of same lift you just took.

The resort also seems massively popular with beginners who litter many of the slopes and create the odd dangerous bottleneck at narrow points on the runs, adding to the chaos of the strangely planed trails. On the plus side, it's much cheaper here than the likes of Happo One and Hakuba 47/Goryu, and with this still being Hakuba, the high-quality snow does fall in large amounts just as much as the neighbouring resorts.

Powder

Similar to the nearby resort of Hakuba 47/Goryu, Iwatake does not really permit off-piste. Whilst the powder is generally nice and light, you still have to stay on trail: the only English sign in the whole resort states that skiing/riding off-piste is strictly forbidden! There's a message to the English-speaking tourists if there ever was one.

The mountain is small enough to easily get your bearings and have a good explore without getting lost, but there's little in the way of un-groomed courses. So if you do wish to protect your pass and respect the locals, just stick to the marked pistes, which can be fun if it's just dumped the night before. The most enjoyable runs are located towards the mid-section of the hill where some of the cat tracks provide natural wall rides, hips and fun little hits on the way down. There's also a pretty sweet natural halfpipe over the rear side of the mountain – ask a local for directions. If you are going to venture off-piste DO NOT DO IT UNDER THE LIFTS, as this is considered the rudest and most blundering way to ignore polite signs.

Iwatake is another classic Japanese 'commuter' resort and a popular destination for weekend warriors on a mission from Tokyo. Generally, the resort has a high percentage of young snowboarders attracted by the park and occasional appearance of a halfpipe. For Westerners the mountain can seem a little confusing, as there's little signage and the few signs that do materialise are, of course, in Japanese. This, added to the snakes-and-ladders style layout, can make navigation a bit of a challenge.

That said, the hill isn't that big and the majority of the runs are beginner to intermediate so getting lost isn't a massive issue, simply a little frustrating. Compared to the other resorts in the Hakuba region Iwatake is mid-sized and good for a day or two (or maybe three if you enjoy park riding), but any longer and you might find yourself stifling a yawn. There are 13 lifts that service the front of the mountain and 2 down the back. Unfortunately these are placed somewhat

NAGANO

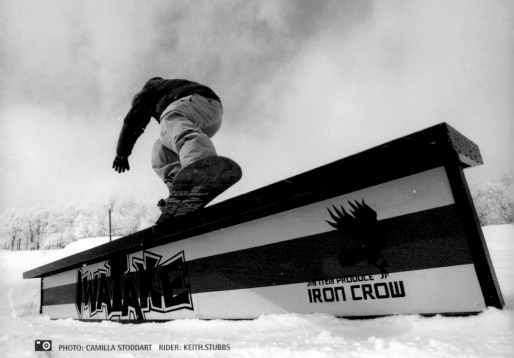

Park

The finest characteristic of Iwatake is the well-built and well-maintained snow park. The park boasts a selection of rails, boxes, jumps and hips that are suitable for a range of levels, but aimed mostly at beginner to intermediate freestylers. The jumps generally range from 3 to 10m (10-30ft), whilst the jibs vary from ride-on boxes to street-style down rails. There's also a reasonably fast two-man chair named the Iwatake View 3rd to lap the park on, so it's easy to get a flowing session cranking with your friends.

In addition to a park, Iwatake advertise a halfpipe. This doesn't appear to be a regular occurrence although rumour has it that it's built well when it does finally arrive. One negative side of the terrain park is that it is located at the top of the resort and fairly exposed, so if the clouds are in, your park session maybe off the cards.

Piste

Those sticking to the trails will be satisfied considering the modest size of the resort. The wider runs are well suited to laying out a few carves, although they're a little short and probably not enough to accommodate upper-end carving skiers. Top-to-bottom runs are of a good length but tend to be fairly broken up with some flatter sections and the odd cat-track. Anyone seeking a little more pitch should check out the runs off Kamoshika 1st pair lift.

Beginner suitability

This place is really popular with Japanese beginners so you won't be alone slip sliding or wedge turning your way down the hill. Having said that, whilst you'll be in good company learning at Iwatake, the volume of beginners can become something of a hazard on the weekends. It seems that there are no easily available English-speaking instructors here, so if you are looking for lessons you'd be best to head to Happo or Hakuba 47. However, if you're past the initial learning phase Iwatake can be a fun resort with a good selection of novice runs perfect for practising linking those turns and gaining that much needed confidence.

Off the slopes

The base building of Iwatake is small and functional but nothing to write home about. There is a small shop where you can buy the basics such as hats and gloves, and a rental spot for some fairly antiquated

looking equipment or a quick tuning service. You can also rent some pretty amazing eighties one-pieces if you feel like colour co-ordinating your group for the day as many of the local Japanese seem to.

On-the-slopes food at Iwatake is actually some of the best and cheapest in the area, as long as you are into Japanese cuisine. There's an excellent take away ramen noodle stand at the top of the gondola if you're up for a quick outdoor warm-up feast, and indoors you can get a super-cheap steaming hot bowl of Japanese curry. For food off-the-mountain it's the ubiquitous 'strongest crepe in the world' stand and a handful of local restaurants that are probably really good, but you'll likely to find yourself playing guess-the-menu if you brave it without any knowledge of the Japanese language.

Access

Iwatake is just 15mins drive north from central Hakuba. Getting to Iwatake by means of public transport is tricky, but there's rumours of a local bus service that heads that way – although the details are hard to find.

PHOTO: KEITH.STUBBS

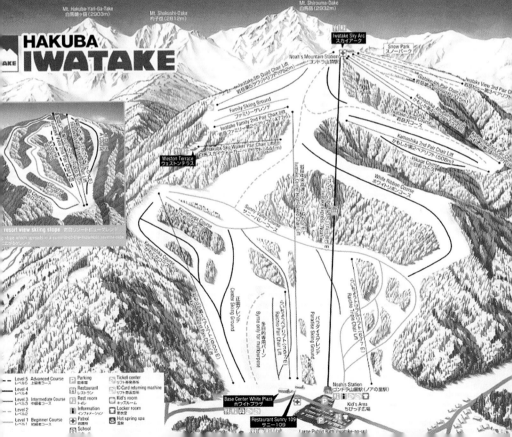

Happo One

Without a doubt this is Hakuba's top freeriding destination

Happo-One boasts some of the steepest and most dramatic landscapes in Japan and provides a great range of terrain to satisfy any intermediate to advanced skier or rider. It's a superb ski resort and should be number one your hit list when visiting the Hakuba region.

The resort offers an extensive selection of both on and off-piste terrain. The marked runs range from wide and gentle to steep and banked, whilst the off-piste provides something for everyone, from next-to-the-run powder turns to scary backcountry lines. The top-to-bottom descent is a fair distance creating heaps of opportunity for those real leg-burning runs that is often lacking in Japan's smaller resorts. It's worth noting that the Happo-One management seem to be slightly more relaxed about those venturing off-piste then the other local hills. At Happo, with a bit of subtlety (i.e. don't ride under the lifts) those powder tree runs you've dreamed about can finally be made a reality. The lack of a permanent terrain park is the one negative thing to be said about Happo. However, the resort has been playing host the Japanese version of High Cascades Camp in springtime and there's talk of this becoming a more permanent feature.

Happo's lift infrastructure is pretty good although many of the chairlifts are of the slow fixed-grip variety so make use of the gondola as much as possible. Having said that, the sole run that leads from mid-station down to the gondola is notably hard to find, so get your maps out and study your routes, only one trail leads back to the gondola but most of the others finish near a lift. There's also night skiing to be found throughout the year, but it only consists of one run – good for beginners but perhaps a little limiting for the more experienced snow-goers. As is standard with most resorts in the Hakuba area, Happo is busiest on weekends and often dead during the week.

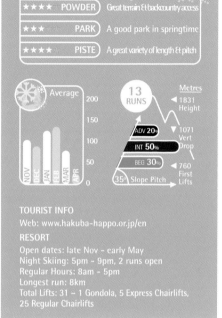

★★★★ POWDER — Great terrain & backcountry access
★★★ PARK — A good park in springtime
★★★★ PISTE — A great variety of length & pitch

Average 200 150 100 50 0
NOV DEC JAN FEB MAR APR

13 RUNS

Metres
◀ 1831 Height
ADV 20% ▼ 1071 Vert Drop
INT 50%
BEG 30% ◀ 760 First Lifts
35° Slope Pitch

TOURIST INFO
Web: www.hakuba-happo.or.jp/en
RESORT
Open dates: late Nov – early May
Night Skiing: 5pm – 9pm, 2 runs open
Regular Hours: 8am – 5pm
Longest run: 8km
Total Lifts: 31 – 1 Gondola, 5 Express Chairlifts, 25 Regular Chairlifts

Powder

The large volumes of snow falling each year, combined with Happo-One's rolling topography of tree lined gullies, occasional rocky outcrops and protruding ridge lines, means powder is the key feature of this resort. Dramatic early-season dumps have resulted in people literally drowning, so be warned – bring your transceivers, shovels, probes and a snorkel if you have it. This is Hakuba's best freeriding destination!

The appreciable Happo freeriding isn't just for advanced riders though. Those less confident in the pow but still keen to venture off-piste can cruise the widely spaces trees at the side of runs, or some of the obvious open faces within resort boundaries. Take note, some of these open faces close frequently, so heed the signs as avalanches can happen regularly. Ducking ropes to ride the trees between the runs is forbidden and passes can be taken if you are caught in closed areas.

Advanced skiers and riders can head into the backcountry with a guide or a group of experienced backcountry regulars that know where they're going. You'll find some amazing steep faces, pillow-laden gullies and gladed trees, and are likely to have a true thigh-deep Japanese powder adventure. It's important to note that once you drop off the side or back of the resort YOU ARE ON YOUR OWN – it is not the responsibility of the patrol to rescue you if you get hurt. Generally, Japanese ski patrol do not exercise much in the way of avalanche control and bombing, so it's often best to hire a local guide... and don't forget your avalanche safety gear. For all your backcountry guiding and equipment needs head to Evergreen Outdoor Centre in the Happo part of Hakuba town.

Park

Having filled in their pipe and removed their park a number of years back to build more beginner runs, management are now eating their words and moving into discussions about building a new terrain park. In 2008 the prestigious US High Cascade camp brought a park to Happo for a one-week session. This was repeated for a longer period in 2009 and is expected to become a permanent feature in the future, which will complete Happo-One as a first class resort on the global stage.

Mind you, with all the powder here you'd be mad to be searching for a park anyway. Explore the resort and practise launching off the natural drops and pillow lines or build your own kicker into those super-soft landings – much more fun then your average groomed snow park.

Piste

Happo-One has great, wide, well-maintained pistes perfect for a bit of self-indulgent euro carving or just a mellow day exploring the mountain. Check out the trails under the Alpine Quad for some great wide turns, or ride from top to bottom for a real leg-burning on-piste shred, complete with steeps, rollers and the occasional minefield of moguls.

There's a huge array of groomed red and green runs to suit those with less experience. Just grab an English-language piste map, head up the gondola and start wandering. If you prefer consistent gradients and wider runs make use of Happo's top section, but

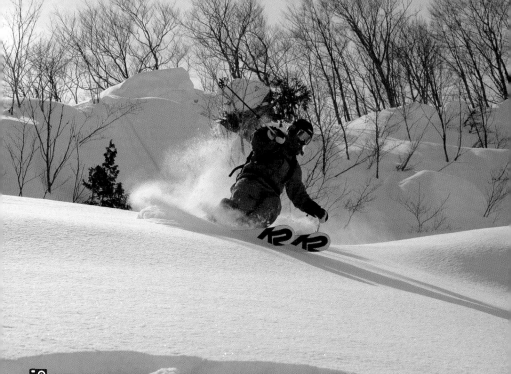

PHOTO: STEVE DOWLE RIDER: SARAH.MULHOLLAND

if you're up for a challenge search out the Olympic courses accessible from Kokusai No.1 chairlift.

Beginner suitability

Whilst Happo offers a number of long green beginner runs, it's worth noting that there is no beginner trail that takes you completely from top to bottom. This could be frustrating for beginners who will either be limited to the lower slopes of Nakiyama or Sakka, or head up the gondola and have to down-load at the end of the day. For groups dominated by beginners Hakuba Goryu is probably a more suitable destination. However, if you are a beginner visiting Happo-One be sure to make use of the night skiing in Nakiyama – it's a great place for learners to get their flood-lit turns cranking. English-language lessons can be arranged at Happo but must be booked in advance, or you can utilise the international instructors at Evergreen Outdoor Centre.

Off the slopes

On the slopes of Happo you have a wide spectrum of casual dining on offer. From McDonalds to Ramen to good old Japanese curry. Richard Branson has even made his way to the summit to open a trendy European-style coffee bar called the 'Virgin Café', which serves cappuccinos and lattes, considered to be exotic Western fare amongst the Japanese. Highly recommended is the crepe stand at the base of the mountain promoting it's cuisine as 'The World's Strongest Crepe' – not only incredibly durable but also pretty tasty.

The local village Happo (a suburb of Hakuba town) is well decked-out with bars, shops and restaurants. There are a variety of onsen to choose from in the area, along with a few snowboard shops, mini supermarkets and the Evergreen Outdoor Centre who have a fountain of knowledge on the region. There's also the impressive-looking ski jump built for the 1998 Winter Olympics; it gets fully lit-up at night and is worth a peak.

Hakuba itself is a popular destination for tourists and Western seasonaires, so beware if you are looking for a full-on Japanese experience. The bonus of this westernisation is that there's plenty of food menus, trail maps and information sings, all written in English.

Access

Happo is the closest resort to central Hakuba and easily accessed by a local shuttle bus around the town. Hakuba itself is only a 1hr drive from Nagano City although it's almost easier to take the train.

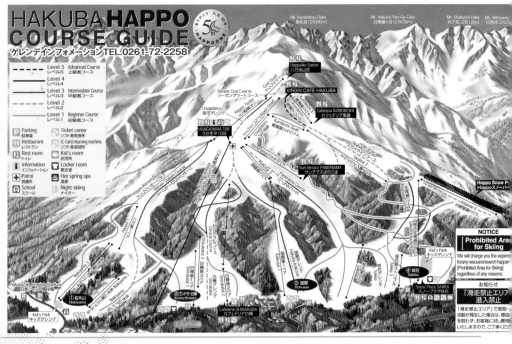

Sun Alpina Linked Resorts

Un-crowded and peaceful, with serene lake and mountain views.

About a 10min drive south of Hakuba or a quick trip on the local train, lies 3 small linked ski resorts, Sanosaka, Aokiko and Kashimayari. If you're looking for quiet and cosy resorts to explore, these are worth a visit. For only a few hundred yen more than the cost of a single resort pass, you can ski all 3 areas, providing plenty of varied terrain and features to enjoy. It's worth noting that the 3 resorts have a joint season pass which is one of the cheapest in the Hakuba valley and worth thinking about if you plan to stay for an entire winter season. Each of the resorts have adequate amenities, restaurants, but good quality hire equipment is limited, so it's wise to organise rental skis and snowboards at one of the bigger shops in Hakuba.

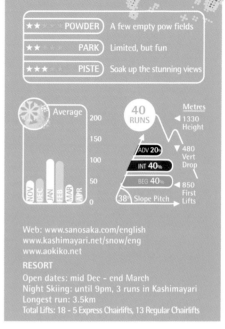

POWDER ★★ A few empty pow fields
PARK ★★ Limited, but fun
PISTE ★★★ Soak up the stunning views

Average
200
150
100
50
0
NOV DEC JAN FEB MAR APR

40 RUNS
1330 Height
ADV 20% — 480 Vert Drop
INT 40%
BEG 40% — 850 First Lifts
38° Slope Pitch

Metres

Web: www.sanosaka.com/english
www.kashimayari.net/snow/eng
www.aokiko.net

RESORT
Open dates: mid Dec – end March
Night Skiing: until 9pm, 3 runs in Kashimayari
Longest run: 3.5km
Total Lifts: 18 - 5 Express Chairlifts, 13 Regular Chairlifts

Powder

Sanosaka and Aokiko may be a little too flat for good pow riding, and the more experienced powder seeker will want to spend most of their time lapping lines of fresh at Kashimayari. On a powder day this resort can be great fun, with an abundance of steep slopes up to 38° and good tree skiing to discover. Take care however as the off-piste rules here are somewhat of a grey area. Sanosaka and Aokiko's more un-crowded mellow slopes are ideal for families and those new to the joys of riding the deep stuff, to learn and progress.

Park

Aokiko has some mini park features: small roller jumps, boxes, rails and a spine, ideal for those trying out park for the first time. Sanosaka by contrast is home to one of Hakuba's larger kickers and a small selection of other features to keep the more confident entertained.

Piste

With the exception of a few mogul fields, the runs here are well groomed and great for cruising around on. The gentlest runs are found at Aokiko and although rather short, they are surrounded by beautiful pine forests and offer great views of the lake. The pistes at Sanosaka are wider and steeper

and a great challenge for intermediate skiers and snowboarders. Kashimayari is the most challenging of the 3 resorts, with much longer and varied runs, with incredible views of the twin Kashimayari peaks standing at 2,889m – photo op anyone?

Beginner suitability

These resorts are so quiet that during the week you'll feel like you've got your own private ski resort to play in, giving beginners plenty of space to work on their skills. There's lots of safe beginner terrain on offer and plenty more to progress up to, if you spend a few days here.

Off the slopes

There are a few small lodges and hotels dotted around the edge of Aoki Lake and one great Italian restaurant near the Blue Lake Hotel at the bottom of Aokiko ski resort, but not much else.

Access

If you don't have your own wheels the most straight forward transport option from Hakuba is to take the Oito train line train and get off at Minami Kamishiro Station, right at the foot of Sanosaka ski area (the resort closest to Hakuba of the three).

NAGANO

Tsugaike Kogen

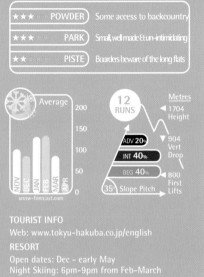

★★★	POWDER	Some access to backcountry
★★★	PARK	Small, well made & un-intimidating
★★	PISTE	Boarders beware of the long flats

Average

snow-forecast.com

12 RUNS

ADV 20%
INT 40%
BEG 40%

35° Slope Pitch

Metres
◄ 1704 Height
▼ 904 Vert Drop
◄ 800 First Lifts

TOURIST INFO
Web: www.tokyu-hakuba.co.jp/english

RESORT
Open dates: Dec – early May
Night Skiing: 6pm-9pm from Feb-March
Longest run: 3.6km
Total Lifts: 23 – 1 Gondola, 10 Express Chairlifts, 12 Regular Chairlifts

Popular with the Japanese and cheaper than other Hakuba resorts.

An authentic Japanese resort more popular with domestic visitors than Australians and other Western tourists. As a result Tsugaike has few English-language signs and information, which can make navigating the resort and it's base town a bit of a challenge. However, this place offers a true Japanese resort experience and it's actually fairly easy to get your bearings on the well-laid out slopes. It's worth a day's visit if you're staying in the nearby town of Hakuba.

Tsugaike has a good range of beginner and intermediate terrain including two small terrain parks, a little backcountry and a mix of marked trails. The on-piste is best suited to beginners and intermediates but beware of the massive flats at the bottom of the hill. Whilst the long flats could be a bonus if you are travelling with children – access to these runs by foot is simple and the sledging opportunities are rife – it's a definite annoyance for the more advanced and particularly impractical when buried under a few feet of powder. Advanced skiers and riders should head for the snow parks and backcountry found off the top of

the mountain. Like many of the Hakuba resorts, the slopes here are busy on the weekends and quiet on weekdays. Saturdays and Sundays can often see road queues to access the car parks. Fortunately, as a large number of the chairlifts come down to the base area long lift lines to get up the mountain are rarely an issue.

Powder

Off-piste opportunities are all hiding at the top of the Tsuga No.1 Pair Lift accessed from the top of the main gondola. From here you'll find some sweet tree runs off the side of the Shirakaba Slope. There's also an entertaining 'inter-forest' slalom-like adventure run which is pretty good for racing friends down or wrapping yourself around trees if you take a wrong turn. As always in Japan, go with a guide before venturing into the unknown, as avalanche bombing is not high on the list of safety concerns. There have been some major slides known to happen in this region, which have increased the measures management take to limit off-piste action. Evergreen Outdoor Centre offer a supply of guides, who can help you work around the backcountry access rules. Powder is certainly there to be had, the one disappointment being that many of the sections at this resort run out onto the aforementioned long flat at the base of the mountain.

Park

Tsugaike offers a minimal but well-maintained park found at the top of the Eve Gondola. It's accessed by two double chairlifts, meaning queues are rare and riders flow smoothly through the park. There are a number of jumps from small to medium in size and a set of well-constructed rails, but no halfpipe – still a good stop for any intermediate skier or rider looking for some fun un-intimidating park time.

Piste

If you enjoy long groomed runs, this resort may be a little disappointing, however there's some reasonable steeps at the top but they're rather short and the flat

NAGANO

section at the bottom makes them barely worth their while. The grooming is good quality and the trails vary in width but if you enjoy laying over your carves there's better resorts in the Hakuba region.

Beginner suitability

Beginners are catered for very averagely at Tsugaike. There are lots of fairly short chairs that run from the bottom of the mountain accessing a number of mellow beginner trails – a good starting point for those learning how to link their turns together. However, at the bottom of these slopes the pitch decreases so much that it's almost impossible to keep any forward momentum. This is particularly challenging for snowboarders who will frequently find them selves catching an edge. This resort is very Japanese so English-speaking instructors are not widely available.

Off the slopes

There's a fair choice of on-mountain food at Tsugaike-Kogen, including the usual Katsu Curry and many noodle-combo options. It's nothing to write home about but you won't be stuck for some reasonably priced warm-filling fodder.

The base town of Tsugaike is larger than many of the resorts-service-towns in the region, and is probably

the only resort other than Happo One or Hakuba 47 / Goryu where you might consider staying. There are a few cool bars, plus a handful of traditional Japanese restaurants and hotels to choose from. Beware; you probably won't get the English-speaking service that you'll find in the centre of Hakuba.

Access

About 15mins drive north of Hakuba, Tsugaike is not far but a little tricky to access by bus as there isn't a resort service available. There is a local bus service that heads that way but details are hard to find and it's not catered for tourists. You're best off making use of a rental car or shelling out for taxis.

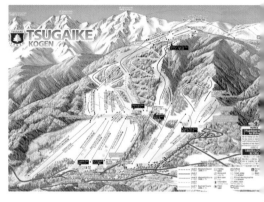

Yanaba Ski Resort

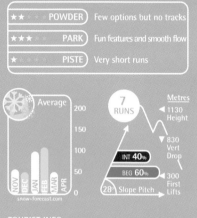

★★ ☆ ☆ ☆ **POWDER**) Few options but no tracks

★★★ ☆ ☆ **PARK**) Fun features and smooth flow

★ ☆ ☆ ☆ ☆ **PISTE**) Very short runs

Average | 200 | 150 | 100 | 50 | 0
NOV DEC JAN FEB MAR APR
snow-forecast.com

7 RUNS
28 Slope Pitch
INT **40%**
BEG **60%**

Metres
◄ 1130 Height
▼ 830 Vert Drop
◄ 300 First Lifts

TOURIST INFO
Web: www.yanaba.co.jp
RESORT
Open dates: mid Dec – early April
Night Skiing: 5:30pm-9:30pm
Total Lifts: 2 - 1 Express Chairlift, 1 Regular Chairlift

Your evening freestyle fix!

Overlooking Lake Aokiko on the outskirts of Hakuba, Yanaba is a small-scale locals' favourite for un-crowded fun-park shredding and evening jib action. Appreciable views over the lake of the North Japanese Alps, plus the easy access and cheap lift tickets make it a great place for learning or a laid-back park session with friends.

This is the only resort offering evening park riding in the area, which can be easily tagged onto the end of a good days freeriding elsewhere in the Hakuba region - if you've still got some fuel left in the tank. So whether you're escaping the crowds to get to grips with your first turns, or perfecting your 270s onto boxes under floodlights, Yanaba is worth a visit just as much as the big-name resorts in the area.

NAGANO

Powder

Despite its low elevation and diminutive size, when a fresh dump of powder has fallen, fresh turns and fun powder drops can be found. Yanaba is definitely not a freeriding resort; long powder lines and backcountry missions are definitely not on the cards here. However, when there's some fresh the typical Yanaba regulars are often still trying to ride the rails, so you can end up riding powder all day if you don't mind lapping the same very short lift. The most fun can be had on the steep section of the upper run which is refreshingly left un-groomed, and launching your self into the powder between the zigzagging pistes below.

Park

This is Yanaba's reason for existing. While Hakuba 47 boasts the biggest kicker in the valley Yanaba focuses on fun, offering plenty of beginner and intermediate sized-features. The kickers and rails are well spread out, so that after a short wait to drop in, the whole park can be ridden as a

PHOTO: ANDREW KELLY

新宿

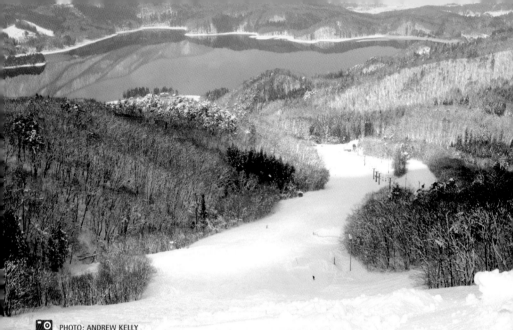

line without stopping. The pipe is not as well maintained as the rest of the park but is the ideal size to boost your first airs out of the lip and, like the rest of the park, has little of the waiting-to-drop crowds that the bigger resorts have. Evening park action is open late and is a very cheap option for those wanting to push their freestyle skills.

Piste

All intermediate skiers/riders and above will exhaust Yanaba's piste options very quickly – possibly before lunch! From the top lift head right for a little steep section or straight down for some moguls (if it hasn't dumped recently). Piste chargers wanting to clock up miles under their boots should look elsewhere.

Beginner suitability

Yanaba's small size makes it perfect for first timers and second/third day novices (especially if your other half is keen to ride park and doesn't want to ditch you for the day). There are enough short challenging sections and reassuring wide gentle pistes to build confidence, without ever being too far from the base lodge for a hot cocoa break. The cheap lift tickets also make much more sense for beginners who generally don't make the most of larger resorts.

Off the slopes

Yanaba isn't part of any tourist town and hasn't got a big base area, but is a short hop on the train from Hakuba town itself. The base lodge is modern and functional, with a restaurant upstairs offering the usual Japanese fare – a numbered ticket is given when you order so unless you are confident of your Japanese bingo ability, remember to hang around looking confused and foreign so they notice you when you miss your number being called!

The main reception area has a café and gift shop (with surprisingly cool stickers and fluffy fluro earmuffs for those pushing the 80's revival style) and plenty of space for stretching out in the warm before or after your snow sliding.

Access

With its own station, 'Yanaba Ski-jo Mae', the resort is easily accessed by public transport. Just 15mins from Hakuba, the regular trains run late enough to make it back after a night session, plus there's a large timetable on the wall in the main reception. Ask the friendly staff if you're unsure. By Car it is equally simple, with the resort car park right on the main road from Hakuba to Matsumoto. It's sign posted well in advance and easily noticeable by the promotional flags on the roadside.

Akakura Onsen & Myoko Kogen town

Lift-served powder gem combining modern facilities and traditional Japanese charm.

★★★ ACCESSIBILITY
Relatively simple

★★★ EVENING ENTERTAINMENT
Friendly welcomes, Japanese-style

★★★★ CULTURE SHOCK
A great Japanese experience

TOURIST INFO
291-1 Taguchi, Myoko-shi, Niigata-ken
949-2106 Japan
Tel: 0255-86-3911
Web: www.myoko.tv/foreign/english

Just over the border from Nagano into Niigata prefecture, Myoko combines huge snowfalls and modern resort infrastructure with a real Japanese atmosphere. Home of the first ski resort to be established in Japan, Myoko is a modern powder destination with a long history. Myoko first gained popularity in Japan in the early 1900s as a summer destination to escape the heat and humidity of city life. Although Myoko is becoming known for large amounts of winter powder, it remains a popular year-round domestic destination thanks to the many natural onsen, the beauty of the Joshinetsu National Park, and the warm rural Japanese welcome visitors get from the locals.

NIIGATA

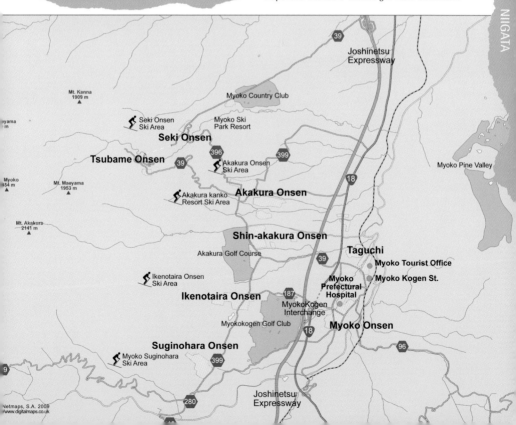

Joshinetsu Expressway

Mt. Kanna 1909 m

Myoko Country Club

Seki Onsen Ski Area

Myoko Ski Park Resort

Seki Onsen

Tsubame Onsen

396

Akakura Onsen Ski Area

399

Myoko Pine Valley

Myoko 454 m

Mt. Maeyama 1953 m

Akakura kanko Resort Ski Area

Akakura Onsen

18

Mt. Akakura 2141 m

Shin-akakura Onsen

Akakura Golf Course

Taguchi

39

Myoko Tourist Office

Ikenotaira Onsen Ski Area

Myoko Kogen St.

Ikenotaira Onsen

Myoko Prefectural Hospital

MyokoKogen Interchange

187

Myoko Onsen

Myokokogen Golf Club

18

Suginohara Onsen

Myoko Suginohara Ski Area

399

96

9

Joshinetsu Expressway

280

Netmaps, S.A. 2009
www.digitalmaps.co.uk

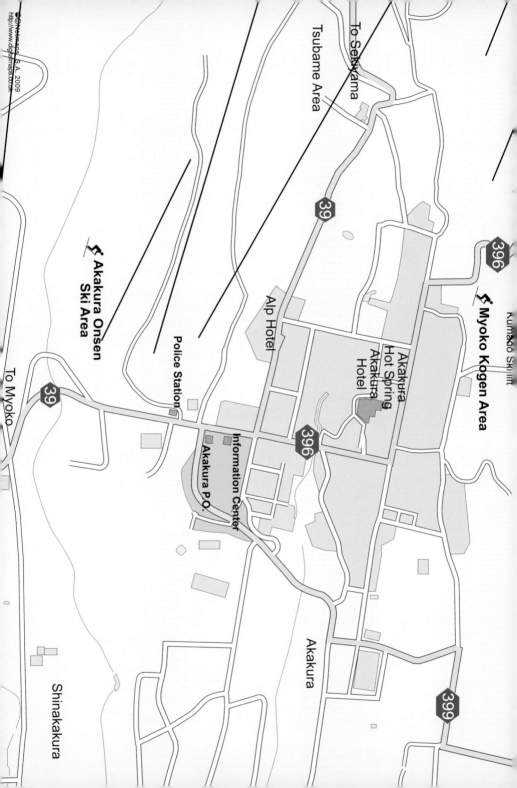

To Sekiyama

Tsubame Area

39

396

Kumado Ski/lift

Myoko Kogen Area

Alp Hotel

Akakura Hot Spring
Akakura Hotel

Akakura Onsen
Ski Area

Police Station

To Myoko

39

396

Information Center

Akakura P.O.

Akakura

399

Shinakakura

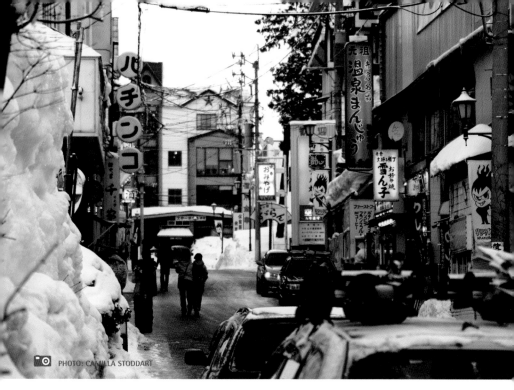

Myoko encompasses 3 main distinct skiing areas, Akakura Onsen, Ikenotaira Onsen, and Suginohara, linked together by shuttle bus but not by chairlift. The resorts span the flanks of the stunning volcanic peak of Mount Myoko (2,454m) and look out over an open valley towards Lake Nojiriko in Nagano. The town of Myoko Kogen itself sits in the valley below, with the Japan Sea to the north, and Nagano City to the south. Within easy reach for a day trip in the Myoko area are the linked resorts of Tangram and Madarao, and the off-piste powder of Seki Onsen.

Myoko's winter heritage started in the 1930s when the son of rich hotelier experienced alpine ski resorts in Europe and decided to build one in Japan, starting with the Akakura Kanko Hotel in 1937. The influence of European ski-in alpine resorts is evident as, unusually for Japan, much of Myoko's accommodation is within walking distance of the slopes. Myoko has managed to develop modern facilities without loosing its strong local identity. The wooden singleseat chairlifts of the 1950s may have been replaced by high-speed quads, but you'll never lose the feeling of being in the heart of rural Japan. Local festivals and unique traditions, such as drying hot red chillies on top of the snow, are as much a part of Myoko's winter as firing up the snow blower to dig out the car.

Accessibility

Myoko is fairly accessible for those travelling within Japan or arriving from abroad. The town of Myoko Kogen is in Niigata prefecture, although it's only just over the border from Nagano prefecture. Nagano City is the main access point for Myoko, allowing you to take advantage of the high-speed Shinkansen (bullet train) from Tokyo (approximately 1hr 30mins). After the smooth Shinkansen ride you must take the slightly bumpier local train to Myoko Kogen Station, 40mins on the Shin-Etsu line. From Myoko Station local buses connect throughout the day to the resort base areas of Suginohara, Ikenotaira and Akakura. Nearly all accommodations will pick you up from Myoko Station as part of their service, and the Myoko tourist office also runs a minibus pick-up service from Nagano City. By car, Myoko's ski resorts are only a 10min drive from the Myoko Kogen expressway exit, and are well signposted in English.

Evening entertainment

Myoko's after-riding scene is distinctly Japanese: warm welcomes and cold beers in local bars and cosy restaurants. Although the Suginohara and Ikenotaira areas have some eateries and drinking holes, the main area for nightlife is Akakura Onsen, easily reached by free shuttle bus until the early evening or by taxi later on. There are enough restaurants here to eat out somewhere different each night for a few weeks. These are popular with locals as well as young Japanese visitors, so you will have plenty of opportunity mix with Japanese people and practice 'nomunication' – the combination of drinking ("nomu" in Japanese) and communication!

With more bars and restaurants within walking distance than most Japanese ski resorts, there is a bustling, lively feeling to the main streets of the Akakura area. Even in heavy snow, you can comfortably wander around to find the next warm place to eat and drink. In Akakura, the Manari curry house on the main street serves filling cheap eats, and the constant queue at the crepe shop shows how good they are for an after riding sugar hit! For traditional Japanese udon noodles with an alpine twist, try the cheese covered 'Alps Udon'

noodles at Fu, downstairs on the main street below the decent Italian restaurant Pomodoro. Over in Ikenotaira, the Alpen Blick Tantra Kan has a fantastic all-you-can-eat Japanese dinner, with all the local 'Myoko Kogen' beer you can drink too! This is well worth the short trip, but reservations are needed in advance.

Myoko Akakura has one bar with live DJs called The Love Bar that hosts parties throughout the season. However, if you're looking for western-style après-ski nightlife you are not in the right place – head to Hakuba instead. Myoko is a place to celebrate the powder turns local style: soaking in an onsen bath then heading out to eat and drink in one of the Japanese izakaya bar-restaurants. Popular with local riders and seasonal workers, is Hoheto, offering big cold beers and tasty Japanese tapas-style bar food. Try the whole roast garlic bulb and excellent barbequed grilled meat, but beware of the local 'to-garashi' – exceptionally hot long green chilli peppers, grilled on sticks, that destroy the myth that Japanese people can't eat spicy food. This can be found downstairs, at the far end of Akakura's main street, and if you have drunk enough, the kareoke bar Hunter is just round the corner.

PHOTO: CAMILLA STODDART

Culture shock

Although Myoko is very much a traditional Japanese ski town, rightly proud of its history and culture with wonderful cobbled streets and classic architecture, it's also very welcoming to overseas visitors. The tourist office has English-speaking staff, who can be contacted in advance through their website. An increasing number of bars and restaurants have English menus, and those that don't will go out of their way to understand and help you. Bring a basic Japanese phrase book, have a crack at some simple phrases, and the warmth of the response you will find will dispel any feelings of un-comfort. As with most places in Japan, the cash-only culture of Japan can be quite a shock, but there is one ATM at the post office in Akakura and a second one at the 7-11 store down in Myoko town. For culture shock to amuse your friends back home, try browsing the local ski shops that have been stuck in time warp, with real fluoro 80s equipment still on sale!

Accommodation

Myoko has an abundance of modern hotels, often with their own onsen baths, and friendly family run lodges, with options from five-star luxury to local Japanese charm. Unusually for Japan, many accommodations are ski-in or close walking distance to the lifts. There's plenty to choose from in the mid and upper price range but there's no cheap backpacker accommodation in Myoko, and self-catering options are limited. The best area to stay is in the Akakura area, as this has the most nightlife and facilities, and easy access to the other resorts.

The owner of Yours Inn lodge in Shin-Akakura is a famous local mountaineer, if you fancy chatting about the challenges of climbing the highest peaks on each continent, or just the weather for tomorrow's skiing. Yours Inn offers catered accommodation for the mountain enthusiast a short walk from Akukura base area. Walking distance to the Akakura gondola, Midori-no-Kaze is a charming wooden lodge with a relaxed homely feel and space to unwind round a wood-burning stove. The warm welcome, double rooms with western beds and good cooked breakfasts make this a good value base for exploring Myoko for a longer stay. For the height of luxury and European alpine style, the Akakura Kanko Hotel sits on the pistes of Akakura resort, with a fantastic restaurant and a movie star location this is the place to

PHOTO: KEITH STUBBS

stay if you are splashing the cash. Stay here and you'll feel like James Bond. Most hotels now have Internet access and there is a 24hr Internet café in the Ikenotaira base area at the Manga Café, which can also provide an emergency place to crash for the night.

Sightseeing and other activities

Myoko is a year-round destination for Japanese tourists who come to sample the large number of onsen and immerse themselves in the natural surroundings. Steam pours out of the onsen buildings as you wander the narrow streets of Akakura, and boiled eggs cooked in the piping hot thermal water are on sale at that side of the street. Even more traditional onsen await the adventurous in Tsubame Onsen, a short taxi ride away.

Beyond the base areas of Myoko, tours to the beautiful Zen Buddhist temple and traditional Japanese gardens of Rinsenji (where you can try Zen meditation to empty your mind of thoughts of powder) can be booked at reasonable prices through the local tourist office in English. Nagano City is only 45mins away by direct local train, where you can find the massive Zenkoji temple and many traditional Japanese craft shops as well as modern big city life.

Ikenotaira Onsen

Myoko's park mecca but too flat for freeride fun!

★★ ☆ ☆ ☆ POWDER | On-piste powder virgins only!
★★★★ PARK | Flowing lines & imaginative
★★ ☆ ☆ ☆ PISTE | Relaxing. Too relaxing

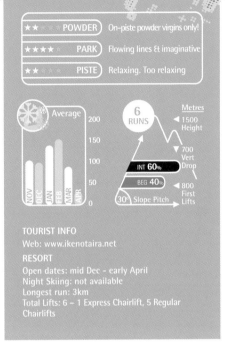

Average | 200 | 6 RUNS | Metres
| 150 | | ◀ 1500 Height
| 100 | | ▼ 700 Vert
| | INT 60% | Drop
| 50 | BEG 40% | ◀ 800 First Lifts
NOV DEC JAN FEB MAR APR | 0 | (30°) Slope Pitch

Ikenotaira sits in the middle of Myoko's big three resorts, between the steeper slopes of Akakura Onsen and the longer runs of Suginohara. Against these larger and steeper resorts it claims its place in the 'big three' by virtue of its three parks. Yes, that's right, there are three distinct snow parks to be found at Ikenotaira.

As the parks attract most of the visitors the pistes are the least crowded of Myoko's big three – shame they are so flat! Ikenotaira is a freestyle resort just steep enough for park. The rest of the resort has a very relaxed feel, with runs meandering gently between beautiful birch forests off the sides of a central wide open piste, and views extending to lake Nojiriko on a clear day.

TOURIST INFO
Web: www.ikenotaira.net
RESORT
Open dates: mid Dec – early April
Night Skiing: not available
Longest run: 3km
Total Lifts: 6 – 1 Express Chairlift, 5 Regular Chairlifts

Powder

A great place for getting to grips with powder for the first time, but too flat for serious powder hounds. As with the rest of Myoko, Ikenotaira gets hit with regular powder storms but it is not the place to head to on a deep snow day. It lacks gradient suitable for all levels except those not yet able to ride powder between trees yet. Off-piste options are limited but the wide open pistes combined with regular snowfall in the Myoko area make Ikenotaira a great place to first get to grips with the soft stuff and get that floating sensation in safe environment. More experienced powder hounds will find it too flat to get enough speed to play with the limited natural hits. The top lift has a small area of trees not roped off, but for most people at Ikenotaira powder is something to slash on the side of the run to the park.

Park

Arriving at the bottom lift, a sign proclaims

"Welcome to Japan's biggest and busiest park" so you know you are in the right place if you want freestyle fun. While the size of the park is big – there are actually three parks in the resort – it is not so busy that you have queue for long to drop in, except on holiday weekends. The 'Main Park' hosts the bigger airtime features, with two 15m kickers, spines and medium sized jumps. After a short piste-jib along the cat track below this, you'll come to the 'Super Park', which refers more to the amount of fun you can have there, rather than the size of it's features.

A refreshing change from parks crammed into small roped-off areas, the 'Super Park' is a long run with various jib features spread out along it. From beginner-friendly, wide, ride-on 'butter boxes', to challenging triple-kinked rails and photogenic wall-rides, the park crew have clearly put a lot of effort into making more imaginative features. With jibbing more and more common

NIIGATA

in Japan, this is Ikenotaira's most popular park. At the bottom of the 'Renaku Course' run there is also a beginners park, the 'Cherry Park'. All the parks are groomed daily. Skiers and snowboarders are both welcome in the parks, and as with the rest of Japan, they are often riding side by side.

Piste

On-piste options are limited, with most runs too flat to keep anyone other than beginners interested. Despite its long trails, which wind serenely between white birch forests, the lack of variety makes Ikenotaira feel like a much smaller resort than it is on paper. The feeling of riding the pistes is relaxing and tranquil rather than the alpine sensation of being in the mountains. Whist this will make beginners feel comfortable, anyone looking for faster carving and challenging runs will be itching to move to the neighbouring resorts in Myoko. Intermediates are better suited to Suginohara's lengthy runs while advanced riders should look to Akakura's steeper slopes. If you do find yourself here for a day of piste riding, try the long 'Alpenblick' run on the skiers' right of the resort, amuse yourself learning new flat-ground tricks, or just enjoy the beautiful view.

Beginner suitability

Ikenotaira's unimposing scale and generally mellow gradient make it a good resort for beginners' first steps in park or powder, or the snow in general. The wide-open runs are a good gradient for building confidence. They're just steep enough for novices to get to grips with soft snow before they have the control to head into the trees. With a whole separate beginners park and enough smaller features in the 'Super Park' Ikenotaira is very beginner-freestyle friendly, and there is no intimidating atmosphere that can be off putting in some parks. The covered bubble chairs throughout the resort provide welcome shelter from Japan's frequent snowstorms, making it even more beginner-friendly, however if you're looking for lessons taught in English this isn't the place to come.

Off the slopes

Ikenotaira lacks a real focal point to the spread out neighbourhood of lodges around its base, but around the cross roads (5mins walk) below the resort there's a Spar convenience store, several restaurants and the 'Comic Café', which is a 24hr Japanese style Internet café. This means Internet access in private rooms

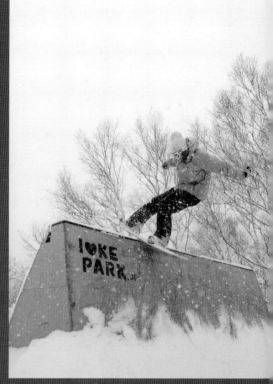

PHOTO: SARAH MULHOLLAND RIDER: ANDREW KELLY

where you can eat, drink, read comic books and even crash out overnight if you need to! Free shuttle buses operate within Myoko between Ikenotaira, Suginohara and the busier nightlife of the Akakura base area. For more information on this, check out the Myoko Town review.

Access

Easily accessed from Tokyo, using the Shinkansen to Nagano City and then direct local train to Myoko Kogen station on the Shin-Etsu line. Most lodges will pick you up from Myoko station, or alternatively take the Suginoswa local bus (15mins) or taxi (10mins and about 1500 yen). By car, Ikenotaira is only 10mins drive from the Myoko Kogen exit of the Joshinetsu expressway and is well signed in English.

Madarao Kogen & Tangram Ski Circus

No clowns or elephants, but plenty of family fun and hidden powder stashes!

Madarao Kogen and Tangram Ski Circus are two smaller resorts joined at the peak of Mt Madarao (1,382m) and through a number of connecting trails/lifts. The resorts are managed independently of each other and are located on the opposite side of the valley to the bigger resorts in Myoko. Madarao is the powder haven and is one of Honshu's hidden freeriding gems, popular with the locals. Tangram Ski Circus is the family-friendly place, aiming at those with children looking for an all-inclusive hotel experience, and offering great views back across the valley to Mt Myoko, lake Nojiriko and Nozawa Onsen.

The option for a joint lift ticket between the two resorts should perk a lot of interest with mixed level groups; Madarao being the larger area for advanced riders and Tangram being the cruisey picturesque resort with a very relaxed feel. Whilst not a large resort this is still well worth a few days of skiing or riding if you're in the Northern Nagano or Myoko region.

Powder

Rip out your fat reverse camber planks or your swallowtail and head for the top of the Madarao side. After a fresh dump of snow, you won't be disappointed here. There aren't many places in the world where you take a one-man chair lift (No.13) to access steep untracked powder through gladed trees. A short hike from this lift takes you to the very top from where a quick traverse heading skiers right along the ridge will give you some incredible views of Lake Nojiriko and Myoko, before dropping an epic line back down to the resort through some nicely spaced trees.

Definitely check out some of the areas that Madarao has specifically opened up for powder skiing. Most notable is 'Airwave' on far skiers

right of the resort. It has a series of rolling jumps through the powder and big vines hanging from trees, which you can grab onto and swing from. For those keen to venture even further in search of fresh lines, you can kit up in avalanche gear and head out on short hikes into some steep tree areas with the backcountry guiding service run by Kitamura-san, an ex-World Cup Ski-cross Racer, who works for the resort.

The Tangram side is much more mellow. One steeper run (King's Slalom) is left un-groomed for more advanced riders but the emphasis here is on grooming the slopes for beginners and intermediates. Those looking for a quick powder fix while their families play on the nursery slopes are left with slashing the banks and the edges of trees along the sides of the piste. Riding off-piste is not allowed in Tangram, so head over the top to Madarao if this is where your passion lies.

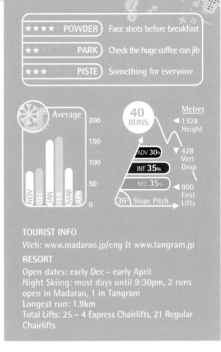

★★★★ POWDER — Face shots before breakfast
★★ PARK — Check the huge coffee can jib
★★★ PISTE — Something for everyone

Average
Metres
200
150
100
50
0
NOV DEC JAN FEB MAR APR
40 RUNS
ADV 30%
INT 35%
BEG 35%
36° Slope Pitch
1328 Height
428 Vert Drop
900 First Lifts

TOURIST INFO
Web: www.madarao.jp/eng & www.tangram.jp
RESORT
Open dates: early Dec – early April
Night Skiing: most days until 9:30pm, 2 runs open in Madarao, 1 in Tangram
Longest run: 1.9km
Total Lifts: 25 – 4 Express Chairlifts, 21 Regular Chairlifts

NAGANO

Park

Tangram has a very small park with 2 small tables, a few flat rails and boxes, plus a spine. Whist well maintained like the rest of the resort, it is small and only just enough to keep an enthusiastic lower intermediate rider happy for a morning while their parents do laps in the hotel pool and younger brother plays on the inflatable hamsters on the kid's piste. Alongside the park there is a wave feature keeping adventurous children entertained.

On Madarao, take either the Super Quad or the No.2 Quad lift to access their also rather small park, located near the base. This park contains about the same number of features and is also only suitable for beginner to intermediate park riders. However, one of its features, a giant coffee can jib, does make heads turn!

Piste

Madarao has a straightforward layout, with most pistes winding their way back to the central base area. Intermediate and advanced riders and skiers will enjoy the piste and off-piste alike, ducking in and out of the open trees on the sides of the runs. The beginner runs are all located at the bottom of the resort, while plenty of black and red trails line the upper parts of the ski area.

The Trails on the Tangram side all lie within a natural bowl and lead back to the base area hotel. This gives a sense of security, making it comfortable for intermediates to experience a variety of runs without

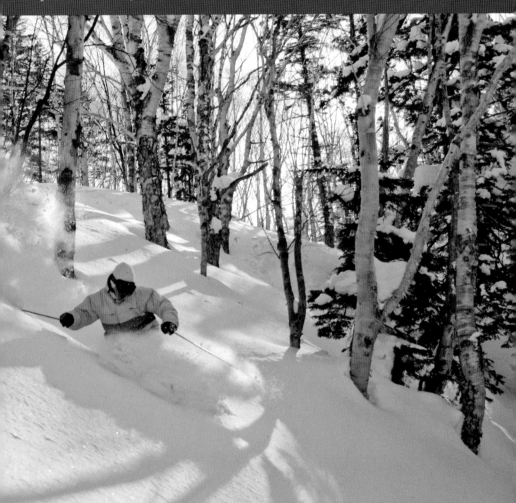

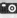 PHOTO: SARAH MULHOLLAND RIDER: TIM MYERS

ever feeling out of their depth. Although short, there is a nice variety of well groomed intermediate runs between the trees. Children have their own piste area with inflatables and childcare staff. The steeper sides of the bowl have a few short steeper runs, but check out Madarao for longer, more challenging trails.

Beginner suitability

Rarely crowded, even at weekends, the mellow and empty pistes of Tangram provide an ideal place for someone to learn to ski or snowboard for the first time, without the feeling of being caught in traffic at the bigger resorts. Madarao's lower area is also good for beginners, with lifts 2, 5 and 11 accessing the mellow green runs, which spread widely across the bottom. The friendly family atmosphere on both sides makes this a great resort to learn to ski or snowboard, although English-speaking instructors are few and far between.

Off the slopes

Tangram Ski Circus is a self contained ski-in, ski-out resort, with the Hotel Tangram at the bottom of the main slopes. There is no base village apart from the hotel, until you reach the town of Myoko Kogen (15mins away by car). The hotel has 4 restaurants, a swimming pool, some natural onsen baths and great childcare facilities. You may feel

like the only non-Japanese people on the slopes, but the hotel is actually popular with visitors from Honk Kong and English is spoken by most of the hotel staff. It's all very modern and user friendly, with a good shop for accessories, rentals, a ski and snowboard school. For groups of 5 or more, the hotel will arrange shuttles for you to other resorts in Myoko – handy!

At the foot of Madarao is a collection of family run lodges and hotels, but not really a village as such. If you do choose to stay here, the lack of nightlife could certainly be made up for by the authentic Japanese experience you are bound to have, given that foreign visitors are few and far between, with 99% of the resort guests being Japanese.

Access

Anyone staying at Hotel Tangram will be picked up by private shuttle from Myoko Kogen Station (15mins). Getting to Myoko Kogen Station can be done through Nagano City. Day visitors to Tangram or Madarao come by car, taking Route 96, which is well signed from Myoko Kogen Station and about 20min drive from Iiyama interchange. Alternatively, two Alpico buses run daily from Nagano City bound for Madarao Kogen with the journey taking around 70mins.

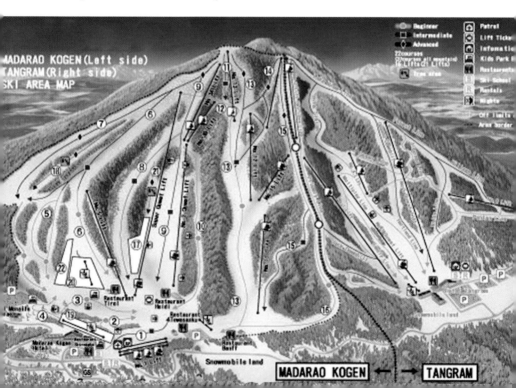

Myoko Akakura

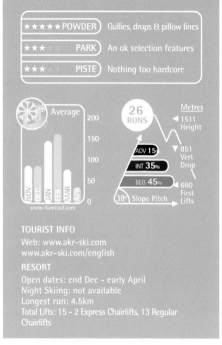

★★★★★ POWDER) Gullies, drops & pillow lines

★★★ PARK) An ok selection features

★★★ PISTE) Nothing too hardcore

Average
200
150
100
50
0
NOV DEC JAN FEB MAR APR
snow-forecast.com

26 RUNS

ADV 15%
INT 35%
BEG 45%

38° Slope Pitch

Metres
1511 Height
851 Vert Drop
660 First Lifts

TOURIST INFO
Web: www.akr-ski.com
www.akr-ski.com/english

RESORT
Open dates: end Dec - early April
Night Skiing: not available
Longest run: 4.5km
Total Lifts: 15 - 2 Express Chairlifts, 13 Regular Chairlifts

Unreal terrain, epic snowfalls and traditionally Japanese!

from the far side of one area over to the other, but the lifts usually run till 4.30 so getting caught out at the end of the day isn't very common. If you have a vehicle it's best to park at the Akakura Kanko base area on the south side of town as you drive in. Here you'll find a stylish café and access to the main gondola. Night skiing is only found on the Akakura Onsen side on a 4-person chairlift known as Kumado – just a few minutes walk from the main street in Akakura town. The terrain available during night skiing is fairly limited, although they do maintain a small terrain park with a number of different features worthy of a few hours twilight jibbing.

Powder

Myoko Akakura's location, close to the Japan Sea, means it gets biblical amounts of the infamous Japanese pow. Their average snowfall is approximately 16m a season! Combine this jaw-dropping statistic with a relaxed off-piste and backcountry riding policy and you get some of the best freeriding/freeskiing Japan has to offer. The most noticeable thing when you first start cruising the Akakura trails is the unusual lack of ropes and fences. It's a refreshing feeling being able to pop off the side of a groomed run into an untracked, powder-laden gully, bounce down a few pillow lines and know that you're riding some of the best snow in the world. There are still a few 'no-go' areas, but they're kept to a minimum and seem to be well reasoned. Akakura's backcountry-access rule is also very noteworthy. They maintain a completely 'at your own risk' policy and make it very obvious at potential access points that they will NOT be responsible for any accidents that occur outside of the resort boundary. These characteristics, when combined, are what make Myoko Akakura so special.

If you head skiers-right from the highest quad chairlift on the Akakura side you'll discover a nice tree-covered

Claiming to be the first official ski resort in Japan – yep, that's right, 'Ichiban!' – you would expect Myoko Akakura to be one of the major players within the Japanese ski industry and known internationally. This couldn't further from the truth. Myoko Akakura is one of Japan's best-kept secrets. This place is epic!

Myoko is located just over the border from Nagano into the Niigata prefecture. It is best accessed from Nagano City, just 1hrs drive, and is only 3hrs travel time from Tokyo. Myoko Akakura is a medium to large sized resort that receives particularly large snowfalls, has an up-to-date lift system including a gondola and various high-speed chairs with bubbles to keep the frosty snow from your face, plus some spectacular freeriding terrain.

Myoko Akakura has two separately managed, but interlinked, lift systems: Akakura Kanko and Akakura Onsen. Akakura Kanko provides access to the more advanced terrain, whilst Akakura Onsen is a bit flatter and better suited for novices. It takes a while to get

NIIGATA

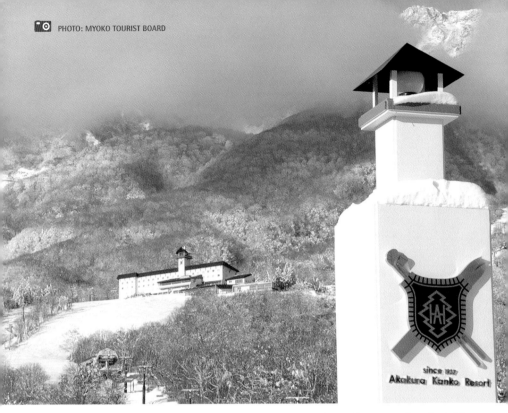

PHOTO: MYOKO TOURIST BOARD

face leading into a fun little gully. This is considered out-of-bounds and is completely at your own risk. The same gully is accessible from the highest 2-man chair as well, but this face gets more sun exposure so the snow can get a little baked. Further down the mountain, in between two 4-man chairs known as Champion No.3 and Champion No.7, are two excellent gullies running parallel that are well worth exploring. The sides of these gullies can be prone to avalanches and are not for the feint-hearted so proceed with caution and don't cut any closures – it's just not worth the risk.

Park

Akakura's main terrain park is found on the Kumado Panorama Course. The park usually has a nice blend of beginner and intermediate freestyle features with the occasional advanced option thrown into the mix. This is all accessible from the chairlift named Hotel No.2. The top section, located above the Akakura Kanko Hotel, provides a nice line of novice rail/box features with three or four different jibs, followed by a small kicker. The area below the hotel presents a larger variety of options with a double line of features. Typically they keep a range of rails and boxes on the

first few hits, followed by some medium-sized tabletops and ending with a hip. Towards the bottom of the run you should come across a series of beginner features: mellow rollers and a couple of super-wide, ride-on boxes. The features are well spaced and maintained to a good standard – but with the amount of snow that falls at Myoko, the park shapers often have their work cut out for them. It is worth noting that, for some reason or another, Akakura don't always keep this size of park and some seasons have seen no park at all.

As mentioned in the intro, the Akakura Onsen side also has a park, which is usually open for night riding. It's found on the Panorama run accessible from the Kumado chair. The features available here seem to vary a lot depending on the conditions and time of season. At its best it will offer a selection of tables followed by four or five smooth jib features.

Piste

Within the 900 metre vertical drop Akakura offers a substantial selection of wide easy groomers and a decent choice of long intermediate trails. For advanced carvers there's only really one run that will satisfy your

need for speed and it's found skiers-left of Champion No.3. All the trails a generally very well maintained, as is typical with Japanese grooming. Most trails keep a fairly consistent pitch and very even fall lines, so you can lay over a few long carves with little effort. There are a few very flat cat tracks designed for cross-resort access that you should watch out for, however they're marked clearly on the course map with a dotted green line – always handy!

Beginner suitability

Apart from those dotted green lines (signifying the very flat cat tracks mentioned above), the trails found on the Akakura Onsen side of the resort are certainly adequate for those learning to link their first turns. Sometimes a little too flat for novice snowboarders (careful of that heel edge!), a few of the trails are more suited to beginner skiers. Although, they're generally all nice and wide with a consistent pitch to help you find your rhythm. The lack of English spoken throughout the whole of the Myoko region does give reason to the lack of English-speaking instructors in the ski school. If you speak some Japanese, a lesson at Myoko Akakura isn't such a bad idea. If not, take your lessons down in Hakuba instead.

Off the slopes

The Akakura resort is serviced by Myoko town. The base village of Myoko Akakura resort is a small suburb of the Myoko town and is also known by the name 'Akakura Onsen'. It's all a little confusing really. Akakura Onsen village has multiple ski-in / ski-out accommodation options all typically offering some form of food and beverage service. On the mountain itself you'll find literally dozens of accessible eateries, all in a traditional Japanese style and with reasonable price tags on their menus. Well worth a mention is the Akakura Kanko Hotel, found smack bang in the middle resort's trails. It's accessible by road too of course, however its mid-mountain location is very appealing to those who want literally doorstep access to the snow and a little luxury at the same time – it's got a swimming pool looking out over the ski slopes.

Access

Myoko is approximately a 1hr drive north of Nagano City. There's a direct train running from Nagano Station, which is best accessed by Shinkansen from the major gateways of Tokyo and Osaka. From the local train station in Myoko there is a bus service that will take you up to the resort itself.

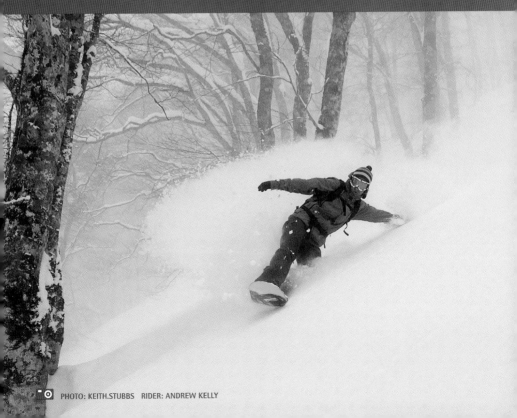

PHOTO: KEITH.STUBBS RIDER: ANDREW KELLY

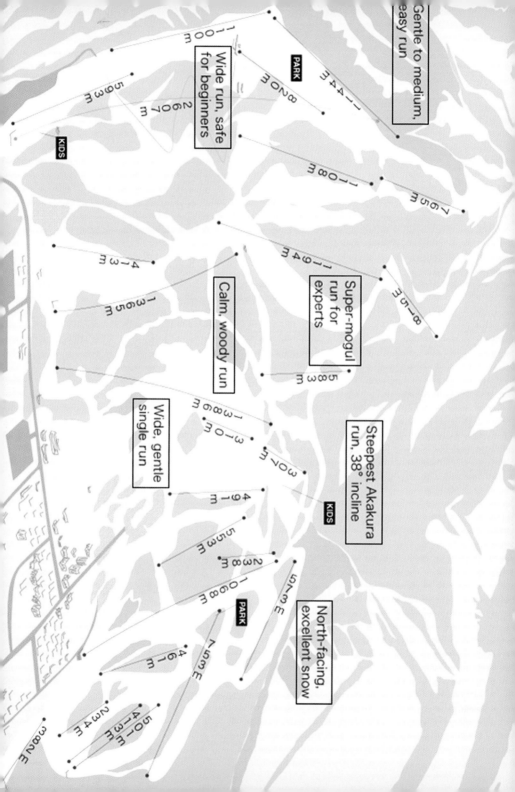

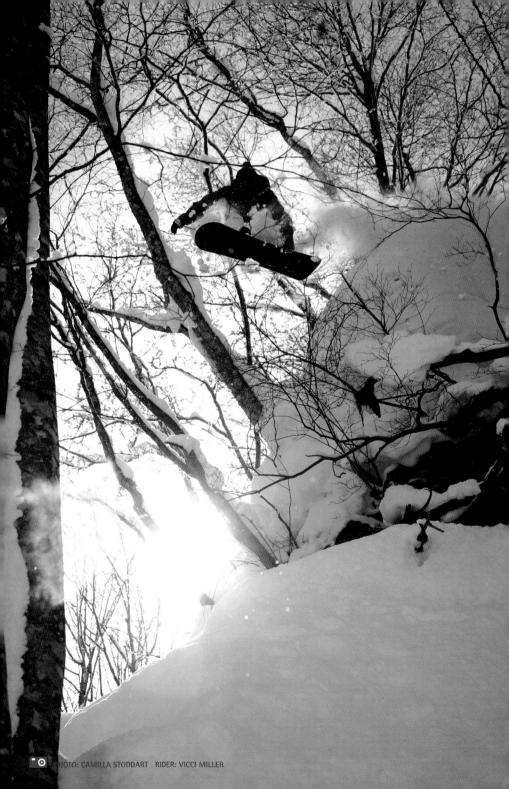

Myoko Suginohara

A rail-loaded park and some deceptively long pistes.

Boasting one of Japan's largest vertical drops and longest runs, Myoko Suginohara is a worthy day trip when staying in Myoko town or travelling through the area. Nestled on the south side of Mt Myoko, Suginohara doesn't quite get the snowfall of neighbouring resort Akakura, or Seki Onsen a short way up the valley. But what it lacks in deep powder days it makes up for with its expansive terrain parks and lengthy pistes.

Suginohara feels as though it's been stretched like a piece of chewing gum, making it a particularly long and narrow ski resort. It has a range of trails to suit most levels plus a little freeride terrain thrown in the mix. The lift system is well developed with an eight-person gondola, a few high-speed chairs and a couple of doubles, the lowest of which comes straight out of the village known as Suginosawa Onsen. The main base area is a short way up the resort, accessible by road, and offers all the standard facilities without the frills. There is a little night skiing available, but it's limited to a beginner run and the main terrain park – a bonus if you like to partake in a little late night jib action.

Powder

Suginohara's south-facing disposition means it gets more sun than the other Myoko resorts, so any pow that falls doesn't keep it's fluffy appeal as long as you'd hope. That said, there is some okay terrain here and this area as a whole is known for it's large snowfalls. The highest lift accesses the steepest pitches and some nice trees. There's a few wooded sections underneath the gondola that are also worthy of a few turns, but you won't find big open faces or pillow lines here. Like it's neighbour Akakura, the off-piste policy is a little vague.

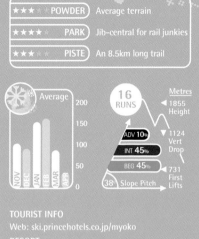

★★★☆☆ **POWDER** Average terrain
★★★★☆ **PARK** Jib-central for rail junkies
★★★☆☆ **PISTE** An 8.5km long trail

Average
200
150
100
50
0
NOV DEC JAN FEB MAR APR

16 RUNS

ADV 10%
INT 45%
BEG 45%

38° Slope Pitch

Metres
◄ 1855 Height
▼ 1124 Vert Drop
◄ 731 First Lifts

TOURIST INFO
Web: ski.princehotels.co.jp/myoko

RESORT
Open dates: mid Dec – end March
Night Skiing: 5pm - 9pm, 3 runs open
Longest run: 8.5km
Total Lifts: 6 – 1 Gondola, 3 Express Chairlifts, 2 Regular Chairlifts

PHOTO: MYOKO TOURIST BOARD

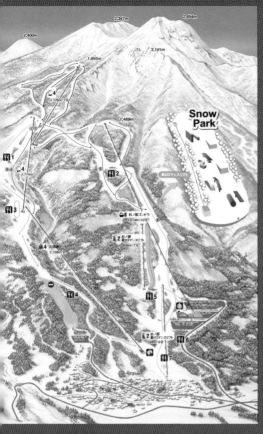

a right towards the double chair. Here you'll find the main park. Floodlit at night and serviced by its own chair lift, this is where the action is. The large flat-down boxes are especially fun. Suginohara also build a simple skier/boarder cross course found on skiers' far right of the resort accessible from the middle quad lift.

Piste

Like most resorts in the world, the longest 8.5km run is fairly flat and aimed at lower levels. It does have some smooth medium pitches through the middle of the run, but if you brave the journey all the way down, you'll encounter some annoying flat sections towards the bottom – for boring advanced skiers/riders and awkward for novice snowboarders. The most consistent runs here are the red trails from the top of the gondola. Whilst fairly mellow, they're reasonably wide and good for keeping your flow. For something a little steeper head up the highest quad chair and go hard.

Beginner suitability

Suginohara has some great terrain for the novice skier and snowboarder. The long smooth green trails in the resort's lower half are ideal for those learning to link their turns together. There's not too much in the way of actual first-time learner-specific areas and English-speaking lessons are hard to come by. So whilst this resort is great for day two or three in your skiing or snowboarding journey, day one is best spent elsewhere.

Off the slopes

With ten different places to eat on the mountain you certainly won't go hungry. Reasonable prices, a small base area with basic facilities, plus a wide choice of eating options, means there's enough here to service most people's needs for a few days. The village below Suginohara doesn't offer much for tourists, but a short distance away you'll find Akakura Onsen where most visitors tend to base themselves.

Access

Suginohara is about 10mins drive from Myoko town, and 20mins from Akakura Onsen. There is a bus service that visits all the resorts, available at a small cost. Myoko itself is 3hrs drive from Tokyo and accessible on the train through Nagano City.

will discover a few ropes but the in-bound off-piste terrain generally appears to be open, although it's at your own risk. There's no real avalanche potential at Suginohara, but accessing the backcountry from the resort's lifts is a no-no.

Park

Flat rails, kinks, C's, rainbows, big wide butter boxes – there are jib features here to keep every level of freestyle skier or rider amping for a few days. From simple ride-on 1m rails, through to street-style double kinks, Suginohara caters well to this market. In addition to great jib features, Suginohara maintain a series of different sized tables, from 3-15 metres. The jumps are shaped well and nicely spaced giving you lots of time to set up in between hits. The parks are easily accessed from resort's base by taking the gondola up then heading down either of the main trails. Enjoy the smaller features en-route then take

Seki Onsen

Small and dated, but off-piste is actively encouraged.

A tiny resort with lots to offer the adventurous skier or rider! Seki Onsen only has two lifts and one pisted run but the potential for riding trees is massive. It also boasts a couple of half-decent kickers, a few boxes and a very irregular halfpipe to keep you entertained if the powder wears you out. This place feels like it's being run by a few keen locals: when the powder's on, the park is off and vice-versa. This little unknown gem is well worth a quick visit when in Myoko, but is best suited to experienced off-piste seekers.

The lift system here is comprised of one two-man and a hysterical single-chair that looks like it was invented by madmen sometime during the 19th century. The higher of the two lifts isn't always open, but seems to be sporadically bought to life when needed to transport keen (and polite) visitors who wish to access the higher, off-piste terrain. It should be noted that this lift is often un-staffed and is not for the safety conscious. Having said that, the chairs only cruise about six feet above the snow's surface ensuring risk of death by fall is minimal. Overall, Seki Onsen is a fun but tiny resort, and proof that good things can come in small packages. Visit for a day trip Monday to Friday to experience a lift-accessed, powder playground quite unlike any other. But, be warned if snow is thin on the ground don't bother making the trip as you'll be disappointed with the one groomed course and ageing lift system.

Powder

This is one of the few resorts in Japan that actively promotes itself as a Mecca for powder, off-piste and tree riding. However, it's only really worth the visit if it has snowed recently. Those who have battled with Japan's strict rules regarding off-piste will appreciate a resort that encourages

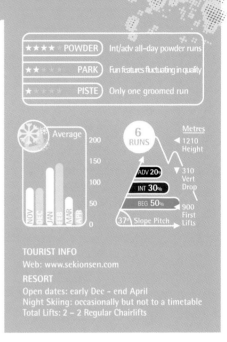

★★★★ **POWDER** Int/adv all-day powder runs

★★ **PARK** Fun features fluctuating in quality

★ **PISTE** Only one groomed run

Average 200
150
100
50
0
NOV DEC JAN FEB MAR APR

6 RUNS

Metres
◄1210 Height
310 Vert Drop
900 First Lifts

ADV 20+
INT 30%
BEG 50%
37° Slope Pitch

TOURIST INFO
Web: www.sekionsen.com
RESORT
Open dates: early Dec – end April
Night Skiing: occasionally but not to a timetable
Total Lifts: 2 – 2 Regular Chairlifts

visitors to venture off the side of the marked runs. That said, DO NOT ski or ride Seki Onsen off-piste without your entire group being equipped with transceivers, shovels, probes and sound avalanche safety knowledge. Although most of the slopes are not exposed and the trees stabilise the terrain, a huge amount of snow falls here and no avalanche control is performed at all. The staff here don't seem to carry transceiver equipment so if you do get caught in a slide you CANNOT rely on them to find you.

However, if you're well equipped Seki Onsen is a gem of a powder resort as the surrounding terrain in simple to navigate and three of the most accessible gullies along the mountain front naturally deposit you back near the lift. No hiking, little traversing and a huge amount of deep powder! From the top of the one-man chair cruise skiers right into the adjacent valleys to catch a few of the many north-facing powder pockets. This aspect gets the least sunlight and catches a huge volume of light pow. Advice aside: head to the

summit, scan the land and go play. The terrain is easy to explore and very accessible, so go eat some snow and have the time of your life.

Park

The slightly lawless and private nature of Seki Onsen is a huge part of its distinct charm. The downside of this untamed charm is that the freestyle facilities on offer are not entirely reliable as the park fluctuates according to the whims of the local crew and how good the powder is that week. At it's freestyling-finest Seki boasts a small pipe, two well-built medium-sized kickers and a few jib features at the base. The best time of season for these features is springtime, as earlier in the winter there is simply too much snow, giving the resort staff a hope-in-hell to excavate the park between the daily snow dumps. It's still worth noting that the park hosts occasional local jib jams for which the rails and kickers are brought up to scratch to produce a fun, varied line.

Piste

Definitely not the spot for piste skiing/riding! Anyone and everyone will get bored of the one groomed run in no time at all. Myoko's other larger resorts are a much better choice for the keen carver or trail cruiser.

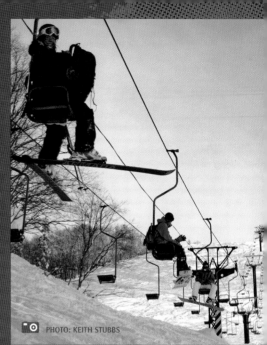

PHOTO: KEITH STUBBS

Beginner suitability

Seki Onsen is not in anyway a resort for beginners. However, if you are in a mixed-ability group and want to visit this resort, beginners can use Myoko Ski Park, an even smaller 'resort' with a simple beginner area, located directly below the Seki Onsen lifts.

Off the slopes

Seki Onsen has very little to offer the non-Japanese speaking tourist. There are a few restaurants and cafés littered around the small village at the base of the resort but most only open on weekends and holidays. There are however a plethora of vending machines for hot coffee and a huge number of local Oonsen, most of whom are very friendly and open to visitors – just make sure you have your language translation book handy.

Access

Seki Onsen is about 20mins drive north from Myoko town, and a little more from Akakura Onsen. There's no public transport accessing this resort so it's 'under your own steam' or not at all. Myoko itself is 3hrs drive from Tokyo and accessible on the train through Nagano City.

PHOTO: STEVE DOWLE

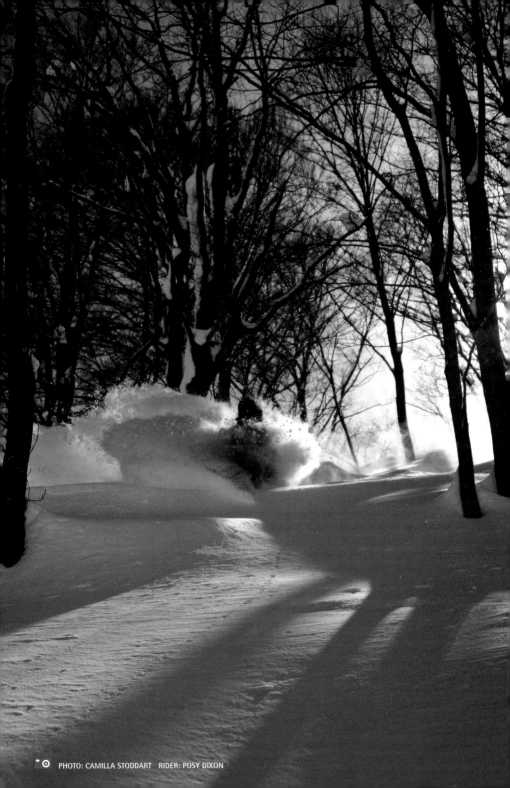

Nozawa Onsen Village

A captivating and culturally-thriving Japanese ski town.

★★★★ ACCESSIBILITY
Lift access right from the town

★★★ EVENING ENTERTAINMENT
Nice bars & plenty of restaurants

★★★★ CULTURE SHOCK
Full of welcoming Japanese charm

TOURIST INFO
Tel: 0269-85-3155
Email: info@nozawakanko.jp
Web: www.nozawaski.com/winter/en

Nozawa Onsen is a village steeped in legend and history and is famed almost as much for its spa water as it is for its turnips. Found in Northern Nagano, Nozawa Onsen is fairly close to Niigata and a short distance from Shiga Kogen. It's easy to get to through Nagano City and should be considered seriously by any international winter tourist looking for a cultural adventure.

Walking around the village gives you the feeling that not much has changed here for a long time, which is a very attractive characteristic for most visitors, and the town is much the better for it. There's cobbled streets, narrow alleys, market stalls and old restaurants with no discernable entrances. If there ever was an old shop that sold Gremlins, it would probably be found here. The village has 13 free public onsens fed by the Ogama Spring, which has been used for centuries to not only clean the local population but to cook much of their food as well. It's worth noting that there are only 2 ATM's in the town that accept foreign cards. One is in the post-office on the main O-yu street – just make sure you get there before it closes. The other is in the JA Bank near the bus station.

Accessibility

Located in Nagano's most northern parts, Nozawa Onsen is best accessed through Nagano City, on the Shinkansen (bullet train) from Tokyo (approximately 1hr 30mins). From Nagano Station board the Nozawa-bound express bus, taking 75mins. Otherwise, if you're driving yourself, take the Joshin'etsu Expressway to Toyota-Liyama I.C. followed by Route 177. The ski resort of Nozawa is super-easy to access from the town. There's a crazy covered access tunnel with airport-like travellators taking you from the centre of town all the way to the chairlifts. It's like something from an old-school James Bond movie, but is very convenient none-the-less. The town also offers a free shuttle bus accessing the other two base areas and stopping at most of the public onsen along the way. Within driving distance from Nozawa Onsen are a few much smaller ski areas, but to get to these you really need your own vehicle. It's probably best just to stick with Nozawa Onsen Ski Resort itself.

Evening entertainment

Nozawa Onsen isn't known for it's nightlife, but it does have a well established bar scene. Walk along the main O-yu Street and you'll see a good few drinking options. The Foot Bar is a good friendly place to start where you can even get a pint of Guinness, and the Stay bar is very close by.

There are plenty of restaurants to choose from in Nozawa, however only a few serve Western food. But why come here if you're looking to play it safe with hamburgers and pizza? This is a town that should attract the culturally adventurous, taste buds included. Take your pick from the many different local restaurants, however Wakagiri is recommended for sushi and is located on one of the side roads off the main O-yu Street near the post office.

NAGANO

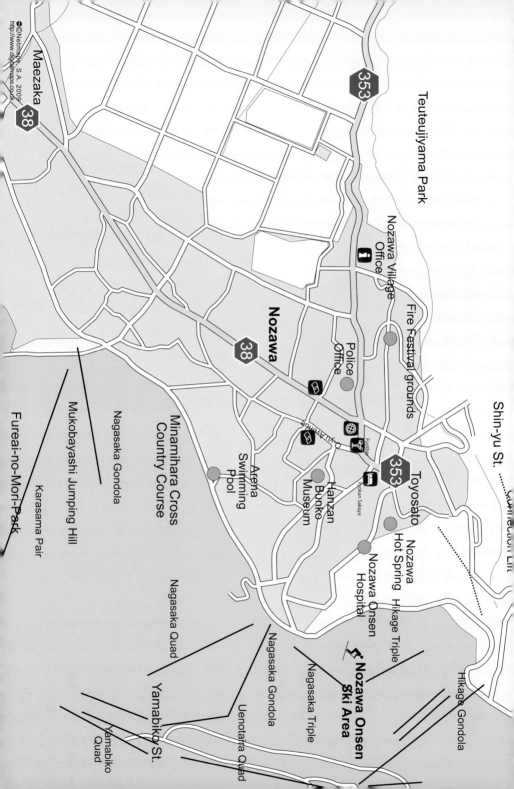

Culture shock

Come to Nozawa to indulge on a true Japanese ski experience. This town is bursting with culture! From the public onsen and visually appealing architecture, to the cobbled streets and locals wandering around in their kimonos. Foreign tourists are at a minimum here, but that's not to say you wont find English information. The tourist office has a wide range of English-language brochures and a few English-speaking staff on hand to help. You're unlikely to come across too many other English-speaking people in the town, but that just adds to its charm.

Accommodation

Much of the accommodation here is traditional. The Ryokan Sakaya is modern yet still very Japanese and is a good option for those with a healthy budget. It indoor and outdoor onsen options, a sauna, and free Internet access in the bar/lobby. For something a little easy on the budget check out Lodge Nagano – a Western-owned business offering very reasonable prices and comfortable holiday living.

Sightseeing and other activities

There are 13 public onsen, which since the Edo period, have been looked after by the Yu-nakama, essentially the villagers. The most ornate of these onsen, the wooden Ô-yu, is dedicated to the Yakushi Sanzon god, and each of the other 12 are dedicated to his heavenly guardians. It's free to enter any of the onsen and they are open very early in the morning until 11pm each evening. A short walk up from the village is the Ogama spring. This isn't the kind of place you want to jump into. For years the locals have been using the natural 90°c water to cook their eggs and vegetables – so it might be best to keep your toes out. The spring serves all the public onsen in the area, although the water is cooled somewhat. Well worth noting is the Nozawa Fire Festival held annually in January. If you can time your visit with this heated escapade you certainly won't be disappointed.

Nozawa Onsen Ski Resort

A well-rounded resort with real charm.

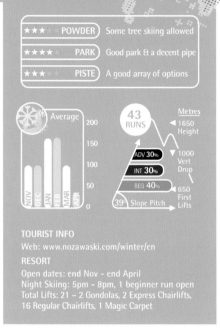

★★★	POWDER	Some tree skiing allowed
★★★★	PARK	Good park & a decent pipe
★★★	PISTE	A good array of options

Skiing at Nozawa goes all the way back to 1912. In fact, the second ever chairlift in Japan was built here! This resort is twinned with St Anton in Austria, which was the hometown of Hannes Schneider, creator of the dreaded snowplough technique amongst others. Hannes taught in Nozawa for a period and has one of the trickier slopes named after him. The mountain has the layout of a huge hairy hand, palm down on the land. Most of the 50kms worth of pistes are cut through the thick birch and beech trees and run along the top of the hand, then down the fingers to the three different base areas. Much of the beginner terrain lies between the fingers and in an area called Uenotaira, which is a wide plateau and plays host the terrain park and halfpipe. Nozawa Onsen town is steeped in history and is one of the most traditional ski towns Japan has to offer. Visitors here can spend their days skiing or riding on a fun, well-rounded resort and their evenings wandering the wonderful cobbled streets exploring old Japanese traditions and Nozawa's quaint architecture.

TOURIST INFO
Web: www.nozawaski.com/winter/en
RESORT
Open dates: end Nov - end April
Night Skiing: 5pm - 8pm, 1 beginner run open
Total Lifts: 21 - 2 Gondolas, 2 Express Chairlifts, 16 Regular Chairlifts, 1 Magic Carpet

Powder

Nozawa gets just as much snow as other Nagano destinations. Whilst a lot of the steeper off-piste terrain is no-go, and much of it is not actually feasible due to the thick trees that adorn the mountainside, Nozawa do offer one tree skiing area up top. On a powder day, head straight up to the top of the mountain to the Yamabiko area. The area under the chairlift is the only official place in the resort where you're allowed to ride in the trees, so make the most of it. As you'll see from the chairlift there's a wide bowl interspersed with birch trees leading into a fun little gully. Away from this area, all the other wooded sections are considered out-of-bounds, so you'll be taking it in your own hands if you venture into this glorious steep, and sometimes very thick, woodlands. It's reputed to offer some great terrain in places and there are few ropes stopping you from entering, but you have

to know where you're going and shouldn't enter if you want to play by the rules.

Park

The resort management here put a sizable budget into building a nice terrain park and even a halfpipe. Overnight and lunchtime maintenance ensures it's always in good condition. It could be considered two different parks with a number of beginner rollers linking them together, turning it into a super-fun 2km-long freestyle bonanza. The park is located on the Uenotaira Plateau and served by a fast 6-person high-speed chair.

From the top of the chair on the Uenotaira trail you'll usually see a series of 8 to 10 rollers. The first park then splits off to the right, however if you continue down the main piste you'll encounter a few more nice, beginner rollers. The upper park off to the right is aimed towards the progressing beginner freestyle skier/rider and typically offers 2 small tabletop kickers and a few rails or boxes. There's also a monster 30m straight rail, separated

NAGANO

from the rest of the features. Veer to the left after the upper park to head towards the halfpipe or stick right and you'll come to the lower park. This is more advanced and often consists of two 5-8m tabletops, and then a series of 3 or 4 fairly mellow rails. The halfpipe is located towards the bottom of the Uenotaira piste on the other side to the lower park and next to the restaurant. Shaped frequently, the crew here keep it in good condition but the left hand wall can get soft quickly on a sunny day, so hit it early.

Piste

The resort has a high wide range of groomed slopes from medium pitch to very steep. It also offers some quality beginner areas, however those who have recently progressed from the beginner slopes will need to raise their game quickly to really enjoy the mountain. Most of the black runs, such as Schneider, Hikage Drop and Kurokura have sections that the resort marks as 'fresh snow areas', meaning they are left un-groomed and quickly develop into mogul fields. A lot of care and attention goes into the piste bashing for the rest of the resort. The Kandahar black runs are used mainly for competitions and are only occasionally open for the public to use; skiers that is, snowboarders will still have to admire from a distance. Skyline, which runs along one of the spines, gets progressively narrower and undulating but is a good adrenaline kick for a while.

Beginner suitability

Beginners have a resort well suited to learning. The base areas such as Hikage, Nagasaka and Karasawa all have good wide beginner slopes with a perfect gradient. When ready, take the gondola heading up to Uenotaira and try the 2km-long beginner run. Despite it being in the same location as the park, the run doesn't get overcrowded and intimidating. There's also an 8km beginner trail all the way back to the village from the top of the Nagasaka gondola.

Off the slopes

The mountain itself has 9 different cafes or restaurants to fuel up. There's a huge variety of prices and something to suit all tastes. Nozawa has no one specific base area. Rather, it has 3 access points where you can purchase tickets and jump on a lift. From the centre of town you take the covered tunnel up to Higage Station, where you'll find most of the typical resort facilities including rentals and lessons, along with a Japanese Ski Museum. Nozawa Onsen the town has much to offer the adventurous tourist and is bubbling with culture.

Access

Nozawa's local train station, Togari Nozawa Onsen, is easily accessed through Nagano City on a 50min local train. The station is just a 10min bus ride from the centre of town. Buses are available from Nagano City and take about 75mins.

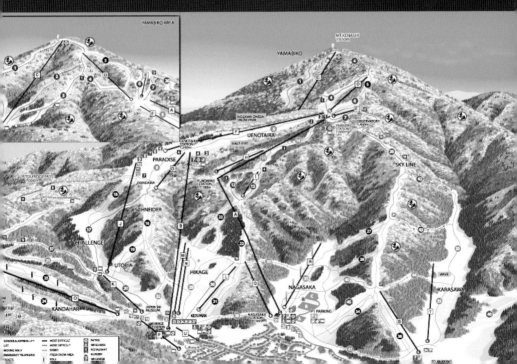

Ryuoo Ski Park

Good for beginners but not much else.

Ryuoo (pronounced "Ruu-O") Ski Park, found in the Kita-Shiga area, has to be one of the most bizarrely laid-out ski resorts on this planet. With a 1,080m vertical drop, 15 chair lifts and a ropeway (cable car), you'd be forgiven for thinking this is a larger resort offering a range of terrain to suit most tastes. Sadly, this it not the case! Ryuoo caters best to beginners and low-intermediates and is a popular local haunt for schools and families. It's predisposed location leaves it with a large flat lower-mountain area and a smaller, also fairly flat, upper-mountain area accessed via the ropeway. In between the two areas is the only steep section with two un-groomed courses and some particularly dense trees.

Lifts have been sporadically placed throughout the resort's lower-half accessing only small sections of runs at a time. The large ropeway stretches the length of the steeper terrain in Ryuoo's mid-section, but accessing the base station means pottering along the flats in between the numerous double chairs. The ropeway deposits you at the foot of the main 4-man chair servicing the upper-half, where there's a one very flat beginner trail and two almost-intermediate runs, plus a few sparse freestyle features. Night skiing is available at Ryuoo on weekends, but it's limited to the lower-mountain area. There are plenty of facilities dotted around the base area, including accommodation providers and eateries, however navigating them can be a challenge for non-Japanese speakers.

Powder

With northwest facing slopes, Ryuoo Ski Park keeps the powder in good shape for days after a dump. However, to enjoy good pow, you need good terrain. As mentioned above, the only section with any pitch to it is found in the mid-section of the resort and is accessed by the ropeway. There are two marked runs, both un-groomed, that wind there way down from the top of the ropeway. On a decent powder day these trails, and the trees next to them, could be worthy of a little action. At any other time they transform into

Average — 200, 150, 100, 50, 0 — NOV DEC JAN FEB MAR APR

14 RUNS

Metres
◄ 1930 Height
ADV 20% — ▼ 430 Vert Drop
INT 60%
BEG 20% — ◄ 1500 First Lifts
39° Slope Pitch

TOURIST INFO
Web: www.ryuoo.com
RESORT
Open dates: mid Dec – early April
Night Skiing: 5pm - 9pm, 3 runs open
Longest run: 2.3km
Total Lifts: 14 – 1 Cable-car, 13 Chairlifts

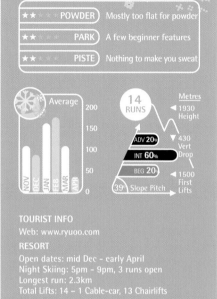

NAGANO

massive poorly spaced bumps and become a challenge for any skier or rider, no matter what level.

Park

Ryuoo does not cater to experienced freestyle skiers or riders. It does however offer some okay beginner features for those venturing into the park for the fist time. There are two areas where this can be done. The first is on the lower-mountain and accessed from chair No.5. Here you'll find a mellow banked-up course followed by a few small jumps. More novice freestyle features can be found on the upper-mountain area, including a few boxes and easy ride-on rails.

Piste

Great trails if you're just linking your first turns, but serious piste skiers and riders will get bored very quickly here. The marked black runs are little more than intermediate trails and there are just too many flat areas to watch out for. If it's good carving terrain you seek, head up to Shiga Kogen instead.

Beginner suitability

First and second timers, have terrain that is very suitable for learning those all-important turning and stopping skills, just watch out for all the other first-time skiers and riders littering the slopes. Whatever you do, DO NOT take the ropeway up and expect to ski or ride down. The lower lifts are much more beginner friendly and there's a ski school that will be more than happy to teach you a thing or two – beware though, English-speaking instructors are not likely to be available.

PHOTO: STEVE DOWLE

Off the slopes

Restaurants for lunch are in abundance as are lodges of varying sorts. Other facilities at Ryuoo include a kids centre, an onsen and a few shops. The nearby town of Yudanaka provides much more for the overseas tourist and is a great place to spend a few cultural-devouring nights. The Snow Monkeys should definitely be appearing your agenda!

Access

Ryuoo Ski Park is about 1hrs drive east of Nagano City on the Joshin'etsu Expressway. You can hire a car in Nagano or take the train to Yudanaka and make the day trip via the Kita-Shiga Kogen shuttle bus, taking approximately 70mins.

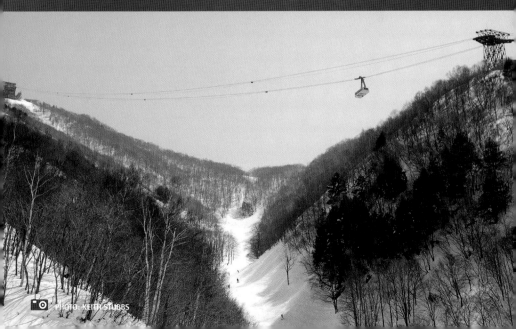
PHOTO: KEITH STUBBS

Snow monkeys

No trip to Nagano should be complete without a visit to Yudanaka's 'Snow Monkeys'. These captivating furry little creatures can melt the coldest of hearts and decrease the most dispassionate of people to forms of baby talk in a matter of minutes.

Playfully entertaining, the 200 plus colony of Japanese Macaques (Japan's indigenous monkeys) spend daylight hours bathing, relaxing and frolicking in the local onsen of Yudanaka and Shibu, not far from the ski resorts of Ryuoo Ski Park and Shiga Kogen. From the latter of these two resorts flows the Yokoyu River all the way through the Jigokudani Yaen Koen (or "Jigokudani Monkey Park") where boiling water bubbles out of slight crevasses in the frozen ground creating the monkey's very own hot springs.

These wonderful creatures migrate to this valley only in winter months when the air temperature is frequently below freezing and the mountains are covered by a thick layer of snow. In the warmer months the monkeys choose to forage in other less-accessible areas of the national park. Apart from the warmth of the hot onsen bath, the main reason that the monkeys visit the valley is food supply. The rangers feed the group a very small and irregular quantity of barley, soy beans or apples, which maintains the health of the group without encouraging dependency.

Steve Dowle's personal reflections

We seemed to have timed things to perfection. The car park was pretty deserted, no big tour buses, and given the amount of promotion they get, you would expect the ticket office to be roof high in plastic replicas and cuddly monkey toys, but it was all incredibly low key which added greatly to the experience.

You get to the bathing pool and the keeper and various signs warn you not to touch the monkeys, but there's nothing telling you what to do when one of them takes a shine to you and jumps on you. I shoot a glance of panic over to the keeper, but he just shrugs and carries on his day.

In no time you are picking out their different personalities. You've got the sensible ones, the jealous ones, the young ones that just play fight with each other until their parents tell them to stop messing around, and the show-off ones who seem strike a pose when there's a camera pointing at them.

After a good few hours a large group of tourists turn up and the magic disappears. My cold heart has been sufficiently warmed; now it's back to business and time to find a resort for a night slide. Incredible.

Access

Getting to the monkey park is done by way of a narrow 2km long footpath through a small forest. There is no way to visit these monkeys without making this walk, which conveniently keeps the masses away.

You're likely to need a 4WD or snow chains if driving yourself here. Take the Joshinentsu Highway to Shinshu Nakano, followed by route 292 towards Shiga Kogen. Look out for the road to Kanbayashi Onsen then, when you arrive, park on the side of the road just below the entrance to the path.

Accessing the park via public transport is tricky. You can take the Nagano Dentetsu train to Yudanaka from Nagano Station. From here it's best to take a taxi on to Kanbayashi Onsen. Some ski resorts may offer day trips to see the Snow Monkeys, but established schedules are rare and should be enquired about prior to your trip, if at all possible.

Shiga Kogen

Japan's largest linked ski resort; it's all about the groomers here!

★★★☆☆ POWDER	Mostly too flat for powder
★★★☆☆ PARK	A reasonable array of features
★★★★★ PISTE	Nothing to make you sweat

104 RUNS

Metres
2305 Height
ADV 15%
851 Vert Drop
INT 35%
BEG 50%
1454 First Lifts
39° Slope Pitch

Found in the Joshinetsu Kogen National Park and easily accessed from Nagano City, Shiga Kogen is a notable destination for the annual family trip or a relaxing ski get-a-way. With over 72 different lifts, including 16 detachable quad chairs, 4 gondolas, and a ropeway (otherwise known as a cable car), Shiga is comparable to resorts in Europe and North America – in terms of size anyway.

But is this really just 'one' resort? Well, it's made up of 21 different 'ski areas', some just with one lift, owned by a number of different companies. Spread over four or five main valleys with access roads funnelling their way through the various under-mountain tunnels, these 21 different areas almost all interconnect, but not quite. With one lift pass covering the whole of Shiga, you can slide your way from one area to the next without ever having to leave the snow, generally speaking. The only exception here is the five areas in the southern-most valley, which are a short bus ride away – free to anyone with a lift ticket.

Shiga Kogen offers a wide variety of terrain, including long mogul runs and motorway-sized pistes, catering to all levels of ability and a few terrain parks too. One of the major drawbacks of this resort is that most of the areas do not allow you to ski or ride off-piste. Furthermore, a few of the areas don't even allow snowboarding – they're still stuck in the 90's at this resort. The many different base areas present almost every amenity you require and most of the ski areas bring out the nightlights for those with enough energy. Shiga's biggest claim to fame is hosting the 1998 Olympic Slalom and Giant Slalom events, as well as the first ever Olympic Snowboard Halfpipe competition, although they seem to have forgotten about the latter, as there's no pipe to be found here these days.

TOURIST INFO
Web: www.shigakogen.gr.jp/english

RESORT
Open dates: early Dec – early May
Night Skiing: 6:30pm – 9pm, each area rotates every night with 2-5 runs open
Longest run: 3.2km
Total Lifts: 70 – 4 Gondolas, 18 Express Chairlifts, 48 Regular Chairlifts

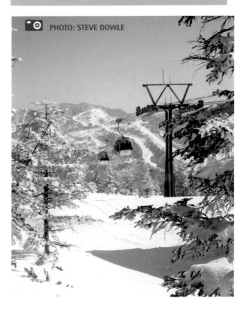

PHOTO: STEVE DOWLE

NAGANO

Powder

Shiga's inland location in the Nagano prefecture means the snow is usually drier than that of Hakuba, resulting in extra light and fluffy pow. Of course, the aforementioned drawback of not being allowed to ride off-piste puts a rather large dampener on things. It's hard to say what the official off-piste rule is, but some areas appear to be more flexible than others. The areas of Shibutoge and Kumanoyu will probably be the most accommodating in your search for freshies, with both spots offering some nice tree-lined terrain, however Kumanoyu is still a ski-only area. Yakebitaiyama, the largest of all the Shiga ski areas, offers some steeper faces and sweet looking gullies, but be careful avalanche control may not be on the agenda and most off-piste sections stay closed.

Park

Although a few of the different areas build and maintain some form of freestyle feature, the only real terrain park is found in the Yakebitaiyama area in the northern-most valley. It's serviced by it's own chair lift (No.43) and offers two different routes down: a beginner's side and an intermediate-advanced side. The beginner's route typically has an array of easy ride-on boxes, smooth rollers and mini-kickers – perfect for your first dabble in the park. The intermediate to advanced side presents a fairly impressive selection of rail/box features including rainbows, c-shapes and kinks. It also offers some nice step-down kickers, flat tabletops and usually a hip or quarterpipe of some sort. There's no halfpipe to be found anywhere in Shiga Kogen for time being.

Piste

If it's groomed courses you seek then Shiga Kogen is your place. The selection of pistes available here is seemingly endless. Every ski area prides itself on their grooming abilities and they sure do keep a high standard. The Yakebitaiyama area offers the largest selection of groomed trails, with a number of black diamond runs advertised as the location for the 1998 Olympic Slalom and Snowboard Giant Slalom events. Surprisingly enough they're called the Olympic Course and the Giant Slalom Course! They're accessible from either of the Yakebitaiyama Gondolas.

If it's cruisey reds and greens you're looking for you will not be disappointed. There are literally hundreds to choose from. Every one of the areas will satisfy your needs here, but the three Ichinose areas are some of the more notable ones all offering wide trails with consistent gradients. Bump skiers are also well catered for at Shiga with numerous mogul runs dotted around the various areas.

Beginner suitability

Beginners are extremely well catered for at Shiga Kogen. Almost all the interlinking areas have good learning slopes and many have their own private ski schools running out of the hotels. The main ski school of Shiga Kogen offers English-speaking instructors

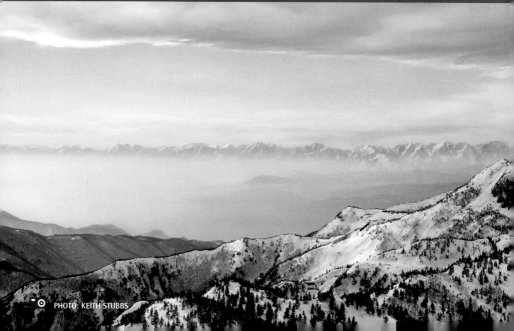

PHOTO: KEITH STUBBS

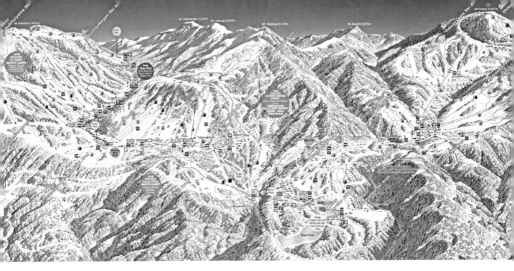

for hire and has different branches from which they operate, with the head school being in the Hasuike area. Those skiers and snowboarders with little experience may find it best to stick to one or two of the many different Shiga ski areas.

The whole resort is so spread out that you could easily find yourself far away from your lodgings at the end of a long day without the energy left to get you home. That said, there's always the local bus service available to deliver you back to your hotel safely.

Off the slopes

Shiga Kogen is so spread out that there isn't any one main servicing town. At the foot of each ski area you'll find clusters of hotels, eateries and other standard resort-like services. The biggest of these clusters is the village known as Ichinose (spoken "Ichty-nosae"). Ichinose is made up of 20-odd hotels each with their own restaurant/bars on the ground floors. There's the typical Karaoke bar, the ethnic Nepalese restaurant serving yummy curries, Hotel Dairoku with it's intimate Izakaya-style restaurant, and Chalet Shiga serving good Western lunches. All in all, there are enough options to vary up your evening meals but this isn't an established ski town comparable to Hakuba and the nightlife is minimal.

Access

Getting to Shiga Kogen is relatively simple. It's about 1hrs drive east of Nagano City, which is best accessed via Shinkansen from Tokyo (approximately 1hr 30mins). You can hire a car in Nagano City and drive straight to Shiga from there. If you don't want the hassle of a rental car, there are numerous shuttle buses that go to the Shiga Kogen region from outside Nagano Station. It's about a 70min journey. Alternatively, head to Yudanaka and catch the snow monkeys; it's a 40min train ride on the Nagano Dentetsu line from Nagano Station. From Yudanaka you will find various shuttle buses making the 20min journey up to Shiga on a regular basis.

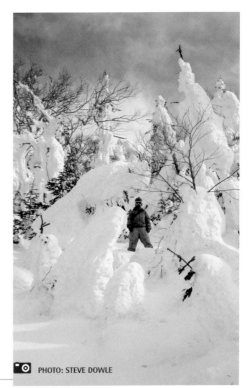

PHOTO: STEVE DOWLE

Yuzawa Town

Popular yet traditional, this is Tokyo's most accessible ski town.

★★★★★ ACCESSIBILITY
An hour from Tokyo by train

★★★ EVENING ENTERTAINMENT
Traditional restaurants & small bars

★★★★ CULTURE SHOCK
Plenty to satisfy the culturally inclined

TOURIST INFO
Kandatsu 300, Yuzawa Town
Tel: +81-25-785-5505
Email: info@e-yuzawa.gr.jp
Web: www.e-yuzawa.gr.jp/english

Yuzawa is a compact traditional town and a completely different world to the hustle and bustle of Tokyo, which serves as the main gateway for most Yuzawa visitors. A ski town with a deep history, this tranquil setting makes a great base for winter tourists looking for a more unique 'Japanese' experience. Walk along the street at night and you'll see plenty of lanterns with Kanji writing adorning the restaurants and shops, little water jets popping up from the cobbled streets to help clear the frequent snowfalls and people sheltering under umbrellas wearing their Kimonos as they head off to the local onsen. Yuzawa is a special little town, providing access to a large number of decent ski resort and giving its visitors a cultural adventure not to be forgotten.

NIIGATA

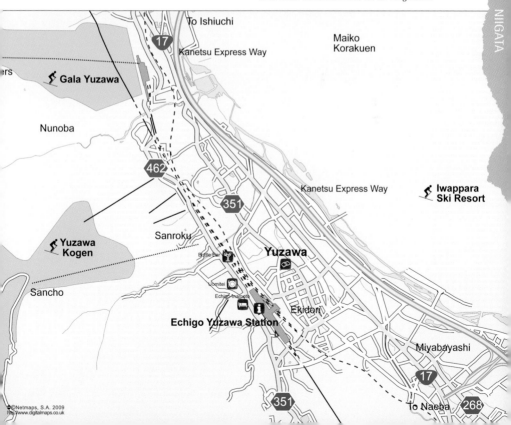

To Ishiuchi

17
Kanetsu Express Way

Maiko
Korakuen

ers

Gala Yuzawa

Nunoba

462

351

Kanetsu Express Way

Iwappara
Ski Resort

Sanroku

Yuzawa
Kogen

Bottle Bar

Yuzawa

Uomitei

Sancho

Echigo Imamoto

Ekidori

Echigo Yuzawa Station

Miyabayashi

17

Sancho

351

To Naeba 268

©Netmaps, S.A. 2009
http://www.digitalmaps.co.uk

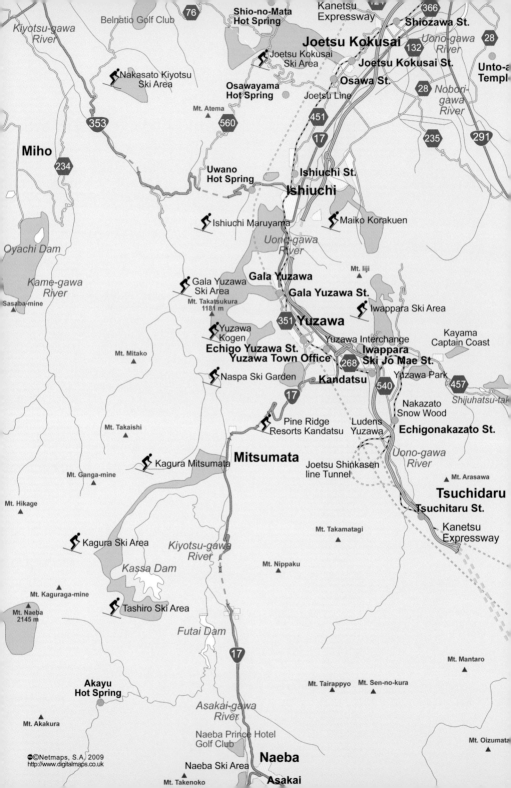

Accessibility

Accessing 16 different ski areas and only a 200km Shinkansen ride away from Tokyo (taking just over an hour), Yuzawa is as good as it gets for convenience. Fly into Narita International Airport, take the Narita Express train to Tokyo Station and catch high-speed comfort ride to Echigo-Yuzawa. It's as easy as that! If you have a vehicle and prefer to drive, Yuzawa is found on the Kanetsu Highway and is a couple of hours drive from Tokyo. But realistically, the train system is so simple and convenient you'd be silly to drive yourself here.

Echigo-Yuzawa station is situated smack bang in the town's centre on one of the main streets. All the facilities you need are within walking distance and shuttle buses make the all-important connections to the resorts. It can be somewhat confusing to work out which bus goes where but ask in your hotel or just get the piste map out and start pointing. You'll figure it out but it may take some time if you're Japanese is limited.

Evening entertainment

Yuzawa is not a major party town like Hakuba or Grand Hirafu in Niseko. It does have a wide choice of bars, restaurants and other entertainments, but you won't find many bouncing 5am night clubs here. If it's culinary cuisine you seek, you'll discover many traditional Japanese eateries along the main high street. Uomitei is an excellent small restaurant that specialises in seafood. Make sure you sit at the bar and watch the chefs in action. The menu is Japanese-only but the staff are incredibly friendly and don't mind if you point and play the usual game of charades. The Kaiseki-Ryori restaurant is a real dining experience serving some amazing ornate dishes but not recommended for the unadventurous. Your late night drinking spot is called The Bottle Bar and it's located downstairs on the main high street - open until 2am most days. Funnily enough, it serves beer from around the world and it even has a pool table. In March, Yuzawa hosts a Snow Festival of sorts with firework displays and a range of other entertainment. Furthermore, a few of Yuzawa's resorts host various music events throughout the season, including the Reggae Snow Splash in Naeba.

Culture shock

The big British and Australian corporations haven't quite reached Yuzawa yet, so it's still very much a Japanese tourist retreat. Whilst this can be a little intimidating for your first trip to J-Land, it does feel like you're in the heart of the country and experiencing the real traditions of this wonderful culture. But don't worry too much, Yuzawa has a well-established tourist information centre with some helpful English-speaking staff ready to help you on your way.

It is worth noting that very few bars and restaurants offer English-speaking services. So on one hand this proves that you're fairly well away from the regular international tourist tracks, but on the other hand, it can make ordering a meal a real challenge – patience is a valuable characteristic here. That said, tour company WeLoveSnow are based here, so be sure to check the restaurant doors for their logo: if you see it then the restaurant will offer menus with professional English translations complete with descriptions explaining what the dishes are – extremely useful.

Accommodation

There are dozens of hotels and ryokans in the Yuzawa area. Most resorts have their own hotels at the base of the lifts and there's a generous amount within the town. If you like to head out in the evenings, look for options within walking distance of the train station. Echigo no oyado Inamoto is an excellent modern ryokan on the upper end of the price spectrum. It's centrally located on the high street and only a few minutes walk from all the necessary amenities. The indoor onsen on the third floor is a great place to watch the sunrise and is open until 11pm every night.

Sightseeing and other activities

It's not just skiing and riding in Yuzawa. The small tourist office in the train station is lined with brochures of all the local tourist spots and goings on. High on the list should be Yuzawa's many beautiful onsen. Komaksu no Yu and the foot-spa Kannakuri are conveniently located just off the main high street, and you can't go wrong by visiting Yama No Yu – a favourite with the locals. If you like a little history there's a few shrines and statues worth checking out, plus there's a small town history museum called Yukiguni-kan that's also worth a visit. It doesn't happen in winter, but it still has to have a mention: the infamous Fuji Rock festival happens in Yuzawa every July; four days in total, with lots of appearances from big international names.

Gala Yuzawa

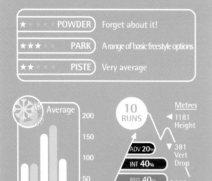

❄ Average — 200

150

100

50

NOV DEC JAN FEB MAR APR — 0

snow-forecast.com

10 RUNS

ADV 20%
INT 40%
BEG 40%

32° Slope Pitch

Metres
◄ 1181 Height
▼ 381 Vert Drop
◄ 800 First Lifts

TOURIST INFO

Web: www.galaresort.jp

RESORT

Open dates: mid Dec - early May
Night Skiing: not available
Longest run: 2.4km
Total Lifts: 9 - 1 Gondola, 3 Express Chairlifts, 5 Regular Chairlifts

Only worthwhile as a quick day trip from Tokyo!

Gala Yuzawa is a well-oiled, convenient money-extracting machine for Tokyoites; who make up around 90% of the visitors here. The resort is owned by the JR-Group (Japan Railway) and it just takes 77mins by train from the main station in Tokyo direct to the resort's own train station, which is a few miles from the town of Yuzawa. You can turn up here with nothing but your wallet, hire absolutely everything, go skiing or snowboarding, take a spa, have a sleep and jump on the train back to Tokyo. Convenience at it's best!

The resort is linked to Ishiuchi and Yuzawa Kogen making it a one of the bigger linked-areas in Japan. However, the link to Yuzawa Kogen is via the Southern Area of Gala has been closed in previous seasons, although the area is still accessible via shuttle bus. To access the slopes you need to take a gondola from the base, called Cowabunga (seriously!), up to 800m where the area starts. The ride up in the gondola can really wet your appetite as you survey some amazing terrain beneath you; designed almost perfectly for freeriding and freeskiing. But something will seem amiss... It slowly dawns on you that there are no tracks anywhere to be seen, and sure enough this is strictly out of bounds. The disappointment continues when you get a visual on the area you can explore. It's a mix of short mostly flat runs and badly placed lifts, ensuring you'll spend a lot of time wondering what would happen if you did drop under the gondola. There is a small terrain park and a halfpipe but it's really beginners and day-trippers who will get the most out of this resort. Intermediate and advanced skiers/riders should head straight to Ishiuchi, offering a much larger area and some excellent parks and pipes.

NIIGATA

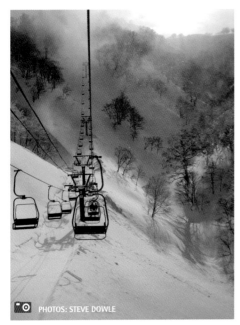

PHOTOS: STEVE DOWLE

Piste

Gala Yuzawa's pistes are consistently well groomed, but rather short. You'll often find yourself skating to get from the top of a lift to the downhill areas, skiers included. The Grenoble run feels like the steepest and is good fun for an intermediate skier or rider in search of some nice corduroy. Starting from the highest point of the resort at 1181m, the top section is good for laying out some nice turns and is also the entry to the Southern Area which has been closed in previous seasons. You will need to tuck-in and go for it on the lower sections to avoid skating across the long flats.

Beginner suitability

Beginners have an area geared very much for learning. There are two main express chairs from the Cheers base that take you up to the main slopes. All routes from here lead you straight back down again. The slopes are impeccably groomed and can easily be tackled by first timers without the need to look at a map. Lessons are available and there are a few English-speaking instructors, so just be sure you ask when you book in case they haven't already guessed.

Powder

Anyone in search of some off-piste will be severely disappointed. The inbound area is compact and there is very little between-the-piste action. The few stashes that do appear are clearly roped off with regular patrols making sure that people obey the rules. At 33° (the Super Swan is the steepest slope in the area and is left un-groomed) it gives a very brief taste of adrenalin but those who enjoy the off-piste will find much better places to ski or ride than here.

Park

Freestyle skiers and riders have a small snow park and a halfpipe both located from the top of the Victoria Chair, providing an easy loop to keep your flow going. The terrain park follows the Swan run; the top flat section of the park usually has a number of boxes, whilst the kickers are found on the steeper section. Here you're likely to find two parallel lines each with a few hits each, depending on the conditions. The advanced line is clearly separated from the beginner line, ensuring that no one will drift across and spoil your approach. The halfpipe if located on the Broadway run and is not geared towards the advanced skier or rider, as is with the resort in general.

Off the slopes

The Gala Yuzawa Cowabunga Base (that's a mouthful) has a number of useful facilities. The train station is in the basement where they'll help out with any additional train tickets you need. The hire shop is found on the next level up, as is the restaurant, gift shops, changing rooms and lockers to store your kit. On the top floor is a day spa available at an additional price.

Access

Gala Yuzawa has its special winter-only train station that is only 1hr from the hustle and bustle of Tokyo. Getting here from Yuzawa town is also simple and is by means of a quick shuttle bus or one stop on the train.

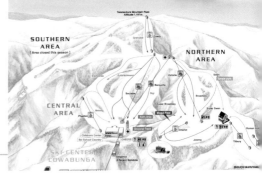

Ishiuchi Maruyama

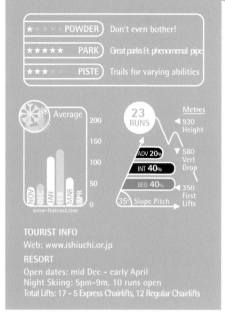

Average — 200, 150, 100, 50, 0
NOV DEC JAN FEB MAR APR
snow-forecast.com

23 RUNS

ADV 20%
INT 40%
BEG 40%
35° Slope Pitch

Metres
930 Height
580 Vert Drop
350 First Lifts

TOURIST INFO
Web: www.ishiuchi.or.jp
RESORT
Open dates: mid Dec – early April
Night Skiing: 5pm-9m, 10 runs open
Total Lifts: 17 – 5 Express Chairlifts, 12 Regular Chairlifts

Acclaimed freestyle features within easy reach of Tokyo.

From the late December to the end of March Ishiuchi offers night skiing on 13 different runs. The three base areas, and the row of bars and restaurants at the bottom of the Kanko No.3 chairlift, look like they have been lifted straight out of a wild-west film set and painted in lurid colours. They do however serve some cheap and tasty food. Around 90% of Ishiuchi's visitors are day-trippers from Tokyo; the service town of Yuzawa being a straight shot on the bullet train from Tokyo Central through to the main train station of Echigo Yuzawa, and the resort being a further 15mins on the free shuttle bus.

Powder

The off-piste opportunities here are very limited indeed. And the Ski Patrol are always quick to make sure that you don't poach the few that do appear. Hang around checking out a possible line and before you know it there will be a tap on your shoulder or a stern look from the patrol, and its back on the piste for you. If you do get caught then your lift pass will be confiscated and you'll be quickly escorted off the mountain. If you're cunning enough and willing to duck under the ropes then there are some opportunities under the Hatsukaisshi Rainbow lift and the Chuo No.3 lift accessible from the Paradise Course. But this just isn't the right resort if you're in search of freshies – try Kandatsu or Kagura for a little more leniency or head over the pass to Tengindaira for some proper pow shred action.

Park

Ishiuchi is an excellent resort for every ability of park rider, from skiers and snowboarders looking for their first airs to those throwing down 900s. The two halfpipes are situated either side of the wide Ginza Course. The intermediate pipe is located directly under the Chuo No.2 chairlift but the Japanese are far too well natured to mock you if you stack it, so rest assured it's a good place to learn how to ride the transitions. At 120m long,

NIIGATA

Ishiuchi (pronounced 'Itchy-Ootchy') is a relatively large resort by Japanese standards and linked to Gala Yuzawa. The resort boasts some nice wide slopes, 4 terrain parks and 2 halfpipes making it one of the best freestyle resorts in Japan. Originally opened in 1952, Ishiuchi is owned by 4 different lift companies, although one pass covers the whole resort. At 350-930m it doesn't reach the elevation of connected Gala Yuzawa and conditions can suffer when compared to other nearby resorts, but you shouldn't forget that this resort still averages over 10m of snow season.

it's a decent length, but walls are relatively small so it's good for ones confidence. The superpipe on the other side of the trail is also 120m in length, but has much higher walls getting up to the 6m mark. Both pipes are maintained impeccably.

There are 4 terrain parks dotted around the resort and each one is well maintained by the hard working park shapers. The main park is served by the Kanko No.4 lift. It features a long rail line with numerous straights, kinks, rainbows and boxes. Parallel to this is 2 jump lines with several 10m tabletops. The second park is located just before the superpipe and features a single line of kickers and a few rails heading around behind the back of the pipe. Not really a park, but there's a pair of kickers (one that's used for big air comps) near the Chuo base area under the Chuo No.1 chairlift. Finally, there's a small beginners park to round things up. This is found on the Summit Course over by the Hatsukaishi entrance.

Piste

The pistes are very well maintained and there are plenty of long wide runs that can be taken at speed. Equally many of the same runs can be ridden slowly if you're in cruise mode and they never seem to get too crowded. The Sancho Course at the top of the resort is perfect for high-end carvers and is the steepest course getting up to 35° in pitch.

Beginner suitability

This is an excellent resort to learn to ski or snowboard at in terms of the terrain on offer. Extremely flat sections or narrow trails aren't an issue for learners to contend with here. All the trails are wide enough not to get intimidated by more advanced passers by. There are some lessons available in English, but be sure to pre-arrange if this is what you require.

Off the slopes

Ishiuchi offers three different base areas to access the resort through: Hatsukaishi, Chuo and Kankou. All offer the standard facilities you'd expect to find including ski rentals, but only Hatsukaichi has a ski school. There's an abundance of on-mountain cafés/restaurants, and even more in the streets below. Everything you need, and reasonable prices too. The local town of Yuzawa offers everything else skiing visitors require.

Access

Ishiuchi Maruyama is only just north of Gala Yuzawa and has its own train station 'Ishiuchi'. Take the train to Echigo Yuzawa Station and then transfer onto Ishiuchi Station, 5mins further. Driving here from Yuzawa town is also very easy and only takes 5-10mins. Alternatively, shuttle buses run here from Yuzawa town as well.

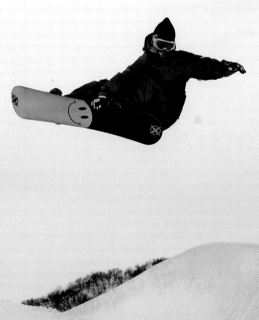

 PHOTO: STEVE DOWLE

Iwaparra Ski Resort

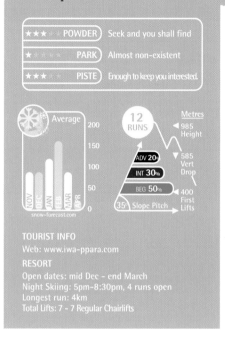

★★★ POWDER Seek and you shall find

★ PARK Almost non-existent

★★★ PISTE Enough to keep you interested.

Average — 200, 150, 100, 50, 0
NOV DEC JAN FEB MAR APR
snow-forecast.com

12 RUNS

ADV 20+
INT 30%
BEG 50%

35° Slope Pitch

Metres
◄985 Height
▼585 Vert Drop
◄400 First Lifts

TOURIST INFO
Web: www.iwa-ppara.com
RESORT
Open dates: mid Dec - end March
Night Skiing: 5pm-8:30pm, 4 runs open
Longest run: 4km
Total Lifts: 7 - 7 Regular Chairlifts

A good family resort

didn't run during the 2008/2009 season. The night skiing offered here is ideal for those utlising the ski-in ski-out accommodation, making the reward of the hotel onsen that much more euphoric. At just 15mins from the centre of Yuzawa, Iwaparra is also very convenient.

Powder

Offering some fun and varied terrain, Iwaparra is on when the snow is good. Note that the rules here are a little vague and whilst there are a number of ropes and fences, it's not completely closed to off-piste skiing and riding. Being south-facing means Iwaparra's powder is best in the morning. A sunny day will bake the snow in no time at all and this mountain doesn't really have steep enough pitches suitable for heavy powder skiing/riding.

After a fresh snowfall zigzag to the obvious top of the mountain via 3 different chairlifts, the last of which is a high-speed detachable quad. Exit left onto run No.8 and pick a short but worthy line in between the groomed switchback through the trees. This is usually untouched and loaded with snow but take note; there may be some temporary fencing and you should obey any closure signs even though ski patrollers are few and far between. Continuing on down, powder can usually be found against the tree-lined piste on either side of this quad chair.

Iwaparra is a mid-sized, well-developed resort that offers something for the entire family. Varied terrain with both on-piste and off-piste options ensures that all skill levels are entertained. The resort has a comprehensive but concentrated lift system, meaning you'll rarely experience any lift queues. There's even a gondola that takes visitors travelling by train from the Iawaparra Ski Jo Mae Station to the very top of the resort, although this

Accessed via one of the twin double chairs, the steep open face on skiers left of run No.13 is prime location to show off your powder skills in front of an audience on the adjacent quad. Make sure you drop in about a hundred meters from the unload platform of the double chair, which is usually where the temporary fences ends. Any higher and you risk finishing your turns in an avalanche terrain trap with a traverse out through deep snow.

NIIGATA

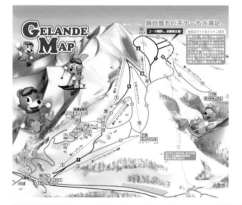

Park

Occasionally some kickers will emerge in the 'terrain park', but don't expect anything too serious – this isn't a park rider's resort. Head to the near by Ischiuchi, or up the valley to Naeba if you want get jibby.

Piste

The full top to bottom is of a decent length, at 585m, but really the only challenging area for upper-intermediates is the first 200 metres from the peak. Exit to the right off the chairlift for the steepest groomed terrain on run No.7 – the only longish black trail on the whole mountain. The middle the resort opens up to give you a great choice of wide runs, accessed by the least crowded chairlifts. Head skiers left towards the far double chair to a little restaurant serving some healthy lunch options, and enjoy the super-wide green trail on the way.

Beginner suitability

Iwappara is a good beginners resort. A well-staffed ski school and Burton Learn-to-ride snowboard school, complete with English-speaking instructors, means this is a great learning destination for both Japanese and foreigners. The wide runs rarely get congested which is great for confidence and improving your skills. Though take care on the more crowded lower slopes that service all the on-snow accommodation (of which there is a lot). If you have kids but want to get some half decent skiing or snowboarding in for yourself then Iwaparra is highly recommended.

Off the slopes

This resort is a popular destination for some for Tokyo's international schools, and for good reason too. Accommodation is plentiful, both right on the slopes and around Yuzawa town. Some of the hotels are more westernised than others, which may suit families better, but there a few cheaper ryokans (and numerous food and beverage establishments) for more of a culture shock if that's what you're after. It is a little hard to find ski rentals and other such facilities here, but that's not to say if can't be found. Just ask hotel staff and they're arrange it for you.

Access

Iwappara is easily accessible from Echigo Yuzawa Station, which is just over an hour by Shinkansen from Tokyo. The hotels offer courtesy shuttles, but there's nothing run by the resort itself. If you're sneaky and arrange ski rentals in advance, some of the rental shops may be kind enough to take you to the resort themselves.

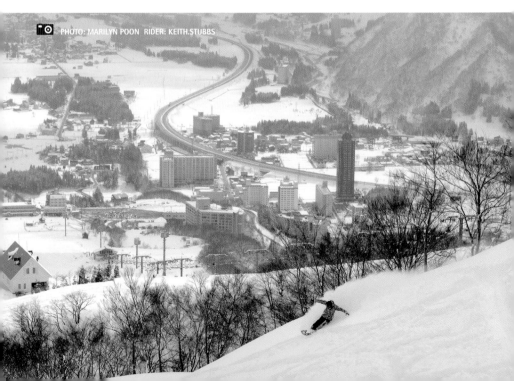

PHOTO: MARILYN POON RIDER: KEITH.STUBBS

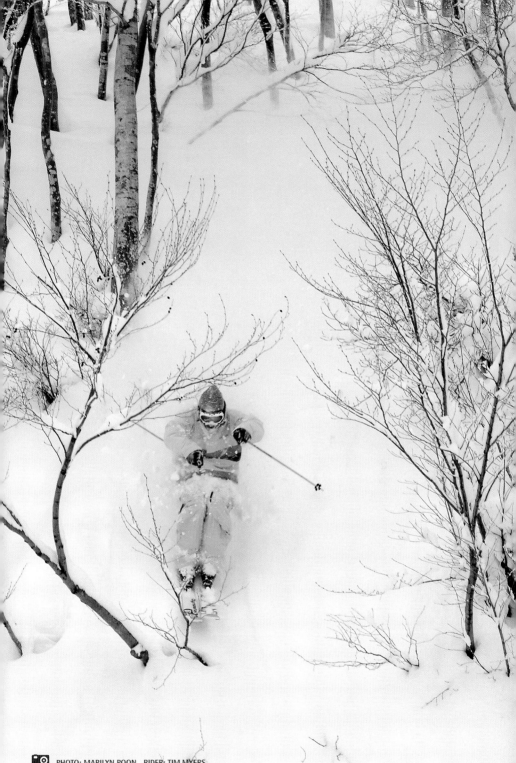

PHOTO: MARILYN POON RIDER: TIM.MYERS

Naeba-Kagura & Asagi

Large linked resort with the goods to suit all levels and interests.

Open from late November to mid-May Naeba, otherwise known as the 'St. Moritz of the East', is one of the most popular resorts in Niigata. A favourable weekend destination for the Tokyo jet-set, Naeba can get crowded, but with over 30 lifts to choose from you're never queuing for that long – although some improvement could be made on the staff's Gondola-herding skills as they rarely fill each cabin. Whilst there are two different geographical areas, Naeba and Kagura, are both available under the one lift pass and are linked together by Japan's longest Gondola, aptly named the 'DraGondola' due to its dragon-like shape. A short 10min walk from the base of Naeba takes you to the Asagai Snowboard Park, also on the Naeba-Kagura lift pass and a must for any park rat.

17 RUNS

Average

ADV 30%
INT 40%
BEG 30%
32° Slope Pitch

Metres
◀ 1789 Height
▼ 889 Vert Drop
◀ 900 First Lifts

TOURIST INFO
Web: www.princehotels.co.jp/ski/naeba-e
RESORT
Open dates: end Nov - early May
Night Skiing: Until 10pm, 4 runs open
Longest run: 9.5km
Total Lifts: 25 – 3 Gondolas, 7 Express Chairlifts, 15 Regular Chairlifts

Overall, this resort does genuinely seem to cater for everyone including families, couples, beginners, intermediates and advanced, perhaps with the exception of big mountain riders/skiers. That said, up top in Naeba you'll find some steeper slopes and purposefully un-groomed 'natural' runs and on the Kagura side there's permitted access to backcountry. Night skiing at Naeba happens most nights between 5pm and 9pm, and until 10pm in holiday periods. The big overhead lights swathe the lower half of the resort in an eerie orange glow, but provide a nice mystical night skiing or riding experience.

Powder

One of Naebas' most attractive qualities is the in-bounds un-groomed terrain. These areas effectively become powder fields within the resort. Marked by the yellow grid areas on the piste map, they're easy to access and offer some tasty treats that you wouldn't usually expect to find within a resort boundary. These sections are popular after any amount of fresh snow, so make sure you're first in the lift line. The

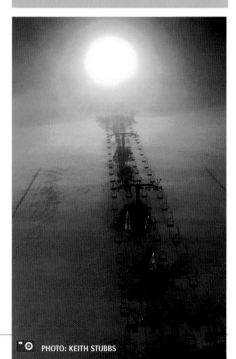

PHOTO: KEITH STUBBS

NIIGATA

upper-mountain area offers more challenging terrain and receives healthy amounts of snow coverage with pockets of fresh seeming to hang around days after a big dump. However, if you only want to ride powder, your best bet is to head to Kagura by taking the Dragondola some 5,481 metres across to the Tashiro area. With a higher altitude, Kagura is well known for good snow and accessible backcountry – which you must assume all responsibility for, so be suitably prepared with the necessary equipment and knowledge.

Park

Naeba has the fun and friendly Malibu Park. Here you'll find some small rollers, an assortment of boxes, medium-sized kickers and a few other jibs. It's location close to the base and the two servicing lifts running alongside, means that you can take quick laps without losing your 'park momentum'. All the features are pretty tame and ideal for easy progression without the risk of serious injury.

The park receives fairly regular maintenance and grooming, but it does get crowded and can be a little cramped. You tend to have to stop and wait for your turn to drop between the features, which can be somewhat frustrating. If you're experienced in the park you'll establish a fairly decent line through the whole thing that resembles something like this: down box, medium tabletop, a wave box or alternative rail feature, a slightly larger table, followed by a flat box and an oil drum, before traversing back across to the lift. To lookers right of the park, is a boarder/skier cross track filled with berms, banks and gap rollers. The track winds down through some trees before popping out worryingly onto the lower half of the park. Pay enough attention at the exit and you can enjoy some fun races with your mates, or the locals if you're the sociable type.

Heavy hitters should head to Asagi, just opposite Naeba. This place is park only! Recognising and fulfilling the need for the ever-increasing freestyle movement the Seibu Group have created a Mecca for park skiers and boarders alike. Asagi doesn't just cater for the pros, although it does that very well with it's massive booters, technical street rails and an international standard halfpipe. There are a number of smaller kickers, boxes and rails there to enable safe learning and progression. The park is very well maintained and the staff are seen regularly grooming

and shaping, keeping the features in tip-top condition. There are 5 runs in total at Asagi, all with nice open spaces between. It's serviced by 3 lifts and, for some reason, doesn't attract the same kind of crowds as Naeba opposite. However, Asagi is not widely publicised so you might have to do a little searching and ask around before you come across it.

Piste

With over 25 runs Naeba is well endowed in the piste department. The trails spread across a large area enabling you take a different path down every time. The pistes are well groomed but predominantly cater for beginners and intermediates, although the runs at the top are slightly more challenging keeping advanced carvers amused for a while. That said, all levels of piste fanatics will have a good time here. Take the 6-person gondola to the top and snake your way down the red run far skiers left. Here you can cruise some 4,000m of trail with high banks either side. You can really pick up bit of speed and crank out some burly turns – but watch out for the crowds and the usual group of learners huddled around the next corner.

Beginner suitability

Naeba is excellent for beginners, with over 60% of the runs suited to this level and just beyond. Plus the hotel is always in sight so you're never far away from home or safety. The lower runs are nice and wide and mellow pitches, but also of a good length so you should spend more time on the snow than sitting on the lifts. Particularly notable are the cordoned off areas for learners to progress without fear of a haphazard out-of-control skier/snowboarder encroaching on their space. Keeping the kids entertained can always be a challenge, but fortunately the WakuWaku Family Snowland, near lift No.4, offers great snow sliding alternatives for smaller children.

Off the slopes

Within the hotel itself is a huge food court offering just about every type of restaurant imaginable, plus a convenience shop for those choosing to eat on the go, rather than enjoying a dining experience. The elusive après ski experience in Japan is alive and well in Naeba. The Naeba Prince Hotel even features an open-air concert venue that attracts everything from pop divas to pro wrestling. If you're looking to party then head to Snodeck which is located at the base of Asagai's Snow Park. With guest DJs on weekends, delicious pizza and a fully stocked bar, Lorne and Kylie, the owners from the UK and Australia, have turned

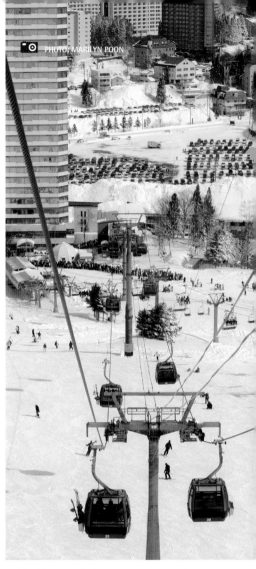

PHOTO: MARILYN POON

this old ramen joint into a warm winter oasis.

Access

Getting to Naeba is fairly simple, although not quite as convenient as the other Yuzawa-based resorts. Driving is the easiest solution, taking Route 17 from Yuzawa. Train is also simple enough, with the Joetsu Shinkansen running direct from Tokyo Station to Echigo Yuzawa, about 80mins. From the West Exit of the station, jump on the Naeba Prince Hotels shuttle bus to Naeba, about 45mins and free for hotel guests.

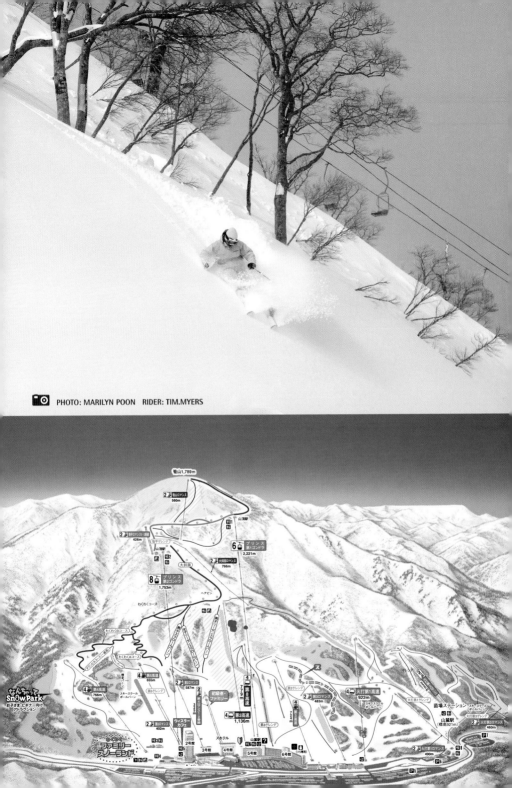

PHOTO: MARILYN POON RIDER: TIM.MYERS

Pine Ridge Resort Kandatsu

Small but fun on a powder day!

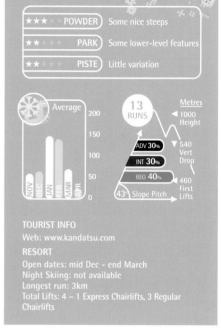

Kandatsu is a small resort a short distance from Yuzawa. It's situated in a bowl surrounded by a thick forest and receives frequent dumps of good quality powder. Three parallel chairlifts make the leisurely pilgrimage up to the main base area, which is a welcome relief from the incessant j-pop that blares out en-route.

From the main area you'll find a long quad chair serving the main beginners slope and providing access to the other three lifts heading up to the good stuff. On the frequent powder days the main beginners run can get extremely slow; the pitch is very slight and you'll struggle to keep your speed. The higher-altitude runs provide some more interesting terrain and will keep upper-level skiers and riders amused for a day or two. There is a park here, presenting some reasonable beginner to intermediate freestyle opportunities.

TOURIST INFO
Web: www.kandatsu.com
RESORT
Open dates: mid Dec - end March
Night Skiing: not available
Longest run: 3km
Total Lifts: 4 – 1 Express Chairlifts, 3 Regular Chairlifts

Powder

Like most Japanese resorts the black runs are left un-groomed and the gradient here makes it worthwhile visiting on one of the hefty powder days that occur. Runs 2 and 3 are the designated powder areas and accessed from the double chair. You're likely to find fresh tracks long into the day but, unfortunately, you still aren't allowed to ride off-piste. The potential to ride the trees is limited anyway due to their thickness and the way the resort is cut out. Furthermore, the eagles-nest patrol towers ensure there's no poaching under the chairlifts. So stick to the marked trails.

Park

Kandatsu's terrain park is situated under the main chairlift. It usually has a reasonable array of rails/boxes and a few kickers, which are aimed towards the beginner/intermediate freestyler and keep in pretty good condition. The pitch of the run-in is pretty shallow, so it's not easy getting enough speed to hit the jumps, and on a powder day it's nigh on impossible. However, even on a pow day, the staff are out there with shovels trying to make the best of it.

Piste

The majority of visitors spend their day on the main slope and never venture further a field.

Despite this, the slope never gets busy enough for crowding to be a problem and the 4-person chairlift is speedy enough to stop major queues forming. Despite its size Kandatsu has some of the steepest black runs in the area, and anyone wanting an adrenalin injection should head to the chairlift near the Galleria restaurant and loop run No.1. All of the intermediate runs are accessed from the same chairlifts, which serve the steepest terrain and frequently criss-cross the black runs as they meander down.

The un-pisted bumpy black runs prevent anyone going too fast at these intersection points, so you don't really have to be too concerned of any possible collisions, and all the runs are nice and wide. At the end of the day you can take the chairlifts back down to the base area, however it's best to give your ears a welcome break and finish with the easy green run which cuts through the forest.

Beginner suitability

The vast majority of visitors here are beginner snowboarders; the main trail is wide and consistent, providing a good environment for learners. Despite this being the only genuine beginner slope Kandatsu, it's a good place to get your first few days under the belt, plus it's a lot quieter than Gala Yuzawa and Ishiuchi.

Off the slopes

The base are here offers some reasonable food and beverage outlets. The Galleria restaurant serves your standard excellent Japanese fare, but on the ground floor you'll find a pizzeria offering excellent pizzas and pitchers of beers.

Access

Pine Ridge is just 10mins by shuttle bus from Echigo-Yuzawa Station and just 2kms from the Kanetsu Expressway.

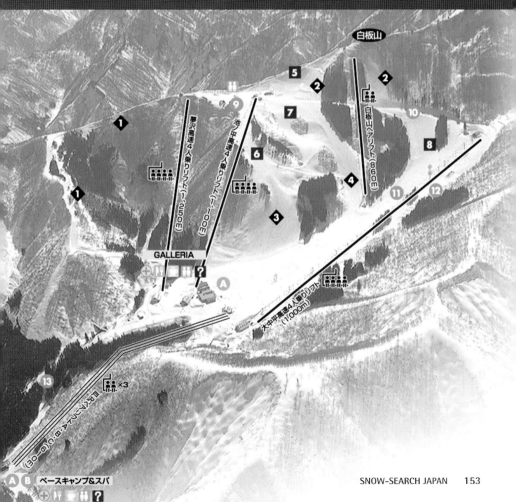

Other Resorts in Chubu

Dynaland & Takasu Snow Park – Gifu

Two mid-sized resorts with almost 1,000m of vertical, linked together via the peaks, offering a range of terrain from beginners through to advanced. Whilst Gifu isn't known for its powder these resorts still get a decent snowfall each year and have snowmaking to back it up. Neither resort allows off-piste skiing or riding, but both offer some un-groomed trails – Dynaland providing the steeper pitches of the two.

Heavens Sonohara Ski – Nagano

This small J-Mountain Group resort is a ski-only area. It caters almost completely to families with young children and could be considered more of a Theme Park than a ski resort. Hello Kitty (the renowned children's character) visits here every weekend to keep the little ones entertained.

Joetsu Kokusai – Niigata

Joetsu Kokusai is a relatively large ski area just north of Yuzawa Town. This is a resort known for maintaining a good park and has been host to the Nippon Freeski Open in the past. With 25 lifts accessing 22 different trails this resort is rather lift-heavy and rarely will all the lifts operate at the same time. The base area only sits at 200m, so this resort is rather low. But with over 800m of vertical, there's enough terrain to spread everyone out and they still get reasonable snow, much the same as the other Yuzawa resorts.

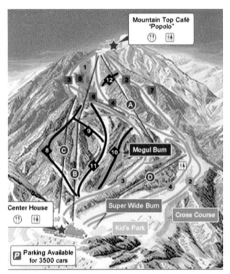

Both areas maintain decent snow parks. Designed by the same guy as the Kawaba terrain park, the Dynaland park has mellower surf-style features, whilst Takasu offer bigger hits and technical jibs. Takasu also keep an international standard superpipe – they've been a stop on the FIS World Cup Superpipe Tour since 2008. Hotel Villa Mansaint is ski-in ski-out accommodation found at the base of Dynaland. It's a 15min drive to the local country town of Takasu where you can find local restaurants and some small intimate bars. There are plans to offer an evening shuttle bus between the resort and town in the future.

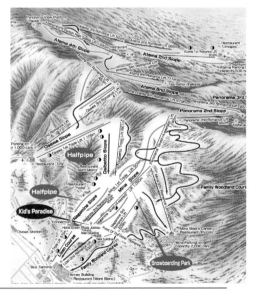

Katsuyama Ski Jam – Fukui

Katsuyama Ski Jam is a city-living day-trippers resort popular with folks from Osaka and Kyoto. It's a reasonable size offering 710 metres of vertical and a decent terrain park. The 12 runs cater mostly to intermediates and are accessed via 9 different chairlifts. Overall, this is good option if you're in West-Japan (i.e. Osaka or Kyoto), but not the place to come on your annual ski holiday.

Norikura Kogen – Nagano

Directly west of Matsumoto City is the compact resort of Norikura Kogen. With 11 lifts, 22 runs and a 500m vertical drop, this shouldn't be considered small, but it's certainly not large either. Generally, the resort caters to the local city dwellers rather than international tourists. Its peak is up at 2,000 metres so the snow is known to stay in good shape and the resort provides some access to backcountry. Norikura Kogen also have a small park and some reasonable beginner runs.

Ontake – Nagano

This is a medium sized resort in the more Southern and Western parts of Nagano, close to Gifu prefecture. It has a high altitude stretching past 2,200 metres and offers a gondola plus 7 chairlifts. The terrain is mostly intermediate and there's little for advanced skiers/riders. Ontake is known to maintain a park of some description.

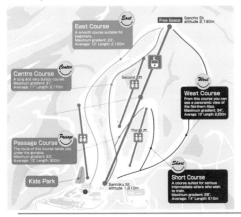

Sugadaira Kogen Ski Area – Nagano

This is a mid-sized well-developed resort close to Gunma and about 1hr east of Nagano City. It only has a 400m vertical drop, but offers 20 lifts over three rolling peaks accessing up to 36 different runs. Out of the three areas (Davos, Omatsu and Minenohara) Davos is the largest and most varied.

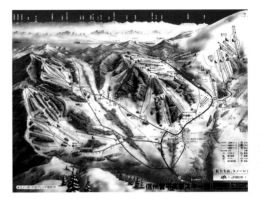

Overall, Sugadaira caters best to beginner and intermediates and does very well at attracting the family market. There's usually a terrain park and some basic night skiing available too.

Takaifuji – Nagano

A small resort in the Kita-Shiga-Kogen area, Takaifuji is very much for locals from the Yudanaka area. Its major selling point is the X-Jam terrain park, offering a selection of jumps rails and even a halfpipe. There are 5 lifts in total here, but the terrain is geared towards beginner and intermediates – all except the park that is.

Washigatake – Gifu

This is a smaller resort, located in the Guso region of Gifu, not far from the larger resorts of Dynaland and Takasu Snow Park. The terrain here is more suited to beginner and intermediate skiers and snowboarders. There is little to keep you occupied off the slopes, so you're best staying in near by Takasu or at the Hotel Villa Mansaint in Dynland. A free 15min shuttle bus is available between these resorts.

Kanto Region

Kanto introduction

The Kanto area comprises the Tokyo metropolis and six other prefectures, including Tochigi and Gunma where Kanto's main ski resorts are found.

With Tokyo being Japan's most prominent international gateway, Kanto offers many tourist attractions, contrasting city-to-mountain scenery and some very accessible skiing and snowboarding.

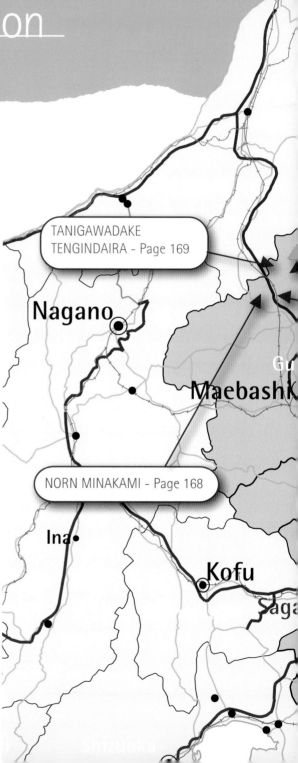

TANIGAWADAKE TENGINDAIRA - Page 169

Nagano

Gu
Maebashi

NORN MINAKAMI - Page 168

Ina

Kofu

Saga

Shizuoka

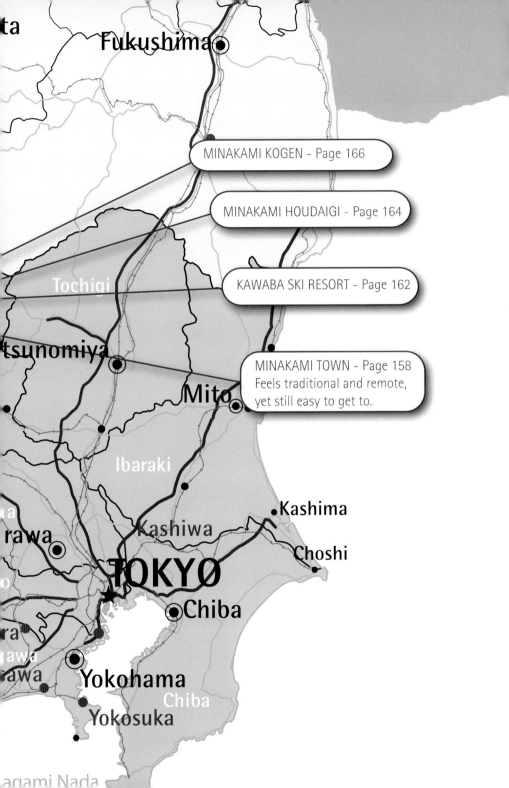

ta

Fukushima

MINAKAMI KOGEN - Page 166

MINAKAMI HOUDAIGI - Page 164

Tochigi

KAWABA SKI RESORT - Page 162

tsunomiya

Mito

MINAKAMI TOWN - Page 158
Feels traditional and remote,
yet still easy to get to.

Ibaraki

Kashima

rawa

Kashiwa

Choshi

TOKYO

Chiba

awa

Yokohama

Chiba

awa

Yokosuka

agami Nada

Minakami Town

Feels traditional and remote, yet still easy to get to.

Close to Tokyo, Minakami is convenient yet still traditional. Located in Northern Gunma and nestled in the Tanigawa Mountain Range, the town is spread throughout a long valley and is well known for its beautiful scenery, as well as its high mountain peaks and adventurous terrain. Compared to the similar nearby ski town of Yuzawa, Minakami isn't quite as simple to access, even though it's geographically closer to Tokyo, however it is generally a little quieter here and is home to some very impressive mountains.

Minakami offers a huge array of summer adventure sports and is famous in Japan for its rafting and canyoning. Minakami-machi is the source of one of Japan's largest rivers, the Tone River, which supplies the whole Tokyo Metropolitan area with fresh water. In winter this quaint little town turns its hand to the ski industry servicing 11 different ski resorts in total; a number of which are very small but there are a few larger ones reaching an altitude of 2,000m. It has facilities suitable for most Western tourists, but is lacking somewhat in the transport department. However, if you have use of a vehicle or are staying somewhere that offers transport as part of the deal, this is no real problem. Minakami is a town that thrives in culture and is more than happy to share this culture with its visitors. It's home to the largest outdoor onsen in Japan, which is just 1 of 17 in the area, and offers lots of traditional off-the-snow pastimes complimenting the vast selection of on-snow options.

★★★★	ACCESSIBILITY
	Easily accessed, yet off the beaten track
★★★	EVENING ENTERTAINMENT
	Periodic music events & cosy restaurants
★★★★	CULTURE SHOCK
	Culture coming out your ears

TOURIST INFO
1744-1 Tsukiyono, Minakami-machi,
Tone-gun, Gunma, 379-1313
Tel: +81-(0)278-62-0401
Web: www.enjoy-minakami.jp/eng

Accessibility

Whilst Minakami is the closest ski town to Tokyo, it's not necessarily the most accessible. It's certainly easy to drive to, but taking the train from Tokyo to Minakami itself requires a change at Jomokogen Station. Having said that, Jomokogen Station is only about 20mins drive down the valley and many accommodation operators offer a complimentary shuttle service to and fro. Visitors travelling without a vehicle should make use of the inexpensive town bus; departing every 45mins or so and visiting all the main tourist spots.

In Minakami's immediate vicinity there's about 5 ski resorts of a worthy size – being more than just a couple of chairlifts that is. Getting to these really depends on which resort you're going to or the accommodation you're staying at. A few resorts like Minakami Kogen offer complimentary shuttles to hotel guests, but this isn't suitable for day-trippers. Getting to most of the local resorts by ways of public transport is rather tricky and hard to find information about, but there are some buses operating. Your best bet is to find accommodation somewhere that provides shuttles direct to the resorts. Either that, or bring a vehicle with you.

Evening entertainment

Generally speaking, Minakami isn't a big party place. The main street in the centre of town has a selection of cosy izakaya restaurants/bars where you can enjoy a few dinks with the locals, but little in the way of crazy nightlife. However, the area of town known as Yuibiso is home to Canyons Adventure Lodge

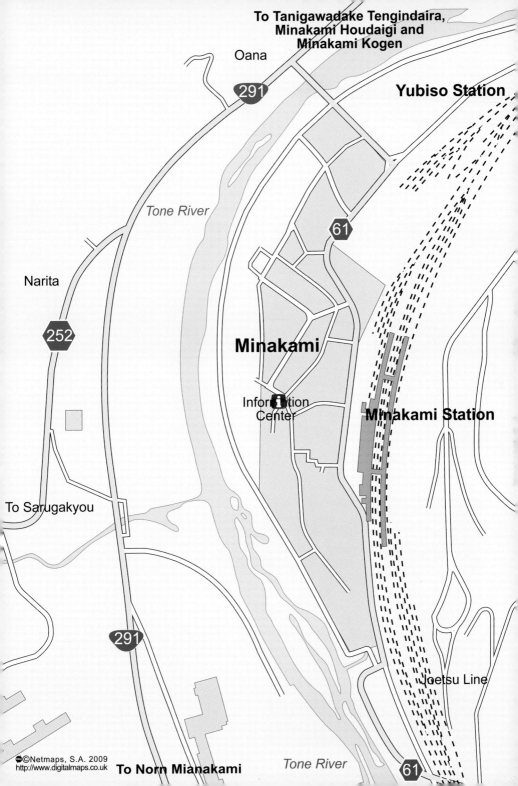

providing some form of live music on a weekly basis throughout the winter months. Owner/Operator Mike Harris throws a number of larger gigs throughout the season, at which time his lodge becomes a buzzing alternative party venue. The Reggae Snow Splash festival visits here every winter, typically in February, and puts on a unique event complete with live percussionists, dub DJ's, Japanese Reggae jam bands, fire dancers, acoustic-rock artists and lots of cheap rum.

If you're not in Minakami for an event though and prefer to indulge in local cuisine, the selection of places to eat will certainly suffice. Head to Labierre for a yummy pizza, or if you're feeling more adventurous try one of the smaller izakayas on the main high street. Daruma has an especially tasty Nikujaga (Japanese Beef Stew).

Culture shock

Minakami is a hive of Japanese culture. You'll come across many old buildings, cobbled streets and interesting shrines as you make your way through the different areas of town. English language isn't particularly evident around the town, however there's a number of English-speaking accommodation owners (like the aforementioned Mike at Canyons) and the tourist office will help in any way they can, although their English skills may be more limited.

Japanese customs are alive and healthy here. The 17 different onsen are utilised regularly by locals and visitors alike, and there's a craft village called Takumi no Sato where tourists can get hands-on experience with traditional Japanese handiworks. All in all, if you're keen to partake in and learn about Japanese culture, but don't want to be out of your depth completely, Minakami is a good choice for you.

Accommodation

Accommodation options in the Minakami area vary dramatically. Firstly, you have to decide if you want to stay in town or at a resort. Most accommodation operators in town provide transport to the resorts, but it's certainly something you should confirm when booking. In the town itself, there are many smaller pensions available at reasonable costs. If your budget is very limited, there's a few minshukus as well, but you'll need to speak some Japanese to make use of these. Alternatively, Canyons lodge has bunkroom options and well-priced doubles – plus they provide great information about the conditions at the local resorts and regular transport too.

There's also a range of decent hotels on the upper-end of the spectrum. Minakami Kogen Ski Resort has a ski-in / ski-out hotel named Minakami Hotel 200. This is a rather plush place with great facilities, a number of restaurants and entertainment options, and is a great option for families with a few dollars to spend. A couple of the lower resorts (Houdaigi or Okutone) also have some ski-in / ski-out options, although they're much smaller.

Sightseeing and other activities

If you need a day off the snow, it's best spent checking out the huge variety of local onsen – onsen-crawl anyone? With such a huge spectrum of choice you won't be disappointed. There are just too many onsens to describe here, however the pick of the bunch has to be Takaragawa Onsen. This is the largest outdoor onsen in Japan (check out the bears on your way in) and has pools of all different temperatures, and they're mixed-gender too, apart from one women-only pool that is.

If you're here in springtime, it's worth checking out the local waterfalls, of which there are 11 in total. Other sightseeing options include the Mask House at Takumi no Sato, for some self-painted souvenirs, and the Tsukiyono Vidro Park, a glass factory where you can try glass blowing and painting yourself. If you're keen for some action you may get the chance to try Yuki Gassen, which is basically paintball on snow without the guns. Ask at Canyons for details on this new, fun snowsport.

PHOTO: MARILYN POON

Kawaba Ski Resort

Nice all-round resort catering best to intermediates.

Kawaba Ski Resort, run by the J-Mountain Group, is located in the Minakami area and is a popular day trip for Tokyoites and others from the Kanto region. Weekends get super-busy here so come on a weekday if you have the option. This is a resort that appeals to intermediate snowboarders and keen bump skiers the most; an unusual combination but one that seems to work well at this mountain.

Set back in a series of undulating peaks, Kawaba is much larger than you first assume. From the base area it's impossible to see the extent of the resort but as you travel up one of the first chairs, ascending over the shoulder of the first peak, you quickly discern the array of options. With a fairly up-to-date lift system, a mix of different trails, various man-made bump runs, two snow parks, some backcountry access and gladed off-piste sections, Kawaba has a decent range of terrain offerings catering for most tastes.

Powder

When there's fresh snow on the horizon Kawaba is a fun choice for intermediate skiers and riders keen on testing their powder skills. However, seeing as most of the aspects are South-facing, the trails get a lot of sun and the snow can get a little baked. There are two designated off-piste areas, with sparsely placed trees – great for those beginning to explore terrain away from the safety of pisted trails. The first, a nice mellow section, is located under the lower section on Chairlift E. The second is accessed from the highest peak on Chairlift D and is only slightly more demanding. Look for the purple shaded areas on the map.

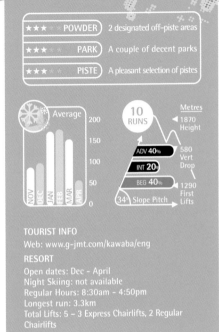

Advanced skiers/riders will be tempted by the steeper tree-lined faces on the upper-section of Chairlift E. There's usually no ropes here and only a couple of signs to keep you out, but this is officially a no-go area. Alternatively, there's some decent backcountry accessible from the top of Chairlift D. If this is what you seek, make sure you visit the 'trekking' desk in the resort's base building and fill out a backcountry form, assuming all your own risks. There are backcountry tours available too, but English-speaking guides might be hard to come by so calling ahead is a necessity.

Park

Kawaba's freestyle facilities are well designed, well maintained and well suited for most levels of park riders – all except the experts. That being said, Kawaba was a stop on the 2009 Step Child Japan Tour so it's certainly got some credibility. The parks here are pioneered by long-time Japanese Pro Snowboarder Ichigo Tanaka.

★★★ ☆ ☆ POWDER — 2 designated off-piste areas
★★★ ☆ ☆ PARK — A couple of decent parks
★★★ ☆ ☆ PISTE — A pleasant selection of pistes

Average — 200 / 150 / 100 / 50 / 0
NOV DEC JAN FEB MAR APR

10 RUNS
Metres
1870 Height
ADV 40% — 580 Vert Drop
INT 20%
BEG 40% — 1290 First Lifts
34° Slope Pitch

TOURIST INFO
Web: www.g-jmt.com/kawaba/eng
RESORT
Open dates: Dec – April
Night Skiing: not available
Regular Hours: 8:30am – 4:50pm
Longest run: 3.3km
Total Lifts: 5 – 3 Express Chairlifts, 2 Regular Chairlifts

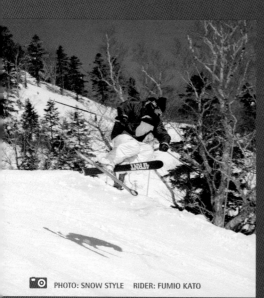

Both accessible from the bottom two chairlifts, these two parks have quite different themes. The upper park, named the 'Surfride Park', is full of flowing hips, banks, rollers and mellow jumps – perfect for a laid back session of slashing and floating. The lower park, called the 'Snowstyle Park' is more focused towards tabletops and jib features and has a nice line of beginner to intermediate ride-on boxes. Rolling through from one to the other is simple and smooth, allowing you to lap both with ease on the same run. It's also worth mentioning the cruisey rollers found on both beginner green trails, No.7 and No.2. If you're just starting to get air, this is a great place to begin. Check out the Freeride Snow School if you're keen for a few pointers.

Piste

You'll find a fair number of groomed runs good for laying out some decent carves here. The intermediate red trails accessible from Chairlift A are ideal to start on, offering wide and consistent pitches. Trail No.9 from the top chair is a little steeper, but nothing worthy of a GS course. Whilst you wouldn't class them as pistes, Chairlift C offers access to some well-sculpted bumps runs, loaded with pre-set freestyle mogul courses.

Beginner suitability

Absolute beginners will struggle a little here. Whilst there are recognised JSBA and SAJ ski and snowboard schools, the terrain isn't very suitable for first time lessons. That said, those with a day or two under their belt will enjoy the long green trails snaking their way down the main valley from the resort's highest peak. For those with the stamina this offers opportunity to really get your turns flowing and your rhythm in-sync. Please call ahead if you require English-speaking instruction.

Off the slopes

The base facility here, known as Kawaba City, is very substantial. It offers almost everything you require, from rentals and lessons through to food, relaxation and shopping (checkout the range of old-school snowboard relics). It's a large building with a multi-story car park built-in. There are three restaurants/ cafés on the mountain in total, one in the base building and the other two further up the resort. All offer a wide selection of food at standard prices. Check out Panorama Restaurant for the view (no surprises there), or Magic Valley for a more intimate eat whilst watching the entertainment from the ensuing snow parks.

Accommodation is available in Kawaba Village just down the road, but it's pricey and fairly limited. If you're here for a few days it's best to base yourself in the nearby town of Minakami.

Access

Kawaba is known as the closest decent resort to Tokyo. At just 1hr and 10mins by Shinkansen to Jomokogen Station, followed by a 20min courtesy shuttle, it's truly accessible for the masses. There are also shuttles from the town of Minakami. Bookings are required for all shuttle buses.

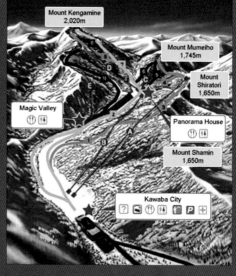

Minakami Houdaigi

Dated facilities, but fun terrain situated in a sheltered valley.

Aging but still functional, Houdaigi is a mid-sized older ski area found a short distance up one of the smaller valleys from Minakami town. From the base area set down in the narrow basin, Houdaigi's chairlifts creep their way up sharp ridgelines on one side of the valley. The chairs themselves, eight in total, are a mix of slow fixed-grip doubles and detachable high-speed quads.

Overall the terrain here is relatively decent. However, due to the no off-piste policy and minimal park, Houdaigi is best suited to those who prefer on-trail skiing and riding. They have a few excellent beginner runs and some reasonable intermediate to advanced groomers, but little for those trying to progress on from the novice level. One of the most notable characteristics of this resort is its sheltered location; when the winds are blowing hard in the Minakami area Houdaigi is definitely the place to come.

Powder

Upon first glance you'll spot some reasonably steep tree-lined terrain at Houdaigi, which on a powder day would present plenty of opportunities for advanced skiers and riders. Sadly this terrain is officially closed,

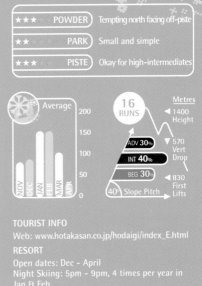

★★★ POWDER — Tempting north facing off-piste
★★ PARK — Small and simple
★★★ PISTE — Okay for high-intermediates

Average — 200, 150, 100, 50, 0
NOV DEC JAN FEB MAR APR

16 RUNS

ADV 30%
INT 40%
BEG 30%
40° Slope Pitch

Metres
◀ 1400 Height
▼ 570 Vert Drop
◀ 830 First Lifts

TOURIST INFO
Web: www.hotakasan.co.jp/hodaigi/index_E.html
RESORT
Open dates: Dec – April
Night Skiing: 5pm – 9pm, 4 times per year in Jan & Feb
Regular Hours: 8:30am – 4:50pm
Longest run: 2.6km
Total Lifts: 8 – 2 Express Chairlifts, 6 Regular Chairlifts

although you're not likely to see many signs telling you so – even if you can read Japanese. There are a few ropes prohibiting access to the more dangerous aspects, but you'll come across plenty of short faces with no fences or otherwise to keep you from entering.

If you visit Houdaigi when there's fresh snow on the ground and prefer to play by the rules, head to the runs numbered 3 and 4. The management keep these trails completely au-natural and their north-facing aspects keep the snow in good condition. If you want something mellower try trail 15, winding through a gully with fun banks to play on.

Park

Houdaigi has a small snow park with a few jumps and a selection of jibs. The park is accessible from a couple of different chairlifts, and is in full view of the base area and the café. There's usually a couple of small to medium tabletops and eight or so rails/boxes,

GUNMA

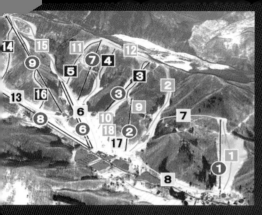

Beginner suitability

Houdaigi provides superb terrain for absolute beginners. The main green trails lay down in the valley bottom and are perfect for those linking their first ever turns. However, if you've got a few days under your belt already there's nothing really suitable to help you take that next step. There is a ski school here but it's fairly small and lessons in English should be arranged in advance. The nearby outdoor centre known as Canyons has a number of native English-speaking instructors available for booking direct and through the resort.

Off the slopes

There are three different cafés at Houdaigi, one in the base building where most people head to for a hot meal at lunchtime, then two others found mid-resort serving similar food but generally utilised for more snack-orientated fuel. Other facilities available at the base include a small rentals and a ski school. Close by, there are a number of pensions providing almost ski-in ski-out accommodation. Alternatively, Minakami town provides a more extensive range of tourist amenities.

including a funky rollercoaster box. The features are maintained well enough and suitable for novice to intermediate freestyle riders.

Piste

The groomed courses at Houdaigi leap from very flat beginner runs to challenging high-intermediate trails; there's nothing here for low-intermediates just getting their legs back. One of the best pistes for carving up a storm with its wide consistent pitch is No.2. Alternatively, No.16, which does occasionally have some un-groomed sections, gets up to 25° offering some much more demanding trench laying action.

Access

Houdaidgi is just a 20min drive from Minakami town and about 40 from Jomokogen Station, which is just 1hr 10mins on the Shinkansen from Tokyo. There is a shuttle bus from the town, visit the Minakami tourist office for scheduling information.

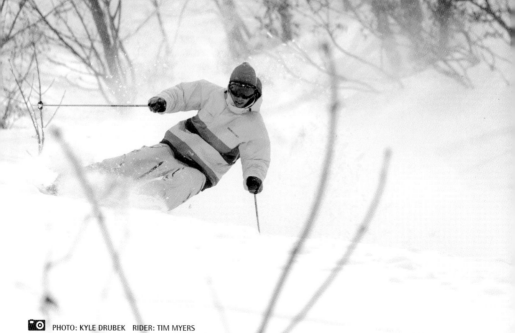

PHOTO: KYLE DRUBEK RIDER: TIM MYERS

Minakami Kogen

Fairly flat family resort with just enough to keep the parents busy

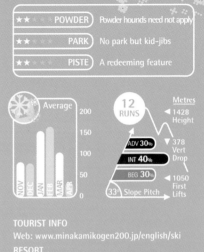

★★ ☆ ☆ ☆ **POWDER** Powder hounds need not apply

★★ ☆ ☆ ☆ **PARK** No park but kid-jibs

★★ ☆ ☆ ☆ **PISTE** A redeeming feature

Average — 200 / 150 / 100 / 50 / 0 — NOV DEC JAN FEB MAR APR

12 RUNS

ADV 30%
INT 40%
BEG 30%
33° Slope Pitch

Metres
◄ 1428 Height
▼ 378 Vert Drop
◄ 1050 First Lifts

TOURIST INFO
Web: www.minakamikogen200.jp/english/ski

RESORT
Open dates: Dec – April
Night Skiing: Not available
Longest run: 3.1km
Total Lifts: 4 – 1 Gondola, 6 Regular Chairlifts
Average Snowbase: 3m

Nestled high above Minakami town, the resort of Minakami Kogen hides behind the tall and rather impressive Minakami Kogen 200 Hotel. Indeed, this may well be the most impressive characteristic you come across at this resort, especially if you're of an intermediate/advanced level. However, the lookout from the resort's top at 1,200m does offer spectacular views of Minakami's numerous lakes and mountains on a clear day.

With only 4 chairlifts and the majority of the runs being exceptionally flat the mountain is by no means vast and certainly not a challenge. It is however very suitable for complete novices and families with young children. The resort's main focus is to develop their family-friendly image, which explains the abundance in amenities. Minakami Kogen can be completely skied/ridden in less than an hour and although very picturesque, rarely will it provide any progression for the advanced among you. That said, Mums and Dads will feel comfortable knowing that the kids are being well looked after on the fantastic kiddy slopes whilst they head off to check out the only two slightly steeper runs.

Powder

Despite Minakami receiving regular snowfalls it's hard to know what to do with it considering how flat most of the terrain is. The only exceptions to the rule are found at the top of the two upper Romance lifts where, if you're lucky, you might be able to squeeze out 3 or 4 powder turns on a fresh snowfall before hitting the familiar plateaus. Off-piste is not allowed, but rarely will you see anything that is incredibly tempting anyway. In between some of the higher runs you'll come across some trees and a few mellow gullies where sneaky lines could be placed amongst the pisted switchbacks.

Park

There is certainly no terrain park or halfpipe at Minakami Kogen, further reiterating its status as a predominantly beginner and family place. You're likely to find some rollers on which to hone your buttery skills or dial-in your 180s, but no jumps and no rails leave you searching for an alternative to get your jib on. Which, rather surprisingly, comes in the form of a kids trail just below the hotel. Here on the Snow Pageant run you'll find a mini boarder/skier cross course and some various animated features to bonk, jib and goof around on. Do watch out for the kids though; anyone taller than 1m looking like they're having too much fun might be escorted away, it is the children's area after all.

Piste

To its credit the pistes at Minikami Kogen are well maintained, nice and wide and adorned either side by huge dense trees – all making for a lovely ambience in which to gently navigate the 12 trails. Of course, you can't pick up much speed, plus there are quite a

GUNMA

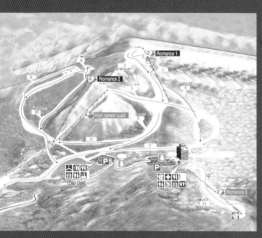

Beginner suitability

This resort is well suited to beginners. The flat long trails make for a completely relaxed environment and are not intimidating in the slightest. With the exception of two runs it's all beginner and intermediate trails here. As one develops their skills, the two slightly steeper runs offer a progressive step up to the next level. The Snow Pageant is especially designed for beginners, serviced by its own double chair.

Off the slopes

This resort is well facilitated with ski hire, a medical centre, and gift shops situated at both car parks and within the hotel. The hotel itself has 2 top-notch restaurants, plus a range of other entertainment facilities. Minakami town offers plenty in the way of sightseeing, but it's a good 30min drive away.

few learners and kids dotted about the place. All in all, this resort might leave the majority of carvers a little frustrated if it's speed you're seeking. Minakami Kogen comes into its own when catering for children, the flat runs and kid-specific trails really help encourage piste awareness and terrain management. Gates to ski through, cheerful bells, colourful signs and swinging balls all make for the unique learning experience.

Access

A few hours drive from Tokyo or a direct Shinkansen to Jomokogen where the resort will pick you up if reserved beforehand and make the 1hr journey up through the mountains. Alternatively, you can take another train to Minakami Station, which is a little closer.

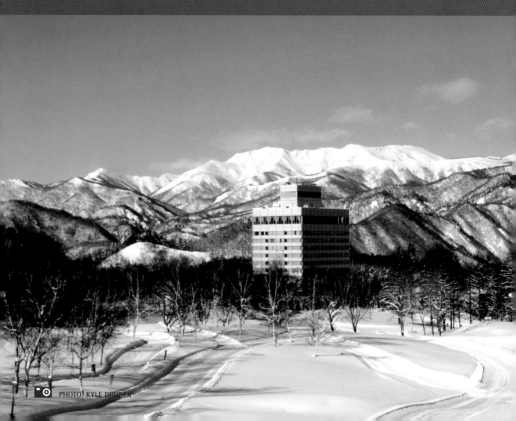

PHOTO KYLE DRUBEK

Norn Minakami

Intermediate night skiing; open late!

This compact locals resort presents a fun night skiing environment best suited to intermediates. With just 4 chairlifts and 5 marked runs Norn Minakami is certainly not a destination resort or one that you can spend multiple days at. It is however fun for an evening session on the snow, plus it's open till 10pm during the week and 12pm on weekends. There's a small selection of trails here, one simple terrain park and a single adequate un-groomed run for those who like more of a challenge.

Powder

As one of the smaller resorts in the Minakami area, there's very little here in the way of off-piste and certainly no backcountry. This isn't the resort to come to if you're searching for powder, although they still get the usual dry Japanese snow. If you do happen to be here when the snow is fresh head straight to the trail marked A for a fairly long black run that is always left un-groomed.

Park

Norn Minakami has a basic snow park with a simple range of beginner freestyle features. This typically includes rollers, banks, small kickers and a few smooth boxes. It's generally kept in good nick and maintained throughout the evening for those in search of twilight action. As this resort is part of the J-Mountain Group, the park is under the 'Snowstyle' branding and plays little cousin to Kawaba's more comprehensive terrain park.

Piste

The groomed runs here are fairly wide and of a consistent pitch. Whilst there's nothing at all that will keep advanced carvers happy, the trails will entertain intermediates for a day. Best head to Kawaba if you want longer runs or steeper slopes.

Beginner suitability

First timers will find Norn Minakami a challenge. The main beginner run is a little too steep for learning to make your first turns, however if you've been on snow for a few days already you'll probably enjoy this resort.

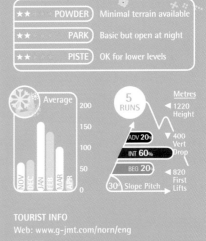

★★	POWDER	Minimal terrain available
★★	PARK	Basic but open at night
★★	PISTE	OK for lower levels

Average — 200, 150, 100, 50, 0
NOV DEC JAN FEB MAR APR

5 RUNS
◄ 1220 Height
ADV 20% ▼ 400 Vert Drop
INT 60%
BEG 20 ◄ 820 First Lifts
30° Slope Pitch
Metres

TOURIST INFO
Web: www.g-jmt.com/norn/eng
RESORT
Open dates: Dec – March
Night Skiing: 4:30pm – 10pm, 2 runs open
Longest run: 2km
Total Lifts: 4 – 2 Express Chairlifts, 2 Regular Chairlifts

Off the slopes

The relaxed base building offers all the basics and a simple café/restaurant. You can rent skis or book a lesson, although English-speaking instructors are not so likely. Minakami town is a short drive away and has all the usual ski town amenities.

Access

Norn Minakami is just 10mins drive from the Interchange on the main highway towards Tokyo. It's easy to access by car, but shuttle buses run only occasionally.

PHOTO: J-MOUNTAIN

GUNMA

Tanigawadake Tengindaira

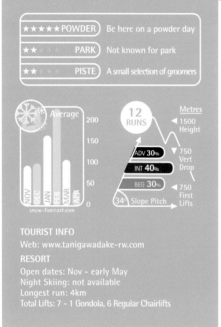

★★★★★ POWDER — Be here on a powder day
★★ PARK — Not known for park
★★ PISTE — A small selection of groomers

Average 200
12 RUNS
150
ADV 30%
100
INT 40%
50
BEG 30%
0
34° Slope Pitch
snow-forecast.com

Metres
◄ 1500 Height
▼ 750 Vert Drop
◄ 750 First Lifts

TOURIST INFO
Web: www.tanigawadake-rw.com

RESORT
Open dates: Nov - early May
Night Skiing: not available
Longest run: 4km
Total Lifts: 7 - 1 Gondola, 6 Regular Chairlifts

Come for a good time, not a long time.

Powder

"Tengin", as it's referred to more commonly, ranks in Japan's top 3 ski resorts for average annual snowfalls. Combine this with some quality backcountry and you have an ideal powder skiing and snowboarding destination. At the top of the ropeway, at 1,319 meters, are 4 double chairlifts accessing the main bowl and the majority of the inbound terrain. The longest of these chairlifts only climes a further 168 meters of vertical but the fast turn around easily makes up for this. At the top of this chair you'll find yourself with a healthy choice of easterly facing terrain, steep enough to not concern you with losing your speed in the deep snow that eventuates after a storm. On a clear powder day, follow the locals here first before the sun affects the snow's quality too much. Although in the earlier and colder months of winter the snow retains its quality well into the afternoon.

From the top of the chairlift on skier's left of the bowl, advanced powder riders can seek out technical lines through the trees and some steeper chutes, heading back towards the chairlift or continuing all the way down to the bottom of the ropeway – the latter gives you a much larger vertical drop and allows for a much longer ride. A similar length ride can be achieved from the ridgeline far skier's right in the upper bowl. Ski Patrol are known to close the resort's lower area frequently due to avalanche danger, which is often the case, although not always. If you're going to stick with the upper bowl area, it's easy plan your lines from any of the chairlifts as the terrain here is very open and easy to scope. Hence you'll be hearing plenty of "yeows" from the chairlift above as you claim or flail your way down.

The immediate 15-person cable car journey (or ropeway as per the Japanese name) will have your face pressed up against the windows as you ascend the 573 meters through a gorgeous valley dotted with immaculate tree skiing and powder laden ridges. There's one particular face that is likely to draw your attention, but may require a change of pants if ridden – and yes, you can ride it, although it's hiking access only and prone to some serious avalanches. Overall, this place is a local's resort, but that's not to say it's unfriendly. What it does mean is that mostly only locals ride here; so there are rarely any lift lines and usually fresh tracks to be had for days after a dump.

Tanigawadake Tengindaira is actually busier in the summer months than in winter. The impressive cable car, replaced just a few years back, is used as an access way for hikers, climbers and troops of sightseeing tourists all-year-round, although much less in winter. There are some impressive views to be had up to and out from the peak of Tanigawadake, one of Japan's highest.

GUNMA

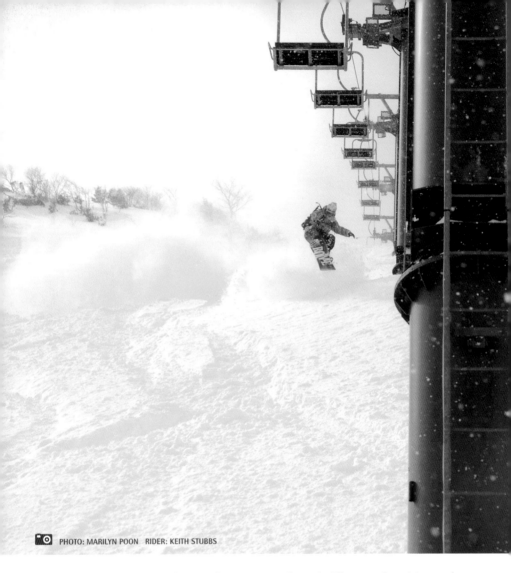

This open terrain and the minimal surrounding shelter does mean you're exposed to any harsh weather that rolls through and the wind affected snow resulting from it. Advanced skiers may find themselves tiring of the inbounds offerings after a few days. With that in mind, you can sign a waiver at the base area, assuming complete responsibility for yourself and allowing you to explore, well, wherever you like. This permits all backcountry routes including a monstrous easterly face that you will no doubt jeer at with your mates from the safety of a cable car cabin. If you do decide to take on the hike to get there, it is strongly advised that you do it late in the season when the snowpack is more stable. If you're a novice backcountry goer or prefer to indulge upon the knowledge of the experts (a wise decision), take an English-speaking guide from Canyons, in the Yubiso area of Minakami town, for the full backcountry experience. The Tanigawadake area is considered to be serious mountain country by Japanese standards, so be prepared.

Park

The terrain park here receives more attention towards the end of the season when the rate of snowfall settles down. Even then, it usually only consists of a few basic kickers and the odd rail or box. This isn't the place to come to for park, but if you're into building your own features there are some great kickers spots to utilise. In fact, there's a bit of secret stash nearby that's perfectly suited for this and frequently driven to in springtime by many a local shredder. Can't tell you where it is though – you'll have to befriend a local to find out.

Piste

The groomed runs of this resort would quickly bore anyone other than a beginner or low intermediate. Of the few groomed runs available, none are particularly long or exciting but there are a few wider trails suitable for novices to progress on.

Beginner suitability

Beginners with a day or two under their belts already will enjoy the dedicated green runs accessed by the shortest double chair. However, this isn't really the place to learn to ski or snowboard, as the lack of an official ski school with English-speaking instructors is most evident.

Off the slopes

The two resort complexes, at the bottom and top of the ropeway, offer a few simple eateries with some tasty Japanese dishes. The panoramic views of the valley below and mountains on the horizon make for a scenic lunch up top. There's a ski and snowboard hire service at the top of the ropeway, which is convenient since you don't have to struggle with your rental equipment inside the cable car.

The local town of Minakami provides all the off-mountain facilities tourists require. If you're near Minakami towards the end of the winter, the friendly fellas at Canyons host a wide range of adrenalin-filled past times including rafting, caving and hiking – all activities that will open your eyes to this unique environment.

Access

Tanigawadake is a 75min Shinkansen ride from Tokyo to Jomokogen Station and then about 30mins by rode to the resort itself. There's no shuttle service operating here, so you either need your own vehicle or you've got to base yourself at a hotel/lodge that offers transport.

 PHOTO: MARILYN POON

An interview with Mike Harris: Adventure lodge Owner/ Operator with a sideline in music event organising

Hi Mike. Thanks for taking the time to sit down with us. So firstly, can you tell us a little about yourself, your background and what you do here in Japan?

"I'm originally from Dunedin, a coastal town in Southern New Zealand famous for Speights Beer, rugby and crazy student antics. I own and operate an outdoor adventure and guiding company, Canyons Ltd. Guiding is a passion of mine, I love to give people unique and challenging experiences.

I also organize music events, the most well known of which is the Minakami Full Moon Party. I'm currently the Head of the Safety Advisory Team for Commercial Rafting and the Chairperson of the Minakami Canyoning Association. I also spend a lot of time talking with the City Council about tourism planning (I'm doing a Masters Degree in Tourism by correspondence at the moment)."

Wow, you've certainly got your hands full. How long have you been running Canyons for now Mike and can you give us a quick run-down on what you offer there?

"I set Canyons up in 2000. We offer Outdoor Adventures in the form of canyoning, rafting, caving, snowshoeing, backcountry skiing and snowboarding, ski and snowboard instruction, and work with a

number of other Outdoor Centres around Japan. We also do Rescue and Training work and provide Outdoor Education services, often through the Canyons Adventure Centre in Minakami; which is inclusive of lodge, café/bar and even a club/movie theatre downstairs – had to slip that in."

What did you do before you came to Japan?

"I studied Japanese at high school and continued at university, which included a four-month work exchange in Japan. After graduating in 1994 I came back to Japan and settled in Hakuba. So I polished most of my guiding skills right here in Japan."

So what was it like setting up a business in a culture so different to back home?

"Challenging. There are many cultural differences when doing business here, which take a while to adjust to. The Do's of business in Japan:

* Get introduced. The old saying, "It's not what you know it's who you know" could not be more truthful for Japan. An introduction to a business from a good friend or relative of the business goes a long way.

* Learn Japanese etiquette and some simple language – the Japanese are very polite. A few simple greetings go a long way.

* Build relationships. The Japanese like to build a relationship of trust over time. It is important to use various formal and non-formal meetings to build such relationships.

* Be patient. Decisions can sometimes take a long time to be reached because of collective decision-making. Patience is a virtue."

What's been the biggest challenge for you or your business in Japan so far?

"The outdoor adventure industry in Japan is still very young, as such there are a lot of grey areas when it comes to licensing. There are also issues with official's attitudes towards adventure sports. In this respect, one of the biggest challenges has been gaining acceptance for the adventure sport industry. There is still a long way to go but things are definitely getting better."

Tell us more about Minakami and the mountains here, why is this area so special?

"Minakami has a very reliable snowfall (Tenjindaiara is always in the top 3 in Japan) and a wide variety of options. There are some great areas for families and beginners, as well as plenty of terrain for the extreme crew. Also, hidden in the mountain valleys are also some of the best hot springs in Japan."

How about one sentence describing why someone should come and visit Canyons for a backcountry expedition?

"Our backcountry experiences are customised to each group's level for maximum satisfaction."

Finally, can you give us a few short phrases that best describe Japan in your mind?

"Surprisingly unknown, world class adventures. Warm and friendly people. Rich in history and culture."

Thanks Mike, good talking to you.

For more information visit their website - www.canyons.jp

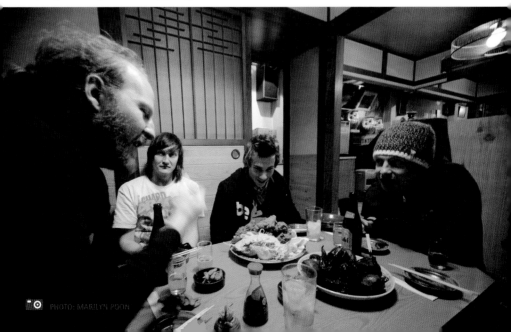

PHOTO: MARILYN POON

Other Resorts in Kanto

Hotaka Bokujo – Gunma

A smaller resort in the Katashina area of Gunma, this is a resort that focuses on freestyle. With just 380m of vert and 11 trails, this is not a resort for freeriders looking for pow. However, it does have a good park called the 'Nigoudaira Boarders Paradise' park, which offers a wide range of jumps and rails, plus a reasonable halfpipe. Check it out if you're in the area and are looking for a dose of terrain park action.

Hunter Mountain Shiobara – Tochigi

This is a small to medium sized resort with a reasonably high elevation (top lift being over 1,600m) in the Tochigi prefecture. The 9 different lifts, including 1 gondola, accesses 12 trails and 500m of vertical drop. Despite its altitude, this is a rather flat resort that caters best to beginner and intermediates, as well as families. It does have an okay terrain park and even offers a small halfpipe at certain times in the season. Hunter Mountain is best visited as a day trip from Tokyo, utilising the good value transport and ticket packages deals.

Kusatsu Kokusai – Gunma

Located just over the border from Nagano prefecture and on the backside of the Shiga Kogen mountain range, Kusatsu Kokusai is a mid-sized resort with a high elevation reaching over 2,000m – high for a Japanese resort anyway. In total, Kusatsu Kokusai has 12 chairlifts and 1 gondola. Within its 926m of vertical drop, the resort offers a range of terrain to suit varying levels over the 10 different trails, with the steepest getting up to 33°. The resort does offer backcountry access and heli-skiing during the months of February and March, plus it has a small park too.

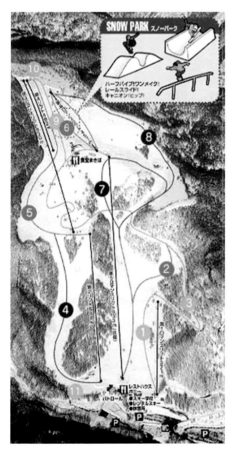

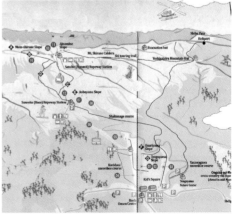

Marunuma Kogen – Gunma

A quiet resort found in East Gunma, Marunuma Kogen is a small to medium in size with a long season sometimes stretching into May. With 610m of vert reaching the 2,000m mark, 13 lifts and 13 different marked trails, there's certainly options for most levels, bar steep and deep powder seekers. Having said that, most of the resort is northerly facing so any fresh snow that falls keeps it's consistency for longer. Being a little further away from Minakami, it's not easily accessed by rail and best driven to by car.

Mt Jeans Ski Resort – Tochigi

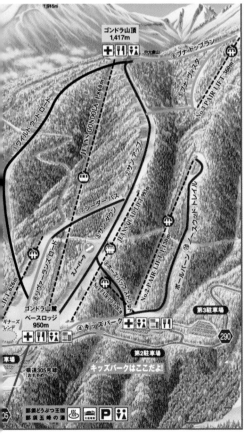

The only other reasonably sized resort in Tochigi prefecture, Mt Jeans is further north of Hunter Mountain and found in the Nasu area, close to Fukushima prefecture. This resort has 7 lifts servicing 10 different trails and 500m of vertical, and is best suited to intermediates.

Minakami Okutone – Gunma

This is a fairly small and simple resort very close to Minakami town. With just a few older-style double chairs and one single this is not one of Minakami's major resorts, but does offer good night skiing sometimes running as late as midnight. Okutone has 533m of vertical drop and mainly caters for local intermediate skiers and riders. It also has a small terrain park.

White World Oze Iwakura – Gunma

Offering 18 trails, 14 lifts and 697m vertical drop this is one of the larger resorts in the Kitashina area of Gunma and caters well to all types of snow goers, except maybe full-time park rats. It does offer a small terrain park and has most of the standard facilities available at Japanese resorts. The resort has a relaxed approach to off-piste and offers some okay steeps. Oze Iwakura is best accessed by car.

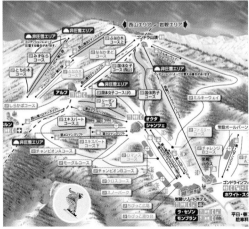

Tohoku Region

Tohoku introduction

The Tohoku region is the area that makes up the Northern part of Japan's Honshu Island. It consists of six fairly small prefectures and extends from Fukushima up to Aomori.

Generally, this is one of Japan's more rural areas with stunning scenery but harsh weather conditions. Tohoku is home to a number of large reputable Japanese resorts including Zao and ALTS Bandai.

URABANDAI NEKOMA - Page 193

LISTEL SKI FANTASIA - Page 190

SNOW PARADISE INAWASHIRO - Page 191

INAWASHIRO TOWN- Page 178
A small and simple town, with historical areas and decent ski resorts.

Aika

Otani
Wajima
Takojima
Noto Uchiura
Monzen
Ukawa
Tsurugiji Kashima
Kata

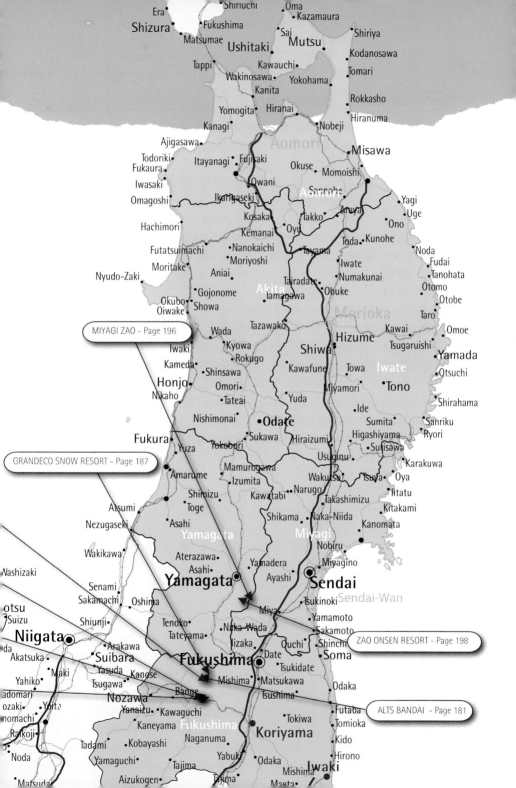

MIYAGI ZAO - Page 196

GRANDECO SNOW RESORT - Page 187

ZAO ONSEN RESORT - Page 198

ALTS BANDAI - Page 181

Inawashiro Town

A small and simple town, with historical areas and decent ski resorts.

The town of Inawashiro is found in the Fukushima prefecture and services a number of mid-sized, lesser-known Japanese ski resorts. Named after the lake it sits above, Inawashiro isn't a major tourist destination itself, but more of a through point for those visiting the likes of ALTS Bandai, Snow Paradise Inawahiro and Grandeco Snow Resort. However, this was the still base for the 2009 FIS Freestyle Skiing World Championships, so it does have some international pull, although that was probably the resorts more than the town.

As a small farming town, this is still not a place you'd base yourself for a weeklong holiday. It is however a good option for an evening when staying at one of the resort hotels, or passing through the region on a road trip. It's mellow yet friendly and has a reasonable selection of amenities.

Accessibility

Inawashiro town is about 4hrs drive almost directly north of Tokyo. Access to the town is possible by both road and rail, and is simple enough if you don't have a vehicle. Take the Shinkansen to Koriyama (about 1hr 20mins) then transfer on the Banetsu-sai Line to Inawashiro Station (a further 45mins or so). The station is almost in the centre town so it's easy enough to get to the accommodation. With that in

★★★ **ACCESSIBILITY**
Simple enough

★★ **EVENING ENTERTAINMENT**
A little too quiet

★★★★ **CULTURE SHOCK**
Rich in history

TOURIST INFO
100 Shirominami, Inawashiro-Town
Tel: (0242) 62-2111
E-mail: inawashiro@town.inawashiro.fukushima.jp
Web: www.town.inawashiro.fukushima.jp

mind however, most tourists stay in a hotel at the base of one of the resorts. Typically, the hotels run regular shuttle services from Inawashiro Station and the town to their accommodation. Information on this can be hard to find, so it's easiest to book with a hotel that speaks English and let them arrange your pick-ups and drop-offs. Grandeco, ALTS Bandai and Urabandai Nekoma all offer shuttle services direct from Koriyama Station making the transfer from Tokyo much, much easier.

The resorts here work quite well together to provide transport between them, giving options to ski or ride different terrain – again, something usually setup through the hotels. It's worth noting that most of these hotels don't offer evening shuttle services. So if you're out of town staying in a resort hotel, it's going to be taxi rides for those colourful evening adventures. There are options to stay in town instead, but then transport to resorts can be awkward. Overall, if you don't have your own transport it's best to utilise the hotels affiliated directly with resorts when visiting the Inawashiro area.

Evening entertainment

A sleepy little town this is; resort party town it isn't. Whilst some of the local ski resorts attract

PHOTO: KEITH STUBBS

FUKUSHIMA

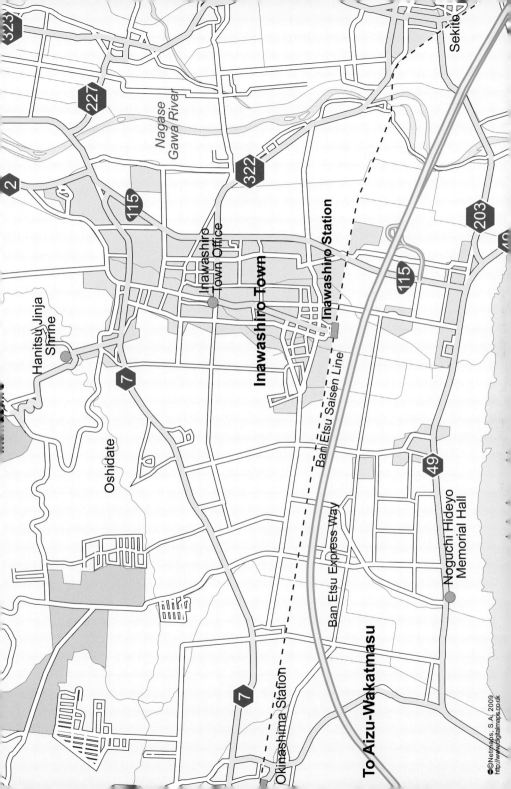

the younger crowds, for some reason or another, Inawahiro town doesn't. It seems that most people actually stay in the resort hotels and few venture down to town in the evenings. Most of the ski package holidays that foreigners take offer vouchers that can be used in the local town restaurants, so why not try some of the local cuisine? There are a number of small izakaya restaurants here and the odd pub/bar, so it could be worth a night out. 'Go' is recommended for its tasty local sake, and its Pork Cutlets with Banana – an intriguing combination that is guaranteed to get the taste buds rolling.

Culture shock

Inawashiro hasn't been targeted by the international ski holiday market just yet. As a result, it's still very Japanese and has little foreign influence. Whilst this is certainly appealing for some, it does mean that English guidance is rare. You'll come across the occasional hotel receptionist who speaks English, but few others. Menus are almost completely in Japanese, as are brochures and signage. So if you like being throw in the deep end, or have some Japanese language up your sleeve, this may be the right choice for you.

The town is comprised of many old buildings so you get a good feeling of Japanese architecture, but there's not too much in the way of 'cultural-experience' activities. There is a local folk-craft shop on the high street where can try the art of Japanese basket weaving. If you really want to explore Japanese tradition, head to the near by town of Aizuwakamatsu: a place steeped in Japanese history.

Accommodation

As already discussed, most international tourists stay in the resort hotels, or those affiliated with. The closest option to town is Hotel Listel at the base of the tiny ski area Listel Ski Fantasia. This is a well-priced five star hotel that offers great all-inclusive package deals. Other resort hotels include the Bandaisan in ALTS Bandai and the Hotel Gran Deco, at Grandeco Snow Resort. In town there are some cheaper options in the form of pensions and minshukus, but you'll need to speak Japanese if you're looking to stay in one these places.

Sight seeing and other activities

Close by is the historical town of Aizuwakamatsu; well worth a day trip from Inawashiro or any of the ski resorts around here. This larger town was the staging point for a famous Japanese battle between the traditional Samurai government and the Westernised government. It has many historical castles and shrines that make for an interesting afternoon off the snow.

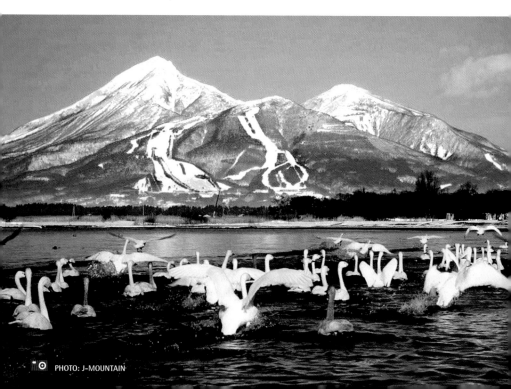

PHOTO: J-MOUNTAIN

ALTS Bandai

FUKUSHIMA

★★ POWDER Stick to the trails
★★★★★ PARK A five-park fiesta
★★★★ PISTE Personified piste

Average 200 | 29 RUNS | Metres ◀ 1280 Height
150
ADV 25% | 100 | ▼ 580 Vert Drop
INT 40% | 50
BEG 35% | ◀ 700 First Lifts
NOV DEC JAN FEB MAR APR | 0 | 37° Slope Pitch
snow-forecast.com

TOURIST INFO
Web: www.alts.jp

RESORT
Open dates: Dec–April
Night Skiing: 5pm - 9pm, 2 runs open
Longest run: 3km
Total Lifts: 12 - 1 Gondola, 3 Express Chairlifts,
8 Regular Chairlifts

Parks for all levels, international pipe and great family facilities.

Asian Open), framing the famous moments in ALTS Bandai's competition history.

Powder

With a fairly short season (late December to mid-March) and a south-facing aspect (meaning it gets the direct sun) alongside the small vertical drop of just 580m, means ALTS is not great for deep snow and shouldn't be considered as a suitable resort for powder seekers. The management here don't want you off-piste (check the cameras!), so instead, enjoy their abundant parks and super-fun pistes, of which there are plenty. Should a heavy dump hit, there's a couple of marked 'powder' areas which they leave un-groomed, and the lower pistes make for some cruisey mellow lines and fun pow slashes on the banks.

There have been whispers that the resort will connect somehow with the neighbouring resort of Nekoma, now owned by the same company. Nekoma's colder temperatures and steeper terrain afford more powder opportunities following a big snowfall. If these two resorts do manage to connect they will become a very appealing ski/snowboard destination for all types of snow goers. In the mean time, if you're staying in ALTS and want some more challenging freeriding it's best to drive round to Nekoma or visit Grandeco.

Park

ALTS Bandai have laid their intentions very clear with the 5 assorted snow parks scattered over the mountainside. Park 9 Street, accessed from the Quad 4, is a long flowing trail with small bumps and sunken boxes, perfect for beginners and super-fun for higher levels too. This run can get busy, which slightly mars the idea and charm of merging the park within the piste – a novel concept none-the-less. The 'Burton Stash' it isn't but it does flow nicely at a reasonable pace and

Billed as a freestylers haven but also targeting families, ALTS Bandai caters well to both markets with their 29 marked trails, 12 lifts and 5 different snow parks. Located in the Fukushima prefecture, ALTS is easily accessed through Tokyo or Sendai and remains a popular destination for many Japanese and even a few foreigners. The slopes (and hotel foyers) can get pretty cluttered at the weekends as the scores of families and legions of trick-thirsty snowboarders descend upon this resort.

The mountain itself has play written over it, especially if you're an advanced rider or skier who likes to jib. The 'Riders' lodge, found halfway up the mountain to lookers right of the resort, is a chilled place to hang out after a good park session. You can even have a skate on the lodge's mini-ramp, complete with spare decks to ride and even sneakers to wear when you get your boots off, although you're likely to draw a crowd of onlookers from the pool table and fast food counter. Lining the lodge walls is a complete history of Nippon Open posters (now called the

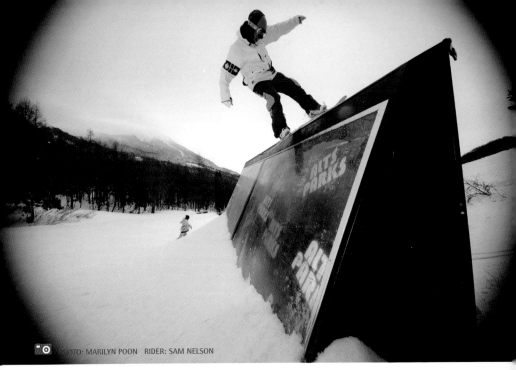

allows park novices to progress quickly on safe features. Park 9 Street takes you from 1,700m all the way to the base, where you'll find the Stadium Park and Night Park. Here is a single 4m-ish kicker and often an eager bunch of people making the short hike to the top to session it. This fun jump is groomed every afternoon and then floodlit until 9pm, making for a fun evening session.

As the night falls you can either ride the Red 8 until late or take up residence in the Global Park, which remains available to the public after the Asian Open has been in town. The Global Park has been a worthy host for the Open series over the years and has entertained a number of top names in the snowboarding. Alongside the two 18m kickers is one of Japan's best and most famous superpipes, standing at 6m high and freely available to the public before and after the big event. This is not a learner's park by any means.

The Black Diamond Park, accessed by the No.7 Quad lift has an impressive array of features. Once you've made your way down the surprisingly bumpy park entrance, caused by an endless stream of side slippers, you're greeted with an obvious line of two 5-6m kickers one after the other,

followed by a right handed hip leading into a 3m wall-ride. Once you've caught your breath you're then confronted with a series of jib options. Two different lines made up of flat boxes, up-downs, down-flat-downs, single bars and kinks will definitely please those inclined. The rails and boxes are well set, groomed and maintained regularly. Running parallel to this is the beginners Entry Park with some safe small jumps and smooth easy ride-on flat boxes. All the parks at ALTS are fun and serviced well by short and speedy lifts. The parks seem to be a feature of the pistes rather than just snow parks on their own – certainly a nice touch. ALTS Bandai is, for the foreseeable future, continuing its aim of facilitating freestyle progression and providing parks for all levels. It's certainly the strongest feature of this resort.

Piste

ALTS provide great pistes, 29 of them in fact. Rather encouragingly, the runs here cater for some advanced users as well as having enough mellow slopes for beginners and intermediates. The runs get progressively steeper and more challenging the higher you go. The cluster of red and blacks (only accessible if you are actually capable enough to reach them) will satisfy many of the best when they're open. These areas don't receive grooming but are marked in-bound runs, so typically end up with bumps.

The abundance of spaced out, nicely groomed, fairly flat and very long greens dominate the lower half of ALTS. Novices will flourish here. As well as varying gently in pitch, these trails are wide and don't offer any unexpected surprises. However, they can get pretty slow and congested at busy times. An incredibly mellow gondola takes you up to far lookers right of the resort. If you haven't mastered chairlifts but are fairly competent on the snow, the gondola provides the easiest way up for a long mix of green and red all the way to the base area. All in all, ALTS Bandai covers most abilities in the piste department with the exception of downhill racers.

Beginner suitability

Perfect for beginners and with an added bonus: ALTS Snow Academy has English-speaking instructors for whatever ability level you ski or ride at and if you think that your skill level has not improved after the lesson, they will refund your money. There's a statement if there ever was one!

There are plenty of wide and gentle green runs to enjoy, as well as 'priority-to-beginner' specific slopes. Plus the Snow Escalator or the Gondola provides easy access for those not comfortable with chair lifts yet. ALTS also have Asia's first Burton Progression Park (the Entry Park) specially developed for beginners and novices in the freestyle department. Furthermore, they have the Wave Course, known as 'Wataro-Zei', which

is a great run for improving your turns and training your sense of balance.

Off the slopes

It is a bit of a domestic tourist trap here, but it hasn't committed any horrendous acts just yet, although the Jamaican-themed food village is something to gawk at. There isn't anything resembling a town here, just two large hotels at the bottom of a mountain. These two hotels do cater well for different budgets and are both comfortable offering good levels of service. Between the Resort Centre and the hotels there's the usual offering of restaurants, launderettes, a rental shop, free shower facilities, a swimming pool, and a mish-mashed convenience store selling just about everything. Be prepared and bring everything you need with you or a decent budget, as it can be pretty expensive.

Access

Accessing ALTS from Tokyo or Sendai is best done through the Tohoku Shinkansen, 90mins to Koriyama from Tokyo Central Station. At Koriyama you can reserve a free shuttle taking you the 80min journey up to the resort – reserve before hand if possible. Inawashiro, on the Banetsu Saisen line, is the nearest station to ALTS Bandai, only about 20mins away but requiring a train change if travelling from Tokyo. Shuttle buses are also available from here.

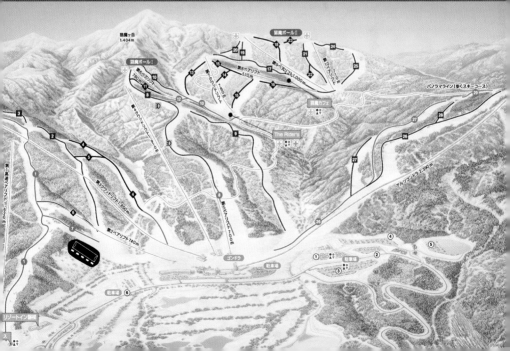

The Asian Open Snowboarding Championships

The Asian Open, held at ALTS Bandai in February each year, is the largest Asian snowboarding competition making up part of the Burton Global Open Series of competitions. Originating in Oze-Tokura 15 years ago, the Nippon open moved to Happo-one, Ishiuchi Maruyama, then to ALTS Bandai where it has remained for the last 5 years.

Previously known as The Nippon Open, this prestigious event has brought competitive snowboarding into the ever-expanding Asian market. 2009 brought with it a change in name; the first ever Asian Open was born.

"Since 1994, the Nippon Open has had a tremendous influence on the competitive snowboard scene in Japan, bringing a world-class competition to Japanese professional and amateur riders, whilst attracting top international snowboarders to the region," says Liam Griffin, Events Director at Burton Snowboards. "With competitive snowboarding gaining momentum in China and Korea, we felt it was time to expand the Nippon Open into the Asian Open Snowboarding Championships, attracting more riders from growing snowboarding communities throughout Asia."

The Asian Open is part of the Burton Global Open Series. This series spans five countries including New Zealand, Canada, Switzerland, Japan and USA and is open to all snowboarders, whether amateur or professional. The Asian Open is also 5-Star event on the Swatch TTR World Snowboard Tour, the second highest Star level on the Tour. At the end of the season, the top male and female tour champion each win what is currently the largest single payout in competitive snowboarding, which in 2008/9 was USD$100,000

For more information visit www.ttrworldtour.com

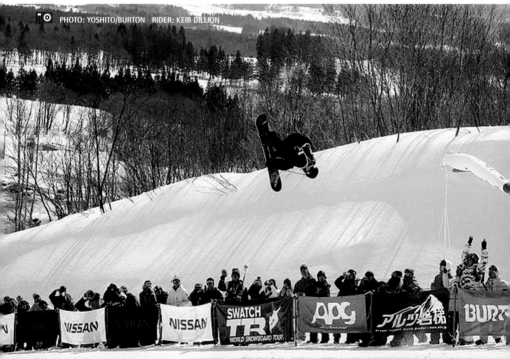

PHOTO: YOSHITO/BURTON RIDER: KEIR DILLION

A first-hand account from Vicci Miller: two-time Asian Open competitor and one of the Snow-search Japan reviewing team

Back when one of the first generations of snowboarders, including the likes of Terje, Sebu Kluberg, Satu Jarvelaa and Shannon Dunn, came to Japan, they were met with fields of powder pillows and many a friendly local. The years following 1994 showed the international competitive snowboard scene finally arriving in Japan. 15 years later and I'm competing in a competition that's changed so dramatically, yet has still maintained its grass roots atmosphere.

As you enter the main ALTS Bandai hotel complex, riders from around the world are greeting with old friends or making new ones. Here, so many different cultures integrate through the love of a sport, leaving language barriers in the dust and making this competition one of my favourite on the TTR Circuit.

For domestic riders it's a chance to ride the best-shaped park in Japan, all thanks to the hard work of Yuji Yamada, the Terrain Park Director at ALTS, and his crew. For international riders it's an opportunity to experience an event unlike any other on the circuit. The 'parkstyle' competition has broken away from the 3 modules to include more hips, kickers and technical rails. Mirani Kusanko describes it well as; "A big competition for the Japanese riders who do not get to ride such large jumps in their local parks. For the locals it is a chance to ride with international riders and make new friends."

This year marks the first Asian Open leading the way for Japanese rippers like Ryo Aono and Soko Yamaoka to follow in the footsteps of their predecessors. Overall this event shows, on so many different levels, that behind the competition we are all just a bunch of kids brought together for the love of snow.

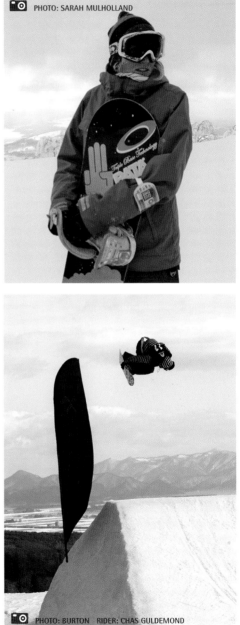

PHOTO: SARAH MULHOLLAND

PHOTO: BURTON RIDER: MIKKEL BANG

PHOTO: BURTON RIDER: CHAS GULDEMOND

We caught up with some of the worlds leading snowboaders to get their thoughts on Japan

"What is different or special about competing in Japan?"

Jamie - Japan is one of my favourite places in the world to travel to. The Asian Open is an awesome event and of course, the filming and powder is insane!

Chas - The respect for snowboarding here brings more fans out and gets guys like myself really fired up to put on a good show. It's sick!

Silvia – It's the most enthusiastic snowboard country in this world! Japanese people are just so passionate about snowboarding and watching snowboarding. Even though I only got 3rd this year, the people made me feel like a rockstar. I love Japan.

> JAMIE ANDERSON, WAS THE 07/08 SWATCH TTR TOUR CHAMPION AND SHE CAME 2ND IN THE SLOPESTYLE EVENT AT 2009 ASIAN OPEN
>
> CHAS GULDEMOND WAS THE WORLD NO. 2 IN 2008/09, WINNER BGOS SERIES, WINNER 6STAR BURTON US OPEN, WINNER 5STAR ASIAN OPEN HALFPIPE AND SLOPESTYLE
>
> SILVIA MITTERMUELLER WAS THE WORLD NO. 6 IN 2008/09, WINNER 5STAR BURTON CANADIAN OPEN 2009, 3RD AT 5STAR ASIAN OPEN 2009

"Have you managed to visit any other resorts while you've been in Japan?"

Chas – Not yet, but I'd love to and plan to in the future.

Jamie - I have been to quite a few resorts in Hokkaido.

Silvia - I have been to Niseko in Hokkaido; it was the best powder of my life. I have also just been at a lot of indoor places on the main island, it was crazy!!

"Do you have any top-tips for people wanting to visit Japan?"

Silvia - I would recommend tracking down that amazing powder on Hokkaido, it really is a once in a lifetime experience. And don't forget to sing some karaoke, that's for sure a must-do.

Chas - Bring your snowboard, keep an open mind, and don't be scared to try the food.

Jamie - definitely go! It is an amazing country and one of my favourites for sure!

"What do you think of the standard of snowboarding in Japan, both in terms of competing and normal riders?"

Jamie - there are some amazing riders from japan! Kazu (Kazuhiro Kokubo) is one of my favourite male riders.

Chas - Seeing people snowboarding in Japan you can tell they are there for one reason only: to have a good time...buttering around and laughing with friends. As far as competitive riders from Japan, the kids are super focused on their goals and they are at the contest to do well. I respect that.

Silvia - Japanese people are not scared. I have seen a lot of crazy tricks in Japan, and I love how they take the crashes and always get up right away with a smile and try again, no matter if they are professional or just riding for fun.

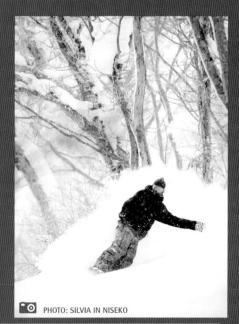

PHOTO: SILVIA IN NISEKO

Grandeco Snow Resort

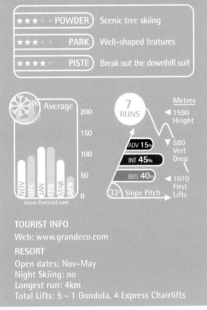

★★★ **POWDER** Scenic tree skiing

★★★ **PARK** Well-shaped features

★★★★ **PISTE** Break out the downhill suit

❄ Average

200
150
100
50
0

NOV DEC JAN FEB MAR APR

snow-forecast.com

7 RUNS

ADV 15%
INT 45%
BEG 40%

33° Slope Pitch

Metres
◄ 1590 Height
▼ 580 Vert Drop
◄ 1010 First Lifts

TOURIST INFO
Web: www.grandeco.com

RESORT
Open dates: Nov–May
Night Skiing: no
Longest run: 4km
Total Lifts: 5 – 1 Gondola, 4 Express Chairlifts

This resort has the kind of aesthetic that reminds you of a winter-wonderland. Rhythmic terrain and spectacular vistas make skiing and snowboarding here a very pleasant experience. The resort, nestled on the mid-sized mountain of Nishidaiten, is well thought out and serviced by express chairlifts and one gondola, providing thoroughly enjoyable skiing and riding. It's

Within lies the potential to become a worthy international resort

located in the Inawashiro area and, although it's one of the further resorts from the town, is only about a 30min drive away.

Grandeco succeeds as a predominately novice and intermediate resort, however if you're the advanced rider of your group you'll still find plenty to satisfy you. The high altitude and quality natural snowfalls, combined with almost top-to-bottom artificial snow making capabilities means you'll be playing here long after surrounding resorts have begun their springtime closing programmes.

Powder

Grandeco certainly has potential to keep powder hounds content, with some obvious (and permitted) tree skiing on a decent pitch. This is one of the highest resorts in the region and, as a result, has a distinct natural snowfall advantage. The two upper quad lifts provide access to some mellow but nice tree riding terrain. There's rarely any ropes keeping you out and the resort management maintain a fairly open off-piste policy. A keen eye will spot the more hardcore terrain just outside of the resort boundaries. If you feel the need to explore these areas further a field it's recommend you book one of the more experienced instructors to give you a quick tour. They can inform you of the best snow conditions and skiable lines. Be aware, most routes end with a hike out.

Park

The park crew pride themselves on keeping a well-manicured park with small to medium sized jumps and varying jib features including rails and boxes. The main park is named 'Indy Park' and is accessed from the No.1 Quad Chair. Towards the bottom of this run you should spot a super-smooth T-box and a giant coffee can on its side – perfect for a quick hike-and-jib session. Around mid-season, when there is plenty of snow to go around, a decent skier/boarder-cross course complete with berms and rollers is available to settle any disputes within your riding crew.

📷 PHOTO: MARILYN POON RIDER: KEITH.STUBBS

Piste

At the base of the resort you can choose between a quad and a gondola to start your day. Both will take you to the upper ridgeline and give you access to another one of the three remaining quad chairlifts on the upper slopes of the mountain. Catch the No.3 Quad Lift to get to Grandeco's highest lift-accessible elevation at 1,590 meters, just shy of the peak, which sits at 1,982 meters. Exit left off the chair and head down to the start of the Giant Slalom racecourse you may have spotted from the lift. This racecourse is open to the public and is great entertainment for that little 'alpine racer' inside you.

Alternatively, the No.4 Quad Lift runs almost parallel on the adjacent side of the mountain and is also accessed, most conveniently, from the top of the gondola. First thing in the morning the on-piste is well groomed and fast when skiing around the trees randomly dotting the fall line, but be sure to enjoy the views of the stunning forest of snow-laden silver birch trees. Furthermore, two competition-standard mogul courses are kept in good condition underneath the lower half of the gondola. You're welcome to have a go however the occasional training camp participant may put you to shame.

Beginner suitability

An excellent beginner run is available from the top of the gondola leading all the way to the base, so even those new to the sport can enjoy the impressive views

from higher up instead of being stuck in the usual rut next to the car park. Between the two ski and snowboard schools there's enough English-speaking instructors to get you up for the first time or improve on your existing technique. Grandeco radiates a very friendly atmosphere and the staff are more than willing to slow down a chairlift for any first timers. Children have a dedicated learning area with a magic carpet and fun colourful features to weave in and out of. All-in-all, this is a great learners resort.

Off the slopes

Found at the top of the No.1 Quad Lift (ascending some 540 meters) is the alpine-style eatery, serving all the usual fare at normal prices. The excellent Western and Japanese dishes served in a sit-down meal style at 'Hotel Grandeco', found at the bottom of the trail skiers right of Quad Lift No.1, are worth the extra Yen. Hotel Grandeco is the only on-hill accommodation. Plus it accesses over 2kms of maintained cross-country skiing tracks, if the chairlifts are not your style.

Access

Kitashiobara is the nearest village at about 15mins by car from the base of Grandeco. Most hotels in the Inawashiro area offer free shuttle buses with their accommodation packages, taking approximately 30mins, plus 'park and ride' options are also available from Inawashiro Station. Grandeco also operate buses from Aizuwatamatsu and Koriyama for those staying further a field.

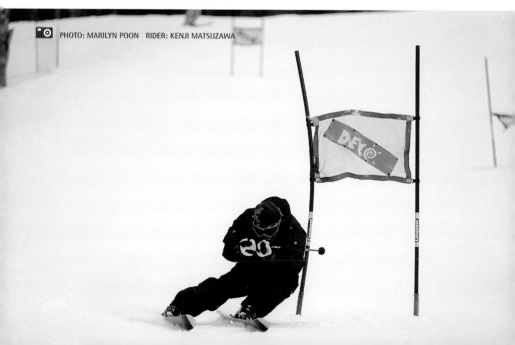

PHOTO: MARILYN POON RIDER: KENJI MATSUZAWA

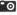 PHOTO: MARILYN POON

Listel Ski Fantasia

Impressive hotel but not much of a ski resort.

With a name like Listel Ski Fantasia this resort has to be considered unique. As the host resort for both the Ariels and Freestyle Moguls discipline at the 2009 FIS Freestyle World Championships, you'd expect this resort to be fairly substantial. Unfortunately, with just two usable double chairlifts (there is a third but it accesses the exact same terrain), five very short runs and a particularly low elevation, this ski area is certainly not substantial and shouldn't be considered as the main destination for international guests on their annual ski holiday. That said, families with young children experiencing snow for the first time would enjoy a short break here, and with a reasonably priced five star hotel at the base, you can relax in some serious luxury while the kids are playing in the snow. Moreover, this plush hotel makes a great base when accessing the other more engaging resorts in the region.

Powder

Listel has very little to offer those in search of powder. The top elevation is only 871m so, on a lean snow year, this place can really struggle. There's only a 273m vertical drop and no off-piste to speak of. The upper chair does access some relatively steep terrain, which on a decent fresh-snow day might keep you interested for a few hours.

Park

There's no park here and hardly any terrain that could be considered trick-worthy. The trail accessed directly from the top chair has a few tiny banks that might keep your interest perked for a few runs.

Piste

Serious carvers will be disappointed here, but those who like to ski the bumps can make the most if it. Apart from the one beginners run at the bottom, there's very little in the way of wide groomed terrain. The few advanced trails accessible from the top chair are short and steep – ideal for freestyle moguls.

Beginner suitability

Beginners have one nice wide trail to keep them

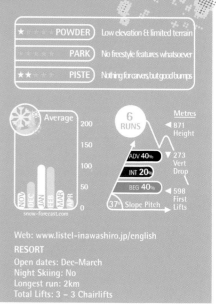

★☆☆☆☆ POWDER — Low elevation & limited terrain

★☆☆☆☆ PARK — No freestyle features whatsoever

★★☆☆☆ PISTE — Nothing for carvers, but good bumps

Average — 200 / 150 / 100 / 50 / 0 — NOV DEC JAN FEB MAR APR — snow-forecast.com

6 RUNS

Metres
◄ 871 Height
ADV 40% ▼ 273 Vert Drop
INT 20%
BEG 40% ◄ 598 First Lifts
37° Slope Pitch

Web: www.listel-inawashiro.jp/english
RESORT
Open dates: Dec–March
Night Skiing: No
Longest run: 2km
Total Lifts: 3 – 3 Chairlifts

satisfied for a day or so. It's consistent and mellow therefore suitable for linking those first turns. Unfortunately, there is nothing to progress on to from here; the next step up is a fairly steep intermediate run from the top chair.

Off the slopes

Hotel Listel is the main feature of this ski resort. It's a five star place marketing itself as a relaxing getaway or a luxurious base from which you can visit the many other resorts in the region. From afar the building appears as a bit of a concrete blot, however when inside it's very pleasing to the eye, although a little dated. Enjoy the expansive swimming pools and hot tubs, souvenir market, games room, selection of traditional restaurants, or even a personal massage (women only though!). Package deals are available at surprisingly decent prices with lift tickets at all the local resorts included.

Access

Listel Ski Fantasia is just 10mins drive from the town of Inawashiro. The hotel operates a range of complimentary shuttle buses from various towns and cities, and to all the local resorts. They pick up from Inawashiro Station seven times a day and Koriyama twice a day.

FUKUSHIMA

Snow Paradise Inawashiro

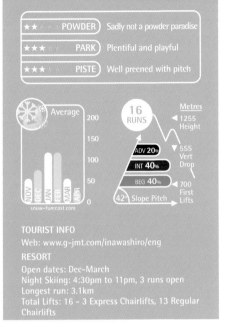

★★ POWDER Sadly not a powder paradise
★★★ PARK Plentiful and playful
★★★ PISTE Well preened with pitch

Average 200
150
16 RUNS
100
ADV 20%
INT 40%
50
BEG 40%
NOV DEC JAN FEB MAR APR 0
42 Slope Pitch
snow-forecast.com

Metres
1255 Height
555 Vert Drop
700 First Lifts

TOURIST INFO
Web: www.g-jmt.com/inawashiro/eng

RESORT
Open dates: Dec-March
Night Skiing: 4:30pm to 11pm, 3 runs open
Longest run: 3.1km
Total Lifts: 16 - 3 Express Chairlifts, 13 Regular Chairlifts

Snow Paradise Inawashiro is made up of two areas, each run by different companies. It's not for us to worry how they do business this way; but instead enjoy the combination of the steeper, faster terrain in the Minero Area, or the placid yet fun trails in the 'Churo' part, marked on the map as Centre Area. Both areas offer impressive views of Lake Inawashiro as you make your way down the runs and a large portion of the lower half in the Centre Area is floodlit until 9pm.

Established in the fifties, Snow Paradise is the oldest resort in the region and stays away from the pseudo glamour and glitz seen in other nearby destinations. This resort is strongly aimed at making skiing and riding a popular and legitimate past time once again for the local community, offering cheap season passes and a variety of school programmes. With seven ski schools it can get a little busy at times but it's still a fun and somewhat charming resort.

Fun and friendly, without all the fuss.

Powder

This resort is fairly low in altitude and, as a result, isn't bestowed with the massive amounts of snow as some of the higher resorts in the region. With the mountain being mostly south-facing, it doesn't make for a particularly strong freeriding or powder-poaching adventure. Off-piste isn't permitted here but no one pays much attention and if you're clued up, you can sign a waiver (in Japanese) and explore some of the backcountry – which, to be honest, it isn't known for.

For the best snow inbounds stay higher up and plan to hit runs 5 and 6, Amanoniwa Course and Oumagaeshi Gerende respectively. Should the Minero Lift No.4 not be operating you can walk across to the Minero Area. Take the quirky single chair, Hayama Lift No.4, up to the top, exit right and walk 5mins through and across the wooded area. You'll pass a very old and well-used public toilet, which is certainly an unexpected sight. Then, if you're lucky and there's some snow about you'll have a quiet mountain with black runs leading into reds and followed by some wide, open greens. Worth the effort!

Park

Snow Paradise does well to offer three snow parks. Two are located in the Centre Area and offer an impressive number of features for all levels. Even when the parks are small in Japan they still show imagination and seem to follow the latest trends as seen in videos and parks across the USA - barrel jibs and gap jumps being the order of the day here.

The park crew have thrown in a few mellow boxes and numerous safe jumps to keep the learners hungry for freestyle progression. The lower park on course 13 is also part of the night-lit area, so can be ridden till late in the evening. The park along the access track from Minero to Centre is

FUKUSHIMA

resort is home to frequent events the trails need to be kept in good order throughout the season. There's a sense of pride and hard work going into this mountain to keep it a solid part of the community, which rests at the doorstep.

Beginner suitability

The wide and mellow lower slopes, roped off beginner areas and a number of different ski schools mean that Snow Paradise is good for beginners. The Miffy Ski Camp is well known in Japan and associated with excellent teaching standards amongst youngsters. There are some English-speaking instructors available, which further enhances the attractiveness of Snow Paradise for learners.

Off the slopes

Snow Paradise has a nice subtle but up-to-date lodge at the base area, plus a small supermarket, a shop selling snow-related goods and an extensive and well priced cafeteria. There are plenty of seats and tables, and the chairs even have pockets for your wet gloves.

Access

It's two trains and only 2hrs 30 mins from Tokyo to Inawashiro, or about 4rs by car. There is a public bus from Shinjuku to Inawashiro that also takes about 4hrs. Most of the hotels offer complimentary shuttles to Snow Paradise and the resort operates transport from the local train station.

placed on a nice gentle piste and is by no means a heavy hitters spot, but the jibs are mellow and fun to dork around on without getting hurt. Those getting familiar with park riding will enjoy this area especially.

Piste

In 2009 this was the training ground for Japan's National Skier-Cross team. With 16 different trails serviced by 16 lifts, the pistes here mean business. The lower half of Snow Paradise has some of the widest slopes you'll encounter in Japan, built before local planning laws came in to effect 20 years ago. The narrower runs located across the upper half were added to Snow Paradise within the last decade and, therefore, do not have the same girth of the lower trails.

The width and condition of the slopes here allow for some fun and fast carving. During the week is quieter and you get more space to cruise around. The Minero Area is the best destination for some testing terrain. The short, steep runs and well thought lift placement ensure a quick turn around, so it's easy to squeeze in a lot of laps. As this

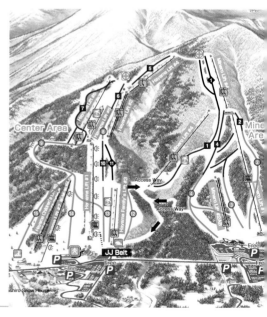

Urabandai Nekoma

★★★ POWDER | Short, but fun & accessible
★★★★ PARK | A perfect progressive park
★★★ PISTE | Wide un-crowded groomers

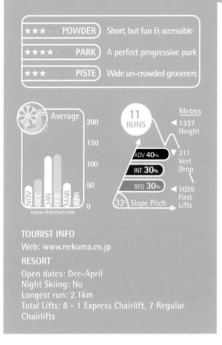

TOURIST INFO
Web: www.nekoma.co.jp

RESORT
Open dates: Dec-April
Night Skiing: No
Longest run: 2.1km
Total Lifts: 8 - 1 Express Chairlift, 7 Regular
Chairlifts

Un-crowded with an excellent park and north facing off-piste.

accessed from the sides of the marked runs. The north-facing aspect of Nekoma resort allows the snow to stay cooler for longer which, when combined with the crowd free slopes, makes finding fresh tree runs days after a storm an easy feat.

With a greater snowfall than ALTS, this tree lined bowl resort nestled in the Caldera slopes of Mt Bandai has some great tree runs that offer a few steeper pitches in places. Wind-lips form around the very tops of the bowl but other features such as pillows and cliffs are a rare commodity. There are three un-groomed marked runs and several gullies that make up the bowl's topography with varying degrees of pitch. Overall the potential for pow at Nekoma is decent offering fun for most levels, even if the runs are a little short lived.

Urabandai Nekoma, meaning 'witch cat behind Bandai', is the north-facing and non-identical twin brother to ALTS Bandai. With a longer season lasting from November through May this un-crowded resort, located in a bowl on the backside of Mt Bandai, offers nice off-piste, fantastic terrain parks and an array of cruisey pistes, all within its limited 6 chairlift system.

Bought in 2008 by the Hoshino Resort brand that owns ALTS Bandai, the plans to link the two resorts with a lift could be made a reality in the near future. Nekoma's progressive park with its extensive jib features is definitely the highlight, however fun easily accessed tree runs and a distinct lack of crowds make it a definite small all-around resort for most type of snow goers.

Powder

The official line here is that off-piste skiing and riding is not allowed. However, the patrollers here are super-mellow and the tree runs are easily

Park

Defiantly the highlight of this little resort; Nekoma's park is shaped by Yuji Yamada – the man behind the wheel in the ALTS Bandai parks. On this side of the mountain however, you'll find an array of smaller entry-level boxes and kickers running alongside a more imposing park with some weighty features, all located under Chair 7. There are usually several well-built kickers here with wide American-style take-offs of varying sizes, all with steep landings. Along with smooth hips, several boxes and street rails there's a number of particularly progressive snow-jib features and a great skate-style mini ramp.

The features here are shaped with safety in mind and the park team maintain and re-shape throughout the day providing one of the most flowing snow parks in Japan. Furthermore, the park is relatively un-crowded for the standard of features it holds, but there is one thing it's missing... pipe!

FUKUSHIMA

Piste

Slightly more crowded on weekends, the groomed courses here generally stay untouched and the corduroy keeps till late in the afternoon. With varying degrees of pitch on the upper slopes the runs provide something for everyone, however the more experienced skier may cover the 6 chairlifts and its accessible terrain fairly rapidly as Nekomo is not known for its size. Generally speaking however, the trails are wide and consistent with something to suit most levels.

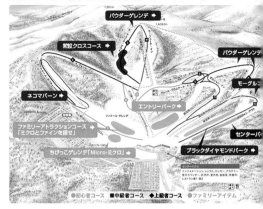

Beginner suitability

Since the buy-out, ALTS Snow Academy have begun running English-speaking lessons from their extensive programme over the mountain. Combined with a large beginner-specific area at the resort's base, accessed by a small double chair, Nekoma makes a good resort for all those starting out. The gently rolling pitches further up provide ideal areas to practice turns and progress with confidence.

Off the slopes

The base of the mountain has a restaurant, several shops and obligatory hot drink vending machines everywhere. There are kindergarten and day care centres, a rental shop and ALTS Snow Academy in one centralised building next to the car park.

Access

The town of Inawashino is just 30mins away by car or bus. Access to the airports is generally by way of Tokyo linking up with the Shinkansen through Koriyama Station. Nekemo has regular buses from ALTS Bandai during the holiday periods and when ALTS closes up in April. It's generally easiest to stay in the hotels of Inawashino town or on the shores of Hibara Lake, just 5mins on the bus from the base of Nekomo.

PHOTO: MARILYN POON RIDER: SAM NELSON

An Interview with Yugi Yamada; The Terrain Park Director for ALTS Bandai and Urabandai Nekoma

Hi Yugi. Thanks for taking the time to sit down with us. So firstly, can you tell us a little about yourself and your experience in the industry?

"Yes. This is my 14th year as a shaper, but I started at Nekoma about 10 years ago. I've been Snowboarding for 17 years now."

So you run the parks on both ALTS and Nekoma, what are the main differences between the two?

"Nekoma has much more snow so we can build bigger and better jumps. At ALTS we focus on rails and boxes more, plus the halfpipe."

Do you have much international influence in the art of building and shaping parks?

"I started shaping with no tuition at all. Since the Nippon Open started here I have learnt a lot with help of international shapers. I was actually the first graduate of Planet Snow Design under Pat Malendoski."

Have you ever snowboarded overseas? If so, how do you think JP parks compare to international parks?

"Yes, a little. I think Japanese park designers and resort

management are very sensitive to safety, this means we maintain features more often but maybe they are a little smaller."

What's the most interesting feature you've seen created at ALTS or Nekoma?

"Oh, I'm not sure. At the Nippon Open last year we had a Cannon Box, that was fun."

You've got some pretty creative features over at Nekoma, how do you see parks progressing in the future?

"Bigger and more technical for those who have the skill, but we have to focus more on the beginner level and build safe features for people to progress on."

Miyagi Zao

A quiet alternative to the weekend madness of Zao.

Miyagi Zao isn't the Mecca of neighbouring resort going by a similar name. However, this place still has potential and will, without a doubt, entertain beginner to intermediate skiers or snowboarders looking to escape the holiday tourist crowds. As the closest major resort to the city of Sendai, Miyagi Zao is a popular day trip for many keen weekend warriors, but long lift lines and crowded trails are not so common here.

On a clear day the long runs overlooking the scenic Japanese countryside allow occasional views of the ocean. The resort has 10 lifts in total, gondola included, accessing its 700 metres of vertical drop. There's a small park and 11 different marked trails, which include a number of un-groomed slopes. Overall, if you're already in the area you won't be disappointed with a day in Miyagi Zao, especially early in the season before the other Zao has fully opened up.

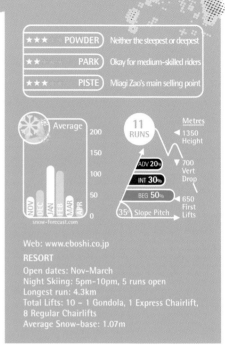

★★★ POWDER — Neither the steepest or deepest
★★ PARK — Okay for medium-skilled riders
★★★ PISTE — Miagi Zao's main selling point

Average
200
150
100
50
0
NOV DEC JAN FEB MAR APR
snow-forecast.com

11 RUNS

Metres
◄ 1350 Height
▼ 700 Vert Drop
◄ 650 First Lifts

ADV 20%
INT 30%
BEG 50%

35° Slope Pitch

Web: www.eboshi.co.jp
RESORT
Open dates: Nov-March
Night Skiing: 5pm-10pm, 5 runs open
Longest run: 4.3km
Total Lifts: 10 – 1 Gondola, 1 Express Chairlift, 8 Regular Chairlifts
Average Snow-base: 1.07m

Powder

Miyagi Zao has some dedicated off-piste runs, which are left un-groomed to satisfy those with a thirst on powder days. First up in the morning, after an overnight snowfall, these runs will deliver to a degree but don't expect fresh tracks to last past brunch.

These 'powder' areas, of which there are 5 in total, are marked on the trail map with a purple shade. Course 11 is rather fun but a little short-lived. There are numerous other places to head into the trees but if the snow is deep, then the lack of pitch will see many struggling, especially snowboarders.

Park

When the powder runs out, the terrain park is home to some clever features for skiers and boarders. The biggest downfall is that it's servicing chairlift is an old double that seems to take the best part of a day getting you to the top. That aside, you'll discover a mixture of ride-on or gap-on boxes and rails, plus a few jumps with transitions in the right places. This resort is good for intermediate park monkeys to build their confidence and have some fun at.

Piste

The on-piste trails have got some length, particularly if you take the gondola followed by Chairlift No.1 up to the highest lift-accessible part of the mountain. From the top there's is a myriad of options appealing

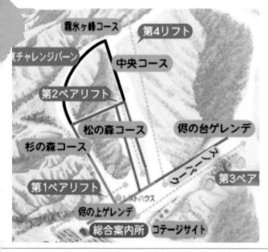

to your descent, all depending on your skill level. Grab a trail map to easily identify (and avoid) the beginner runs, which wind from one corner of the mountain to the other. Speed demons won't find anything outrageously fast aside from firm corduroy on a cold morning. Nevertheless, there are some challenging runs for intermediate carvers. Ultimately, if you just want a relatively quiet mountain with groomed, cruising runs then Miagi Zao will do the job nicely.

Beginner suitability

Beginner terrain is good here but English-language lessons are not common. Runs suitable for learners can be found all over the mountain. There's an abundance of groomed beginner areas right in front of the resort complex, serviced by a choice of chairlifts. Find your legs in the safety of the bottom then venture up higher once you're warmed up. Take in the views on your way down the long, flowing green marked as No.1 on the trail map.

Off the slopes

Miagi Zao has a variety of places where you can fuel

up, mostly traditional Japanese eateries. The largest restaurant is at the base, but a number of others are dotted around the mountain. There's the usual ski rental service available, as with most resorts. The servicing town of Tohgatta-Onsen (pronounced "Tow-gatta") can't be considered a 'ski town' but it does offer a small variety of accommodation and a few other standard tourist facilities. The Royal Hotel offers very comfortable accommodation and has a free shuttle bus to the ski resort.

Access

Miagi Zao is the other side to Zao Onsen and takes an hour by road, winding around the base of the mountain range. It's convenient if you have your own vehicle and are coming from the Shiroishi Tohoku IC, which is only 20mins on route 457. Driving here from Sendai will take an hour or so and is simple enough, but it's more of a challenge by public transport. The closest JR station is Shiroishi-Zao; from here you can take a 60min bus ride to Tohgatta or to the Royal Hotel. Shuttle buses run frequently up the mountain from the town, taking just 15mins.

Zao Onsen Resort

There's a reason why Zao rhymes with wow!

Actually pronounced "Za-ou" in the local tongue, this is a large but lesser known resort (amongst Westerners anyway) in Yamagata prefecture, and is one of the oldest ski resorts in Japan. Zao is one of the most charming, rustic and authentic resorts in the world. With an expansive lift system, a wide selection of terrain and a traditional but very accommodating service town, this is a great choice for many different types of skier and snowboarder.

At present the visiting populous here is mainly made up of middle and upper class Japanese, as well as South Korean couples and families. If you want to avoid the Western trappings that can appear in other Japanese resorts, you could do a lot worse than Zao. Come here to sightsee, enjoy the traditional village and take advantage of the excellent facilities on the mountain. Most notably, Zao has an abundance of natural onsen, fantastic restaurants and scores of good all-inclusive package deals with prices ranging from reasonable to very expensive. The resort itself is fairly localized and easy to get around, although it can be tricky to understand the layout from the trail map, as it comprises so many different ridges and peaks. Night skiing is available until 9pm on the lower pistes and is the perfect way to prepare your body for an evening in the onsen.

Powder

Although Zao doesn't really have any 'permitted' backcountry access, there's certainly potential. From the highest point you'll spot plenty of options but you're not allowed to access it without a guide or instructor. You can however ski anywhere off-piste within the resort boundaries as long as it's not under the chairlift; but if it's roped off, do not enter. You're likely to find some pockets of powder and nice mellow lines through the gullies lower down the mountain – a good bit of fun! At higher altitudes you'll find yourself among the 'Snow Monsters', a splendid natural effect caused by the build up of many months of wind blown

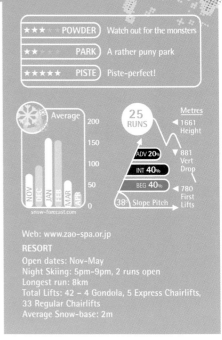

★★★ POWDER Watch out for the monsters
★★ PARK A rather puny park
★★★★★ PISTE Piste-perfect!

Average 200 150 100 50 0
NOV DEC JAN FEB MAR APR
snow-forecast.com

25 RUNS

Metres
◄ 1661 Height
ADV 20% ▼ 881 Vert Drop
INT 40%
BEG 40% ◄ 780 First Lifts
38° Slope Pitch

Web: www.zao-spa.or.jp
RESORT
Open dates: Nov-May
Night Skiing: 5pm-9pm, 2 runs open
Longest run: 8km
Total Lifts: 42 – 4 Gondola, 5 Express Chairlifts, 33 Regular Chairlifts
Average Snow-base: 2m

snow. Known as "Juhyo" these 'monsters' usually occur in the coldest months from December to February. The Snow Monsters never cease to amaze you as they manage to look eerie, friendly and inviting all at the same time. It is possible to ride through the lower parts of the Juhyo, but you must check with patrol, and more than likely be with a guide or instructor.

Zao is generally west-facing, but has both north and south-facing areas as the resort sits within two large bowls. The southwest winds load up skiers left of the resort and you can really burn your way through quality powder all the way to the bottom. The season here is a long one starting late November and ending early May, with an average snowfall of 12m and most of it falling in February and March.

Park

Zao actually has two parks: the lower beginner-orientated 'Dragon Park' and a slightly larger park further up, named the 'Boarders Paradise Park'. The Dragon Park is very basic and usually includes 3 small

YAMAGATA

kickers, a few transitions and some very low boxes. Boarders Paradise fairs a bit better with a hip, some rusty rails and, its saving grace, a rather nice 6m-ish tabletop at the bottom.

The parks are serviced well by lifts that run along side them ensuring quick laps if you think it's worth it. With seven different lift companies dotted throughout the Zao resort it's not hard to see why it might take a while for the freestyle facilities to take shape. It's also not clear who is actually responsible for them. The parks are quite ropey at best, but the staff do appear to be trying and have lots of enthusiasm, bless them. And if anything, the parks fit within the casual and rustic theme of Zao as a resort. However, if you're a keen freestyler don't expect to progress much here. There's no halfpipe in Zao and the parks are not something that look likely to improve much in the near future. But her, you never know.

Piste

Where Zao comes into it's own is on the pistes. With over 460 ski-able acres there certainly is a lot to cover. 38 chairlifts along with 4 cable cars and gondolas service around 60 different trails. Many of the runs overlap and rejoin each other meaning there's no end of ways to get down the hill. This constant interlinking

makes for some truly long leg-burning pistes and there's even a 9km run for those wannabe marathon skiers among you.

Being one of the oldest ski resorts in Japan, explains why the lower runs are wide and the upper ones much narrower. Japanese resorts now have restrictions on how wide they can make their pistes, but Zao's lower trails were built before this law was passed. Zao also boasts the steepest slope in the region at 38° and is definitely not for novices. Furthermore, there's a run here named Hahnenkamm after the famous piste in Kitzbul, Zao's sister resort in Austria. This is a serious downhill-length run with constant pitch that will keep any hardcore carver happy.

Zao does well to cater for all levels, providing 40% of the runs for beginners, the same for intermediates and 20% for the advanced. All-in-all the abundance of casual crusiey runs, the range of harder trails, a smoothly operating lift system, mixed in with the Snow Monsters and a scenic backdrop make for some very pleasant skiing and riding around the pistes of Zao.

Beginner suitability

There are seven ski schools, most of them catering for English-speaking customers, although you'd be best to

PHOTO: MARILYN POON RIDER: TIM MYERS

PHOTO: MARILYN POON RIDER: KEITH STUBBS

book ahead if you specifically require this. Your chosen accommodation provider can generally help you to book your lessons, directing you to their preferred school rather than concerning themselves with the cost. There's beginner terrain suitable for everyone and a number of different areas suitable for learning. The whole mountain is easy to use access and the resort has signs written in English.

Off the slopes

The trailside facilities at Zao are excellent. It's almost like being in one of the larger Austrian or French resorts. There are many little (and larger) cafés and restaurants all over the mountain, most being intimate owner-operator style places. Each of the base areas offers all the usual amenities, plus even more eateries lining the access roads.

As a town Zao Onsen offers many other attractions and past times including a fun 'Family Snow Park' complete with tube riding. Most notably, Zao Onsen has a famous open-air sulphurous hot spring (or onsen) known as Zao Dai Roten Buro. It's built into a beautiful mountain ravine making for a fantastically tranquil setting, although it is only really usable in springtime. But don't worry there are two other open-air hot springs and three public bathhouses in the village. Onsens are also found at many of the local hotels.

The charm of the resort doesn't end there, with Zao's many authentic food and beverage establishments and very few overbearing tourist shops this is a magical resort town full of wonderful culture and tradition. And just to top it all off, local law has it that there will be no more development in Zao, ensuring that it will never lose the very ambiance that makes it so very special.

Access

It takes 3hrs to reach Yamagata from Tokyo via Shinkansen. The resort is then a further 45mins from Yamagata Station. Sendai Airport is about 1hr 30mins from Zao by bus or just 1hr by train, although you have to then transfer onto a local shuttle bus. If driving here yourself travel along Yamagata

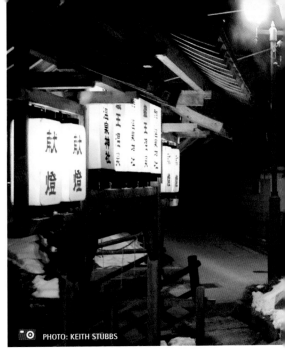

PHOTO: KEITH STUBBS

Expressway from the Tohoku Expressway with the nearest interchange being the Yamagata Zao, exit here to reach Zao Onsen within 45mins.

Other resists in Tohoku

Appi Kogen – Iwate Prefecture

Northerly-facing with a long season often extending into May, Appi Kogen is a good-sized resort with a strong domestic reputation. It has 20 lifts in total accessing its 21 different trails and 828 metres of vertical. Spread over two peaks, the terrain is suited to intermediates mostly, but offers reasonable beginner areas and a few advanced trails, including a couple of un-groomed pitches and a small park. The resort offers night skiing, on-snow accommodation and all the other usual facilities. Appi's geographical location means it receives snow with extremely low moisture content. The downside to this is the reduced size of snowfalls, comparatively to Japan's other powder destinations.

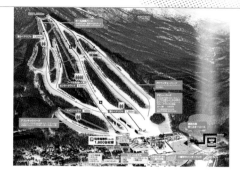

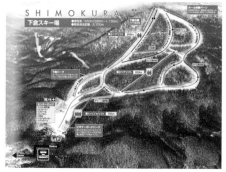

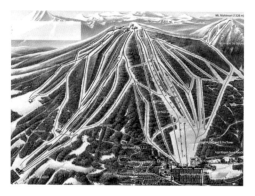

for a few days, but anyone progressing to higher intermediate or advanced levels will get bored quickly here. The resort does offer a small park and a mix of good kids facilities, but overall this is a family resort that's popular mostly within this region.

Hachimantai Resort Panorama – Iwate Prefecture

Located just south of Appi Kogen and due west of Hachimantai City, Hachimantai Resort Panorama is a relatively small but convenient ski area most suited to beginners and intermediates. Its 4 chair lifts and 460m of vertical drop will keep lower levels content

Hakkoda – Aomori Prefecture

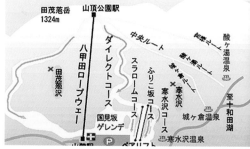

Known as a major backcountry skiers and riders destination, Hakkoda isn't your standard ski resort, but more of a lift accessible off-piste haven. One large cable car accesses 654m of vert, with very few groomed trails and lots of fresh powder lines. Aomori is known for being very cold and Hakkoda is no exception. This is an isolated resort suitable for high intermediates and advanced skiers/riders only. It's the kind of place everyone carries backcountry packs filled with all the necessary equipment, so be prepared. Alternatively, there are local guiding companies that should be utilised is your ability or knowledge is at all questionable.

Minowa Ski Resort – Fukushima Prefecture

One of the smaller resorts in the Inawashiro area, Minowa is a compact resort situated at relatively high altitude, at least when compared to other Fukushima-based resorts. Its base elevation is 1,050m, however it only rises a further 450m up from this point. The three chairlifts access 11 different trails, mostly catering to beginners and intermediates.

Shizukuishi – Iwate Prefecture

Shizukuishi is a mid-sized Prince Hotels resort close to the ski areas of Appi Kogen and Hachimantai. With 60% of its trails catering to intermediates, 791m of vertical drop and 16 trails spreading over two peaks, this resort is relatively substantial. It offers a well

developed lift system compete with a cable car and gondola, although this is known to close with minimal winds. Resembling Furano Ski Resort in Hokkaido, Shizukuichi also forbids off-piste skiing and riding. It does however have some steeper trails and leaves the odd one un-groomed for powder lovers. It also has a reasonable terrain park and some good kids facilities.

St Mary's – Miyagi Prefecture

This smaller resort, close to neighbouring resort of Miyagi Zao, is a family-orientated place with just 4 chairlifts and 5 runs. St Mary's has a good but basic beginners area at the base, complete with a 'Kid's Land' play area. The mountain itself stretches up 500m in elevation and offers a few options for intermediates, but nothing really for advanced skiers/riders. However, it has been known to offer night skiing and riding till midnight.

Tazawako – Akita Prefecture

Offering a reasonable selection of terrain and some beautiful views of nearby lake Tazawa, this is a mid-sized resort with good facilities. The 6 chairlifts access 13 different trails, taking skiers and riders 608m from top to bottom. The terrain on offer is mostly suited to beginners and intermediates, but they do have a few black trails to keep advanced snow goers content for a day. Tazawako has a good selection of facilities for most tourists, but aims mostly towards families.

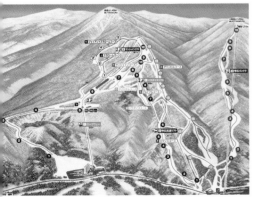

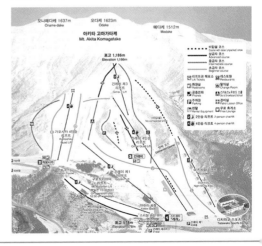

Hokkaido Region

Hokkaido introduction

This is the second largest and most northern of Japan's 47 prefectures. With its un-spoilt landscapes and minimal population, relative to other Japanese regions,

Hokkaido provides rolling mountains blanketed in deep snow all winter long, often covering down to sea level. Known for receiving particularly dry powder along with large snowfalls, Hokkaido is home to a few internationally renowned resorts, such as Niseko and Furano, plus a large number of other small to medium ski areas.

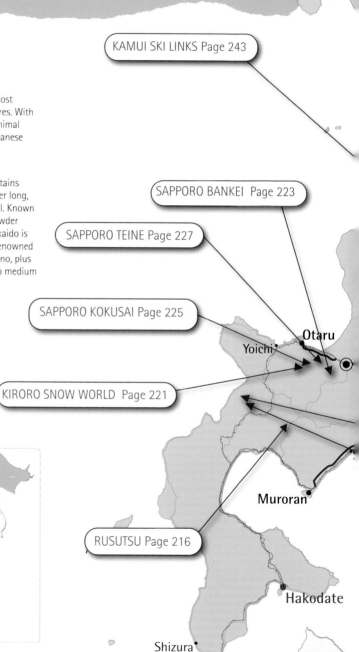

KAMUI SKI LINKS Page 243

SAPPORO BANKEI Page 223

SAPPORO TEINE Page 227

SAPPORO KOKUSAI Page 225

KIRORO SNOW WORLD Page 221

RUSUTSU Page 216

Otaru

Yoichi

Muroran

Hakodate

Shizura

Ushitaki

Mutsu

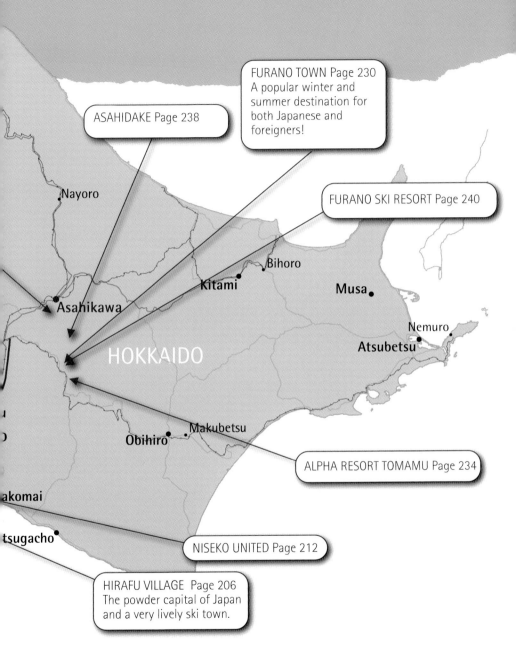

ASAHIDAKE Page 238

FURANO TOWN Page 230
A popular winter and
summer destination for
both Japanese and
foreigners!

FURANO SKI RESORT Page 240

Nayoro

Bihoro

Kitami

Musa

Asahikawa

Nemuro

HOKKAIDO

Atsubetsu

Makubetsu

Obihiro

ALPHA RESORT TOMAMU Page 234

akomai

tsugacho

NISEKO UNITED Page 212

HIRAFU VILLAGE Page 206
The powder capital of Japan
and a very lively ski town.

Hirafu Village & Niseko area

The powder capital of Japan and a very lively ski town.

When most people think of skiing in Japan "Niseko" is the word that often springs to mind. Niseko is the area that put Japan on the world map for skiers and snowboarders and it continues to be one of the most popular ski resort towns in the country.

Located in West Hokkaido close to the Japan Sea, Niseko is a rural area surrounded with farming land. Up until about 15 years ago the region was relatively quiet and had very few western visitors. Then came the Australian invasion! The growth of Niseko has been led by Australian tour operators and developers who have modernised the town to complement the amazing ski area it lies beneath. Niseko now provides

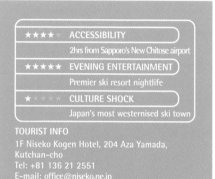

★★★★☆ **ACCESSIBILITY**
2hrs from Sapporo's New Chitose airport

★★★★★ **EVENING ENTERTAINMENT**
Premier ski resort nightlife

★☆☆☆☆ **CULTURE SHOCK**
Japan's most westernised ski town

TOURIST INFO
1F Niseko Kogen Hotel, 204 Aza Yamada, Kutchan-cho
Tel: +81 136 21 2551
E-mail: office@niseko.ne.jp
Web: www.nisekotourism.com/en

HOKKAIDO

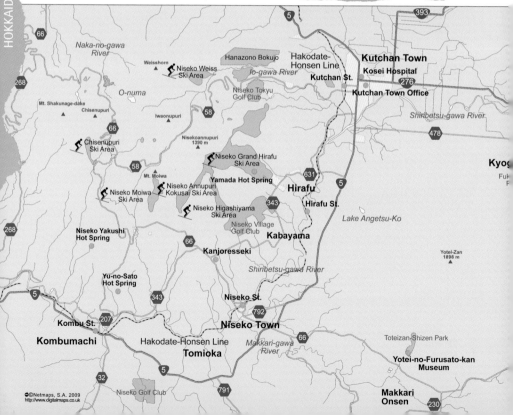

©Netmaps, S.A. 2009
http://www.digitalmaps.co.uk

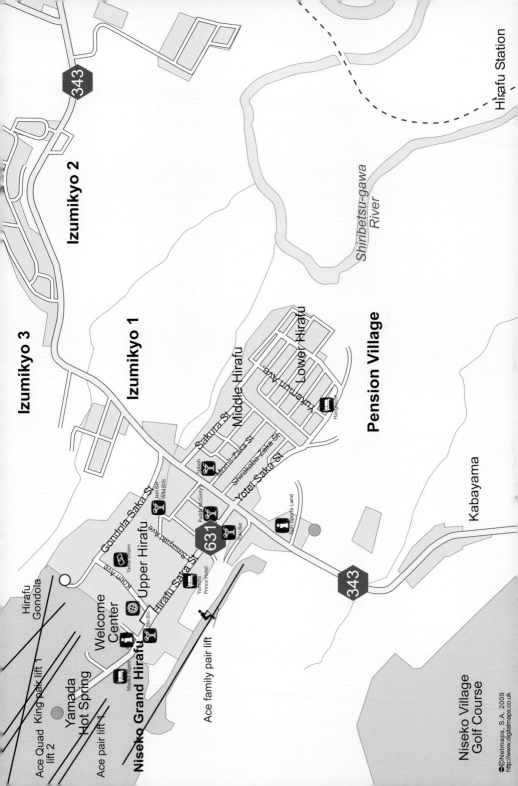

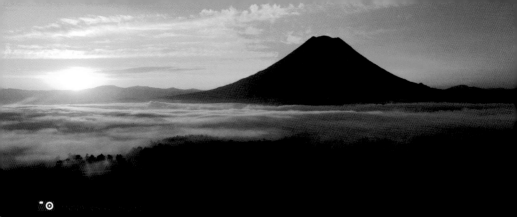

modern facilities and caters for both singles and families, and the extremely wealthy or the not so wealthy (well, as un-wealthy as you can be and still afford to ski or snowboard!). Although this is the most westernised ski town in Japan, it is still possible to experience Japanese culture here. From the traditional izakaya restaurants to the many natural onsens, this is still Japan but with a Western flavour.

The most common cause of confusion when planning a trip to Niseko is in the town name itself. Niseko is actually a town a few kilometres away from the closest ski field. The main tourist area is Hirafu Village, at the base of Grand Hirafu ski area, where 90% of people who visit 'Niseko' will stay. The other villages in the area are at the base of the other ski areas - Annupuri, Hanazono (the second Grand Hirafu base area) and Niseko Village (a clever name change in 2008 from their original name of Higashiyama). The biggest town close by is Kutchan, which is about a 10min drive from Hirafu. Here you will find major supermarkets, homeware stores, a train station, and many traditional restaurants and bars. Hirafu and Hanazono are technically suburbs of Kutchan, while Niseko Village and Annupuri are part of Niseko town.

Of the different villages, Hirafu is by far the most developed and exciting. Being close to Kutchan is also a huge advantage. Until recently there was no ATM in Hirafu, so a weekly visit down to Kutchan was a must for international seasonairres. However, Hokkaido Tracks have just solved this problem installing an ATM in their own office.

Other than Grand Hirafu, Annupuri has a few good pensions and restaurants, Niseko Village consists of one comprehensive Hilton Hotel plus one other hotel,

and the Hanazono base area, which is just a car park at this stage (although they have exciting plans to build an entire village in the near future).

Accessibility

For international tourists the biggest headache is usually getting to New Chitose Airport, Sapporo's main airport. A relatively small number of international flights go direct to New Chitose from the likes of Hong Kong and Seoul in Korea. Others will have to fly to Tokyo and transfer to a domestic flight. The catch is that most international flights land at Tokyo Narita and often your domestic flight will leave from Tokyo Haneda, 1hr 15mins across the city. Once at New Chitose it's quite simple to get to Hirafu, Annupuri or Niseko Village. The quickest and easiest way is to catch one of the many buses that depart from 9am to 9pm each day. There are 4 main companies you can book with, all similar in price: Chuo, Donan, White Liner and Hokkaido Resort Liner. The other option is the train, which leaves from the airport and takes you to Kutchan. You generally have to change trains at Otaru en-route. It's only on the other side of the platform but can be very annoying when dragging all your ski or snowboard gear. Once you arrive in Kutchan you then have to make your way to your accommodation, most likely in Hirafu. Many hotels / pensions will pick you up but, if not, the options are either a taxi or the local bus.

If you're staying in Hirafu then getting around town is easy. Most accommodation isn't ski-in / ski-out but there are free local shuttle buses that will pick you up and take you to the lifts. They run every 15 to 20mins from 8:30am to 9pm, so they're also very useful for getting to your favourite restaurant or bar in the evenings. As well as the shuttles to the base of Grand Hirafu ski area, there are also free buses to the

Hanazono base: a worthwhile option first thing in the morning to beat the crowds skiing over to Hanazono. Heading to Niseko Village or Annupuri from Hirafu is also relatively easy but you have to pay for the local bus. It's actually quicker, and a lot more fun, to ski there from Hirafu. Just take the chairlift all the way to the top and head skier's right – you'll be there in no time!

Other accessible resorts from Hirafu include Niseko Moiwa (offering a free service from Hirafu) and Rusutsu Resort. Getting to Rusutsu is a little expensive and takes about an hour, but it's well worth making the journey in busy periods as they rarely have the crowds of the Niseko United ski areas. If you're keen to get away from the ski fields for a day there are plenty of local buses from Hirafu to Kutchan, costing minimal amounts. There's also a free night bus that runs from 5pm until 11:30pm every night so make the most of it and check out this traditional Japanese town.

PHOTO: LUKE.HURFORD RIDER: TOMOKO.KAZAMA

Evening entertainment

Hirafu caters extremely well for its international guests who like to eat out, have a quiet drink, or party the night away! There are a staggering 200 restaurants in the Niseko area if you count Niseko Town, Hirafu, Kutchan, Annupuri and Niseko Village. The majority are in Kutchan but over 40 are in Hirafu, giving you a real assortment all within easy walking distance. Niseko town and Annupuri have several excellent restaurants, and Niseko Village has about 6 different restaurants located inside the Hilton Hotel.

As you would expect, it's easy to find wonderful Japanese cuisine. If you like it raw head to Fuji Sushi in

Hirafu for some delicious sushi and sashimi. If you like your food well cooked then try the Yakitori restaurant 'Yosaku' where they serve grilled meat skewers. At Juu restaurant in Kutchan you can cook your own Okonomyaki on a grill at your table, or if you don't think you're up to the challenge their friendly local chef will help you out. Don't forget ramen – the staple diet for most young skiers and snowboarders living on a tight budget. There are plenty of ramen restaurants where you'll find a filling meal for a good price. For those Westerners longing for the less adventurous menus Hirafu has got you covered. From steaks to pizza, Mexican or burgers, and even fried breakfasts, you will find it all here.

If you enjoy drinking and partying into the early hours then Hirafu is definitely the place to be. Plenty of bars offer happy hour specials (Irish bar Paddy McGinty's is real a favourite) and all-you-can-drink deals (Nomihoudai in the local tongue, pronounced "nomi-ho-die"). The majority close at 1am but that doesn't mean your night's over yet - head on to Splash, Barunba, Blo Blo, Yuki Bar or Jam Bar to name a few. These bars will stay open anywhere from 3am to 5am. Hirafu is also a great place to catch some live music. On most nights in the peak season you'll find a bar with a DJ, jazz musician or acoustic guitarist. If that's

not enough you can make your own music. There are a couple of Karaoke venues in Hirafu and Kutchan for your singing pleasure.

Culture shock

Previously known for being over-run with Australians - their numbers are dropping and being replaced with tourists from Hong Kong and Singapore - Niseko isn't the place to visit if you want a real Japanese cultural experience.. In saying that, you'll still get a taste of Japanese lifestyle here and if it's your first visit to this wonderful country Hirafu will ease you in gently. Hirafu's facilities and architecture have changed a lot in recent years so you'll find a lot of Western-style buildings and hotels scattered amongst the Japanese pensions.

The cultural experience of Niseko does vary more if you stay outside of Hirafu. Niseko town and Kutchan have not been affected by the influx of foreigners as much, so they're great locations if you want more of a Japanese experience. All of the towns servicing Niseko United have English signage and most of the restaurants have some English-speaking staff, as well as English menus. It's very easy to survive here without a translator or any ability to speak Japanese, but you should still make an effort to learn a few polite phrases.

Accommodation

Over the years, Westerners have made up the majority of international visitors in Niseko, being mostly Australians and New Zealanders. However, as mentioned previously, the many English-speaking visitors are now being joined by large numbers of Hong Kong Chinese and Singaporeans too. And don't forget the Japanese – they account for over two-thirds of the winter population here. Due to this varied mix you'll find a variety of accommodation styles including traditional Japanese pensions, modern Western apartments and hotels, log cabins or backpackers.

For the biggest variety of accommodation and ease of getting around, Hirafu is the best place to stay. For those on a tight budget there are a couple of backpackers (check out Hangloose in Hirafu for the cheapest option) and for those who want luxury there are several hotels and apartment buildings with ski-in / ski-out options. The traditional pensions are great value and a great experience, offering a personal touch from the pension owner, who generally lives there too. If you're with a group and want your own apartment, contact Hokkaido Tracks and they'll find you something suitable – but be sure to book ahead.

Annupuri also has some excellent accommodation, usually at better prices than in Hirafu. The trade-off is the lack of restaurants and bars, but if this doesn't bother you Annupuri is a good option. Niseko Village has the well-endowed Hilton Hotel. If you're looking for a bit of luxury and prefer to stay in the comfort of the hotel during the evenings, Niseko Village is a good choice with its spas, massage rooms, 6 restaurants, a bar and the usual conference facilities.

Sightseeing and other activities

If you're not on the mountain, snow mobiling or cat skiing, the best thing to do is relax in one of the many onsen. There are plenty in Hirafu, one at the Hilton in Niseko Village, and several in Annupuri – one of which is the only mixed onsen in the area. But don't get too excited guys, the girls are provided with a one-piece to wear in the water! The onsen itself is one of the largest in the area and also one of the nicest, definitely worth a visit.

No trip to Niseko is complete without photos of the stunning Mt Yotei, Hokkaido's version of Mt Fuji. Mt Yotei is a volcano that stands 1,898 metres high and is the perfect backdrop for all your Niseko photos. For those a little more adventurous, you can pay for a guided hike to the top, a 4 -6 hour trip depending on your fitness.

There is nothing to see in the way of temples or shrines in the immediate area as Niseko is quite rural. If you want to visit a beautiful city however, Otaru is about 1hr 30mins away on the train. This coastal town is famous for its historical buildings, beautiful canal, amazing seafood and delicious chocolate!

PHOTO: NATALIE MAYER

Niseko United

Infamous for powder, this is Japan's most internationally publicised resort.

Niseko United is by far the most well-known resort in Japan and certainly the place everyone thinks of when it comes to riding some infamous Japanese pow. The one 'united' mountain is comprised of three different ski areas, An'nupuri, Niseko Village (previously named Higashiyama) and Grand Hirafu (which is divided into two areas, Hirafu and Hanzonno). They're all linked together through the top of the mountain and one lift pass can be bought covering the whole resort.

Each of the four zones has its own base area, Hirafu being the most developed in the region. With its ever-growing reputation, Hirafu has stacks of new buildings sprouting up every year to fill the increasingly huge demand. The local resort towns have managed to retain some character – though not necessarily completely Japanese – and they now resemble slightly alternative Colorado ski towns. The word is out on Niseko and international tourists are arriving by the coach load, literally!

But don't let this put you off. This is still seen as Japan's premier ski resort and certainly not without reason; a snowfall of over 14m's per season; a continuous vertical drop of 1,000m; a massive selection of terrain including off-piste, backcountry, park, pipe, night skiing – the list never ends. It's an epic mountain with something for everyone, but ultimately, Niseko is a freeriding resort for powder lovers. The management maintain one of Japan's most progressive off-piste and backcountry access policies almost guaranteeing that powder seekers will go home happy. That being said, freestyle addicts need not worry, you certainly haven't been ignored, there are 2 halfpipes and 4 different terrain parks spaced out over the resort. Plus there's also a wide choice of groomed runs for every level of skier and rider looking for a cruisey time.

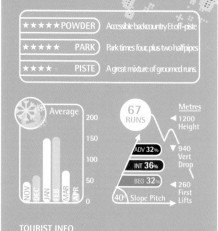

★★★★★ POWDER	Accessible backcountry & off-piste
★★★★★ PARK	Park times four, plus two halfpipes
★★★★ PISTE	A great mixture of groomed runs.

TOURIST INFO
Web: www.niseko.ne.jp/en

RESORT
Open dates: late Nov–early May
Night Skiing: Every day until 9pm, 20 runs open
Regular Hours: 8:30am – 4:30pm
Longest run: 5.6km
Total Lifts: 34 – 3 Gondolas, 7 Express chairlifts, 19 Regular Chairlifts, 5 Surface lifts
Average Snowbase: 3.2m
Average Snowfall: 11m

Almost the entire area is floodlit and open every night until 9pm. The lights are so bright that you can still ski/ride the trees between the pistes after sunset – it's a strange but incredible experience and often the slopes are empty. The lift system here is fairly modern with gondolas and express chairs whisking you to the top of the tree line. Above this point things do change somewhat with lots of slow one-man chairs ascending towards the peak. This lack of development is due to a change in environmental law; the resort is no longer allowed to develop the top few hundred meters, so its going to be single chairlifts forever it seems. This often leads to bottlenecks when crossing between An'nupuri and the Niseko Village area and is one of the few drawbacks to this extensive resort.

Powder

Niseko's highest lifts are all within a few hundred metres from the top of the mountain (Mt Annupuri, 1,308m). Most people looking for fresh lines head straight for the peak. A 20min hike from the top single chair will provide close to 360º of views from volcano to sea. It's worth noting that the lift line for this chair can get frustratingly long on a powder day, however the accessible terrain is almost endless with open powder bowls, trees and gullies. The length of your ride is governed by how far you want to hike to get back inbounds. The majority of the lines on the

Hanazono side end at a convenient cat track for your returning hike, although some runs from the peak can get you back to a lift without having to remove your skis or board at all.

Make sure you check the conditions before you head out-of-bounds, but most importantly, you're only allowed backcountry by going through one of specified gates. If the gate is closed then you're strictly not allowed in that area. Patrol do a good job of getting the gates open as early as possible so if you come across one that's closed, DO NOT ENTER, it'll be closed for a good reason. Heed the warnings and absorb as much knowledge from staff and locals as possible, making sure you know exactly where you're heading. You'll see plenty of status updates printed and placed at the bottom of the gondolas and at any of lifts that accesses these gated areas.

It goes without saying that you should be carrying your backcountry equipment when heading out of the boundary, however if you don't have all the necessary gear it is available to hire or buy – it's simply not worth heading out there without it. Furthermore, there are plenty of companies offering guiding services, so be sure to utilise them if you're not 100% confident. Alternatively, there's oodles of pow shredding to be done within the resort boundary between the nicely

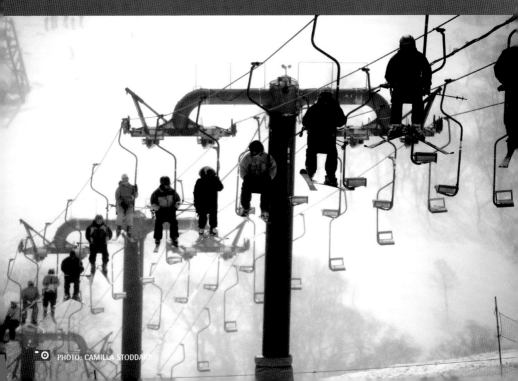

PHOTO: CAMILLA STODDART

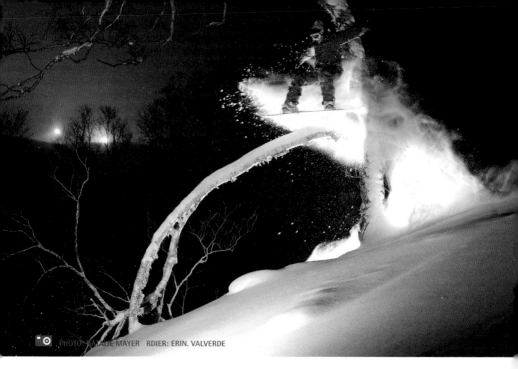

spaced birch trees. You'll find natural pillow lines in abundance and very few roped-off areas. Niseko's backcountry and off-piste is sensational with plenty to choose from all within easy access of the resort.

Park

Those looking for some fun freestyle action will not be disappointed with two halfpipes and four terrain parks. The parks range from beginner to expert and are well maintained with a good variety of hits and jibs. Stomping Ground is the main park and pipe and is found in Hanazono. It's accessed by the Hanazono No.1 lift, leaving from the Hanazono base area north of Hirafu town, and begins with a fairly good halfpipe leading onto two separate lines. Each line consists of few kickers and a number of different rails with kink options, flat boxes and C shapes. The bottom of the Stomping Grounds park features a slide-on-top bus to get your buttery goodness flowing, plus a further four or five more rails around the corner.

The second halfpipe is located in Grand Hirafu and is seemingly less consistent in terms of maintenance. It's tucked away on the Kokutai trail where you'll also find another snow park, known as the King Park and

geared towards beginners and intermediates. Niseko Village has the third park: simple but good, generally catering to intermediates and above, and serviced by the Wonderland one-man chair. Not to be outdone, An'nupuri has Niseko's fourth park. This one seems to be somewhat scattered around the ski area and caters mostly to intermediates. All in all, there's a huge selection of terrain park offerings at Niseko and pretty much something for every level.

Piste

The 1,000m vertical drop that Niseko offers will give those looking to clock up their piste miles plenty of opportunity. There are dozens of long wide runs especially heading towards the Hanazono area. That said, all areas have a good selection of groomed trails presenting a mixture of greens, reds and a few pisted blacks. The majority of marked black runs you see on the map are frequently left un-groomed and are either full of powder or mogulled-up, depending on the conditions. Generally speaking, Niseko's well-groomed runs provide an awesome choice for everyone wanting to stay on trail, from novice turners to expert high-speed carvers.

Beginner suitability

Beginners are catered for at all the different areas. Niseko Hirafu has the most popular learning terrain, with many different ski schools operating there and a number of easy green runs to play on. Niseko Village has some great novice terrain particularly the runs accessible from the Banzai chair. The Niseko Village area also has a very nice top-to-bottom green run and a good kids centre. By far the most beginner-friendly terrain is found at the Hanazono base.

New in 2008/2009, the two COVERED magic carpets provide easy access to the best learn-to-turn terrain Niseko has to offer. The only instructors that have the privilege of utilising this terrain during lessons work for Niseko International Snowsports School (NISS). For those with a day under their belt already there are plenty of options to slowly graduate up the mountain at a leisurely pace and a huge array of other ski schools to find good English-speaking instructors at.

Off the slopes

As previously mentioned, there are a number of base areas servicing Niseko United. The An'nupuri base area is very quiet and there's little but the huge Prince Hotel at Niseko Village. Whilst this can't really be considered a village, it does offer a huge array of comfortable resort-style facilities and there

are a number of pensions near by offering cheaper accommodation. Hirafu is the place for those wanting a proper ski town.

Not to be confused with the main town of Niseko found just down the road, Hirafu has a good number of onsen, bars, restaurants and places to stay, making for a nice selection holiday amenities. Many of these restaurants, bars and lodges are owned and run by Westerners so you can easily get away without any Japanese at all. There are still a few authentic Japanese restaurants but they have become the exception to the rule. There is a free shuttle bus service running around the resort but it seems to be a little intermittent. Prices are on the higher side in Hirafu as it's a destination in popular demand, particularly in the months of January and February. For further amenities and slightly more reasonable price tags you can head to the local town of Kutchan, just 10mins drive away.

Access

Sapporo's New Chitose airport is the gateway for most international visitors. At just 2hrs by bus, it's relatively easy to get here. There are numerous buses that operate the route and options to take the train too, although it's definitely more complicated. There are also buses operating frequently from the centre of Sapporo City.

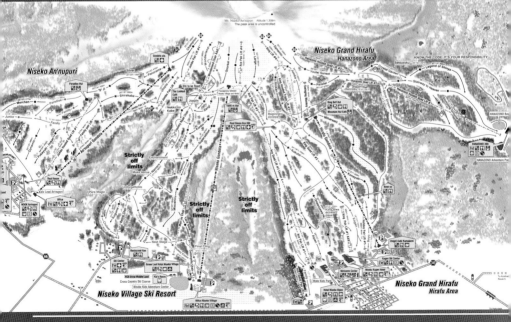

Rusutsu Resort

When Disneyland met a ski resort!

At the base of Mt Yotei set in an area of 4,000 hectares, Rusutsu is one of the largest and most unconventional ski resorts in Hokkaido. With incredible views over the Pacific Ocean on clear days, its attraction as a ski resort is almost out-shadowed by the fact that it feels like Disneyland on the snow. The towering roller coasters make an impressive backdrop to this family-orientated paradise, complete with a purpose-built hotel and resort complex providing endless attractions, ensuring its visitors never become bored.

The original Highland Lodge has changed somewhat since the opening in 1981 as the Rusutsu Kogen Hotel: since being extensively developed into the modern theme-park style resort it is today by the Kamori Kanko Group. Here you'll find everything from carousels and entertainment arcades, to wave pools and 4D movie theatres. Complimented by 42 kilometres of pisted runs accessed by 19 lifts, most suited to beginner and intermediate skiers/riders, Rusutsu is one of the most individual ski resorts in the world.

Powder

The off-piste policy here is "intentionally vague". Therefore, tree skiing and riding is permitted pretty much everywhere except if cutting ropes or skiing/riding under chairlifts. The tree runs in this resort are great fun on a powder day, offering lengthy descents of varying pitches, although there's nothing super-steep to really stoke the experts, however there are a number of drops and the odd pillow line to be had.

Rusutsu's snow quality is exceptional and fresh pow can stay untracked for days. The steepest runs here can be found down the Isola A, B and C face where powder usually collects after the regular snowfalls. The higher trees accessed by Isola Grand lift, dropping above the Isola A run, tend to stay untracked for

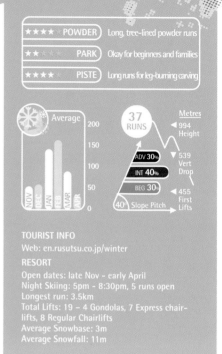

★★★★ POWDER Long, tree-lined powder runs

★★ PARK Okay for beginners and families

★★★★ PISTE Long runs for leg-burning carving

Average

200
150
100
50
0

NOV DEC JAN FEB MAR APR

37 RUNS

Metres
◄ 994 Height

ADV 30%
▼ 539 Vert Drop

INT 40%

BEG 30
◄ 455 First Lifts

40 Slope Pitch

TOURIST INFO
Web: en.rusutsu.co.jp/winter
RESORT
Open dates: late Nov – early April
Night Skiing: 5pm - 8:30pm, 5 runs open
Longest run: 3.5km
Total Lifts: 19 – 4 Gondolas, 7 Express chair-lifts, 8 Regular Chairlifts
Average Snowbase: 3m
Average Snowfall: 11m

longer and the area below Isola Quad No.1 often keeps till much later in the day. By dropping in skiers right from under Isola No.5 Pair you can access a fun gully, cutting back and forth effortlessly creating a zigzag pattern that makes the run twice as long, if you legs can hold up to the burn. Intermediate off-piste skiers and riders will enjoy the trees between Heavenly View and Heavenly Ridge as they're fairly mellow and the piste can be easily accessed if falling over in powder is high on your list of things to avoid. Also, this area offers amazing views providing plenty of photo-break opportunities while your amigos lap around.

Ski Patrol are pretty relaxed here and are only concerned for your safety. Backcountry is not really allowed but possible at your own risk, therefore full equipment, transceivers and knowledge of the area/snow conditions is essential.

Park

Rusutsu's marketing focuses on families; and so does the park. The small but well-built and maintained features provide a playground that is perfect for beginners and intermediates, all within a 100m area just above the horse stables and Rusutsu Resort Hotel, on West Mountain. There are usually a few smaller jumps, a box and rail, 2 wall rides, and a mini skate bowl section. All the features are regularly maintained but the snow park is not the main attraction at this resort and local rippers are rarely seen. Earth-shaped before the snow falls, Rusutsu's 'halfpipe' – although more of a ditch that a pipe – has some potential, but has really lost its way. It's maximised when laying first tracks through it after a fresh dump. The pipe has certainly been lost in translation!

Piste

Rusutsu's three mountains, East, West and Isola are serviced by 19 gondolas/lifts and criss-crossed with 37 different trails, making up the 42kms of pisted runs. The trails are wide and well groomed, serviced by detachable lifts run at high speeds to maximise your time on the slopes. The contrasting pitches of the runs allow something for everyone in this resort although the terrain will not challenge advanced to expert levels. West Mountain, just behind the hotels, is a great warm up and has several beginner-intermediate slopes accessible from its 5 different chairs. There's also a few advanced, un-groomed steeps plus a great mogul run located right under the West Gondola dropping down to the scenic roller coaster park below. West Mountain has such varying pitches that it makes a great area for families and groups of mixed levels who wish to access different terrain but meet up to ride the lift together. Its close proximity to the hotels and main resort complex means that it's perfectly suited for night skiing, which takes place until 9pm every night.

From East No. 1 Gondola the larger East and Isola mountains can be accessed. Mt Isola has a large array of intermediate runs that travel down the fall lines of several gullies and finish at one of the 6 different

PHOTO: SARAH MULHOLLAND

chairlifts. The runs here are generally un-crowded, even at weekends, and lift lines are rare. Isola No. 4 Quad accesses some very scenic trails down Heavenly View and Ridge, but the lift only runs at weekends. The same area can be accessed with the Isola No. 3 Quad, which stretches all the way to the peak for some breathtaking views of Lake Toya and the Pacific Ocean. Rusutsu doesn't offer too much for the advanced carver, as their steeper runs tend to be un-groomed and fairly short, descending rapidly into the flatter gully bottoms.

Beginner suitability

This resort is a paradise for beginners. There are several green runs on both East and Isola Mountains that offer great novice level terrain. However, snowboarders linking their first turns may find West Mountain much better suited to their needs. The most convenient area of the three, West Mountain is certainly the most beginner-friendly and has terrain of varying pitches to keep any more experienced partners or parents amused. The 'White Lover' and 'Family' runs are ideal for first time skiers and snowboarders, offering a gently rolling pitches perfect for practicing turns. Group and private lessons are available with English speaking instructors. Rental shops provide up-to-date equipment and the 'Fresh Skiers Programme' provides a cost effective group two-hour beginner lesson package for up to 6 people.

Off the slopes

When the sun goes down, the Rusutsu Resort complex offers maximum entertainment for all, ensuring your hard day on the slopes will be rewarded. In the base of the North Wing the carousel and amusement park are surrounded by a small shopping mall. Themed attractions and a Disneyland feel on the inside of this vast complex make it a kids dream, no matter what the age.

The amusement arcade has a Wild West Interactive ride, a 4D Movie Theatre and so many skill-cranes and video games that you can easily become absorbed for hours, almost forgetting that this is just one small area within the whole complex. An indoor swimming pool with a waterslide and wave machine, plus an onsen bath and a full size gymnasium also feature high on the entertainment priority list. Then there's the karaoke rooms and tea lounges that can be found in the North and South Towers, and Highland Lodge. The hourly musical fountain show in the South Tower is defiantly one to watch, giving Rusutsu a very 'Las Vegas' atmosphere.

Winter outdoor activities include dog sledding, horse riding, motocross, snowmobiling, snow rafting, orienteering, jet trains and night snow cat cruising. The indoor activities are just as extensive with handy crafts, glassmaking, leatherworking, pinhole camera courses and lessons on bakery, cheese, potato cake, and ice cream making, all available if you feel you

need to grow your list of skills. They're well worth the time, even if it's just for the story that you went on a skiing holiday to a resort with roller coasters and learnt how to make cheese.

The outdoor roller coaster amusement park is only open in summer due to the harsh weather conditions of winter. Golf courses, 4 of them in total, compliment the seminar and conference centres allowing this Resort to be used by businesses for rather unique conventions. A monorail links up South Tower to Highland Lodge and the Tower Lodge throughout summer and winter. Cheaper accommodation in the form of pensions can be found alongside the main road and just outside the resort.

Rental shops, day care, kindergarten, a waxing room, ski lockers and laundry rooms are available for guests of the hotel. A total of 16 restaurants can be found throughout the complex including Chinese, traditional Japanese, Italian, French and general buffet-style cuisines, catering for almost every taste. Oktober Fest is a particularly amusing buffet dinner venue with German-style singing puppets putting on a show as you make your way through the vast selection of dishes available. After all of this, there are various sports bars to help complete your evening. However, if you're not completely exhausted by this point, then maybe you haven't experienced the full extent of Rusutsu's crazy wonderland.

PHOTO: KEITH STUBBS

Access

Rusutsu Resort is located about 90mins by road from Sapporo's International New Chitose Airport and 40mins from Niseko. There are buses from both Sapporo Central Station and the airport running daily and taking a little under 2hrs.

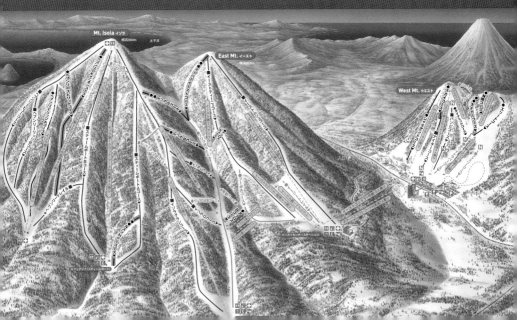

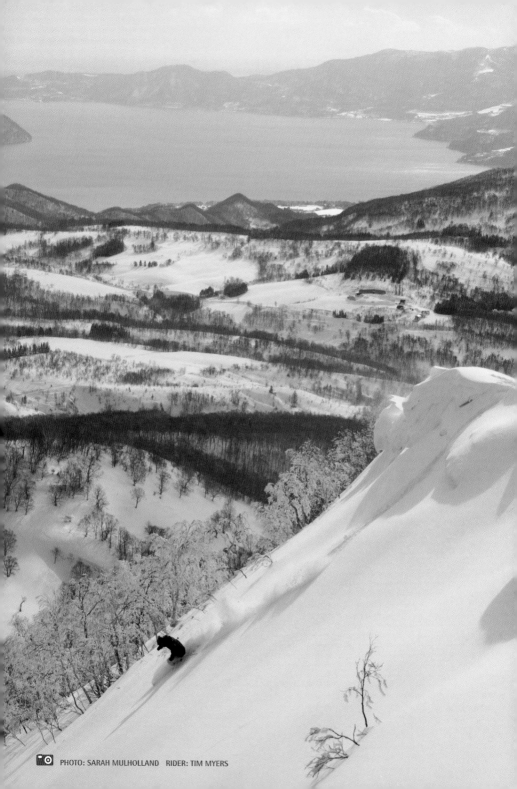

PHOTO: SARAH MULHOLLAND RIDER: TIM MYERS

Kiroro Snow World

★★★ (POWDER) Regular powder days, average terrain
★★★ (PARK) Spring good, limited in mid-winter
★★★★ (PISTE) Long, wide & consistent.

Average 200
150
100
50
0
NOV DEC JAN FEB MAR APR
snow-forecast.com

21 RUNS
ADV 35%
INT 33%
BEG 31%
36° Slope Pitch

Metres
◄ 1180 Height
▼ 610 Vert Drop
◄ 570 First Lifts

TOURIST INFO
Web: www.kiroro.co.jp/english
RESORT
Open dates: late Nov – early May
Night Skiing: until 8pm, 3 runs open
Longest run: 4km
Total Lifts: 9 - 1 Gondola, 5 Express Chairlifts, 3 Regular Chairlifts
Average Snow-base: 2m
Average Snowfall: 13m

Regular snowfalls and modern lift facilities. Great for intermediates!

area complete with hotels, restaurants, shops, a swimming pool and hot spring, a kids snow park and adults snowmobile centre; pretty much everything except a lively bar. There's no local ski town here, so it's not somewhere you would think of visiting for a two-week holiday; maybe a long-weekend though.

Powder

The freeriding terrain at Kiroro is reasonable. Like a number of other resorts in Japan, skiing or riding the trees is not officially allowed although the patrol staff here have some discretion and will leave you alone if you look like you can handle it. As for the snow... well, powder days are so frequent that locals just take it for granted, meaning there's absolutely no need at all to race for first tracks. Head up Nagamine Peak and ride Powder Line when it's fresh. This is the most publicised un-groomed trail and is good to warm the legs up. If you're keen for something a little steeper take the gondola up to Asari Peak and crank it down the C Course. For the most part, you'll see plenty of tempting tree-riding options at Kiroro with some fun little pillow drops and banks. Watch out for the flat sections though, they creep up on you quickly if you're not paying attention.

Park

Overall, the freestyle opportunities at Kiroro are fairly standard. The main terrain park, located near the base area and accessible from the Centre Express lift, is pretty limited during mid-winter due to the constantly falling snow. There's some okay rails and a range of jumps that seem to change dramatically depending on the time of season. When springtime rolls around the park guys push harder to maintain a more diverse range of features and often build a second terrain

Kiroro Snow World was originally created by Yamaha (yep, the guys that make keyboards and motorbikes!), but recently sold it to another, more ski-orientated company. The coastal-Hokkaido location means this resort receives ludicrous amounts of snow. The quality is slightly wetter than that of Hokkaido's more inland resorts, but with over 14m's a season, who really cares?

The abundance of white stuff means the resort opens earlier than anywhere else in Japan and doesn't close till late May, permitting approximately 167 riding days in total. The lifts here are of a high standard; mostly detachable high-speeds with bubbles helping to keep the frost bite off your face. They currently access a moderate range of terrain options spreading over two peaks: Nagamine and Asari. What's more, Kiroro have plans to expand the skiable area over the next few years. Kiroro have a resort-style base

HOKKAIDO

There's also a new kids centre / ski school catering well to international guests.

Off the slopes

As mentioned previously, there's no ski town servicing Kiroro. The resort has two accommodation options: the Mountain Hotel found right at the resort's base and the Hotel Piano which makes up a large part of the resort complex – just 10 minutes walk from the lifts (or 2mins on a shuttle bus). Both offer a range of prices and very comfortable rooms.

Eating options on the mountain are vast and varying in prices. Down below, at the Hotel Piano Resort Complex, you have about 10 different restaurants to choose from. The Ginza Lion is a funny Beetles-tribute restaurant with a balanced menu of Japanese and western food. Yangsuu is a nice D-I-Y style BBQ place but a bit overpriced for what you get. And Pop is a good all-you-can-eat buffet, well worth it if you've got a big appetite. Nightlife here is non-existent. There's a flashy bar in the Hotel Piano where the barman will devise some interesting Japanese cocktails, but make sure your bring your Platinum Visa Card! Alternatively, you can rent a Karoke room with your mates and create your own entertainment.

Access

Kiroro is just 1hr 30mins drive from Sapporo or 2hrs 30 from New Chitose Airport. There are frequent bus services running 2/3 times a day from the centre of the city. The closest train station is Otaru, but that's followed by a local 1hr bus ride, so not particularly convenient.

park further up the hill on Asari A Course. This usually hosts a line of three or four small-medium tabletops. Unfortunately, there's no halfpipe to be found at Kiroro for now, but times change and there's talk of building one in the future.

Piste

The range of groomed trails at Kiroro is decent. They're fairly long and wide, varying in pitch, well maintained and most of them finish at a high-speed lift. If you like to carve up the trails you'll be guaranteed to get your quotas worth here. For the best pick of a good bunch head to Nagamine A and C Courses. And if moguls float-your-boat then check out Nagamine B Course too.

Beginner suitability

Beginners have a small 2-man chair lift at the base area accessing a nice easy slope perfect for learning the basics, after which there are many choices to progress on to. Longer intermediate runs include Yoichi B Course from the Yoichi Express Quad and the lengthy Panorama Course from Asari Peak accessed by the gondola. There's a good ski school here but if you're planning on having a lesson you'll need to book in advance to guarantee yourself an English speaking instructor.

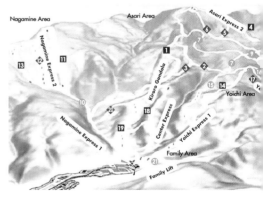

Sapporo Bankei

★★ ★ ★	**POWDER**	Limited terrain but north facing slopes
★★ ★ ★ ★	**PARK**	Nothing to shout about.
★★ ★ ★ ★	**PISTE**	A few steeper groomers.

13 RUNS

	Metres
◄ 483	**Height**
ADV **30%**	▼ 283 **Vert Drop**
INT **40%**	
BEG **30%**	◄ 200 **First Lifts**
33° Slope Pitch	

TOURIST INFO
Web: www.bankei.co.jp/skiarea/skitop.html

RESORT
Open dates: Dec – early April
Night Skiing: 4pm – 10pm, 9 runs open
Longest run: 1.3km
Total Lifts: 6 – 6 Regular Chairlifts
Average Snow-base: 1.2m

Sapporo's most convenient ski resort.

Sapporo Bankei is a small, northerly-facing resort found in Sapporo City itself and is literally just 15mins drive from the center. Although the resort has a limited selection of terrain, it's still worth visiting for an evening under the lights. And with night skiing on till 10pm, along with the ability to purchase passes by the hour, Bankei is certainly definable as 'value for money'. If you're in Sapporo for a few days and develop an itch for some quick shred action, this is the place to go.

Powder

Like all resorts in Hokkaido, Bankei gets some quality snow; and it stays in quality condition too, with the majority of slopes being north facing. However, the freeriding terrain is rather limited and with such a short vertical drop you can't really

HOKKAIDO

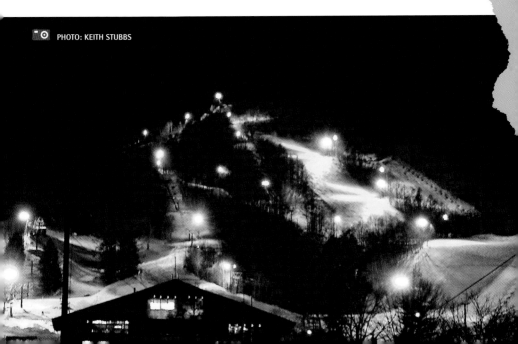

PHOTO: KEITH STUBBS

expect too much. There are a couple of steepish, un-groomed faces found on the resort's upper slopes, which are accessible from the main 3-man chair. There's also a few simple bowls dotted around that can be satisfying with some fresh snow. The trees are fairly inaccessible as they're so tight, so you're limited to the maintained trails. Fortunately for the resort, this leaves any off-piste decision to the laws of nature.

Park

Freestyle facilities are also on the slim side here. Bankei have a very basic park, located on Central B Course, with a few boxes and some small kickers, in addition to one larger tabletop. Park maintenance doesn't seem to be the highest of priorities here, so if you're in search of jib-centric spots, this ain't it! You will find a number of fun natural hits and cat track drop-offs to practice those buttery spins on though.

Piste

The groomed courses are well taken care of here. Carving fanatics will find some nice corduroy to layout those smooth arcs. The steepest run is accessible from the upper-most chairlift called Orange. The lower trails offer consistent pitches at lesser angles.

Beginner suitability

Beginners are well catered for with the largest Ski School in Hokkaido. There's a good few English-speaking instructors to help you on your way and lessons are reasonably priced too. Bankei has a number of different lifts accessing perfect learn-to-turn terrain; have a look for the shorter 2-man chairs around.

Off the slopes

Eating options on the slopes are limited to one café at the resort's base. Prices are standard as is the menu. There's a great BBQ-style restaurant located adjacent to the base area, known as 'Gams' – well worth a visit after a good evening on the snow. They serve up some tasty homemade sausages and offer an all-you-can-eat Lamb deal for next to nothing. It's a quirky little place known for its electric train that brings your food and drinks to your table. Definitely good for a few laughs!

Access

Bankei is 20mins drive from downtown Sapporo; taxi and lift ticket packages are available. There are buses every 30mins from Maruyama-koen Subway Station.

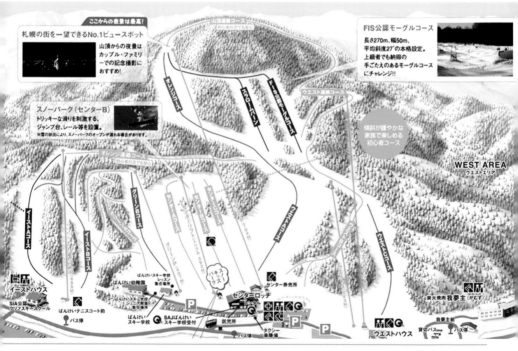

Sapporo Kokusai

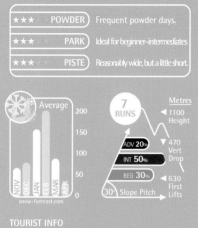

★★★ **POWDER** — Frequent powder days.

★★★ **PARK** — Ideal for beginner-intermediates.

★★★ **PISTE** — Reasonably wide, but a little short.

Average
200
150
100
50
0
NOV DEC JAN FEB MAR APR
snow-forecast.com

7 RUNS
ADV **20%**
INT **50%**
BEG **30%**
30° Slope Pitch

Metres
◀ 1100 Height
▼ 470 Vert Drop
◀ 630 First Lifts

TOURIST INFO
Web: www.sapporo-kokusai.jp/english

RESORT
Open dates: late Nov – early May
Night Skiing: not available
Longest run: 3.3km
Total Lifts: 5 - 2 Gondolas, 1 Express Chairlift, 2 Regular Chairlifts
Average Snow-base: 3m
Average Snowfall: 14m

A fun mid-sized resort close to Sapporo City.

Sapporo Kokusai is located about 60mins drive from the centre of Sapporo City. It's a mid-sized sized resort, popular with snowboarders, offering a nice mixture of riding opportunities for both locals and visitors alike. Japanese skiers and riders that want to do a season without the hassle of moving to a resort often take a part-time job in Sapporo and spend their free time skiing or riding here.

Kokusai maintain a fairly small but decent park and often have a boarder/skier-cross track too. The trail map only shows 6 runs in total, however the map's perspective is rather poor and the runs are actually a lot longer than they first appear. Much like the resort of Kiroro, Sapporo Kokusai gets well and truly dumped on during the winter months granting many a powder day. The off-piste regulations could definitely be considered a grey area and you'll find some interesting terrain that's easily accessible – but use your discretion. The lift system and base facilities are modern, with

a gondola accessing the resort's peak and a few high-speed detachable chairlifts floating around. There's no town here and no hotels at the base, so visitors tend to stay in Sapporo City and make the 1hr drive out for day trips.

Powder

Any powder seekers heading to Kokusai will appreciate the remarkably regular snowfalls that occur here. Being a costal resort it snows very frequently and falls in massive amounts. The downside is that there's nothing particularly steep. Kokusai, much like it's not-so-distant cousin Kiroro, was built on fairly mellow rolling hills and has little to offer high-level freeriders. Having said that, the Downhill Trail offers some nice lines getting up to 35° in pitch, as does the run leading from there onto Eco Trail. Tree skiing/riding or off-piste at Sapporo Kokusai is very much a grey area. Whilst the resort states that off-piste is not permitted, the options are numerous and the Patrollers generally just look the other way. Take a peak at the fun terrain visable as you travel up the Sky Cabin gondola: this looks very tempting (and is super-fun), but it's not the best decision to ski or ride directly underneath the lifts. So whilst the snow here is of a high standard providing regular powder days, the terrain and rules are somewhat limiting and there's little in the way of backcountry access which, by the way, is considered a definite no-no.

Park

Park skiers/riders are well catered for here. The main terrain park, found on the Woody Trail, is aimed at beginner and intermediate freestyles. It offers a super nice triple-entrance tabletop varying in size from 3 to 9 meters (10 to 30 feet). Here you will also find dozens of easy rail features leading on to series of small jumps and rollers. If you like a jump with a bit more weight to it, head down the

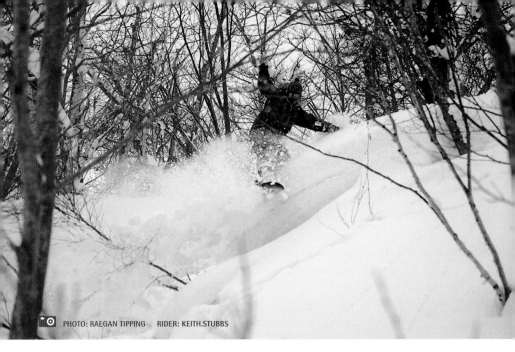

PHOTO: RAEGAN TIPPING RIDER: KEITH.STUBBS

Swing Trail and check out Kokusai's biggest booter – a hefty step-down with a gap around the 15 metre mark (50 feet-ish). Of course, these features change depending on the time of season, but Kokusai is known with the locals for consistency and regular shaping of its features. Unfortunately there's no halfpipe here any longer, but they do occasionally build a quarterpipe. They also often have a boarder/skier-cross course where they hold a number of regional competitions.

Piste

Those looking to cruise the pistes at Kokusai will enjoy the Swing Trail and the Down-hill Trail the most. Both are reasonably long with excellent grooming that present opportunities for some nice long carved turns. It's worth noting that there's a section on the Down-hill Trail that the Cat Drivers leave un-groomed, so if you're of a lower level it's best not to head that direction. There's little in the way of steeper groomed runs here, so if you fancy yourself as a GS racer this isn't the resort for you. However, if you're up for an easy day of piste skiing/riding and enjoy fairly long and wide runs, this could well be a good choice.

Beginner suitability

Sapporo Kokusai is a good resort to learn at. Beginners will be content when riding the Fairy

Tale Trail from the Quad Chair back towards the base area. It's a nice long run with the perfect gradient for those starting to link their turns together. Those keen for a little more adventure should try out their skills on the Family Trail next. English-speaking instructors are available on request but you may need to arrange this ahead of time.

Off the slopes

No town here, this is just a ski area. However, with the city of Sapporo on your doorstep who needs a town? Kokusai's base facilities are good. Food outlets on the mountain, all found in the base area complex, are priced reasonably and with four different cafés/restaurants to choose from you should easily find something to please your belly: sit down for a hot curry or grab something quick and fried to takeaway. The selection is varied. There's also a nice chill-out area full of comfy couches to take a break – or even have a little sleep, as is the local custom in Japan.

Access

Within an hour drive of Sapporo City on the Sattaru Expressway, Kokusai is pretty darn accessible. There are buses running from Sapporo Station and the city's central hotels. Taking the train here is not a viable option, so use the buses or hire a car.

Sapporo Teine

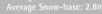

★★★★	POWDER	Great off-piste for a small resort
★★★	PARK	Quality features for inter/adv
★★★	PISTE	Ranging from steep to flat

Average 200 150 100 50 0

NOV DEC JAN FEB MAR APR

snow-forecast.com

15 RUNS

ADV 30% INT 35% BEG 35%

38° Slope Pitch

Metres
◄ 1023 Height
▼ 650 Vert Drop
◄ 340 First Lifts

TOURIST INFO
Web: www.sapporo-teine.com/snow

RESORT
Open dates: late Nov - early May
Night Skiing: 4pm - 9pm, 4 runs open
Longest run: 6km
Total Lifts: 13 - 2 Gondolas, 1 Express Chairlift, 10 Regular Chairlifts
Average Snow-base: 2.8m

A surprisingly well-rounded resort with great off-piste!

Even as one of the host resorts for the 1972 Winter Olympics, Sapporo Teine is still relatively unknown in the Western world. It's close proximity to the centre of Sapporo City and the panoramic ocean-to-urban views make this resort both convenient and attractive. Combine this with some tantalising off-piste terrain, wide trails and a well-built snow park, and you have a thoroughly standout resort.

Once upon a time Teine was two completely different ski resorts. Now owned by the Kamori Kanko group (also owning Rusutsu and Sahorro), Teine is still comprised of two areas: Teine Olympia and Teine Highland. Teine Highland is where the more engaging terrain can be found. With specific areas of permitted off-piste and a number of 'secret' steeper pitches, these tree-lined faces offer some worthy challenges for advanced skiers and riders. Teine Olympia offers more mellow terrain, with wide groomers, gentle learning slopes and a compact but quality park. Overall the lift system is efficient, comfortable and well laid-out. It's worth noting that the cable car on Teine Highland didn't operate for the '08-'09 winter season and may not be used for future seasons. However, accessing the exact same steep terrain is the fastest chairlift in Hokkaido – the perfect quad to lap on one of Hokkaido's renowned powder days.

Powder

Quite unexpectedly, as a resort that's just 30mins from the centre of Sapporo, Teine offers considerable off-piste terrain ideal for both intermediate and advanced powder enthusiasts. On the trail map, you'll notice a number of shaded areas indicating the places you can go to shred trees without breaking any rules. The marked area named N2 is great for upper-level skiers and riders, whilst the area called N1 is a little less intimidating

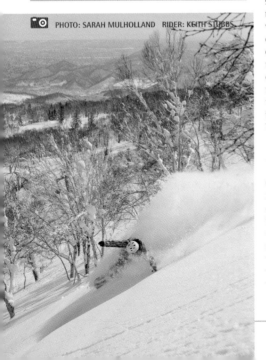

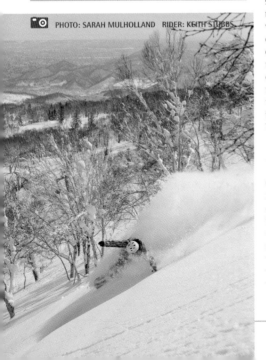
PHOTO: SARAH MULHOLLAND RIDER: KEITH STUBBS

HOKKAIDO

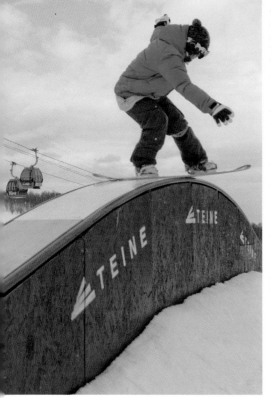

variety and a few jib lines. The rails and boxes are of a good standard offering both ride-on and gap-on options. The park at Teine is known to move locations depending on snow levels, but more recently it's been found on the run named 'O2', accessible from a short double chair.

Piste

Back in '74 Teine was used for the Olympic Slalom and Giant Slalom events. It's steep pitches are perfect for laying our some high-speed carves, although the run they used for those events is never groomed these days and makes a better mogul run for those who like to hit the bumps. Head to the trail named H3 for the next steepest pitch if you're looking to layout some deep trenches. Alternatively, check out O6 in the Olympia area for more steep corduroy and O7 for a little less pitch.

Beginner suitability

There are two different ski schools to be found at Teine, one in each area. English-speaking lessons are known to be available, however like most of the lesser-known resorts in Japan, it's best to book in advance. With more suitable beginner terrain down in Olympia and the harder stuff up in Highlands, this resort makes a great day trip for those couples with a massive split in ability.

and more suitable for intermediates. There are 3 other permitted off-piste sections, known as N3, N4 and surprise, surprise... N5. Most of these marked off-piste areas offer nicely spaced tree lines sitting on a northeast aspect, meaning the snow stays cool and fresh. It's often easy to score fresh tracks many days after a big storm has rolled through, unless it managed to time its delivery of the white stuff with a weekend – typically the time when Teine is at it's busiest. The actual north side of Teine is considered out-of-bounds and there's many a sign telling you it is not permitted to ski there – something that is subtly ignored by the locals.

Park

Teine Olympia keeps a compact but perfectly shaped terrain park best suited to intermediate and advanced freestyle riders. With just a few kickers, the park here certainly can't be considered big, but it is well built and fun for those who are already comfortable in the air. There's usually a few different lines to choose from, one of the jump

Off the slopes

There's four different restaurants/cafes to be found at Teine, offering a range of food and beverages. Prices are reasonable and the quality is decent. The three base areas are spread out allowing customers with a car a wide choice of parking depending on where you want to ski or ride. That said, the Highland base area seems to be the most convenient. With Sapporo City just 30mins away, accommodation and entertainment is in abundance. The Art Hotel Sapporo offers some reasonable packages, accommodation and passes inclusive. They also run a complimentary shuttle bus to the slopes of Teine, however it can take quite a bit longer than driving yourself.

Access

In good traffic the centre of Sapporo City is just a 30min drive. In bad traffic it can take over on hour. Access from Sapporo New Chitose, the main international airport, isn't particularly convenient. It's best to make your way into the city and then bus or drive out to the resort.

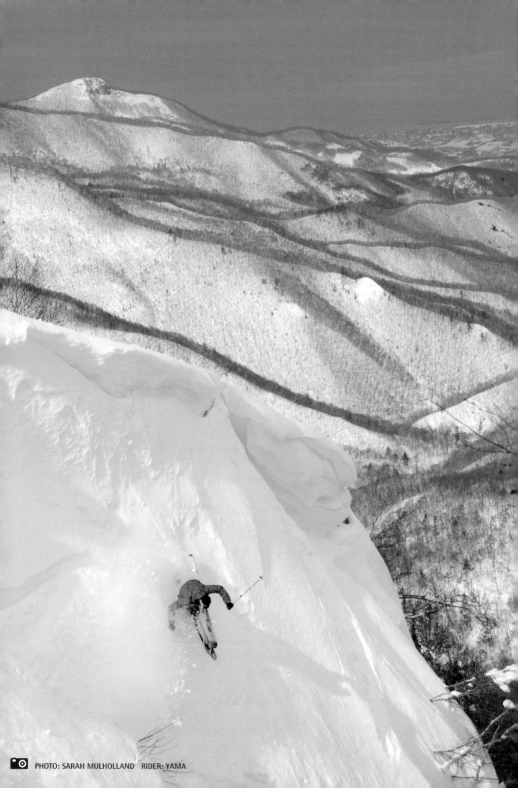

Furano town

A popular winter and summer destination for both Japanese and foreigners!

Known for its abundance in lavender as well as its cold and crisp conditions, Furano is not only the skiing-hub of central-Hokkaido, but it's a major all-season destination for many Japanese holiday makers. In essence, this is a farming town with a sizable tourist tint, making for a pleasing blend of old and new. Combine all the necessary tourism infrastructures with Furano's attractive landscapes, collection of traditional buildings, charming people and the huge array of local produce, and you have a town that ticks almost all the boxes for most Western snow-goers in Japan. Even with the English-speaking interest, Furano is a town that's managing to avoid becoming overly westernised.

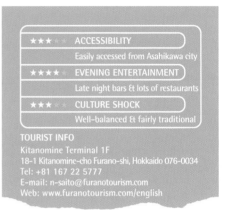

★★★☆☆	ACCESSIBILITY
	Easily accessed from Asahikawa city
★★★★☆	EVENING ENTERTAINMENT
	Late night bars & lots of restaurants
★★★☆☆	CULTURE SHOCK
	Well-balanced & fairly traditional

TOURIST INFO
Kitanomine Terminal 1F
18-1 Kitanomine-cho Furano-shi, Hokkaido 076-0034
Tel: +81 167 22 5777
E-mail: n-saito@furanotourism.com
Web: www.furanotourism.com/english

The area called as Rokugo is well known domestically the as the setting for an old Japanese television soap called 'Kitano Kuni Kara', translated as 'From The Northern Country'. This attraction, combined with the local lavender and other such produce means it is actually busier in summertime than in winter. The months of January and February still pull in a steady numbers, but March is typically quiet – and there's often still great snow to be had. Furano is split between the main town, the Rokugo area and the Kitanomine area servicing the Kitanomine side of Furano Ski Resort. Most of the tourist facilities are concentrated in Kitanomine offering a wide range of accommodation and dining. Further options can be located within Furano's main centre, where a large selection of restaurants and cafes, and a few bars, can be found.

Accessibility

Located just a short distance from the city of Asahikawa and a few hours drive from Sapporo, Furano is easiest to access through Asahikawa Airport, but a little further from Sapporo's New Chitose Airport. Travelling to Furano internationally can be a little tricky as flights only go into New Chitose from Asian cities like Hong Kong and Seoul. You can get here through Tokyo, but that often requires a change from Tokyo Narita Airport to Tokyo Haneda, especially if flying direct into Asahiawaka.

Furano also has a train station on the Nemuro Honsen Line. It's a direct train from Asahikawa City, but when travelling from Sapporo you're required to make a change at Takikawa Station, which can be a hassle with lots of baggage. The most efficient and simplest means of transfer are the direct buses from both Asahikawa Airport and Sapporo New Chitose Airport.

The town sits right at the base of Furano Ski Resort and accesses two different base areas with a free shuttle bus service connecting all the dots till about 10pm in the evening. Other well-established ski resorts accessible from Furano town include Alpha Resort Tomamu and Kamui Ski Links.

If you don't have the convenience of your own vehicle, getting to Kamui and Tomamu is relatively simple with the slightly infrequent shuttle service to and fro. Also within reach are the impressive backcountry areas of Asahidake and Tokachidake. However, the main ways to get to these secret stashes is with a guiding service or under your own steam, although there's a regular bus service up to Tokachidake from the nearby Kami-Furano.

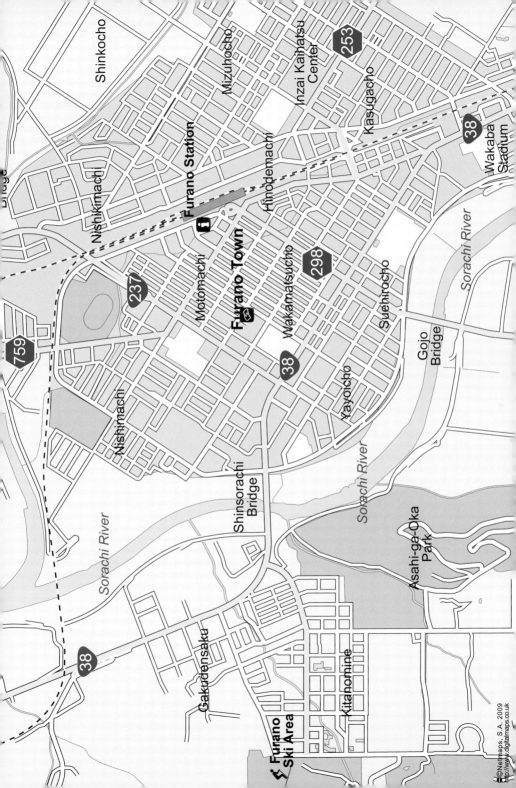

Shinkocho

Shinkochō

Mizuhochō

253

Inzai Kaihatsu Center

Kasugacho

38

Wakaba Stadium

Furano Station

Hinodemachi

Sorachi River

Nishikimachi

i

Furano Town

298

Suehirocho

237

Motomachi

Wakamatsucho

Gojo Bridge

759

38

Yayoicho

Nishimachi

Sorachi River

Shinsorachi Bridge

Asahi-ga-Oka Park

Sorachi River

38

Gakudensaku

Kitanomine

Furano Ski Area

Evening entertainment

Like most Japanese ski towns Furano is a little sleepy when compared to the big party resorts of Europe and North America. Still, with over 200 restaurants and bars to choose from you'll never have to visit the same place twice. However, you wont find any bouncing nightclubs here – it's simply not that type of town. Head to Bar Bocco for an enjoyable evening mixing with the locals or if you're seeking a big night out check the Kareoke bars for their happy hours before midnight and finish off at one the 500yen shot bars tucked away on the back streets in the centre of town. If you're staying up in Kitanomine and don't fancy the journey into the centre, try Café & Bar Tirol for a quiet drink served by one of their pretty bar maids or head to Bar Ajito for well-priced cocktails and a few games of pool.

If it's a unique dining experience, you wont be disappointed. From Sushi and other traditional Japanese dishes to Mongolian BBQ's and Teppan Yaki – the selection is enormous. Some top picks have to be Yuiga Doxon for a very unique but extremely tasty curry, and the Furano Brewery Yama no Doxon, where you will receive some of the friendliest service possible whilst drinking their thirst-quenching home-brewed beers and eating their tasty Curry Dorias. Also, be sure to try the Okonomiyaki (Japanese pancakes) at Teppan Yaki Masaya.

Culture shock

Furano town is well adjusted for overseas tourists. The local tourist office has a few fluent English speakers and many an English brochure to help you make those key decisions like where to buy your postcards. Even so, as there's only a small resident Western population here you still feel like you're well ensconced in Japan.

There's a nice element of Japanese culture present in Furano, although, as is with most of Hokkaido, you don't get quite the same richness in tradition as you see in Honshu. It's fairly easy to find Western food and English-language menus, with approximately half the eateries in town catering to this market, whilst the rest generally have pictures to make the selection process

simple. Many of the service staff you'll encounter will understand enough English to interpret your requests, however don't rely on this entirely and carry a phrase book with you – it's good to make an effort. Visit the Furano Tourist Office in Kitanomine if you need some English language assistance, or drop in to Furano Connection (also in Kitanomine) for bookings direct with the local operators – they're always keen to offer friendly advice and meet your personal needs.

Accommodation

Options here are plentiful. From backpacker style B&Bs to up-market Western hotels, there's a lot to choose from. All ski-in / ski-out options are owned by the Prince Hotel Group and are at the upper-end of the price spectrum. Check out North Country Inn for a good value English-speaking hotel. It's a little out of town but they run their own shuttle bus service to the Furano ski lifts (taking just 5mins) and are on the town's bus route too. Alternatively, there are many different pensions dotted around the Kitanomine area, of which Snowflake Lodge is highly recommended. This cute little place offers simple accommodation with excellent service at reasonable rates – plus it's close to the bars and restaurants. Finally, if you're on

a tight budget Alpine Backpackers is the best low-cost accommodation in town.

Sightseeing and other activities

Furano is home to a small number of shrines and temples; all of which are lovely, but not as historical as you would find in other parts of Japan. As mentioned previously, the area called Rokugo is popular with the Japanese. The area known as Ningle Terrace is a series of cute little craft shops in the woods found at the Furano base area. The Goto Sumio Museum of Art makes for an interesting afternoon off the snow, as does the local cheese factory and winery. But if you're craving something sweet, pay a visit to the Furano Delice in Kitanomine. Conveniently close to the ski lifts, Delice has a large team of bakers churning out an impressive array of sweet treats – perfect for a mid-afternoon snack when you're finished on the slopes.

For more action-orientated individuals there's dog sledding and snow-mobiling to be enjoyed. Tokachidake is well worth a visit too, if not for its stunning backcountry skiing, then for one of its four different onsen – there's even a completely wild onsen up there, but watch out, it's extremely hot!

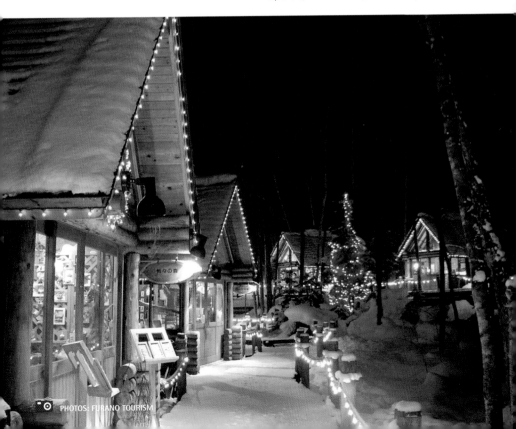

Alpha Resort Tomamu

Something for everyone: off-piste, on-piste, park and pipe, plus backcountry.

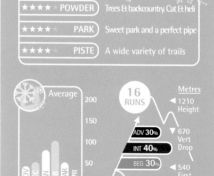

★★★★☆ POWDER	Trees & backcountry. Cat & heli	
★★★★☆ PARK	Sweet park and a perfect pipe	
★★★★☆ PISTE	A wide variety of trails	

This is a resort that caters for all kinds of skiers and snowboarders. From families with little rippers wearing over-sized helmets, to powder seekers and park rats. Its central-Hokkaido location means the pow is super dry and the snow stays in great shape for weeks at a time with the help of the cold climate. That said, it can get rather chilly here, especially in the months of January and February.

The main resort is spread over two peaks with ten different lifts accessing a good variety of terrain options, all offering a view over their crazy tower hotels into the mountains beyond. Unlike many Japanese resorts, Tomamu allows you to ski off-piste! Riding in the trees is actively encouraged here and the resort provides off-piste tours plus some great backcountry guiding services including cat and heli skiing. It has a worthy terrain park plus an amazing superpipe, and some great 'secret' feature areas for children (or even us big kids).

Average — Snowfall chart: NOV, DEC, JAN, FEB, MAR, APR (200, 150, 100, 50, 0)

16 RUNS

Metres
◄ 1210 Height
▼ 670 Vert Drop
◄ 540 First Lifts

ADV 30%
INT 40%
BEG 30%

35° Slope Pitch

TOURIST INFO
Web: www.snowtomamu.jp/en

RESORT
Open dates: Dec - early March
Night Skiing: 4pm- 7pm, 2 runs open
Longest run: 4km
Total Lifts: 10 – 1 Gondola, 2 Express chairlifts, 7 Regular Chairlifts
Average Snowbase: 2m
Average Snowfall: 4m

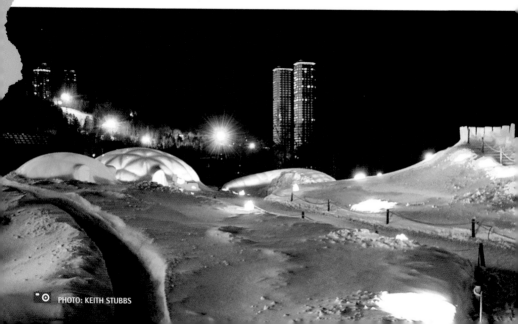

PHOTO: KEITH STUBBS

There aren't many resorts in Japan that can boast these arrays of options.

There are a few downsides to Tomamu, one of which is the dated lift system. It's comprised of a number of slow double and single chairlifts that access the bowl area and the terrain park, plus a rickety gondola. There are two high-speed detachable chairs but they access the smaller peak of the two. The other negative is the lack of a town. Tomamu does have a very comprehensive hotel complex with many great facilities, but it is just a series of hotels, so whilst it is very comfortable it doesn't provide much of a culture experience.

Powder

The powder here is light and dry and the off-piste options are in abundance. Powder days certainly aren't quite as frequent here as they are in the Western areas of Hokkaido, but when it does snow the quality is usually very high. Those who like to ride the trees need to head straight up the gondola and explore the options found in the Bowl Area. However, to ski or ride off-piste here you need to register with Ski Patrol first in the main Resort Centre at the gondola base. They will then ask you to wear a bib and a helmet; a little strange but hey, at least they allow tree skiing/riding here. The area known as Under 4 is also worth some runs and is found under chair number four, funnily enough. Wow, a resort that actually allows you ski and ride underneath the chairlifts!

Those in search of the highest quality powder are best off on a cat or heli tour, taking you into the

backcountry peaks. The cat tours are suitable for intermediate to advanced skiers/riders who are comfortable in the trees and off-piste. There's nothing super-steep on these tours, so don't go out expecting to drop big cliffs or straight line 45° faces. The heli tours are more suited to advanced skiers/riders as the pitch can get up to 40° in some places.

At this stage Tomamu only offers these heli tours a small number of days per season, so you have to get in quick to secure a spot – they post the dates during October every year. The cat tours are scheduled every weekend but you usually need to book a week or so in advance. They can be a little on the pricey side, but it's one of the few places in Japan that you can partake in such backcountry activities, so it's probably worth the cash.

Park

Tomamu's snow park, known as 'Slope Style', is found under lift No.7. To get there you need to head up the gondola and take a cat track along the ridge. When you arrive you're likely to find a perfectly shaped pipe and a well-sculpted park, suitable for all levels of rider, except maybe the pros.

There are usually two superb double-takeoff step-down jumps with gaps varying in length from 6 to 16 metres (approximately 20 to 50 feet). There's a series of boxes and rails, from C shapes and rainbows to flat bars and double kinks. Near the bottom of the park Tomamu maintains a few smaller jumps for the novice freestyle riders among us. All these features are

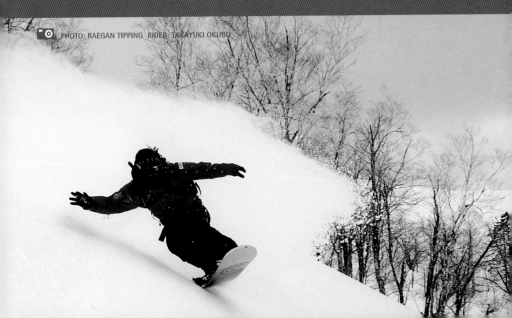

PHOTO: RAEGAN TIPPING RIDER: TAKAYUKI OKUBO

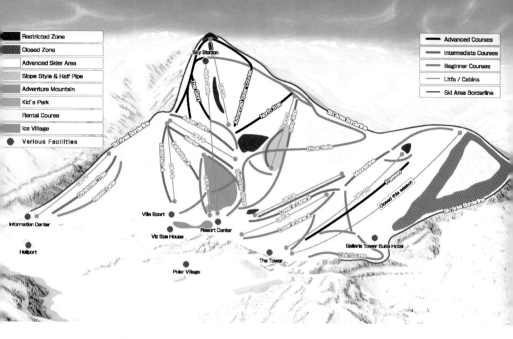

maintained to perfection and the park often closes for 30mins at launch time to re-shape the features. This resort truly prides them selves on their quality terrain park.

As for the halfpipe, it's usually more of a superpipe with walls approaching 6 meters (or 18 feet), and is truly impeccable. It's earth-shaped – dug out of the ground in the summer months – and usually opens in January. The transitions are cut to perfection, providing the ideal place for those wanting to expand their bag of tricks or simply those just learning to get up the walls. What's more amazing is that it rarely gets very busy; unusual for a pipe of this quality.

Piste

There's a good selection of groomed runs at Tomamu, from fairly steep to almost flat. The most consistent groomers are found off of chair 10, providing smooth corduroy suitable for all levels. The trails accessible from the gondola end in a long, flat ride back to the base so keep your eyes open and your speed up. This flatter section of the resort can become annoying if you're lapping the gondola so it's best to stick to the higher chairlifts if you prefer a consistent pitch. However, this mellow terrain is great for learners and ideal for

kids – they have a few hidden tree-lined play runs specifically designed for children.

Beginner suitability

Beginner skiers and boarders are well catered for at Tomamu. They have a Salomon learn to ski programme and a Burton Learn To Ride centre (LTR). The runs accessible from lift No.3 are perfect to learn to turn on, after which you should look to lift No.2 for a bit more of a challenge. Tomamu have terrain that's ideal for slowly progressing your skill base, with trails for every level from absolute beginner upwards. The kids-specific runs are amazing and offer a whole bunch of fun features to play on. There are English-speaking instructors available, but it's still a good idea to book ahead of time if that's what you require.

Off the slopes

As previously mentioned, there's no ski town at Tomamu resort. The closest community is a 10min drive away, so whilst convenient it doesn't really support the tourist trade. Tomamu is basically a resort complex with a nice selection of hotels, self-contained apartments, restaurants and leisure facilities. It's certainly extensive and there's a whole range of pricing options available. However,

it's still a complex as opposed to a real town. Head to the Viz Spa House after a hard days riding and relax in the wave pool or spa baths, and take some time to explore the wonders of the Ice Village – an incredible selection of igloo-style sculptures that includes a bar. Like many Japanese resorts, but unlike those in Europe and North America, the same company that runs the mountain owns the whole resort complex as well. This has its downsides but it does mean you can find some reasonably priced package deals – accommodation generally comes with your lift tickets and meals included.

The selection of eating establishments is reasonable. Within the area known as Forest Mall you'll find a decent seafood restaurant under the name of Ippuku. Alternatively there's an interesting mix of offerings at Yamase; try the Chicken in Japanese Plum Sauce for a tasty starter. If you're keen for a wider selection, head to Nininupuri for a large all-you-can-eat buffet. It serves an equal mix of Japanese and Western cuisine and offers an all-you-can-drink for a ridiculously cheap price. Unfortunately the breakfast options at Tomamu are not quite as extensive. You are limited to just two options and they're located at either end of the resort complex.

The biggest letdown of the Tomamu resort complex is the lack of nightlife – it's pretty much non-existent. There is the odd bar in some of the hotels, but they're really just a 'sit-down-and-relax' kind of place and are rather over-priced. If you're looking for good party resort Tomamu is not the place for you.

Access

Tomamu has its own train station just a few minutes drive to the chairlifts on their courtesy shuttle. The Sekishou-sen line runs straight from Sapporo City direct to the resort taking around 1hr 30mins, and with just one train change it's also pretty quick and easy to get here from Sapporo's New Chitose's Airport. Driving to Tomamu from Sapporo takes a little longer, but it's less than an hour from Furano, and shuttle buses run on selected days.

PHOTO: KEITH STUBBS

Asahidake

Hokkaido's highest peak with mega lift-accessible backcountry!

The Asahidake Ropeway is just a single cable car that accesses some extensive backcountry terrain. This ski resort – although not really a resort – is the epicentre for many of Hokkaido's backcountry skiers and snowboarders. It has an at-your-own-risk policy and only closes terrain when it's absolutely necessary. However, if you're keen to explore this mountain make sure you; a) have all the correct gear and b) know exactly what you're doing. If you fall short on either of those, it's quite simple, HIRE A GUIDE!

The lift itself deposits you at 1,600m above sea level, some 700m below the summit. Whilst that doesn't sound particularly impressive, it's still the highest lift in Hokkaido and, considering most resorts' lifts are under the 1,000m mark, it's a reasonable difference. From the top lift station there are two long groomed trails winding their way back to the base and many a hiking route available to those with a more adventurous mindset. It's worth noting that whilst the cost of a day pass is very reasonable, the cable car only departs every hour and doesn't run continuously. Time your missions so you arrive back 5mins to the hour and you'll be set – quick bathroom break and back on the ropeway for the short 10min journey up again.

Powder

The off-piste terrain here is extensive, the snowfall is almost limitless and the options to explore new lines are seemingly endless. Whilst the terrain is excellent, it's not just extreme steeps to be found here and there are flatter areas lower down that are best avoided. You'll come across very few signs here and the off-piste sections aren't named, so finding your way to the goods is tricky from description alone. Take the red trail from the top of the cable car and check out the steeper section on skiers left near the top, or on skiers right about half way down as the run merges into a black. On

★★★★★ POWDER	Epic lift-accessible backcountry!	
★★★★★ PARK	Ain't no park here	
★★★★★ PISTE	Go to Furano if you want piste	

Average
200
150
100
50
0
NOV DEC JAN FEB MAR APR

3 RUNS

Metres
◄ 1600 Height
ADV 50% 500 Vert Drop
INT 50%
◄ 1100 First Lifts
30° Slope Pitch

TOURIST INFO
Web: www.wakasaresort.com/eng

RESORT
Open dates: early Dec – May
Night Skiing: not available
Longest run: 3.5km
Total Lifts: 1 – 1 Gondola
Average Snowbase: 4m
Average Snowfall: 12m

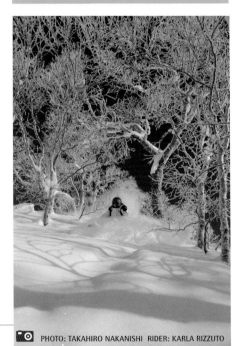

PHOTO: TAKAHIRO NAKANISHI RIDER: KARLA RIZZUTO

the map – it's not a real trail map, but does show the contours of the terrain – there are two avalanche-prone areas highlighted red. Both sections are well worth a look if you're an expert, but you'll need to hike for the best stuff. These are known to slide frequently, so be very careful.

Of course, there are drawbacks to such an untamed freeriding paradise. Asahidake, being the highest peak on this island, attracts some hefty storm systems and weather can deteriorate quickly to levels not uncommon in parts of the Alps (European and New Zealand's Southern). Asahidake's inland location within Hokkaido means the snow is usually very dry, but that doesn't stop the snow becoming unstable and avalanches happening. So carry all your avy gear and know how to use it. Alternatively, go and seek the services of knowledgeable locals like Hokkaido Powder Guides, based in Furano town.

Park

Asahidake doesn't have and doesn't need a terrain park. This is a backcountry skier's and rider's mountain, so those in search of freestyle will have to adapt and utilise the natural terrain on offer. You'll find plenty of well-formed windlips, drops and banks to play on, but if it's manmade features you seek then you're best off heading to Tomamu.

Piste

With only two main trails – although they class it as four by dividing the upper and lower sections – there isn't much to satisfy the hungry carver or intermediate piste cruiser. Course A has the steepest groomed pitches and keeps an average gradient of around 20°. Courses B and C are more mellow, with the latter of the two getting rather flat towards the bottom. In truth, if wide trails with well-manicured corduroy is what you're looking for then head to Furano Ski Resort instead.

Beginner suitability

This is not a beginner's mountain in a way, shape or form. No lessons, no learner areas and no easy lifts! Tomamu, Furano and Kamui are all a better choices if you're a novice skier or rider.

Off the slopes

With just one base building there isn't much in the way of facilities, but that's not what this place is about. There's a café serving hot food for decent prices, drinks machines to purchase your hot coffee-in-a-can and a small shop in case you forget your gloves. That's all you really need!

Access

Getting to Asahidake is best done with a guiding company. However, people do hire a car and drive themselves. It's about 1hr and 30mins from Furano town, but you're likely to need a 4WD. Alternatively, there is a bus twice a day from Asahikawa that takes 1hr 45mins.

PHOTO: JAMES MUTTER

Furano Ski Resort

Perfect corduroy, but no park and no off-piste allowed.

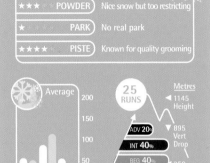

★★★	POWDER	Nice snow but too restricting
★	PARK	No real park
★★★★	PISTE	Known for quality grooming

Owned by the Prince Hotels Group, Furano Ski Resort is one of the major players in Hokkaido's bubbling ski industry. Furano's in-land location means the snow settles light and dry, it also means it gets pretty chilly throughout the months of January and February – down filled jackets come in real handy. As one of Japan's more famous ski areas, Furano has played host to the World Cup Snowboard and numerous FIS Ski Races, although like most resorts in Japan it's still relatively unknown in the Western world.

The ski resort is split into two areas, the Kitanomine Zone and the Furano Zone. Throughout both areas you'll find a good selection of terrain suitable for most levels of skier and snowboarder, in addition to some pleasing night skiing. The lifts range from tiny single-chairs through to comfortable Gondolas. The ropeway (or cable car) on the Furano Zone is super quick, whisking 101 people at a time up to the top in just 5mins. There always seems to be a few un-used lifts here but the lack of people means you'll hardly ever wait in a line – except early season when ski race kids flock here from all over Japan. The resort is serviced well through the long-standing tourist destination of Furano Town. Found in central Hokkaido, Furano is best accessed from Asahikawa City – car, bus or train, take your pick. Travelling from Sapporo is also an option, although it takes a little longer. Train is certainly not recommended here.

Powder

In some respects the freeriding here is very admirable: some averagely steep terrain, exciting trees and amazing powder. However, Furano maintain a rigorous 'no off-piste' policy restricting you to the marked runs only – a rule in which the

Average
200
150
100
50
0
NOV DEC JAN FEB MAR APR

25 RUNS

ADV 20%
INT 40%
BEG 40%

34° Slope Pitch

Metres
◄ 1145 Height
▼ 895 Vert Drop
250 First Lifts

TOURIST INFO
Web: www.furanotourism.com
RESORT
Open dates: late Nov – early May
Night Skiing: 5pm– 9pm, 8 runs open
Longest run: 4km
Total Lifts: 10 – 2 Gondolas, 2 Express chair-lifts, 6 Regular Chairlifts
Average Snowbase: 2m
Average Snowfall: 8m

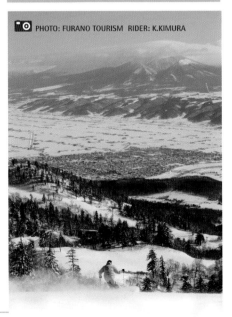

PHOTO: FURANO TOURISM RIDER: K.KIMURA

Ski Patrol are known for enforcing. Having your pass pulled, or at the minimum getting an earful of harsh-sounding Japanese, can really lower the tone of your day. Nevertheless, if you're happy to play a wee bit of 'cat and mouse' you can snake constant fresh lines many days after a storm.

The most challenging terrain is found in the Kitanomine Zone; keep your eyes open when riding the Gondola and the Link Lift and you'll spot the goods. Ideally, if you're good at meeting new people, befriend a local to show you the best lines but remember to return the favour later with a few rounds of sake. If you're content to play by the rules here you will discover a good few marked trails that the cat drivers leave un-groomed. These can be fun on a powder day but usually get tracked out fairly quickly, leaving some sizable bumps behind. For the better of the un-groomed runs head up the Downhill Lift No.3 or hit the bowl known as Kumaotoshi C (when it's open) found at the top of the Gondola.

Park

With Furano being a previous stop on the World Cup Snowboard circuit you would expect the freestyle facilities to be in abundance. Well, this is certainly not the case! Their attempt at a park, usually located at the bottom of the Gondola, is very poor and consists of one jump with a very flat run-in, plus the occasional lame jib feature. For a resort of this size, it's quite astounding that the Furano management are simply not interested in maintaining a terrain park and attracting the freestyle crowd.

Furano does occasionally offer a halfpipe, which is found on a run named Prince C near the Furano Zone base. When built and operational, the pipe is of a decent size with walls around the 6m mark and it's a good length too. The Furano Management don't always acknowledge that they even have a pipe, so you might find there's nothing more than a hole in the ground. Having said that, it's known for being in its best shape late February onwards. This is a very 'hit-and-miss' situation.

Piste

This is where Furano really prides itself. Those in search of fine corduroy will be content at this resort for days on end. Furano maintains a large variety of pistes, at different degrees of difficulty, all with near-perfect grooming. They even groom over two foot of fresh, much to the dismay of powder lovers. When

PHOTO: TAKAHIRO NAKANISHI

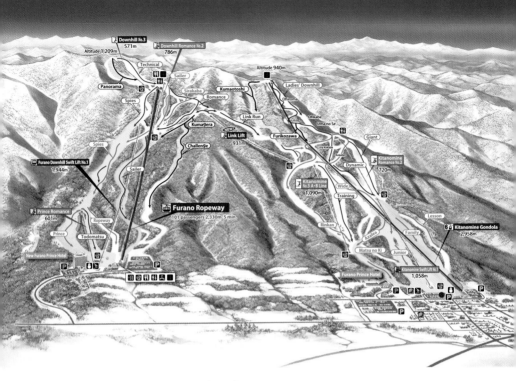

skiing or riding in the Furano Zone head to Speise C and Sailor C for some nice long cruisers.

In the Kitanomine Zone ride the trails off of the Swift Lift No.1 if you prefer to take it easy, or check out Ladies Downhill C and Giant C for something a little steeper. There's a few flat cat tracks dotted around to watch out for – the connecting trails between the resort's two different zones can catch you out if you put in too many turns.

Beginner suitability

The lower half of both zones accommodate beginners nicely. Lessons are predominantly given in the Kitanomine Zone using the Swift Lift No.1. Here you have an ideal gradient and fall line to get your turns flowing. In the Furano Zone beginners have a short 3-man chair named Prince Romance accessing a small selection of mellow runs. If you've got the legs for a longer ride head up the 4-man chair found at the same location. Those seeking lessons can be accommodated at a number of different ski schools, most of which have English-speaking instructors.

Off the slopes

As mentioned previously, Furano Ski Resort has it's own service town – or more like, Furano Town has it's own ski resort. The town is fairly spread out with the centre being around 20mins walk from the Kitanomine base area and quite a bit further from the Furano base, although there is a free bus service that operates until about 10pm. Furano town is a popular holiday destination throughout Japan and is actually busier in the summer months than in winter. Facilities on the mountain are adequate. There are a number of places to eat in both zones that appeal to most budgets and standard base facilities such as lockers and parking.

Access

There's a direct train line available from Asahikawa City taking under an hour. Taking the train from Sapporo isn't as easy and requires a change en-route. It takes about 3hrs to drive from Sapporo New Chitose Airport but only 1hr from Asahikawa Airport. Alternatively there are plenty of bus options too, all taking about 4hrs from Sapporo City or New Chitose Airport.

Kamui Ski Links

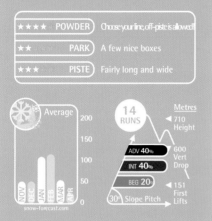

★★★★ **POWDER** Choose your line, off-piste is allowed!

★★ **PARK** A few nice boxes

★★★ **PISTE** Fairly long and wide

Average

200
150
100
50
0
NOV DEC JAN FEB MAR APR
snow-forecast.com

14 RUNS

Metres
◄ 710 Height
ADV **40%** — 600 Vert Drop
INT **40%**
BEG **20** — ◄ 151 First Lifts
30° Slope Pitch

TOURIST INFO
Web: www.kamui-skilinks.com

RESORT
Open dates: Dec – late March
Night Skiing: not available
Longest run: 3.5km
Total Lifts: 5 - 1 Gondola, 4 Regular Chairlifts
Average Snow-base: 3m
Average Snowfall: 9m

An open-terrain policy but the lifts are passed their prime.

Located just a stones throw away from Asahikawa City, Kamui Ski Links is a relatively old and simple resort with a forward-thinking management team. It has an open-terrain policy allowing you free reign in your quest for fresh tracks. Kamui receives the typically dry central-Hokkaido powder and plenty of it too. In addition, Mother Nature seems to allocate them a large amount of blue-sky days so you can be sure to catch some rays whilst riding the slow chair lifts.

Accompanying these old fixed-grip chairlifts is a limited base building with a café and some other standard facilities. Parking is ample and skier numbers never seem particularly high, so there's no need to worry about waiting in lines anywhere on the hill. This is not a destination resort and is best when visited on a day-trip from the nearby resort town of Furano. Pick your day well and you will be rewarded!

Powder

Unlike the 'big brother' resort of Furano, Kamui's Management have an applaudable approach to riding the trees and backcountry. There are no in-bound restrictions as long as you pass through the correct gates and heed the signs. Patrol will come and rescue any injured skiers/riders and will NOT confiscate your pass. Wow, that's refreshing!

The Panorama Course and the terrain found below the gondola is always fun on a powder day; with plenty of shouts of "pillow lines" and "yeeeow" transpiring. The area next to Shinsetsu Course, found off of chair No.5, is also good – don't wait too long though, it's popular with the locals and can get tracked quickly. Check out the trees either side of the Shirakaba Course for some late-in-the-day freshies. Accessing the backcountry from the top of the resort is also possible. There's very

HOKKAIDO

📷 PHOTO: TAKAHIRO NAKANISHI

limited English-language signage and, as usual, knowing where to go is essential – so it's worth joining a guided trip or, at the very least, inheriting some local knowledge before you depart.

Park

The terrain park at Kamui is pretty limited. Near the bottom of the gondola you're likely to find a small-to-medium sized tabletop or two, plus a few boxes and rails. There's a real nice flat-down kink rail just waiting to be slid with a little 'gap-to-down' action. Other than that the features are fairly basic, although popular with the local shredders coming out of Asahikawa City. There are quite a few natural hits to be discovered in the off-piste area next to the Shinsetsu Course. Also, keep your eyes peeled for the mighty step-up built into a bank somewhere – it's not too hard to find but you'll need a serious amount of speed.

Piste

From Kamui's gondola, landing you at the top of the resort, you can access a nice variety of groomed trails. If you like it steep and fast hit up the Silky Course accessible from the top of the gondola, or the Dynamic Course off of chair No.5. The grooming here is good, but the majority of slopes are south facing so it's best to get up early and enjoy the trails before they get too much sun.

Beginner suitability

The lower half of Kamui Ski Links has a nice selection of easy green runs accessible from both chairs 1 and 4. When you're feeling confident, head up the gondola and give the Crystal Course a whirl. Whilst there are certainly enough options here to keep beginners content for a day or two, Kamui is very much a mid-sized resort and not the place for weeklong visits.

Off the slopes

With only two on-mountain cafes and no service town, the eating options here are limited. Your best bet is to take lunch in 'The Den Café 751', found at the top of the gondola. It has a chilled vibe and serves some tasty, hot Western and Japanese style snacks. When visiting Kamui you're best off staying in the town of Furano. Asahikawa City has plenty of options for accommodation and food, however it's generally just a gateway to inland-Hokkaido and not your typical ski holiday destination.

PHOTO: RAEGAN.TIPPING RIDER: KEITH.STUBBS

Access

Kamui is less than 30mins drive from Asahikawa City, but more like an hour from Furano. Via train, it's only about 20mins from Asahikawa to Fukagawa and a further 20 on a shuttle bus to the resort itself. There are also some slightly irregular bus services from Furano town.

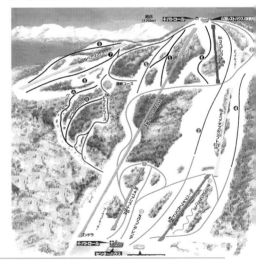

An interview with Hisayuki Kojima: Ex-Professional Alpine Snowboarder, Coach and Pension Owner.

Hi Kojima-san, thanks for taking the time to sit down with us. Firstly, can you tell us a little about yourself?

"Yes, I am an ex-Alpine Snowboard Racer who competed at World Cup level internationally. I am a coach and work with a few of Japan's current top Alpine Snowboarders. I also own a Pension, BBQ Restaurant and Café/Bar, here in Furano."

When did you start out as a pro and how long did you compete for?

"I started racing professionally when I was 23 and kept on racing till I was 36. I used to be a high school teacher of Physical Education and this got me into coaching."

You've competed all over the world in many different events, what are some of the more memorable places & competitions?

"I came 1st in the South America Continental Cup in Chile. That was my best placing internationally and I like Chile a lot."

Where's the best place you've ridden in the world and how do you think it compares to Japan?

"The glacier of Pitztal in Austria. It's great for me because Japan doesn't have any glaciers."

Where are some of your favourite places to ride in Japan – and why?

"Furano - for its piste grooming and snow conditions, and the cat drivers are very good. Then Asahidake for the off-piste – it's very easy to get to good terrain there."

So you've retired from competitive riding, do you still get much time on snow – you do some coaching, but your accommodation & restaurant business must take up a lot of your time?

"It's no problem; I get enough time on snow because I have some excellent staff. During the winter here I get about 100 days on snow. Then I still get to travel as a coach, maybe one or two months in Austria and a few weeks in New Zealand if I'm lucky."

What's different about Furano town when compare to other Japanese ski towns?

"In Furano all the guests can enjoy skiing and snowboarding at their own pace and level. Many people come to Furano again and again, because the town offers something for everyone. And, Furano has appeal for both summer and winter tourists. It's a very special place to me and I enjoy sharing it with all the visitors that come here."

For more information visit www. kojimaacademy.com / www. snowflake-factory.com

Other resorts in Hokkaido

Kurodake, Central-Hokkaido

Found in Central Hokkaido's Daisetsuzan National Park, Kurodake is an off-piste orientated ski area with just 2 lifts and 3 marked trails. The main lift is a 3km long cable car and is followed by a small double chair, together ascending up the 850m of vertical to 1520m.

The cable car closes for some periods of the winter for maintenance work, typically in January and February. Overall, Kurodake is known to offer good intermediate tree skiing, excellent backcountry access and some seriously hardcore freeride terrain, complete with hefty cliff drops.

Sahoro Resort, Central-Hokkaido

A mid-sized ski area within an hour drive of Furano Sahoro is commonly known as a Club Med resort offering all-inclusive ski activity weeks.

MAP: KURODAKE

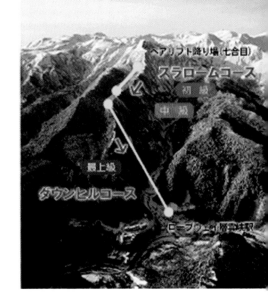

MAP: SAHORO

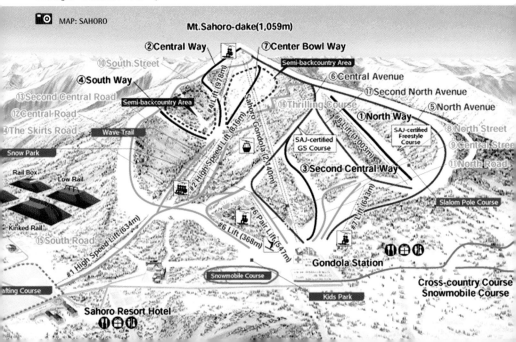

With a gondola and a few different chairs (8 lifts in total), spread out over 610m of vertical rise, this is an area that has options for most type of snow goer.

There's a park and a little off-piste but, most notably, they often re-groom some trails during the day, meaning fresh corduroy can still be enjoyed after a good sleep in.

Niseko Moiwa, – West-Hokkaido

Moiwa is the little cousin to the three Niseko United ski areas. A quiet alternative to the bubbling resorts round the corner, Moiwa is fun and worth a day trip but fairly limited terrain-wise.

With just 2 chairlifts, 7 marked runs and only 470m of vert, this is certainly much smaller than the other resorts in West Hokkaido. It's known among skiers in Hokkaido for hosting some quality race training and events, but does offer some reasonable off-piste too.

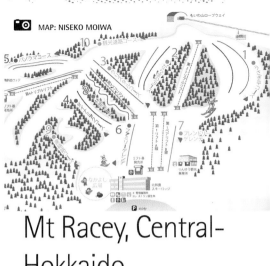

MAP: NISEKO MOIWA

Mt Racey, Central-Hokkaido

A smaller resort found halfway between Sapporo City and Furano. Mt Racey offers 5 different lifts accessing 14 trails over a 408m vertical drop, and mainly caters to local intermediate skiers with large school groups visiting frequently. It does have some form of a terrain park, a bit of night skiing, one steeper un-groomed run but no real off-piste to speak of.

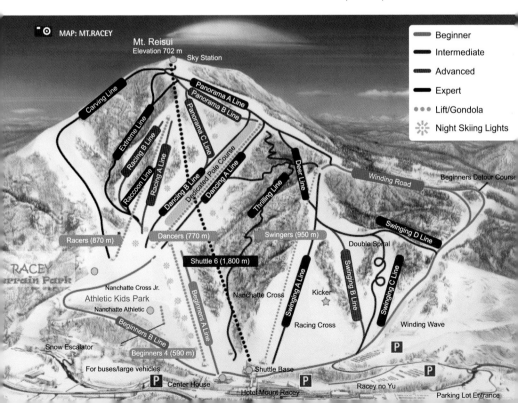

MAP: MT.RACEY

Language Guide

A little understanding here will go a long way on the slopes or in the restaurants of Japan!

When Westerners start learning the Japanese language, they are often confused by the pronunciation used when they see Japanese written in their native Roman alphabet. In order to be able to speak and communicate well in simple Japanese, it is important to first take a few moments to understand a little about how to pronounce Japanese syllables. A little understanding here will go a long way on the slopes or in the restaurants of Japan! So lets get started.

Japanese pronunciation is actually quite simple. There are no complex pronunciations such as the "th" sound or differing "R" and "L" sounds that we have in English. In fact, I think it is safe to say there are no pronunciations in the Japanese language that we do not have in the English language.

Firstly, there are 5 main vowel sounds, namely a, i, u, e, o. Their pronunciation is the same as English phonics, i.e. "a" as in "apple", "i" as in "ink", "u" as in "umbrella", "e" as in "egg", and "o" as in "orange".

More complex syllables are pronounced by adding one or two consonants before each vowel. For example, "ka" as in "cabin", "sa" as in "sad" "chi" as in "children", and "shi" as in "shiver".

Japanese also contains long vowel sounds, but these can often be mistaken for English pronunciations when written in alphabetical characters. If you see two vowels together, assume that they are an extension of the regular vowel sound. So for example, the Japanese for "big" is "ookii", with the "oo" sound read as "oh" (as in oh dear!) as opposed to the "oo" sound in "book" or "look".

Common everyday phrases

English	Japanese	Pronunciation
Hello	こんにちは	Konnichiwa
Good morning	おはようございます	Ohayo gozaimasu
Good evening	こんばんは	Konbanwa
Good night	おやすみなさい	Oyasumi nasai
Goodbye	さようなら	Sayonara
Thank you	ありがとうございます	Arigato gozaimasu
Please (when you are asking for an item e.g. in a store)	をください o kudasai
Please (when you are asking someone to do something for you)	おねがいします	Onegai shimasu
Yes	はい	Hai
No (the answer to a question)	いいえ	Iie
No (if someone says/does something that is incorrect. E.g. if the waiter brings the wrong food to your table)	違います	Chigaimasu
Excuse me	すみません	Sumimasen
Sorry, I don't understand	すみません、分かりません	Sumimasen, wakarimasen

English	Japanese	Pronunciation
I don't speak Japanese	日本語が分かりません	Nihongo ga wakarimasen
Do you speak English?	英語を話せますか？	Eigo o hanasemasu ka?
Could you speak more slowly please?	もう少しゆっくりと話してください。	Mo sukoshi yukkuri to hanashite kudasai.
No good/not permitted	だめ	Dame
I'm sorry.	ごめんなさい	Gomen na sai

Numbers

English	Japanese	Pronunciation
One	いち（一）	Ichi
Two	に（二）	Ni
Three	さん（三）	San
Four	し（四）	Shi (or Yon)
Five	ご（五）	Go
Six	ろく（六）	Roku
Seven	しち（七）	Shichi (or Nana)
Eight	はち（八）	Hachi
Nine	きゅう（九）	Kyu
Ten	じゅう（十）	Juu

English	Japanese	Pronunciation
20	にじゅう（二十）	Ni-juu
30	さんじゅう（三十）	San-juu
40	よんじゅう（四十）	Yon-juu
50	ごじゅう（五十）	Go-juu
60	ろくじゅう（六十）	Roku-juu
70	ななじゅう（七十）	Nana-juu
80	はちじゅう（八十）	Hachi-juu
90	きゅうじゅう（九十）	Kyu-juu
100	ひゃく（百）	Hyaku
1,000	いっせん（一千）	Issen (or just sen)
10,000	いちまん（一万）	Ichi man
100,000	じゅうまん（十万）	Juu man

Number counting

Counters: In the Japanese language, different terms are used to count different things, so for example, flat objects such as sheets of paper are counted "ichi-mai, ni-mai", whereas larger printed matter such as books or magazines are counted "issatsu, ni-satsu" etc.

It is probably impossible to remember all of these for the sake of a holiday in Japan, so here are a few useful general counters that you can use to get the meaning across. Of course, simply using numbers will get the message across, but using these counting words may make life a lot easier.

English	Japanese	Pronunciation
One "item"	ひとつ（一つ）	Hitotsu
Two "items"	ふたつ（二つ）	Futatsu
Three "items"	みっつ（三つ）	Mitsu
Four "items"	よっつ（四つ）	Yotsu
Five "items"	いつつ（五つ）	Itsutsu

English	Japanese	Pronunciation
Six "items"	むっつ（六つ）	Mutsu
Seven "items"	ななつ（七つ）	Nanatsu
Eight "items"	やっつ（八つ）	Yatsu
Nine "items"	ここのつ（九つ）	Kokonotsu
Ten "items"	じゅっこ（十個）	Jukko

Days of the Week & Months

English	Japanese	Pronunciation
Monday	月曜日	Getsu yo-bi
Tuesday	火曜日	Ka yo-bi
Wednesday	水曜日	Sui yo-bi
Thursday	木曜日	Moku yo-bi
Friday	金曜日	Kin yo-bi
Saturday	土曜日	Do yo-bi
Sunday	日曜日	Nichi yo-bi

English	Japanese	Pronunciation
January	一月	Ichi gatsu
February	二月	Ni gatsu
March	三月	San gatsu
April	四月	Shi gatsu
May	五月	Go gatsu
June	六月	Roku gatsu
July	七月	Shichi gatsu
August	八月	Hachi gatsu
September	九月	Ku gatsu
October	十月	Juu gatsu
November	十一月	Juu-ichi gatsu
December	十二月	Juu-ni gatsu

Food and Dining

English	Japanese	Pronunciation
Do you have an English menu?	英語のメニューはありますか？	Eigo no menyu wa arimasu ka?
What are today's specials?	今日のおすすめは何ですか？	Kyou no ossusume wa nan desu ka?
What do you recommend?	おすすめは何ですか？	Osusume wa nan desu ka?
I am a vegetarian.	私はベジタリアンです。	Watashi wa bejitarian desu.
I am a vegetarian. (version 2)	私は菜食主義者です。	Watashi wa saishoku shugi sha desu.
I cannot eat meat.	私は肉が食べられません。	Watashi wa niku ga taberaremasen.
I cannot eat fish.	私は魚が食べられません。	Watashi wa sakana ga taberaremasen.
I cannot eat meat or fish.	私は肉と魚が食べられません。	Watashi wa niku to sakana ga taberaremasen.
Does this contain meat?	この食べ物には肉が入っていますか？	Kono tabemono ni wa niku ga haitteimasu ka?
Does this contain fish?	この食べ物には魚が入っていますか？	Kono tabemono ni wa sakana ga haitteimasu ka?
Does this contain meat stock?	この食べ物は肉のだしで作られていますか？	Kono tabemono wa niku no dashi de tsukurarete imasu ka?
Does this contain fish stock?	この食べ物は魚のだしで作られていますか？	Kono tabemono wa sakana no dashi de tsukurarete imasu ka?
Does this contain any traces of nuts?	この食べ物には少しナッツが入っていますか？	Kono tabemono ni wa nattsu ga haitteimasu ka?
Do you have anything without meat or fish?	肉と魚が入っていない食べ物はありますか？	Niku to sakana ga haitteinai tabemono wa arimasu ka?

English	Japanese	Pronunciation
Do you have an "all-you-can-drink" plan?	飲み放題プランはありますか？	Nomi houdai puran wa arimasu ka?
Do you have an "all-you-can-eat" plan?	食べ放題プランはありますか？	Tabe houdai puran wa arimasu ka?
Do you have an "all-you-can-eat-and-drink" plan?	食べ飲み放題プランはありますか？	Tabe nomi houdai puran wa arimasu ka?
(We will) pay separately.	別々で払います。	Betsu betsu de haraimasu.
(We will) pay together.	一緒に払います。	Issho ni haraimasu.
Ramen noodles	ラーメン	Ramen
Buckwheat noodles	そば	Soba
Udon noodles	うどん	Udon
Rice	ライス	Raisu
Rice (alternative)	ご飯	Gohan
Bread	パン	Pan
Fish	魚	Sakana
Beef	牛肉	Gyuu niku
Pork	豚肉	Buta niku
Lamb	ラム肉	Ramu niku
Chicken	鶏肉	Tori niku (or "Chicken")
Vegetables	野菜	Yasai
Salad	サラダ	Sarada
Pickles	お漬け物	Otsukemono
Cheers!	乾杯！	Kanpai!

Bar and Nightlife

English	Japanese	Pronunciation
Do you have a seating (charm) charge?	チャームチャージがありますか？	Chaamu Chaaji ga arimasu ka?
Do you have an all-you-can-drink system?	飲み放題プランはありますか？	Nomi houdai puran wa arimasu ka?
How much is 1 beer?	ビール一杯でいくらですか？	Biiru ip-pai de ikura desu ka?
1 beer please.	ビールを一つください。	Biiru o hitotsu kudasai.
Whiskey & water	ウィスキー水割り	Uisukii mizu wari
Shochu spirit	焼酎	Sho chu
Sake	日本酒	Nihon shu
Oolong tea (cold)	ウーロン茶	Ooron cha
Cocktails	カクテル	Kakuteru
Could you call me a taxi please?	タクシーを呼んでください。	Takushii o yonde kudasai.
Could I have the bill please?	お会計をお願いします。	Okaikei o onegai shimasu.
What time do you open?	お店は何時から開いていますか？	Omise wa nan ji kara aiteimasu ka?
What time do you close?	お店は何時に閉まりますか？	Omise wa nan ji kara shimarimasu ka?
Can I buy you a drink?	一杯ごちそうしてもいいですか？	Ippai gochiso shitemo ii desu ka?

Around Town

English	Japanese	Pronunciation
Hotel	ホテル	Hoteru
Convenience Store	コンビニ	Konbini
Supermarket	スーパー	Suupaa
Drug store/chemist	薬屋さん	Kusuri ya san
Bank	銀行	Ginko
Post office	郵便局	Yubinkyoku
Bus stop	バス停	Basu tei
Taxi rank	タクシー乗り場	Takushii noriba
Souvenir shop	土産物屋	Miyagemono ya
Restaurant	レストラン	Resutoran
Izakaya	居酒屋	Izakaya
Coffee shop	コーヒーショップ／喫茶店	Ko-hi- shoppu/kissaten
Ramen shop	ラーメン屋	Ramen ya
Soba noodle restaurant	そば屋	Soba ya
Sushi restaurant	寿司屋	Sushi ya
Hospital	病院	Byouin
Sports shop	スポーツ店	Supootsu ten
Airport	空港	Kuuko
Train station	駅	Eki
Ski hill	スキー場	Sukii jo
Onsen/hot spring	温泉	Onsen
Car park	駐車場	Chuusha jo
Police station	交番	Koban
Tourist information	観光案内所	Kanko annai jo
Turn left	左に曲がる	Hidari ni magaru
Turn right	右に曲がる	Migi ni magaru
Go straight	まっすぐ	Massugu
Across from ~	～の向かいに	~ no mukai ni
Next to ~	～のとなりに	~ no tonari ni
How do I get to ~	～へはどうやって行けばよいですか？	~ e wa doyatte ikeba yoi desu ka?
Please help me, I'm lost!	助けてください！道に迷いました！	Tasukete kudasai! Michi ni mayoimashita !

Hotels

English	Japanese	Pronunciation
I'd like to check-in	チェックインしたいのですが。	Chekku in shitai no desu ga.
I'd like to check-out	チェックアウトしたいのですが。	Chekku auto shitai no desu ga.
Do you have any vacancies	お部屋は空いていますか？	Oheya wa aiteimasu ka?
Do you have room service?	ルームサービスはありますか？	Ruumu saabisu wa arimasu ka?
Smoking room	喫煙室	Kitsuen shitsu
No-smoking room	禁煙室	Kin'en shitsu
International telephone	国際電話	Kokusai denwa
Restaurant	レストラン	Resutoran
Bar	バー	Baa
Bell-boy	ベルボーイ	Beru boui
Sauna	サウナ	Sauna
Gym	ジム	Jimu
Hot spring	温泉	Onsen
Public bath	銭湯／大衆浴場	Sento/Taishu yokujou
One night	一泊	Ippaku
Two nights	二泊	Nihaku
Three nights	三泊	San paku
Four nights	四泊	Yon haku
Five nights	五泊	Go haku
Six nights	六泊	Roppaku
Seven nights	七泊	Nana haku
Is there a youth hostel nearby?	近くにユースホステルはありますか？	Chikaku ni yuusu hosuteru wa arimasu ka?
I have a reservation.	予約してあります。	Yoyaku shite arimasu.
I'd like to make a reservation	予約をしたいのですが。	Yoyaku o shitai no desu ga.
Can I pay by credit card?	クレジットカードで支払えますか？	Kurejitto kaado de shiharaemasu ka?

Travelling by rail

English	Japanese	Pronunciation
Single ticket	片道	Katamichi
Return ticket	往復	Oofuku
One person	一人	Hitori
Two people	二人	Futari
Three people	三人	San nin
Does this train go to Sapporo?	この列車は札幌へ行きますか？	Kono ressha wa Sapporo e ikimasu ka?
What time does the Sapporo train depart?	札幌行きの列車は何時に出発しますか？	Sapporo iki no ressha wa nan ji ni shuppatsu shimasu ka?
Which platform does the Sapporo train depart from?	札幌行きの列車はどのプラットホームから出発しますか？	Sapporo iki no ressha wa dono purattohoomu kara shuppatsu shimasu ka?
How much is a return ticket to Niseko?	ニセコまでの往復券はいくらですか？	Niseko made no oofuku ken wa ikura desu ka?
Is this seat free?	この席は空いていますか？	Kono seki wa aiteimasu ka?
What time does this train arrive in Niseko?	この列車は何時にニセコに到着しますか？	Kono ressha wa nan ji ni Niseko ni tochaku shimasu ka?

Driving

English	Japanese	Pronunciation
Driving license	運転免許証	Unten menkyo sho
Manual transmission car	マニュアル車	Manyuaru sha
Automatic transmission car	オートマ	Outoma
2-wheel drive	二輪駆動	Ni rin kudou (also know as "FF" – eff eff)
4-wheel drive	四輪駆動	Yon rin kudou (also known as "yon-ku")
Petrol	ガソリン	Gasorin
Can I have 1000 yen of petrol please?	千円分のガソリンをください。	Sen yen bun no gasorin o kudasai.
Full tank (fill-her up!) please.	満タンお願いします。	Mantan onegai shimasu
Self-service petrol station	セルフ（ガソリン）スタンド	Serufu (gasorin) sutando
How do I get to Niseko?	ここからニセコへはどうやって行けますか？	Koko kara Niseko e wa douyatte ikimasu ka?
How far is it to Niseko?	ニセコまでは何キロですか？	Niseko made wa nan kiro desu ka?
How long does it take to get to Niseko?	ニセコへ行くにはどれくらい時間がかかりますか？	Niseko e iku ni wa dorekurai jikan ga kakarimasu ka?
Turn left / Turn right	左へ曲がる ／ 右へ曲がる	Hidari e magaru / Migi e magaru
Go straight	まっすぐ	Massugu
Speeding	スピードをだし過ぎ	Supiido o dashi sugi
Accident / Road accident	事故 ／ 交通事故	Jiko / Koutsu jiko
Icy road / Blizzard	アイスバーン ／ 吹雪	Aisu baan / Fubuki
Police car	パトカー	Patokaa
Ambulance	救急車	Kyukyusha
Fire engine	消防車	Shoubousha

On the slopes

English	Japanese	Pronunciation
can i go over there?	あそこで滑っても大丈夫ですか?	Asoko de subettemo daijoubu desu ka?
is off-piste allowed?	コースから外れても大丈夫ですか?	Ko-su kara hazuretemo daijoubu desu ka?
That was a cool jump!	カッコ良いジャンプだよ!	Kakko ii jannpu da yo!
I like your skis/snowboard	いいボード (スキー) ですね!	Ii boudo (sukii) desu ne!
What's the snow like?	今日の雪はどうですか?	Kyo no yuki wa dou desu ka?
Powder snow	パウダースノー	Pauda suno
Fresh snow	新雪	Shin setsu
Sticky snow	べた雪	Beta yuki
Wet snow	湿雪	Shissetsu
Deep	深い	Fukai
Steep slope	急斜面	Kyuu syamen
Gentle slope	緩斜面	Kan syamen
Bumpy slope	荒れた斜面	Areta syamen
Mogul	モーグル	Mouguru
Danger	危ない (危険)	Abunai (kiken)
Avalanche	雪崩	Nadare
Warning	警告	Keikoku
Rescue	レスキュー	Resukyu
First aid kit	救急箱	Kyu kyu bako
Ski patrol	スキーパトロール	Sukii patororu
Help!	助けて!	Tasukete!
Chairlift	チェア・リフト	Chea rifuto
Cable car	ロープウェイ	Ro-pu uei
Gondola	ゴンドラ	Gondora
Beginner	初心者	Shoshinsha
Intermediate	中級者	Chukyuusha
Advanced	上級者	Jokyuusha
Summit	頂上	Cho jo
Off piste	オフ・ピステ	Ofu pisute
Valley	低地	Teichi
Icy	氷	Kouri
Rock	岩	Iwa
Lift ticket	リフト券	Rifuto ken
Slope	スロープ	Syamen
Piste	ゲレンデ	Gerende
Ski instructor	スキーインストラクター	Sukii insutorakutaa
Lesson	レッスン	Ressun
Meeting place	待ち合わせ場所	Machi awase basho
One lesson costs	一つのレッスン料金は__円です。	Hitotsu no ressun ryoukin wa _ en desu.

Index